# F·R·I·E·N·D·S
# FOREVER

· · · · · · · · · · · · · · · · · · · · · · · · · · · · · · · · · · · · · · · · · · ·

## THE ONE ABOUT THE EPISODES

GARY SUSMAN, JEANNINE DILLON & BRYAN CAIRNS

**HARPER** DESIGN
*An Imprint of HarperCollins Publishers*
www.hc.com

# FRIENDS FOREVER

HarperCollins books may be purchased for educational, business, or sales promotional use. For information please email the Special Markets Department at SPsales@harpercollins.com.

Published in 2019 by
Harper Design
*An Imprint of* HarperCollins*Publishers*
195 Broadway
New York, NY 10007
Tel: (212) 207-7000
Fax: (855) 746-6023
harperdesign@harpercollins.com
www.hc.com

Distributed throughout the world by
HarperCollins Publishers
195 Broadway
New York, NY 10007

Produced by becker&mayer!
an imprint of The Quarto Group

ISBN 978-0-06-297644-4

Printed in Canada

First Printing, 2019

All images courtesy of Warner Bros. Entertainment Inc.
All stock design elements © Shutterstock

# Contents

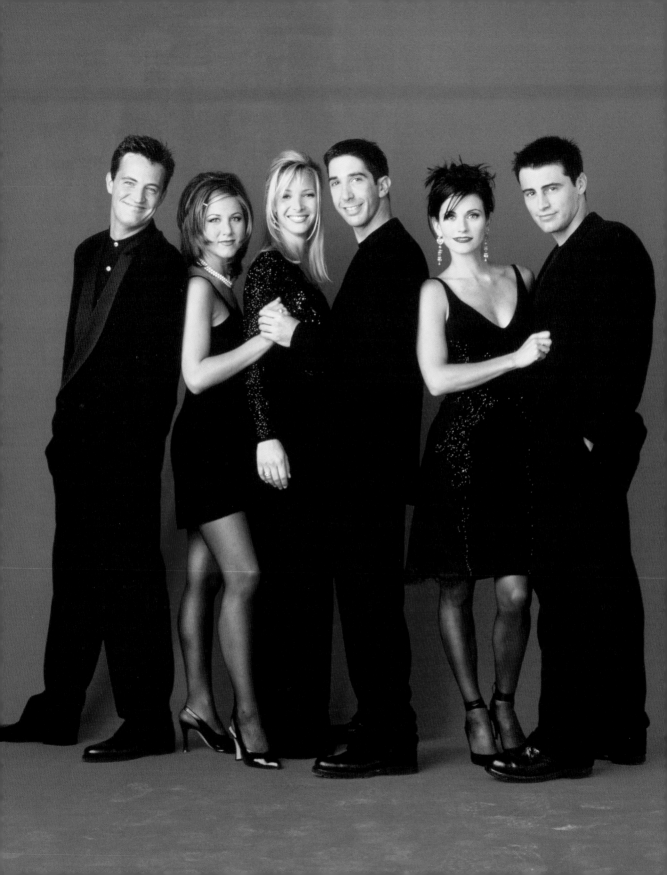

# The One About the Show

## "IT'S ONLY A TV SHOW."

· · ·

That's what *Friends* co-creators Marta Kauffman and David Crane used to tell each other, laughing about the pop-culture tsunami they'd created, as well as the attempts by scholars to explain its ever-widening impact and what it all meant.

Of course, if *Friends* really was "only a TV show," you wouldn't be reading this book. Really, it was never only a TV show. From the moment it debuted twenty-five years ago, on September 22, 1994, it was an out-of-the-box hit. It turned its little-known cast into paparazzi-hounded superstars, helped NBC create its unbeatable Thursday night "Must See TV" slate, expanded the range of permissible adult content on prime-time network television, influenced dozens of other shows, and became one of the most beloved series of all time. A quarter-century later, removed from all the history and hoopla, the ten seasons and 236 episodes of *Friends* still comprise one of the most popular and lucrative series ever created—a body of work that continues to endear itself to new generations of fans worldwide, including many fans born after the show went off the air in 2004.

It also got a decade of comic mileage out of a folk song about a stinky pet feline.

Okay, maybe it *is* only a TV show.

This book is a celebration of that show. In these pages, you'll read about how the show came together—everything from finding the absolutely perfect actors to play each of the six main characters to designing Monica's improbably vast apartment and the cozy coffee oasis that was Central Perk. In the episode guide, you'll read all the behind-the-scenes dish about how your favorite *Friends* moments came to be. And yes, you'll read about the show's ever-widening impact.

So find a comfy place to sit and pour yourself a steaming, foamy latte. We've got a lot to talk about.

## HOW THE SHOW WAS CREATED

· · ·

Whose idea was *Friends*? Depends on who you ask. Then-NBC-executive Jamie Tarses said the idea for a show about a group of twentysomethings hanging out had already been in the air for a while. Her then-colleague Warren Littlefield claimed he'd been thinking of doing a show about young adults in the big city.

· · · · · · · · · · · ·

> ## Of course, if *Friends* really was "only a TV show," you wouldn't be reading this book.

· · · · · · · · · · · ·

Don't forget, 1994 was also the year the Generation X wave crested and began to ebb. Remember Generation X? If you don't, that's okay; those of us born between 1965 and 1980 pretty much expected to be forgotten. A demographic footnote sandwiched between the baby boomers and

OPPOSITE *Friends'* main cast is played by the following actors, shown from left to right: Matthew Perry, Jennifer Aniston, Lisa Kudrow, David Schwimmer, Courteney Cox, and Matthew LeBlanc.

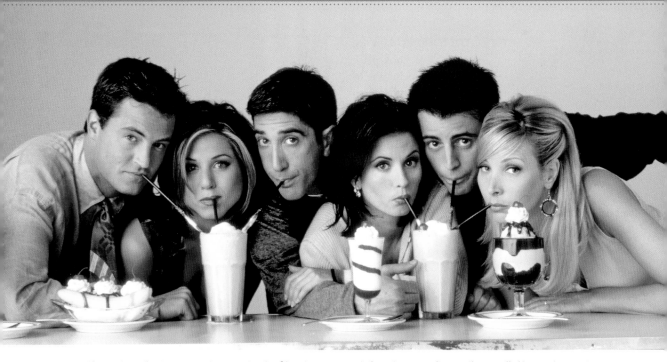

Since the first season, the cast of *Friends* has posed for dozens of creative publicity photos such as this one, known among fans as the "milkshake poster."

the millennials, Gen X was the ignored middle child, the Jan Brady of generations. Unlike those other groups, Gen X didn't even have a name, just an algebraic placeholder.

Gen X did show up on pop culture's radar in 1994—for all the wrong reasons. This was the year when Nirvana frontman Kurt Cobain died, when the movie *Reality Bites* was met with a collective shrug at the box office, and when Elizabeth Wurtzel's memoir, *Prozac Nation*, suggested that her experience with depression and mood stabilizers was characteristic of her entire generation. Whatever window of opportunity Gen X had to make an impact on the culture of its era seemed to be closing. About the only lasting legacy its members had mustered was to make hanging out and drinking coffee in coffeehouses—pre-Starbucks-on-every-corner—a thing.

As for how it all began, *Friends* is the brainchild of Marta Kauffman and David Crane. The two writer/producers had created the HBO comedy

*Dream On* (1990–96) together, but they'd had trouble following it up with another hit. *The Powers That Be* lasted one season (1992–93) on NBC, and CBS canceled their 1993 series *Family Album* after just six episodes. The resulting period of uncertainty in their lives reminded them of their own experiences a decade earlier, when they were in their twenties as struggling New Yorkers trying to make it as off-Broadway playwrights. That recollection yielded a premise for another show: six twentysomethings hanging out at a coffeehouse and lending each other moral support as they entered the uncertainty of adult life in the real world. Why six? Because after *Dream On*, a show that depended heavily upon one lead, Kauffman and Crane wanted to try something new and almost unheard of on TV: an ensemble comedy with six equally important roles.

Crane recollects in a 2019 interview regarding initial conversations about the DNA of their new series and where they wanted to take it: "There

were some practical elements in that a show we had done previously, *Dream On,* all took place in a guy's head. He was the lead and he was in every scene, which just gets really difficult to do. So we thought, 'Let's do a show that's a true ensemble,' which is hard to do. There aren't a lot of true ensembles where you're not following any particular character. In *Cheers,* obviously you're following multiple characters, but Sam and Diane were your hook. Yes, we had Ross and Rachel, but we didn't know we were going to have Ross and Rachel to *that* degree. So, we went back to our twenties. Marta and I met in college. We were living in New York for the eighties. We had a group of friends that was not unlike the Friends. Our pitch was, 'It's that time of your life where your friends are your family. It's now the family you make rather than the family you were given.' That was really it. Then we just came up with six characters we really liked. I don't even know today if you could get away with a show that's such a simple concept. The premise is so basic. It's really just the lives of these six people and—where do we go? That was the gist of it. We went in and pitched that one line and that was pretty much it."

Kauffman and Crane wrote a seven-page treatment for their idea. The passage explaining the premise read, "It's about sex, love, relationships, careers, a time in your life when everything's possible. And it's about friendship because when you're single and in the city, your friends are your family."

· · · · · · · · · · · ·

## "If you put us on Thursday nights," Bright said, "you can call us *Kevorkian* for all I care."

· · · · · · · · · · · ·

"It was not a show for one generation. It was for everybody," Crane said in 2004. "Honestly, all we were trying to do was make a show we would enjoy watching," added Kauffman.

Even the choice of a coffeehouse as the group's hangout was random, Kauffman and Crane recalled in 2012. It wasn't an attempt to tap into the Gen X zeitgeist. Rather, it was practical. *Seinfeld* already had a diner, and *Cheers* had had a bar, so they needed some other place. "Literally, we were walking down the street and saw the Insomnia Cafe and thought, 'Oh, that would be a cool place to put these people,'" Kauffman said. *Insomnia Cafe* became the title of their show.

Kauffman and Crane had earned some interest from the Fox network for another pitch, for a show idea they themselves didn't like as much; they even worried that the networks would pick the wrong show, and they'd be stuck. But when they came to NBC, their pitch for *Insomnia Cafe* was exactly the kind of twentysomething-ensemble show that Tarses and Littlefield said they'd been looking for. What really sold Littlefield was the well-rounded specificity of each of the six characters. "They so knew who their characters were," he recalled.

The show wasn't a hard sell. In a 2019 interview, Kauffman said, "We had competing offers, but [NBC] gobbled it up. The only change they wanted us to make was they wanted us to add an older character in the coffeehouse, who we jokingly used to call Pat the Cop. But we explained that we thought the show worked with just young people, and that if the stories were universal, the show would be watched and people would feel things for it, even if they weren't twenty years old. It certainly worked out that way."

Of course, before the pilot made it to air, there would be other title changes: *Six of One, Across the Hall, Friends Like Us,* and finally, *Friends.* There was some trepidation about that, since ABC was about to launch a similar show—yet another comedy about young adults hanging out and looking for romance—called *These Friends of*

*Mine.* (A year or so later, when *Friends* became an enormous hit, the ABC sitcom chose to change its title, renaming itself after its lead character, who had the same first name as the actress who played her: *Ellen.*)

Kauffman and Crane's producing partner, Kevin S. Bright, didn't care that the name *Friends* sounded generic, since the show was scheduled to air during prime-time TV's most coveted half hour: 8:30 p.m. on Thursdays, bookended by *Mad About You* and *Seinfeld.* "If you put us on Thursday nights," Bright said, "you can call us *Kevorkian* for all I care."

It didn't take long for this freshman show to find its groove. Co-creator Kauffman said in a 2019 interview, "Somewhere around the fourth or fifth episode we started to figure out what made the show work best. The lesson we had to learn over and over again is it was always better to have them together than them with outside characters. The outside characters had to enter their world. That was a lesson we had to learn a few times before we finally figured that out. It's funny. At least in my memory, our second season was a little bumpier. It took us some momentum to figure it out."

Co-creator David Crane adds, "Certainly, there was growth in the first season. There was discovery. I would say there was a point in the first Thanksgiving show where we saw how Monica could be really funny. Not just caring and supportive, but actually funny. We knew what to write then after that."

## THE CREATORS

• • •

Kauffman and Crane were both from the Philadelphia area and had been undergraduates at Brandeis University in the late 1970s. They wrote a number of plays together before breaking into television with *Dream On.*

After the successful launch of *Friends,* NBC naturally wanted more from them, and they brought the network *Veronica's Closet* (a hit vehicle for Kirstie Alley from 1997 to 2000) and executive-produced *Jesse* (1998–2000, starring Christina Applegate as a struggling single mom). Eventually, they would go their separate ways. Crane and his husband, Jeffrey Klarik, co-created the comedy *Episodes* (Showtime, 2011–17), a spoof about the TV industry that starred a post-*Friends* Matt LeBlanc as himself. Kauffman and Howard J. Morris co-created *Grace and Frankie* (Netflix, 2015–), a comedy that reunited *9 to 5* stars Jane Fonda and Lily Tomlin as two seventysomething housemates.

One important player in the success of *Dream On* was producer Bright. He'd produced TV comedy specials for comedians from George Burns to Robin Williams, as well as much of the first season of the groundbreaking Fox sketch comedy series *In Living Color.* In 1993 he became business partners with Kauffman and Crane in Kauffman/Crane/Bright productions, so he was on board *Friends* as an executive producer before the show had a network home. He'd go on to produce the entire series and direct sixty episodes, including the finale. In later years, he would also produce Kauffman and Crane's *Veronica's Closet* and *Jesse,* as well as *Friends* spin-off *Joey.*

The last key member of the initial creative staff was legendary TV comedy director James Burrows. He directed most of the episodes of such classic sitcoms as *Taxi* and *Cheers* (a show he also co-created). Burrows may have been largely unknown to TV audiences, but to writers, producers, and actors, he was well-known for his light comic touch, his complex blocking of actors, his eye for lighting, his expansion of the traditional three-camera sitcom to four cameras, and his ability to handle grown-up material (children are seldom seen or heard on a Burrows show).

Burrows also had a keen grasp of dramatic structure—important on an unorthodox show like *Friends* with its equally shared plots. (For example, a typical sitcom episode interweaves a primary "A" plot and a "B" subplot, but with *Friends* having six equally important characters,

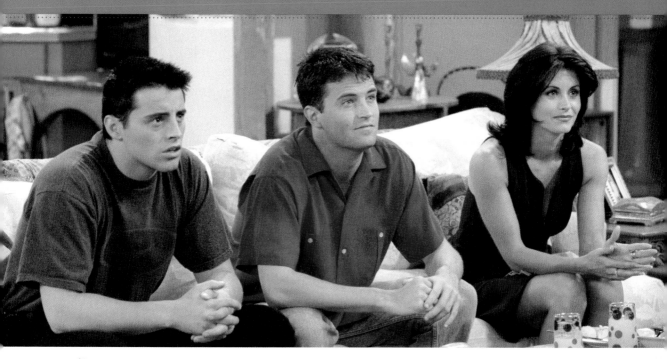

Friends characters Joey, Chandler, and Monica sitting on Monica's comfy couch, shown here in season 2, episode 1, "The One with Ross's New Girlfriend."

a twenty-two-minute episode often zigzagged among "A," "B," and "C" plots of roughly similar weight.) And Burrows was also a master at creating small moments that revealed character. (Think of the scene in the pilot where Ross and Rachel split an Oreo as he musters up the courage to ask her about asking her out sometime. The cookie was Burrows's idea.) *Friends* was ultimately blessed to have Burrows direct its pilot and fourteen other episodes during its first four seasons.

Years later, after Burrows had gone on to direct *Will & Grace* and *Mike & Molly,* and after *Friends* had gone off the air, reporters would almost always ask the *Friends* cast when and if they'd reunite for a reboot. The answer was always some variation of "Never," or "Why ruin a good thing?" But in 2016, after twelve years of such questions, five of the six (all but Matthew Perry) did reunite for a prime-time TV special: NBC's all-star tribute to Burrows.

Burrows signing on to direct the *Friends* pilot was a sign that the show had a near-certain chance

of becoming a critical and commercial hit. Now all it needed was the right actors to play the central group of six.

### CAST AND CREW
● ● ●

Imagine a version of *Friends* that starred . . . well, anybody other than the six relative unknowns that the producers picked. Can't do it, can you? Really, it's a miracle that they chose the exact right six stars, actors who jelled not only with their own roles but with each other as a group. It could have gone south at any moment during the casting, given the other talented hopefuls who auditioned, the uncertain availability of some of the first-choice actors, and the writers' original conceptions of the characters, which were a bit different from what the six stars eventually brought to each role.

The audition process to cast six leads with great on-screen chemistry would be no easy task for the show's creators. "It was lengthy. It was

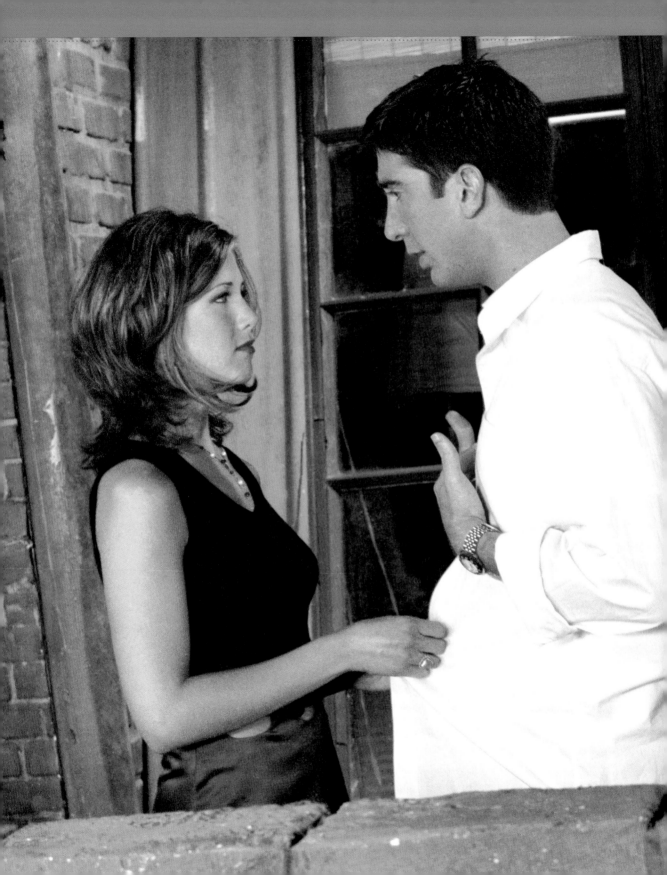

hard. It's always hard. You are trying to find some kind of magic. That's always going to be challenging," Crane said in a 2019 interview. "Some of the actors we knew of beforehand. For instance, we had come very close to putting David in a pilot that we did the year before. We always knew he was wonderful. From the beginning, when we were writing Ross, we had him in mind. I think we probably ended up seeing some other people only because I believe David had lost faith in television at that point. He was always very much at the top of our list."

Crane goes on to explain their casting process, "My husband, Jeffrey Klarik, was writing on *Mad About You* at the time. He said, 'You have to see Lisa Kudrow. She absolutely is Phoebe.' When she walked in and read, it was like, 'Oh my God. He's right. She is Phoebe.'"

Kauffman and Crane had worked with Matthew Perry on *Dream On* as a guest star. Crane said, "But he already had a pilot for the year, so he wasn't available. You don't want to hire somebody who already has something in place because if that other thing goes, you are screwed. Someone then saw the other thing he was doing—a show called *LAX 2194,* which was basically about baggage handlers in the future—and said, 'I don't think you have to worry about that thing moving forward.' We cast him in second position, taking the risk that the future baggage handlers was never going to happen."

Who were the most difficult to cast? "Monica and Rachel." Crane explains, "Rachel, in the wrong hands, could be a really unlikeable character. She's selfish. She's spoiled. We meet her running out on her own wedding. The one person she turns to is Monica, who she didn't even invite to the wedding. We saw a lot of really talented women read it and no one came close. Then Jennifer came in and she was fantastic. We went,

'Oh my God. You love her.' The problem was she also had another show. This one was going on the air. We took a giant risk that it was ultimately going to get canceled. It was a summer show. We shot four episodes before that got canceled. It was a huge risk. Today I don't think anyone would ever do it. But everyone was just very positive, and everyone loved Jennifer that much. If that show had gone forward, we would have had to reshoot four episodes."

When asked what some of the traits were that evolved from the characters as the series progressed, Kauffman explained, "A lot of it has to do with when an actor breathes life into a character [like Monica's competitiveness]. You begin to discover things. That's when the character starts to become three-dimensional. For example, when we first talked about Joey, he was this tough womanizer guy. Because Matt LeBlanc played it so sweetly, as a guy who wore his heart on his sleeve, that added dimension to the character. I also have to say he played stupid really well. He isn't stupid, but he played it really well."

So, how did the creators come up with the characters' names? In a 2019 interview, Crane explained, "There was a good friend of Marta's in college named Chandler. We had the character of Joey. We knew he would be an actor. We wanted something that would be simple. When I was growing up, there was a friend of my parents named Phoebe, which struck me as a really bizarre name. I don't think the other ones were based on real-life people. You keep going until it feels right and sort of sticks."

### He Was on a Break

The easiest and first role to be cast was Ross Geller, as Kauffman and Crane had written the role with David Schwimmer in mind after he'd auditioned

OPPOSITE The on-off relationship between Ross and Rachel would become the major arc of the series. This image is from season 2, episode 1, "The One with Ross's New Girlfriend."

unsuccessfully for another show of theirs. At twenty-seven, Schwimmer had appeared in small recurring roles on *The Wonder Years* and *NYPD Blue* and had co-starred in a sitcom called *Monty* that was canceled after six episodes. After that, he soured on sitcoms and returned to the theater company he'd founded in Chicago, the Lookingglass Theatre Company. But his agent persuaded him to give the *Six of One* pilot script a look, noting that it was an ensemble piece. That word, "ensemble," appealed to the stage actor in him and helped sell Schwimmer on the project.

Other actors had auditioned to play Ross, including Mitchell Whitfield, who would get the consolation prize of guest-starring as Rachel's jilted groom Barry, and a pre-fame Eric McCormack, who would land the starring role of Will a few years later on the Burrows-directed *Will & Grace*. But Schwimmer was always the showrunners' first choice.

When asked in 2019 what his favorite physical comedy moment for Schwimmer was, Crane said, "The two that really come to mind are moving the couch up the stairs and the leather pants. I'm going to add one more to that list. In the first season during the blackout, when the cat jumps on his back, I can't remember in my whole actual life laughing that hard. By the way, what you see on TV, we had to cut it down. The audience just went crazy. They couldn't stop laughing. It went on and on and on. David is wrestling with this fake puppet cat. It was brilliant. He kills it. And then with the leather pants—little touches like when he puts the lotion on and smacks his own head . . . c'mon. He's a master!"

---

### How *You* Doin'?

---

Joey Tribbiani was also easy to cast. Among those who auditioned were Hank Azaria (already a voice star on *The Simpsons,* and later to play the recurring role of Phoebe's sweetheart David) and Vince Vaughn, still two years away from his star-making role in the movie *Swingers.*

And then there was Matt LeBlanc, twenty-six, best known for starring in two very short-lived sitcom spin-offs of Fox's *Married . . . with Children*: *Top of the Heap* and *Vinnie and Bobby.* The Newton, Massachussets–born performer was Italian on his mother's side and certainly knew what being a struggling actor felt like.

The night before the audition, as LeBlanc recalled in 2012, an actor pal persuaded him to go out drinking with friends, assuring him that group carousing would help him get into character for the ensemble comedy. That night, LeBlanc fell and face-planted on the sidewalk, and suffered a gash on his nose. "I went to the audition with this huge scab on my face, and Marta said, 'What happened to your face?'" he recalled. "I said, 'Aw, it's a long story.' She thought it was funny and laughed, and that kind of set the tone for the room."

"He just was Joey," Littlefield recalled in 2012, of LeBlanc's audition. "He owned it. It was undeniable in the room. He was delightful. There was no nail-biting on that one."

Even so, LeBlanc felt uneasy about always leering at the three female Friends. He worried that, as a one-dimensional creep, Joey would soon wear out his welcome with the other characters and with the viewers. Early in the show's run, he asked the writers, "Could it be that Joey thinks of these three girls as little sisters, and wants to go to bed with every other girl but these three? Then I'd buy that they're friends. Otherwise, I just don't think they'd even talk to him if he hits on them every single time." The writers agreed, and while Joey continued to consider all other women fair game, he took on a protective posture toward Rachel, Phoebe, and Monica. Thanks to LeBlanc, Joey went from boorish bro to benevolent big brother.

Crane said in 2019, "The character of Joey wasn't always as blue collar. I don't want to use the word *dumb*, but there are things where Joey is not the sharpest tool in the shed. That was in the pilot. I think in the original first draft of the script, that wasn't there. It's incremental."

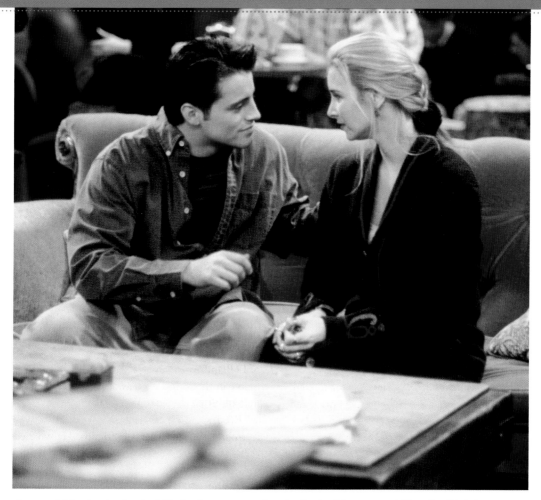

Joey and Phoebe in Central Perk, from season 1, episode 17, "The One With Two Parts."

Twenty-five years later, the writers don't regret not giving Joey a major love interest. Kauffman said in 2019, "The biggest crush we saw for him was the one with Kathy, where Chandler ended up in a box. Then there was his crush on Rachel. That was as close to intimacy with a woman that he probably got without sex. It wasn't time for him yet."

## The Good Twin

Phoebe Buffay was supposed to be offbeat, so the auditioners included some offbeat comic talents, such as stand-up Kathy Griffin and then-unknown Jane Lynch. Ellen DeGeneres auditioned, even though she already had the lead role in ABC's similar *These Friends of Mine,* to debut that spring.

Lisa Kudrow, thirty, already had a recurring gig as Ursula, the hostile waitress of NBC's *Mad About You.* It was her breakthrough role after nearly a decade of honing her comedy skills, first in Los Angeles's celebrated Groundlings troupe (where she worked alongside fellow then-unknown Conan O'Brien), then on two failed TV pilots. Having appeared in the legendary final episode of *Newhart,* she landed a recurring role on Bob Newhart's next show, the short-lived *Bob.*

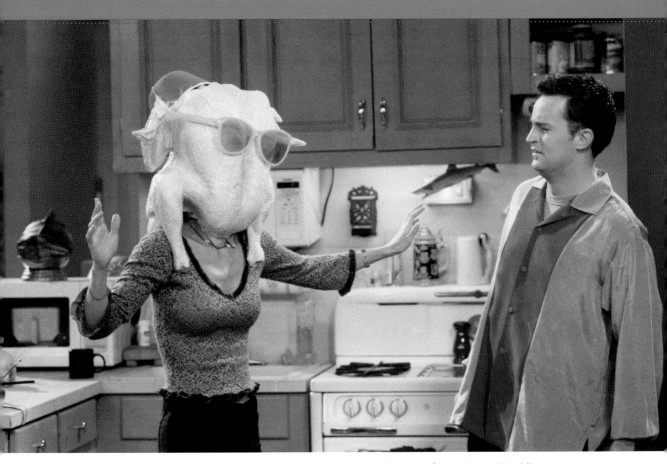

Monica with a raw turkey on her head from season 5, episode 8, "The One with All the Thanksgivings."

In 1993, she was cast as Roz Doyle on *Frasier*, but when it became clear to the show's creators that she wasn't right for the character, they replaced her during the pilot's taping with Peri Gilpin, who went on to play the role for eleven years. So Kudrow was nervous about pleasing Burrows, the very director who'd fired her from *Frasier*.

Nonetheless, her loopy delivery suited Phoebe, even though Kudrow thought of herself as more like Rachel. "No, you're the quirky girl," the show-runners insisted. Kudrow was happy to be working on another show with NBC, as she believed the network would protect her concurrent gig on *Mad About You*.

The spiritual and compassionate Phoebe was the polar opposite of Kudrow's *Mad About You* harridan. So when NBC scheduled *Six of One* at 8:30 to follow *Mad About You*, the new show's writers had a brainstorm: what if Phoebe was Ursula's twin sister? This opened up a variety of possible storylines, which *Friends* would exploit over the years, in which the sisters are mistaken for each other, as well as crossover-episode possibilities between the two series.

Of course, the *Six of One* producers needed the permission of *Mad About You*'s showrunners to make this connection. It didn't hurt that Crane's husband, Jeffrey Klarik, was a writer for *Mad About You*. "If [Ursula] had been my creation on my show, I don't know if I would have been as generous as [*Mad About You* creator] Danny Jacobson was with us," Crane recalled in 2012.

Phoebe's major love interest was Mike, played by actor Paul Rudd, which allowed the creators to explore a new dynamic for Phoebe in later seasons. Kauffman said of that relationship, "He was her sanity. He was a regular guy and she's such an extreme character. It rooted her. It made her more real. We also got to explore the triangle with the scientist David. He was a goofier character, even though people rooted for that relationship at the time. But once Paul Rudd came into the picture, I think he almost filled out another dimension of Phoebe, who was someone who wanted something more normal, conservative in a way."

### Could I BE Any Harder to Cast?

The *Six of One* team thought Chandler Bing would be easy to cast. He was not.

The quippy, sarcastic character was based in part on Crane himself. "There's a bit of Chandler in me, in terms of his insecurities and defending himself with his humor," Crane said.

Just as Vince Vaughn had read to play Joey, Vaughn's pal and future *Swingers* co-star Jon Favreau read for Chandler. (Later, he'd have a guest arc as Pete, Monica's tech-millionaire boyfriend.) Producers also sought Jon Cryer for the part, but he was doing a play in London at the time. He has said that he sent in a taped audition but the producers never got it.

Like Chandler, Matthew Perry was a child of divorce. Raised by his mother, he nonetheless chose the profession of his father, actor John Bennett Perry. He moved from Ottawa, Canada to Los Angeles as a teen and landed starring roles on several series (*Second Chance*, *Sydney*, *Home Free*), none of which lasted more than a season on the air. He'd also had guest spots on a few shows, including *Beverly Hills 90210* and Kauffman, Crane, and Bright's *Dream On*.

So when the twenty-five-year-old read for Chandler, the showrunners knew he could play the part well. Trouble was, he was already committed elsewhere. He'd landed a role in a Fox pilot called *LAX 2194*, a comedy about airport baggage handlers set 200 years in the future.

Another rising actor, Craig Bierko, read for the role. Some of the producers liked him, some didn't. Turned out he'd been coached for his audition by Perry, Bierko's friend and *Sydney* co-star. Fortunately, Bierko decided he didn't want the part; Perry became available when Fox decided not to go ahead with *LAX 2194*.

Crane has said that jokes about everyone questioning Chandler's sexual orientation were always going to be part of the show, but that once Perry took the job, "I don't think we ever considered making Chandler gay."

This influenced the thought process behind giving Chandler a transgender father. Kauffman said, "I think it had to do with how Chandler had some interesting character traits. He had a disconnect from his family. For us, especially considering there was an episode where everyone thought Chandler was gay, we thought we would stay in the LGBTQ area with him in his life. The idea just popped in, 'What about Kathleen Turner?' I wish I knew then what I know now. The transgender stuff played very often as the joke. I'm not sure we had back then the sensitivity that I would have now."

● ● ● ● ● ● ● ● ● ● ● ●

## "I don't think we ever considered making Chandler gay."

● ● ● ● ● ● ● ● ● ● ● ●

Kauffman said in 2019 of Perry's unique delivery and emphasis of words, "That's all him. That is his genius." She continued, "Without wanting to do specific lines that are repeated a million times, that's an example of something Matthew did so well. It became a signature for him. We used to do this thing where if we really, really wanted him to emphasize a certain word,

we would have to underline the *other* word. He always found a way to twist what we had written to make it his—in the best way."

## I KNOW!

Kauffman and Crane wrote Monica Geller with Janeane Garofalo's voice in mind; they initially conceived the character as more wisecracking, cynical, and tough than she ultimately became. Kauffman had based her in part on herself. "I have a lot of Monica in me, in terms of everything having to be a certain way," she said in 2012. "Putting the top on the pen until it clicks."

Monica was also going to be more brazenly sexual; in fact, Kauffman and Crane imagined that Monica and Joey, being the most sexually active characters, would eventually hook up and become the series' chief romantic arc. (Thank goodness that never happened.) The Ross-and-Rachel idea came later.

Garofalo wasn't interested. Other actresses read for the part, including Jessica Hecht (who'd ultimately play Susan, new wife to Ross's ex-wife, Carol), future *King of Queens* star Leah Remini, and Jami Gertz. (Gertz was also shortlisted to play Rachel but turned the part down.) Eventually, the decision came down to two actresses: Nancy McKeon, well known for having played tough-talking tomboy Jo on *The Facts of Life*, and Courteney Cox.

At the time, Cox, then twenty-nine (two years older than Schwimmer, who'd ultimately play her older brother), was best known for her recurring role as Alex Keaton's girlfriend on *Family Ties* and for having appeared in Bruce Springsteen's "Dancing in the Dark" video as the girl the Boss pulls from the audience onto the stage to dance with him. In early 1994, Cox had two prominent, if thankless, roles: on a *Seinfeld* episode, as a girlfriend who pretends to be married to Jerry in order to claim a dry-cleaning discount, and as the female lead opposite Jim Carrey in *Ace Ventura: Pet Detective*.

The producers had auditioned her to play Rachel, but she didn't think she was quirky enough and asked to read for Monica instead. Her reading was so strong that the showrunners had a hard time deciding between Cox and McKeon. Littlefield said he'd support a decision either way. Kauffman, Crane, and Bright took a walk around the Warner Bros. lot, and when they returned, they chose Cox, having found something fresh in her take on the character.

## It's Not Easy Being Green

The last—and most difficult—role to cast was Rachel Green. Téa Leoni was on the shortlist, but she chose a starring role in the sitcom *The Naked Truth* over Rachel. Besides Leoni and Cox, auditioners included Jane Krakowski, and *Saved by the Bell* alumnae Elizabeth Berkley and Tiffani Thiessen.

For Jennifer Aniston, *Six of One* was just another pilot, one of six she tried out for in 1994. The twenty-five-year-old had been on the cusp of fame for years without ever really making it. The daughter of soap actor John Aniston (he'd played Victor on *Days of Our Lives*—the real show, not the fictional one that would later hire Joey to play Dr. Drake Ramoray), Jennifer had been on a number of shows that didn't really go anywhere. On NBC's short-lived adaptation of *Ferris Bueller's Day Off*, she'd played Ferris's sister Jeannie. (It was the role played in the 1986 movie by Jennifer Grey, who'd guest on *Friends* as Mindy, Rachel's rival for Barry's affections.) She'd been a regular on the Fox sketch comedy series *The Edge*, which lasted one season. She'd even starred in a movie, but—unfortunately—that movie was the notorious horror oddity *Leprechaun*.

**OPPOSITE** Monica and Rachel from season 6, episode 6, "The One on the Last Night."

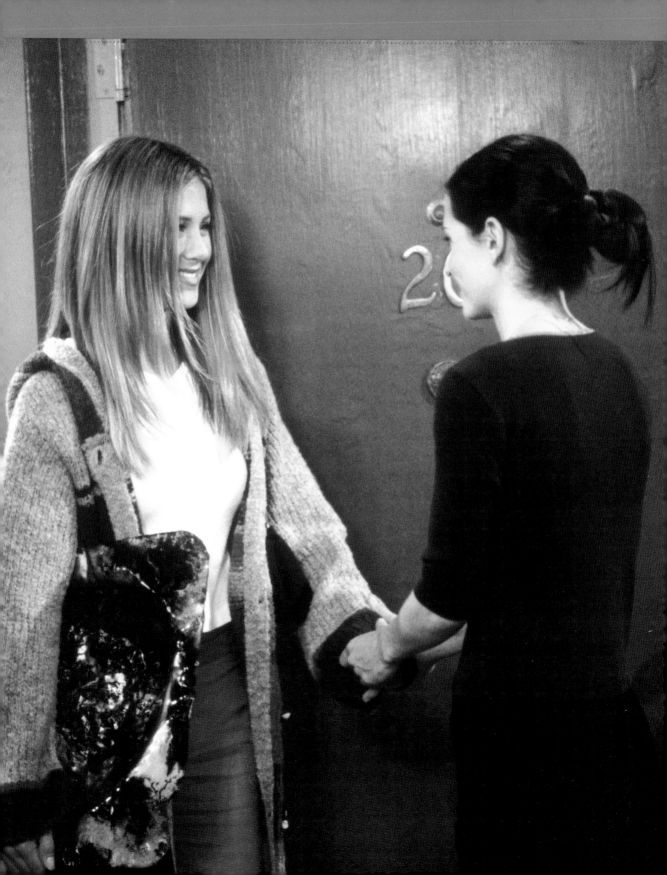

One day in 1993, Littlefield recalled nineteen years later, he ran into Aniston at a gas station on Sunset Boulevard in Hollywood, and she seemed discouraged. "Is it ever going to happen?" she asked the NBC executive. Littlefield, who knew her from *Ferris Bueller*, reassured her that she was talented and that her big break would come. Neither one knew that it was just around the corner.

When she read for *Six of One*, Aniston had landed a co-starring role in a CBS sitcom called *Muddling Through*, which the network had left on the shelf all year but was set to debut in the summer of 1994. She read for Monica, but she convinced the producers she was better suited for Rachel. The showrunners agreed she was right for the part, though they were worried that her commitment to *Muddling Through* would preclude her from being on the rival network's show. Aniston was worried too, as she thought Rachel was a better gig. In fact, they were all afraid that CBS would refuse to adjust Aniston's schedule to allow her to shoot both comedies at once, in order to sabotage the fledgling NBC show.

Around this time, as Aniston told Oprah Winfrey in 2011, she also auditioned for NBC's *Saturday Night Live* and even received an offer to join the sketch comedy institution's cast, but she turned it down for *Friends*. Her real-life friends thought the decision was crazy, she recalled.

Even after the *Friends* producers hired Aniston, she never felt secure about the job. She heard from actress-friends who said they'd read for Rachel after Aniston had been hired. She was left out of some of the advance publicity photo shoots of the *Friends* cast. Littlefield may have been the only one who wasn't worried; he was sure *Muddling Through* would fail and that CBS would cancel it.

Aniston went ahead and shot the *Friends* pilot that summer anyway. Fortunately for her and for Team *Friends*, CBS did yank *Muddling Through* after its ninth episode aired, just two weeks before *Friends*' September 22 debut.

Obviously, the relationship with Ross would be the main, long-running arc. But what did other love interests, such as Tag, bring out in Rachel, and allow the creators to tell? Kauffman said, "It was so much fun to have her involved with a hunk. It was fun to see the older woman/younger man relationship and how she couldn't resist it. In some ways, having a crush on Tag made Rachel youthful. It was a girly crush."

## WHAT MAKES *FRIENDS* SO SPECIAL

• • •

What does make *Friends* so special? There are the obvious elements: the perfectly cast sextet of stars, the witty writing, the empathetic directing, that earworm of a theme song. For nostalgic viewers of a certain age, there's the sense that *Friends* captured and encapsulated a time in their own lives and made it look rosier than it probably was in reality. Maybe it's the fact that the six characters are all roughly equal in importance, making it easy for viewers to pick one to identify with.

But there's something else, and it has to do with the way the group of six becomes something much grander than the sum of its parts.

Most sitcoms are about families. That's been true since the days of *I Love Lucy*, *Leave It to Beaver*, and *The Brady Bunch*. Even sitcoms that aren't about literal families are often about makeshift families, usually made up of coworkers. (Think *The Mary Tyler Moore Show*, *M\*A\*S\*H*, *Cheers*, *The Office*—the list goes on.)

What's unusual about the *Friends* sitcom family is that the six principals are neither related (except for Ross and Monica), nor coworkers. Really, they don't have much in common at all, except that they're all twentysomethings embarking on their lives as grown-ups in the real world, with similar dreams of career success and romance. Their common aspirations make the three gals and three guys a family of sorts, one that's special because they've chosen each other. Not because they were forced together by blood or profession, but because they all genuinely like one another.

As it turns out, each of the six Friends is searching for a family of his or her own, often stemming from the families they grew up in. Phoebe is literally searching for a family, having been largely abandoned by hers. Her parents and her twin sister are still too dysfunctional to want anything to do with her, but she does connect with her half brother, Frank Jr., even starting a new family with him by becoming a surrogate mom to his triplets. Fittingly, she winds up marrying a man, Mike, who adores all her idiosyncrasies, even as his own family rejects them.

Chandler also longs for the traditional family he lacked in childhood, feeling abandoned by his glamorous mom (often absent on book tours) and his transgender father (who literally abandoned traditional fatherhood and took up show business). By the end of the show, he finally gets to be the suburban, happily married father he didn't have during his own youth.

Rachel similarly comes from a dysfunctional family, with an indulgent mom and an impossible-to-please dad. At the start of the series, she doesn't know what she wants to do or what kind of man she wants to be with; she only knows that she doesn't want the choices everyone expects her to make, including aping her parents' union by marrying Barry.

Joey comes from an apparently stable, very large family, and he seems to be the only Friend who had a happy childhood. He finds out early on in the series, however, that his dad is cheating on his mom, who willingly ignores the infidelity for reasons of her own. Joey finds in the Friends a group like his own family—a large brood that loves him unconditionally—but without the hypocrisy and disloyalty.

Monica and Ross have each other, but that's not always a blessing. Monica grew up feeling slighted, believing her parents always compared her unfavorably to her big brother. As the unofficial mom of the group, Monica gets to be the kind of mother she didn't have, one who neither judges others nor disapproves of their life choices.

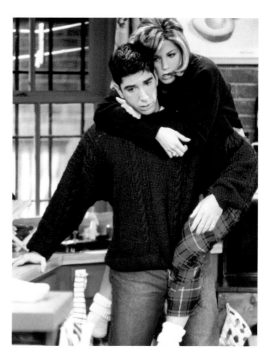

Rachel hops on Ross's back in season 2, episode 7, "The One Where Ross Finds Out."

As for Ross, he starts the show with his own family falling apart, as his wife Carol divorces him to be with Susan. He's the first of the Friends to marry (indeed, he has three failed marriages over the course of the series) and the first to become a father. By dating Rachel, the girl who ignored him when they were teenagers, he has a chance to rewrite his own childhood with a happy ending. But after he bungles that relationship—by sleeping with the hot copy-shop girl when "We were on a break!"—he dates many other women, and all of those relationships fail because no other woman is Rachel. By the end of the series, he's not only won back Rachel, but he also has their daughter, Emma, his son, Ben, and an extended family that includes Monica and Chandler and their adopted babies, Carol and Susan, Phoebe and Mike, and Joey. It's not the kind of family envisioned by his baby boomer parents, or that anyone else expected, but it's a family just the same.

# CHANDLER
# MURIEL BING

*Droll. Dry.*

*A wry observer of everyone's life. And his own.*

*Works in front of a computer doing something tedious in a claustrophobic cubicle in a nondescript office building.*

*Survives by way of his sense of humor. And snacks.*

—initial character description of Chandler

Yep, Chandler is funny, all right. He gets a lot of the show's best punchlines (including the final line of the series), and his sarcasm is not only his defense mechanism but his defining characteristic. Of course, there are a lot of hang-ups and neuroses that went into making that sarcasm both continuous and necessary.

Chandler is the only Friend with no siblings. He's the only child of famous erotic novelist Nora Tyler Bing (Morgan Fairchild), whose books and interviews are a source of embarrassment for her son, and Charles Bing (Kathleen Turner), who embarrasses Chandler by becoming a transgender performer named Helena Handbasket. Chandler was little when his parents announced their impending divorce at Thanksgiving, leading to his use of humor as an emotional shield, his fear of commitment, and his loathing for Thanksgiving.

In college, he and roommate Ross Geller became close friends and started a terrible band together called "Way! No Way!" (Hey, it was the eighties.) After graduation, he lands a temp job in statistical analysis and data reconfiguration, a gig he barely understands and likes even less, but as one of the series' running jokes, he keeps getting promoted. Financially, he's the most successful of the Friends.

Having moved in across the hall from Ross's only sister, Monica, after she gives him a tip about a vacancy in her building, Chandler has found a roommate and new best friend in Joey Tribbiani.

The two have little in common, save for a shared love of *Baywatch*, but Joey admires Chandler for his intelligence, while Chandler admires Joey for his confidence with women.

Chandler, despite being played by Matthew Perry, does not think of himself as attractive to women. Thanks to his childhood, he sees himself as a Freudian field day of sexual inadequacy. He's so often mistaken for gay that even he has doubts about his sexuality. The middle name "Muriel," his closeness with Joey, and his finicky nature all help make Chandler's gay-panic an ongoing gag throughout the series.

Chandler's self-loathing—"Could I *be* any more [unflattering adjective]" is his catchphrase—is one reason he keeps returning to Janice (Maggie Wheeler), the ultra-annoying girlfriend with the machine-gun laugh and vowel-mangling *Noo Yawk* accent. It's not so much that he loves her; he just doesn't believe he can do any better.

Fortunately, he finds the one woman in New York whose uptightness and self-esteem issues mesh with his own. And she was right across the hall the whole time.

Chandler could've come off as a sweet-but-insufferable pest like Janice. But Perry, besides having ace comic timing with Chandler's quips, played up the character's vulnerability well. As a result, fans came to cherish Chandler's oddities, which, by the way, includes a formidable skill at ping-pong. And a third nipple.

## JOSEPH FRANCIS TRIBBIANI JR.

*Handsome. Macho. Smug.*

*Lives across the hall from Monica and Rachel.*

*Wants to be an actor.*
*Actually, wants to be Al Pacino.*

*Loves women, sports, women, New York,*
*women, and most of all, Joey.*

—*initial character description of Joey*

Joey is a singular character in the history of television: a womanizer with a soft heart. He wasn't written that way. Originally, he was supposed to be a more typical cad, as you can tell from the above description. But when Matt LeBlanc was cast, he astutely asked the writers: if Joey is such a callous, narcissistic letch, why do the others like him? LeBlanc would ultimately play him with a big-brotherly sweetness that made Joey not only lovable but unique.

Oh, also, he's pretty moronic. That was another contribution of the actor's, one that began during the taping of the pilot when the writers recognized that LeBlanc was really good at playing dumb. Joey may have been smart about women, but he was nearly clueless about everything else in life. Even so, that dimness, combined with his soft-heartedness, came off less as stupidity than a sweet naïveté, which made him all the more adorable.

Joey is an actor, although he's not quite as talented as he thinks he is. He's most famous for his brief role as Dr. Drake Ramoray on *Days of Our Lives*, a role he suddenly loses after boasting to a reporter that he improvised his character's best lines. (That boast irks the *Days* writers, who quickly kill off Joey's character.) His brief stints alongside movie A-listers such as Al Pacino and Charlton Heston also end in comic disaster, due more to Joey's nerves than to his ego.

Still, the confidence that keeps him auditioning also helps him pick up women with ease. Joey understands women, maybe because he comes from a large Italian American family and has seven sisters. (They are [deep breath] Mary Teresa, Mary Angela, Dina, Tina, Gina, Veronica, and Cookie.) He has the unusual ability to make any phrase sound dirty (listen to him deliver the phrase "Grandma's chicken salad"), yet his signature pick-up line, "How *you* doin'?" never sounds truly sleazy.

Other Joey traits: He can eat anything (he's the only one who likes Rachel's horrible Thanksgiving trifle made with beef and bananas). And he's fiercely loyal, especially to longtime roommate and best bud Chandler. He is comfortable maintaining relationships with a large group of friends, including his platonic female friends, perhaps because of having so many sisters. In fact, he's so respectful of their boundaries that, when he develops a crush on Rachel later in the series, it feels (to many viewers) disturbingly incestuous and out of character.

Of all the six Friends, Joey arguably grows and changes the least over the course of the series. At the end, he is the only one who's not coupled up, and he's still working as a struggling actor. Of course, that situation allowed NBC to build a spin-off series around the character, the short-lived sitcom *Joey*.

# PHOEBE BUFFAY

*Sweet. Flaky. New Age waif.*
*Monica's former roommate.*
*Sells barrettes on the street and*
*plays guitar in the subway.*
*A good soul.*

—initial character description of Phoebe

Early in the series, Phoebe tells new pal Rachel that she never lies. This is a lie.

In fact, Phoebe lies often. She has an extensive criminal past, and an alias, "Regina Phalange." She frequently lies to the other Friends, usually to protect someone from learning a hurtful truth. Indeed, the contrast between what we think we know about Phoebe—that she's a caring, optimistic, spiritual, sensitive, good-natured, loyal friend—and what she casually reveals about herself is one of the show's slyest running gags.

Phoebe's sweetness and duplicity stem from her traumatic upbringing. Abandoned by her birth parents, she was raised by an adoptive mother who killed herself when Phoebe was fourteen. As a young woman, she lived on the street and survived via a life of crime. For a long time, her only family has been her estranged "evil twin," her sister Ursula, the bitter and rude waitress Lisa Kudrow played on *Mad About You*. It's no wonder she latches on to half brother Frank Jr. (Giovanni Ribisi), the one family member who accepts her.

Despite street smarts and shrewdness, Phoebe is surprisingly naive, her mother having shielded her from many cruel realizations, such as the truth about Santa Claus and well-known scenes from movies like *Bambi* and *Old Yeller* in which animals die. She's also not well-educated; she drives Ross crazy with her rejection of science, and she and Joey are the only two Friends who haven't

gone to college. Indeed, she's a lot like Joey, down to her tendency to take things literally. Maybe that shared, unspoiled take on the world is why Phoebe and Joey are each other's platonic best friend of the opposite sex.

Phoebe's free-spiritedness makes her beloved among the group. She's the opposite of high-strung Monica, which is why she had to stop being Monica's roommate, clearing the path for Rachel to move in. (Phoebe managed to hide from Monica the fact that she'd moved out, in order to spare her feelings.)

Phoebe's day job is as a massage therapist, but her passion is music; somehow, she has managed to persuade the management at Central Perk to let her perform there, strumming her guitar and singing her original songs, many of them horrifying yet upbeat ditties. Her signature song, "Smelly Cat," had a melody co-composed by Kudrow herself, with help from the guest star on the episode in which Phoebe introduced the tune, Pretenders frontwoman Chrissie Hynde.

Kudrow had the charm and comedy chops to make her character's oddities not only sweet but even attractive. Phoebe has a number of suitors—ice dancer and green-card husband Duncan (Steve Zahn), naval officer Ryan (Charlie Sheen), and especially Minsk-bound research scientist David (Hank Azaria). Fittingly, it's a random guy Joey fixes her up with, Mike Hannigan (Paul Rudd), whom she ultimately marries.

*Smart. Cynical. Defended.*
*Very attractive.*
*Had to work for everything she has.*
*An assistant chef for a chic uptown restaurant.*
*And a romantic disaster area.*

—initial character description of Monica

Monica was initially going to be the ensemble's first-among-equals, leader by virtue of her hard-earned, world-weary wisdom. Instead, as Courteney Cox portrayed her, she became the group's cheerful den mother, with her incomprehensibly spacious and supposedly rent-controlled apartment becoming an even homier hangout for the gang than Central Perk.

Part of that maternal nature comes from Cox's own status, when the cast first assembled, as the most famous actor of the sextet. Part comes from Monica's skills as a chef, making her one of the rare New Yorkers who actually uses her kitchen and always has delicious food on hand. And part comes from Monica's hilarious tendency to be a tightly wound control freak.

Monica's obsessive nature dates back to her childhood. To her way of thinking, parents Jack (Elliott Gould) and Judy (Christina Pickles) Geller always seemed to favor her big brother, Ross, and always seemed to find fault with Monica or damn her with faint praise. (Indeed, they seem to do that throughout the series, whenever they visit Monica or when she visits them in the suburbs.) Monica grew up obese (judging by the fat suit Cox wore in flashback scenes) and resentful. Nonetheless, she still had some charisma, enough to befriend popular and pretty Rachel Green at Lincoln High.

The low self-esteem that Monica felt as a teen also led to her slimming down as an adult, via a crash diet inspired by a crushing remark about her appearance from a guy she was attracted to. (As it turned out, that guy was her brother's college buddy, Chandler.) But her lifelong fascination with food and cooking—which she'd enjoyed ever since having an Easy Bake Oven as a kid—continued into her chosen profession.

Monica's childhood issues continue to show in her neat-freak cleanliness, her occasional hyper-competitiveness with her brother, and even her longtime romance with her parents' friend, Dr. Richard Burke (Tom Selleck), which appalls her folks when they find out about it. The romance ends, though, when Richard, who has already raised a family, tells Monica he doesn't want to become a father again. Her yearning to be a mother is a theme throughout the series. It's an urge she satisfies in part as mother-hen to her friends, which is one reason her obsessiveness comes off as a funny and lovable quirk instead of as disturbing.

Monica may be a "romantic disaster area" throughout the first four seasons, but then, so is everyone else on the show. That her tendency toward impulsive and unlikely choices in men leads her ultimately to Chandler is a terrific joke that leads to an even better one, as their stability and strength as a couple becomes a sweet and wry contrast to the continuous drama of Ross and Rachel.

## RACHEL
## KAREN GREEN

*Spoiled. Adorable. Courageous. Terrified.*
*Monica's best friend from high school.*
*Has worked for none of what she has.*
*On her own for the first time.*
*And equipped to do nothing.*

—initial character description of Rachel

Rachel is perhaps the Friend who grows and evolves the most over the series' ten-year run. By the show's end, of course, she's a confident single mom (to toddler Emma), a sought-after fashion professional with stints at Bloomingdale's and Ralph Lauren on her résumé, and a full-fledged independent grown-up. And she also—finally—realizes what she wants in a romantic partner.

None of that sounds like the Rachel we meet in the pilot—the spoiled suburban princess who is prepared only to be a pampered wife. She doesn't know what she wants, only that she doesn't want the life everyone has always expected for her. She also doesn't know how to do anything practical. As a result, the show will generate a lot of laughs over the years from Rachel's flustered bewilderment, especially in contrast with roommate Monica's hyper-competence.

Rachel grew up as one of three daughters of an impossible-to-please doctor, Leonard (Ron Leibman), and an indulgent mom, Sandra (Marlo Thomas, who played the Rachel Green of her day as the star of late-sixties sitcom *That Girl*). The show never spells it out, but Rachel is Jewish; there are a number of cultural references throughout the series that suggest this, but the most explicit is her reference to her "bubbe," the Yiddish word for grandmother. As a teen (as shown in hilarious pre-nose-job flashbacks), Rachel was friends with

Monica Geller at Lincoln High School, but by the time she's engaged to dentist Barry Farber, she and Monica have all but lost touch. Nonetheless, it's Monica's doorstep she flees to when she abandons Barry at the altar.

In Jennifer Aniston's portrayal, Rachel is sweet and adorable enough to be endearing, despite being spoiled, inept, and pushy. So there's no malice in her treatment of Ross throughout the first season; she simply has no idea how much of a crush he still has on her, or how hurt he is when she dates Italian hunk Paolo. Of course, they will ultimately get together and split up and try to be platonic friends many times over ten seasons, but they're never good at expressing their feelings for each other. Their miscommunications are both funny and surprisingly poignant.

Rachel becomes more self-possessed over the years, both romantically (as her relationships with Ross and other boyfriends evolve) and professionally (stepping up the ladder from Central Perk waitress to fashion executive). In fact, over the course of the show, we'll meet two of Rachel's sisters, Jill (Reese Witherspoon) and Amy (Christina Applegate), who are just as spoiled and sheltered as Rachel used to be. The Manhattan-dwelling Rachel can barely relate to them anymore, except as reminders of the path she's grateful not to have taken.

## ROSS
### EUSTACE GELLER

*Intelligent. Emotional. Romantic.*
*Monica's brother.*
*Suddenly divorced.*
*Facing singlehood with phenomenal reluctance.*
*A paleontologist. Not that it matters.*

—*initial character description of Ross*

Ross is the oldest of all the Friends and, in some ways, the most mature. He is the first of the Friends to be married (also the first to be divorced) and the first to become a father. As a paleontologist—first on the staff of the fictitious Museum of Prehistoric History, then later as a professor at New York University—he literally works with fossils. The son of a Jewish father and a gentile mother, Ross often seems to fit the stereotype of a nerdy Jewish New York intellectual. He should seem older, but more often he comes off as a needy little boy.

A self-described geek, Ross grew up feeling like the favored child of Jack and Judy Geller, compared to his kid sister, Monica. In high school, Ross tried to seem more mature, evidenced by growing a mustache. He composed sci-fi–themed electronic music on his little synthesizer keyboard, music that only Phoebe thought was any good. And he harbored an unrequited crush on Monica's friend Rachel.

Ross grew out of some of his geekiness after high school. He found a lifelong friend in college roommate Chandler Bing. His sibling rivalry with Monica turned into a relationship of mutual support and caring. (Though it doesn't usually take much provocation for him to revert to a petulant child sparring with his sister.) He married his first girlfriend, Carol Willick (Jane Sibbett), a union that lasted several years, until Carol's growing friendship with Susan Bunch (Jessica Hecht) blossomed into love. She left him, but not before conceiving their son, Ben.

The other Friends will joke a lot at Ross's expense over his loss of Carol to another woman; that, plus Ross's overwhelming air of vulnerability (a David Schwimmer specialty) often make him seem less than traditionally masculine, especially compared to, say, Joey. Yet throughout the series, Ross dates a string of beautiful, smart, desirable women. His geekiness and earnest sweetness prove attractive to women. His occasional efforts to appear sexier—like his disastrous attempt to rock black leather pants, or his spray-tan fiasco—do not.

But none of the relationships last very long because each woman (all but one of them, anyway) is not Rachel Green. He often gets tongue-tied around her—most shockingly, when she crashes his wedding to Emily (Helen Baxendale) in London. After numerous near-misses and breakups, they'll finally attempt a mature, platonic relationship as Emma's parents, but they ultimately can't avoid their romantic feelings for each other. Somewhere in his heart, Ross believes he was destined to be with her. (As do we all.) Or, as Phoebe once put it, "He's her lobster!"

Phoebe and Joey playfully box in a scene inside Monica's eclectic apartment, from season 3, episode 7, "The One with the Race Car Bed."

### SET DESIGN

• • •

The one thing about *Friends* that generates the most eyerolls? It's Monica's sprawling two-bedroom apartment, of course. Who in Manhattan has an apartment that big? And how can an often-struggling chef like Monica and a waitress like Rachel afford the rent?

Sure, it's explained in a later episode that the expansive West Village pad is rent-controlled and that Monica took over the lease from her grandmother, which was not exactly kosher. Financial website Coinage estimated that, on the open market, the 1,125-square-foot apartment would rent for $4,500 a month at 2017 prices, but Monica was paying only about $200 a month.

Even so, to anyone who's ever lived in New York City, that explanation seems a stretch; the place is just too fabulous. Joey and Chandler's place across the hall—with its tiny kitchen (dominated by the foosball table that the guys use as a kitchen table) and a living room barely big enough for the pals' twin recliners—seems a lot more realistic.

Of course, the real reason it's so big is to fit cameras, lights, and six actors. But it's also meant to feel as welcoming and fun as possible. That's the spirit behind the purple walls, the open layout, the Parisian loft-style windows (all the better to peep into Ugly Naked Guy's apartment), the eclectic mix of decor, and that one door that seems to lead to nowhere. "Lavenders, greens, yellows, and pinks—it sounds like too many colors came out of the can," *Friends* production designer John Shaffner told *Entertainment Weekly* in 1995. "But it melds together to create a joyous space."

Shaffner said in a 2019 interview, "Coming to work on *Friends* was kind of like going back into

a very special time in our lives together, when we were of the age of the characters of *Friends*, when we started out friends. It was like expanding our own personal stories in a way to live the life of the characters . . . So, we were talking about this environment where these characters were going to live. We said, 'Well, you know, we lived this life. Let's draw on the experience that we had in New York.' We got out pictures of our apartment on the sixth-floor walk-up on 14th street, between 8th and 9th, and said, 'This is it.' I drew the apartment one day and sketched out the ideas. My partner Joe Stewart worked on the coffeehouse. We sort of based it on this little restaurant we would go to in the West Village because it had a door on an angle in the corner. It was a corner restaurant. We were able to get that diagonal corner upstage in the coffeehouse. Everyone would walk in and it would be a powerful walk towards camera, especially in the pilot where Rachel busts through the door in a wedding dress. We wanted that to be like, 'Pow!' That's one of the reasons for the geography that we laid out in that."

Shaffner said of Monica's apartment, "We based it on our old apartment in New York, where we had this funny situation where we had a room and we sort of delved off of it in making every door in the apartment come from the main center room. We didn't get the wall completely torn out. Landlords didn't seem to care, in the late '70s, what you did in the apartment on the sixth floor of a tenant building. In our apartment, I built the shelves for the dishes and stuff. When we designed the set, I said, 'Well, she doesn't really have kitchen cabinets. Let's just do open shelves, like the ones I built.' There are a lot of personal things in that set. One thing in particular was the fact that it was a six-floor walk-up. When you have a six-floor walk-up in Manhattan, it's way cheaper

than the first three floors. The sixth floor was the maximum they could build without an elevator for a long time. That's why our Friends got to have such a nice apartment at a pretty good price, because it was on the sixth floor. They played it up a little bit in the pilot, where every time they would come in the door, they would be panting because they were on the top floor. That joke does wear thin after awhile."

Shaffner was able to add his own creative flair to Monica's apartment and explains how he came up with the set design. "Having studied theater, I really felt this show had a lot of opportunity for a lot of physical comedy over time and a little bit of farce in the classic sense. That's one of the reasons I really wanted the geography to have all the doors open into the main room. The bathroom door—and both Monica and Rachel's bedroom doors—opened right into the main room. There was always the option of someone going into one room and then having to come back out of that room and into the main room again. I kept thinking, 'If someone is in the bedroom, and then has to go to the bathroom, they have to walk across to the bathroom.' Then I did a little bit of a hallway as if maybe the apartment may have been bigger, but it got cut down. And there was that door in the back, which we never explained until it was decided they would make that Monica's closet and do a whole episode about it."

Shaffner continues, "Creatively, what we tried to do was provide opportunities for the writer and the director to stage things and write things. In Manhattan, we always thought it was fun to go up on our apartment's roof. We knew we could do a roof set, but wouldn't it be fun if they had to crawl out the window and there was a little bit of a 'tar beach,' as we used to call it, in the setback of this older apartment building?"

> Who in Manhattan has an apartment that big?

A couple of things came about as a result. Shaffner explains, "We first drew this apartment and presented the model with two tall, narrow windows, just like what were in the boys' apartment. We were at lunch at Paramount Studios with Kevin and the director, Jim Burrows. Jimmy looked at us and said, 'I know what you are doing. I love the layout. I just wish there was something really different about the windows. Couldn't it be like a skylight?' Of course, I wanted to say, 'Skylights are in the ceiling. You'll never see that in a sitcom because we don't have a ceiling.' So I went home and looked at pictures. Joe and I said, 'Well, what about these roof windows that you always saw in an artist's studio?' It was almost operatic up there, that little window in the garret. I did do some more research and, yes, there are windows in Manhattan that look like that. I had a book with pictures in it. The window then became something that helped define the set."

So, why were the walls purple? Shaffner explains, "Kevin, in one of our meetings, he said, 'I just don't want this to be another all-white set. I want some color.' I said, 'I have an idea. I want to paint it purple.' Kevin looked at me funny and said, 'What do you mean? I can't even imagine it.' This was twenty-five years ago, and we really didn't have a lot of the tools we have now to illustrate things in terms of Photoshop. Normally, we could have illustrated it with a sketch. We had already created a white model, which is usually our first step in presenting. Then we can talk about the geography and then we can segue into talking about color palettes and furnishings. They can all grow out of that. It's something you can put on the table and everyone can look at and point at and put their fingers on. I went home, got out some watercolor, and I painted the little white model purple. I painted a little area green and I added a little yellow trim. I brought it back to Kevin and the team and they went, 'Well, I think we can envision this. Go ahead.' I said, 'Look, if we all hate it, we can always repaint it. It's not that big of a deal.' I looked at all my color

chips and I said, 'I think this is the color.' We painted it and everybody loved it. Also, it gave a really strong identification to the show when you tuned in. You'd go, 'Click, click, click. Oh, there's *Friends*.' Of course, by choosing such a strong color, it forced Greg, our decorator, into making choices that were neutrals. The sofa was that dirty off-white color. The woods were neutral, white woods. The carpet was fairly neutral. He put colors into chairs. He said, 'Maybe they got different types of chairs and Monica painted them different colors in the dining area.' We had a little more fun with color on the counter and things like that. Then there were those golden drapes. I used green in the hallway past the bathroom."

Ever wish you could plunk down and relax on Monica's couch? It was as comfy as it looked on TV, Cox told *EW*, adding that the actors liked to sleep on it. (But not the couch in Joey and Chandler's apartment, which Cox said was "gross.") The only glitch was the throw pillows, which Cox said poked painfully into the actors' backs.

Less inviting was Monica's refrigerator. Even though it was stocked full of food and drinks, it wasn't always turned on. The contents were often spoiled, which is why you seldom saw characters take something out of the fridge and eat or drink it. "There was a smell in the refrigerator for two months," LeBlanc told *EW*, "like a rat had died in there or something." At least its decorations were realistic—a subway map, actual take-out menus from Manhattan restaurants, and a photo of a cat, the dear departed pet of set designer Greg Grande. (No word on whether the photo's placement on that pungent fridge made the animal the inspiration for "Smelly Cat.")

One of the trademarks has always been the picture frame on the back of the door. Shaffner said, "The set was standing, and Greg was starting to dress, and we were starting to look at things. I said, 'Greg, what can we do with this door? Every apartment building in New York has a slab metal door for fire codes. They were retrofitted. I don't see any way around this, but it's so blank.' He

One of the most recognizable doors in television: the back of the purple door with the yellow frame in Monica's apartment, from season 10, episode 8, "The One with the Late Thanksgiving."

looked at me and I said, 'In New York, when we lived there, people I knew either had coat hooks on the back of the door, where you would hang your umbrella, because you always had to have that. Sometimes you would put a chalkboard there because if you live on the sixth floor, you always want to write down something, so you don't forget it when you are going out. There's bags hanging on the back of the door. I don't know what else.' So he came back a day or so later. He showed me this little picture frame and he held it up and put it over the peep hole. I said, 'Fantastic. It's great.' The yellow color was just so perfect with the purple. I give credit to a good decorator, who after a conversation like that, goes out and uses their imagination and has ideas and brings more to the picture."

*Friends* opens at Central Perk. When asked about his vision for the coffee shop initially and how it evolved over time, Shaffner said, "First of all, the thing about the coffee shop is we recognized they needed another living room to hang out in for the storytelling. By this time, there wasn't quite the internet explosion, of course. There were places to get coffee, but there really wasn't quite the bohemian, furnished atmosphere around at the time. I had a friend in New York, and I said, 'Go around and take pictures of every coffee place you can think of.' It was just at the beginning of the Starbucks era. Some of us were old enough to remember the late fifties and early sixties where coffeehouses were places people congregated and hung out and sat on the sofa and read magazines. Yes, there were the odd places in New York at the

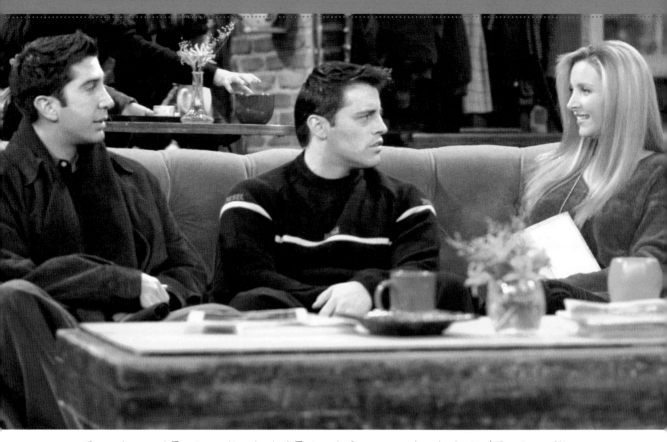

Ross, Joey, and Phoebe on the Central Perk set, from season 4, episode 13, "The One with Rachel's Crush."

time that might have had tables and chairs and people hung out, but we envisioned this place as almost another living room."

Shaffner explains, "In our original design, we had made the set much deeper. Kevin had said, 'No, no. Not so deep. It should look cozier.' So, we shrunk it down. We worked closely with our set decorator, Greg, who in the end is responsible for selecting—with our guidance and the producer's approval—all the objects and furnishings. We selected all the colors, the materials, and the finishes on the floors. We had the idea that it was an old building and they just pulled up all the old linoleum and all the old tiles, so there was this floor of concrete that had mixed-up stuff on it. We said to Greg, 'Let's just get lots of rugs and lay them all on top. That will cozy it up.' I designed the little

counter where they served the coffee from. It was kind of crowded, to tell you the truth. Greg had never really been to New York. We explained— and this was true in both the coffeehouse and in Rachel and Monica's apartment—that when you are young and live in New York, you have an incredible resource called the street. To get rid of stuff, it's a real pain in Manhattan. So, if you go out the night before the trash gets picked up, especially on the Upper East Side, it's amazing what you can find. We sort of envisioned that as part of the overall eclectic look. I will say, once Greg understood this eclectic look, he brought a lot of wonderful things into the coffeehouse, in particular that amazing sofa that he found in the warehouse at Warner Bros. The colors went with the room. It was inviting. You could kind of

slouch in it. That particular set was really about creating that quasi-bohemian coffeehouse past in the present. If you recall, in the show, they don't sit around with iPhones and computers. They sit around with cups of coffee and talk to each other."

Central Perk also had a lot of decor you couldn't see, except maybe on freeze-frame. For instance, the reading material strewn about included some art photo books ("very racy," according to Kudrow) and ancient magazines. ("I'm still reading articles in *Redbook* from 1989," Cox said in 1995.) The coffee blends in the jars and bags bore Starbucks-like, New York–themed names, such as Ms. Liberty Blend and Broadway Mocha Quartet. "Whether or not we ever see it on TV, the cast can appreciate it," Grande said.

Less complicated was Joey and Chandler's place, although they needed to differentiate it from Monica and Rachel's apartment. Shaffner said, "It was the pared-down version. It was almost a reflection plan in that you walk through the door, but then you were right in the little kitchen. Then you walked into the bigger living space and you had the two narrow windows. I continued the idea that there was the bathroom door on that side of the stage, upstage of the kitchen. The two bedroom doors were on the camera-left wall. Again, they had to cross the room. Everybody had their own door. When they had the ducks, they would have to go to the bathroom where the duck was. They would have to come out of their bedroom to cross the living room to go to the front door. The main thing was when I went into the first meetings on this, I said, 'We don't have any color in the apartment to begin with. Everything is either brown or tan. These boys are afraid of col-

or.' For a while, we were able to keep that. Then, of course, it evolved when Joey got a job and he got a little more adventuresome. They got the recliners and then the yellow leather sofa. The walls were never changed. In the first episode, it was brown drapes, brown carpet, brown furniture. No color. It was two boys who were afraid of color."

What makes a great set design is taking into consideration the characters' personalities. When asked about the other Friends' apartments, Shaffner said, "Ross didn't live in an old building in Manhattan. He had the kind of bachelor pad building, where you couldn't quite see into the kitchen, but you knew where the front door was. It was a very plain window. I imagined it was one of those brick buildings built in the sixties, maybe not quite so nearby. Maybe it was a little farther north. We never really said where in Manhattan he lived. Very plain and, again, colorless. In the first episode or two, we had him building furniture. Then we were able to flesh out his collections. Then he moved. It was the only set that I ever asked an actor what color to paint it, and that was his apartment. At this point, I said, 'Maybe we want to do something adventuresome.' As the series grew, Ross became a more sophisticated personality. His furniture got a little more grown-up."

Phoebe's apartment was in an older building. Shaffner said, "I had this vision. I said, 'I want to do a yellow. I found yellow-mellow; that sounds just like Phoebe.' We started there and I think Greg got some green in there. It was the most bohemian of the apartments. We never did spend a lot of time in her apartment. In the end, everybody had their own color schemes. Phoebe's

> "If you recall, in the show, they don't sit around with iPhones and computers. They sit around with cups of coffee and talk to each other."

One of the special "outdoor" scenes that production designer John Shaffner had to create for season 3, episode 9, "The One with the Football."

things had yellow or aqua or blue-green. Ross had the red and then the purple. I don't think you walked away . . . thinking, 'Oh my God. There's so much color.' It seemed organic to the characters and the storytelling."

The prop *Friends* fans asked about most was that tasseled Italian lamp of Monica's. Turns out the Fortuny fixture was also the apartment's costliest prop, acquired for about $2,200. Grande said it helped give the room a "bohemian feel." Perry said he tried to balance a cookie on top of it once, as a joke, but it wouldn't stay.

Less visible to viewers were the titles in Monica's CD collection. These were chosen not to suggest Monica's musical taste, but because they were Warner Bros. artists whose CDs the producers didn't have to pay for. Among the

discs were albums by artists as varied as Anthrax and Nico. There was also, in a meta touch, the *Friends* soundtrack.

On the outside of the door was the apartment number 5. (Joey's was number 4.) But that was only for the first nine episodes. Then someone realized that, on the upper floor of an old Manhattan apartment building, the numbers would be higher. Suddenly, without having moved, Joey and Chandler were living in apartment 19, while Monica and Rachel were in apartment 20.

As for Central Perk, its defining feature was that invitingly plush orange couch. It's the one thing that seemed to stay the same, even as tables and chairs moved, or as a stage mysteriously appeared for Phoebe to perform upon, or as the artwork on the walls (painted by set dresser Scott Bruza, so

that WBTV wouldn't have to license paintings by independent artists) was quietly replaced, which happened every three episodes. That couch—which, aside from one memorable moment in season 3, episode 1, no one but the Friends ever sat on—was a 1920s prop from the Warner Bros. basement, which Grande reupholstered.

The elaborate-looking Pasquini espresso machine was real. In fact, James Michael Tyler, who plays Central Perk mainstay Gunther in most of the episodes, initially got the role because he was a barista in real life when the producers hired him as an extra to play one of the anonymous Central Perk staffers, and he was the only extra who could actually operate the espresso machine. Eventually, of course, Tyler got promoted to a speaking character, even as Gunther got promoted from barista to manager. He ended up appearing in 148 episodes, more than any other guest character, all thanks to his espresso-brewing skills.

There was another, old-fashioned espresso machine on top, which Grande thought had more personality than the Pasquini brewer. But it did not actually dispense coffee. The steaming mugs of java the Friends drink were generally brewed offstage and warmed on burners by the bar. The pastries served were also real but inedibly stale. "If you try to eat them, you might lose a tooth," Grande said.

Besides Central Perk, there were a few sets that Shaffner was particularly proud of that don't get their due. Of Carol's (Ross's first ex-wife's) apartment he says, "I always liked that apartment, the way I worked the kitchen and the hallway that went past the kitchen, behind it to the bedrooms and the window in the back, and where I located the front door . . . But one set I will never forget was the Thanksgiving football game. Initially, we had a meeting about it. They said, 'It will never look right if we do it on a soundstage. We have to do this outside.' We went around on the backlot at Warner Bros. There's a couple of little park areas. We figured we could bring in more trees and lay out on the grass. We could add a little autumn colors in the trees. I was like, 'Oh good.

I don't have to worry about that. This is easy for me.' About a week before that episode started, Kevin and the line producer called me up and said, 'We have to do the football game onstage. We've realized we have airplane problems. It's going to take all day. The sound isn't going to be very good. The lighting is going to be changing. Why did we ever think we could do this outside?' I now had to make a real giant park onstage. I said, 'Number one, it won't fit on Stage 24. We have to find another stage.' We found Stage 25, which became where *Big Bang* was set. We brought in some bleachers and laid out this thing. I actually built the full-color model of that."

Shaffner continues, "I first presented the idea they were inside the park looking toward the street. I had found some interesting backdrops of apartment buildings. I thought with a high-enough wall and enough trees and a few cars parked out there, it would look really good . . . They said, 'No, no. Do it the other way around.' We pretended we were on the sidewalk looking into the park. I had to scrounge away in the warehouses of Warner Bros., whatever we could find that had brick on it, and create the ideas of apartment buildings on the right and the left. A wall in the back. A backdrop behind that. Then, getting greens to come in and create trees that had autumn leaves in them, where they wire on every single leaf. Then, what do we do about the ground? We don't want them playing on real dirt. It has to be padded. It's the time of year where the grass would be dying off. I had worked with Ed Stephenson and he had showed me that sometimes you used jute carpet padding turned upside down. We did a layer of padding and then two layers of this. We put some dirt on top of that and then we did lots and lots of autumn leaves. I have to be honest: it looked all smooth and like a park. But the more they rehearsed on it, the better it looked because the dirt got scrunched up and the leaves got pushed into the ground more. It just got realer as the week went on. That was a very anxious project because it was big and it

was outside but inside, and I had to rely on all the departments of Warner Bros. to bring their best game—especially the greens and the painters."

## FILMING LOCATIONS

• • •

Do you like the New York City vibe of the locations on *Friends*? Spoiler alert: it's all fake. Almost the entire series was shot at Stage 24 on the Warner Bros. lot in Burbank, California, about 3,000 miles away from Manhattan's West Village. (Fun fact: Before *Friends*, Stage 24 was the home of *Full House*.)

Even the opening credit sequence, which sees the Friends splashing in a fountain that looks a lot like the Bethesda Fountain in Manhattan's Central Park, was shot on the Warner Bros. lot, as was the epic Thanksgiving football game and the gang's fateful trip to Vegas.

The only major on-location shoot during the series took place during the episodes surrounding Ross and Emily's London wedding, at the end of the fourth and beginning of the fifth seasons. Yep, they actually shot those in London, in part because it made plot sense that Ross's British fiancé would want to get married there, and in part as a service to the show's avid British fanbase. (Plus, it was a way to get stunt-cast guests like Sarah Ferguson and Richard Branson to make cameos.) So yes, the show shot at real London tourist spots like Westminster Abbey, Big Ben, and the Tower of London.

Of course, there were establishing shots of various New York City locations, including the Moondance Diner (Monica's workplace on the show for a while; it was a real downtown restaurant until it was torn down in 2012), Bloomingdale's (the site of Rachel's first major fashion job), and even the Twin Towers of the World Trade Center. (After September 2001, of course, the show stopped using those shots, which was pretty much the only sign, along with an American flag on the wall of Central Perk, that the terrorist attacks of 9/11 had affected the series.)

Most commonly, there were the exterior shots of the building at the corner of Bedford and Grove Streets that supposedly housed Monica's and Joey's apartments. Yes, 90 Bedford Street is a real building, but the show never filmed inside it, and it almost certainly doesn't have any apartments as grand as Monica's.

According to the invitation Rachel receives in "The One with the Invitation," the apartment building's address is 495 Grove Street. In the actual New York City, that address belongs to a different Grove Street, across the river in Brooklyn.

In early 2019, Cox happened to be dining in the West Village and filmed a short Instagram video of herself pretending to go home for the night, to 90 Bedford, complete with *Friends* incidental music. The clip, which she entitled, "The One Where My Rent Went Up $12,000," got half a million likes.

When the series wrapped production in 2004, Warner Bros. officially renamed Stage 24. It's now known as the *Friends* Stage.

## COSTUME DESIGN AND NEW YORK STYLE

• • •

For a group of young adults leading fascinating lives in the City That Never Sleeps, the Friends were surprisingly unhip. Think about it. They didn't listen to hip-hop, grunge, or any other then-cutting-edge music; their collective idea of a cool concert was Hootie and the Blowfish. They didn't have unusual piercings or tattoos, as was made clear during Rachel and Phoebe's disastrous and out-of-character visit to a tattoo parlor. And their clothes were curiously . . . sensible.

**OPPOSITE** The outside of Central Perk was actually still inside the soundstage, shown here in season 3, episode 5, "The One with Frank Jr."

Ross may have been the group nerd, but stylewise, they were all nerds. Monica and Chandler, both uptight, usually wore either casual wear or clothes appropriate to their jobs (a chef's uniform for her, a business suit for him). Joey's acting gave him some cachet, as did his self-confident masculinity, but not even he could pull off his attempt at accessorizing with a manbag. Phoebe's outfits may have been a little more hippie-chick-retro than the others, but otherwise, her clothes only hinted at her kooky personality. Even Rachel, the most fashion-minded of the group, dressed pretty square. But then, think about where she worked when she became a fashion professional: Bloomingdale's and Ralph Lauren. Both carry classy, classic old-school looks, neither of them exactly cutting-edge.

You did see a lot of black clothing on the show, but then, you would in the real New York, where people wear black because it's practical, not because they think it makes them seem brooding and more interesting. Along those lines, costume designer Debra McGuire tried to make a point of not letting them wear jeans too often, despite Kauffman's objections, since real-life New Yorkers seldom wear them. Still, the Friends wore a lot of denim—not just jeans, but jackets, vests, and even bib overalls.

And that casual ordinariness was okay. The fact that you could buy most of the characters' outfits at the Gap—or at least, knockoffs of them—only made the Friends seem more accessible, more like yourself or people you'd hang out with in real life. Indeed, it may be one of the reasons the show has aged so well. Just as *Friends* contains so few topical references to the pop culture of the 1990s that would make it seem dated now, so the show's fashion choices also seem generic enough to be durable. Indeed, the popularity of *Friends* among Gen Z viewers has arguably sparked a revival of casual nineties fashion.

That's not to say that the Friends didn't appear well-dressed; indeed, they made everything they wore look terrific. If they weren't necessarily trendsetters, they still wore some archetypal nineties clothes well. For the guys, that meant oversized flannel shirts layered over T-shirts, bowling shirts or sweater vests for Chandler, and turtlenecks for Ross. For the gals, it meant crop tops, slip dresses, chokers, and short skirts paired with tall boots.

That's also not to say that McGuire's job was easy. With six stars and three or so guest stars per episode, plus storylines that might span several days, McGuire was responsible for fifty to seventy-five costume changes each week. No wonder she often dressed the cast in reusable, everyday, mix-and-match items.

Rachel's outfits included items like plaid skirts, argyle sweaters, leather necklaces with pendants, sweaters with shirt collars, and print pants, tight or baggy. She was not the first nineties woman to wear these items, but she wore them better than most, and fans wanted to wear them too.

Phoebe's clothes were, naturally, more eclectic and funky. Think of her lacy tops with appliqué flowers, her fuzzy Day-Glo orange overcoat, her flower-print tea dresses, or her fuzzy pink pigtail holders. Nothing too risqué or revealing, Phoebe's clothes were bohemian yet demure.

In the last six seasons, many of Phoebe and Rachel's most popular wardrobe items—notably, a strapless yellow dress of Rachel's—came from a London boutique called Idol (which, sadly, no longer exists). McGuire cleaned out the shop during the London shoot of Ross and Emily's wedding.

Again, many of these items were readily and inexpensively available to the public—or so it seemed. McGuire noted that Joey's leather jacket was actually an Armani, which in real life would have been out of the struggling actor's price range. Other costume items, McGuire told *The Telegraph* in 2016, were also deceptively unaffordable in real life.

As late as 2017, McGuire said, not a week went by without letters from fans wondering where they could buy a dress they'd seen on the show. "I always write back and say, 'That was twenty years ago.'"

One of the many sets of wedding outfits that the Friends wore throughout the series—like this one from season 8, episode 1, "The One After 'I Do.'"

The actors didn't take any of their wardrobe off the Warner Bros. lot as souvenirs, she said, because they didn't want to look like their characters in public.

But if the actors didn't think their costumes had any fashion shelf life, many fans did. The best compliment she ever got about the costumes, McGuire said, came from no less a fashionista than designer Tom Ford. "I got a note from Richard Buckley, his partner, saying they watched the show every night when they have dinner," McGuire said, "and that Tom wanted me to know that the clothes looked better than ever."

## THE WEDDING OUTFITS

● ● ●

With all the nuptials that occurred over ten seasons of *Friends*, it's no wonder that the wedding and bridesmaid dresses McGuire had to provide turned out to be some of the show's most memorable costumes. During the show's run, McGuire also had a boutique in Pacific Palisades,

where much of her business was bridal wear. She made gowns for several real-life celebrity weddings, including Lisa Kudrow's. So she knew the territory.

Indeed, the items fans wanted for themselves more than any other, McGuire told *Racked* in 2017, were those unusually flattering bridesmaid dresses that Rachel and Phoebe wore at Monica and Chandler's wedding. McGuire recalled that the elegant, pale yellow gowns were purchased off the rack at Neiman Marcus; the label, she said, was "some random formalwear brand."

The strapless wedding gown Rachel wore in the pilot episode was also ready-made. McGuire said it was a stock item from the Warner Bros. costume closet. It was just something she found among the "millions of dresses" there during the rush to meet the pilot's production deadlines. Unfortunately, she didn't keep it or make duplicates, which she regretted when she needed the gown years later for flashbacks.

Many other bridal outfits on the show came

from Lili Bridals, a bridal shop in Tarzana owned by the family of *Friends* casting director Leslie Litt. Among others, the gowns Rachel and Phoebe wore in season 4's "The One with All the Wedding Dresses" came from Lili.

The gown Monica wears in that episode is supposed to be the same one Emily wears when she walks down the aisle with Ross a few episodes later. But Helen Baxendale was pregnant, so McGuire had to make some changes—notably, adding a jacket—to hide the actress's baby bump, as well as to conceal the fact that it wasn't the same dress.

• • • • • • • • • • • • •

## "The taffeta was bad, the color was bad, the puffy sleeves were bad. It was exactly what I wanted."

• • • • • • • • • • • • •

For the then-controversial lesbian wedding episode, McGuire took pains to make outfits for Susan (Jessica Hecht) and Carol (Jane Sibbett) that were non-traditional in style and color (beiges and grays) but soft and satiny. Susan's ensemble was inspired by the outfit McGuire wore at her own wedding. McGuire had been a polo player, so her own wedding dress—and Susan's—came from nineteenth-century English equestrian outfits, with a jacket, a bustle, a long skirt, and a hat that resembled both a top hat and a wedding cake. "I really loved the idea of these women being women, of them looking beautiful and feminine, because of the stereotypes about gay women," McGuire said of the thought that went into the bridal wear design. "We took it very seriously."

McGuire also put a lot of thought into designing the "hellacious" hot pink bridesmaid

outfit Rachel wore to Barry and Mindy's wedding. "The taffeta was bad, the color was bad, the puffy sleeves were bad," McGuire said. "It was exactly what I wanted." To her astonishment, some fans really liked it.

She tried to design a dress for Monica's wedding to Chandler, but it didn't fit on the first try, and rather than wait for alterations, Cox went with an off-the-rack gown McGuire had bought as a back-up.

For the show's last wedding—Phoebe and Mike (Paul Rudd)—McGuire went with a combination of store-bought and original designs. Phoebe's lavender gown came from a boutique in Westwood, but the jacket she wore over it was a McGuire-designed piece, made with fabric imported from India. Similarly, the bridesmaids' dresses were by Michael Kors, but when Phoebe and Mike decided to have the ceremony on the snowy street in front of Central Perk, the bridesmaids all covered their gowns with different-colored jackets.

### THAT HAIRCUT (YOU KNOW THE ONE)
• • •

Of course, the one element of *Friends* style that did seem fashion-forward at the time was Aniston's layered, face-framing shag hairdo. It worked so well on her that suddenly, women and girls all over the world were storming salons and demanding "the Rachel." If *Friends* spawned a defining, far-reaching style trend, it was that coif.

Aniston's hairstylist, celebrity hairdresser Chris McMillan, took credit for crafting the influential cut. "I told her she should grow her fringe out, get some highlights and just try something a bit different," McMillan told *The Telegraph* in 2016. "We cut the length and added in all these layers to blend the bottom to the bangs—and the rest is history."

The only one who didn't like "the Rachel," it seems, was Aniston herself. "I think it was the ugliest haircut I've ever seen," she told *Allure* magazine in 2011, adding that she didn't

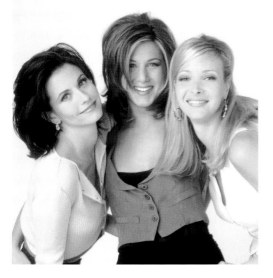

"The Rachel" shown here in the middle for a publicity photo for *Friends*, season 2.

understand the enduring appeal of "the Rachel." Aniston said, "What I really want to know is, how did that thing have legs?"

To be fair, Aniston may have felt some hostility toward the haircut that helped make her famous because she found it so hard to maintain. (Indeed, she wore it only during the first two seasons of *Friends*.) As she noted in 2018, when honoring McMillan as Hairstylist of the Year at the *InStyle* Awards, "Nobody has the ability to actually do what Chris did to this haircut." While she thought it looked "amazing" when McMillan styled it, she found that later, "I was totally left with this frizzy mop on my head, because I had no idea how to do what he did."

McMillan admitted that "the Rachel" required serious upkeep effort. "It needed regular trims to keep the layers looking sharp," he told *The Telegraph*. "It's high-maintenance, not a wash-and-go style. You need to blow-dry with a round brush to help define all those flicks. If you aren't someone who wants to put effort into your hair, this isn't the cut for you."

## THEME SONG

• • •

TV theme songs used to be a big deal. Sure, today's network programmers won't waste precious seconds on them, lest you flip the channel while you wait for the song to end and the show to start. But think of some of the most memorable shows from the 1950s to the 1990s—from *I Love Lucy* to *The Andy Griffith Show* to *Gilligan's Island* to *The Brady Bunch* to *Cheers* to *The Golden Girls*— and one of the first things that will pop into your head is a melody that makes you smile or even start humming or singing. *Friends* was perhaps the last TV show to have a theme song like that.

Originally, the opening-credits theme wasn't even going to be an original song. We might have watched the Friends playing in the fountain to the tune of R.E.M.'s then-recent hit "Shiny Happy People." But WBTV couldn't clear the rights to that upbeat tune, so they set about commissioning a song that had a similar beat and chiming guitar sound—a song that, not coincidentally, would belong to its parent company's music publishing arm, Warner Chappell Music.

The task initially fell to Marta Kauffman's then-husband, composer Michael Skloff. He wound up composing the incidental music throughout the series, as well as the melody of what became "I'll Be There for You." But the finishing touches came from two unlikely sources: a lyricist best known for her disco-era R&B tunes, and an alt-rock guitar duo.

The lyricist was Allee Willis, a woman best known for co-composing such late seventies/early eighties R&B hits as Earth Wind & Fire's "September" and The Pointer Sisters' "Neutron Dance." Decades later, she'd co-write the lyrics to the Broadway musical version of *The Color Purple*.

In the early nineties, Willis had become disenchanted with writing dance music and was trying to break into directing. One of her mentors was *Friends* executive producer Kevin S. Bright. So when he needed a lyricist for the *Friends* theme, Willis recalled him saying he was looking for

"someone who's kooky, but commercial." As she recalled to *Songfacts* in 2008, Willis took the gig as an easy way of getting out of her contract with Warner Chappell, to whom she owed one last tune.

Willis had to write the lyrics in a hurry; she recalled landing the assignment just three weeks before the show was to premiere. She watched the pilot and crafted lyrics for a verse and chorus around the one line Skloff had given her, a line that was supposed to suggest loyalty in the face of hard times: "I'll be there for you."

To record the song, WBTV needed to hire a band who was also part of the Warner family. Kevin S. Bright championed The Rembrandts, an alt-rock guitar duo he liked, who happened to be signed to a Warner record label.

Danny Wilde and Phil Solem had had a top-20 hit off their self-titled 1990 debut album, the single "Just the Way It Is, Baby." Their second album, 1992's *Untitled*, had expanded their cult following. As underground rockers accustomed to performing original material, they didn't seem like obvious candidates to be a band-for-hire to play the peppy pop tune Skloff and Willis had composed.

But they watched the pilot and liked it. They took what Skloff and Willis had written, created the song's now-familiar guitar and vocal arrangement, and added a second-verse lyric and a bridge, though they weren't used for the forty-second version played during the opening credits. "We completely made it our own," Wilde said of The Rembrandts' reworking of the song. "I remember thinking it was awesome, a really cool little pop tune," he told *The Independent* in 2004. "It had great harmonies and this upbeat vibe. More than anything, it was fun."

Still, "I'll Be There for You" didn't sound like any of the other songs that Wilde and Solem had recorded, and the pair didn't want to release it as a single. But when *Friends* took off in popularity, demand for radio airplay was so strong that a single materialized anyway, based on an extended mix made by a Nashville radio DJ. The label rushed Wilde and Solem into the studio to record

their full-length version as a single. Soon, "I'll Be There for You" was No. 1 on the Billboard chart—the last TV theme song to achieve such a feat. It stayed on top for eleven weeks.

Why did the song resonate so much with listeners? Sure, it was inextricably tied in fans' minds to a beloved show, and sure, it had a catchy, cheery melody that belied the verse's downbeat lyrics. But there was also something universal about the sentiment those lyrics expressed. Maybe the line "Your job's a joke, you're broke, your love life's D.O.A." was meant to describe life in your twenties, but it's a feeling everyone from teenagers on up has experienced at some point (maybe more than one point) in their life.

Thematically, the song's lyrics resembled those of "Where Everybody Knows Your Name," the tune from James Burrows's *Cheers* that had become a hit single a decade earlier. Both songs are about a refuge from the harsh realities of modern life, a haven based on moral support and friendship. Whether you commiserate over a beer or a coffee, the spirit is the same. Your friends are the people you can rely on to comfort you, week in, week out. Every Thursday night, in fact. No wonder the song and the show clicked.

## CURTAINS UP

Before the *Friends* pilot was shot, Burrows helped Kauffman and Crane streamline the unconventional script. Originally, the second act was supposed to end with Rachel's parents arriving and chewing her out. They were cut, but the act still ended on an unconventional note, with both Ross and Rachel, in separate apartments, looking wistful and worried as they wondered about their futures.

Other changes: NBC thought the script skewed young. Did it have to take place in a coffeehouse? Why not a diner, like *Seinfeld*? And why was there no mature adult authority figure on the show, someone to advise these kids with the wisdom of age and experience? Kauffman and Crane wrote in a mentor, a cop named Pat who

might have become a recurring character, but they decided he didn't work and left the six Friends to solve their problems on their own.

As the pilot taping day approached, costume designer Debra McGuire was scrambling, not just to find outfits for the cast, but also because she was working on a production of her own. Three days before the taping, she gave birth. She brought her newborn daughter to the set in a basket.

During the shoot, Kudrow was worried that her oddball character wouldn't fit in, or that Burrows wouldn't like her performance again, and that she'd be fired. She was especially fearful when Burrows tried to stage the sequence where the gang convinces Rachel to cut up her credit cards by having Kudrow play the scene from under the table, just because Phoebe was supposed to be quirky. Of course, the scene didn't work that way, but Burrows made sure Kudrow didn't get blamed. He took responsibility for the failed experiment and shot the scene instead with Phoebe sitting in among the group.

Schwimmer was worried too that the new comedy wasn't going to be the collaborative experience he'd been promised. He'd felt his ideas went unappreciated on *Monty* and didn't want a repeat of that fiasco.

That's when Cox stepped in, à la Monica, and took the lead. As the most famous actor in the cast, with the most TV experience, she could have lorded her status over the others. Instead, she told her castmates, she'd just done a *Seinfeld* episode, and she'd found the actors there gave each other tips and suggestions on how to make the scenes even funnier. "You guys, feel free to tell me," Kudrow recalled her saying. "If I could do anything funnier, I want to do it."

Actors seldom give each other notes that way, but here was Courteney Cox, giving her lesser-known castmates permission to give her notes.

> "The six of you will never be able to do this again."

Kudrow also remembered her saying, "We all need to make this thing great," and "I know I'm the one who's been on TV, but this is all of us." Said Kudrow, "She was the one who set the tone and made it a real group that way. And I thought that was a real turning point."

The pilot episode would ultimately air without a title, though later it would be known as "The One Where Monica Gets a Roommate." Indeed, it's because the episodes would air without their titles displayed that the *Friends* writers developed the convention of naming all their episodes "The One Where . . ." or "The One with . . ." Where did the idea come from? "That was David Crane," confirms Kauffman in 2019. "He was talking about how when people are talking about shows, they always say, 'You know, the one with the thing, or whatever.' He just decided that would be a fun way to title it."

After the pilot taped, Burrows was certain not only that *Friends* was going to be something special, but that its six cast members were going to become huge stars, famous beyond what they could have imagined.

To celebrate the taping, the director got WBTV boss Les Moonves to lend him the corporate jet. Burrows flew his six new young pals to Las Vegas. He bought them dinner at Caesars Palace, where Joey would one day work as a greeter dressed as a gladiator. He even gave them a few hundred dollars each for gambling, as none of them had any money of their own.

As they wandered the casino floor in anonymity, Burrows told them to enjoy this moment, as it would be the last time in their lives they'd be able to walk around a public place like that in peace, without being recognized. "Your life is going to change," LeBlanc remembered Burrows saying. "The six of you will never be able to do this again."

# Season One

Season 1 introduces the six main characters—Rachel Green, Monica Geller, Phoebe Buffay, Joey Tribbiani, Chandler Bing, and Ross Geller—and begins with Rachel, who just left her fiancé, Barry, at the altar, arriving at Central Perk in her wedding gown. Rachel moves in with her high school friend Monica, whose brother is Ross. Viewers discover early on that Ross has been carrying a torch for Rachel since high school. He also finds himself single, estranged from his wife, Carol, who is pregnant with his baby—and who is also involved with her new partner, Susan—just to keep things interesting. Several episodes revolve around Ross's attempts to share his feelings for Rachel with her.

The other characters have multiple romantic encounters, most of which go terribly wrong. The audience meets the recurring character of Janice, a girlfriend Chandler struggles to break up with.

Later in the season, Ross, a paleontologist, leaves for China for a fossil dig. He misses out on Rachel's birthday party but manages to deliver a meaningful gift: a brooch resembling the one that belonged to Rachel's grandmother. In this moment, Chandler accidentally reveals Ross's feelings for Rachel—much to her surprise. Rachel realizes that she in turn has feelings for Ross and rushes off to the airport to welcome him home, only to find out that he has a new girlfriend, Julie. Ross has a lot going on this season, including the birth of his son Ben.

OPPOSITE TOP AND BOTTOM *From season 1, episode 4, "The One with George Stephanopoulos."*

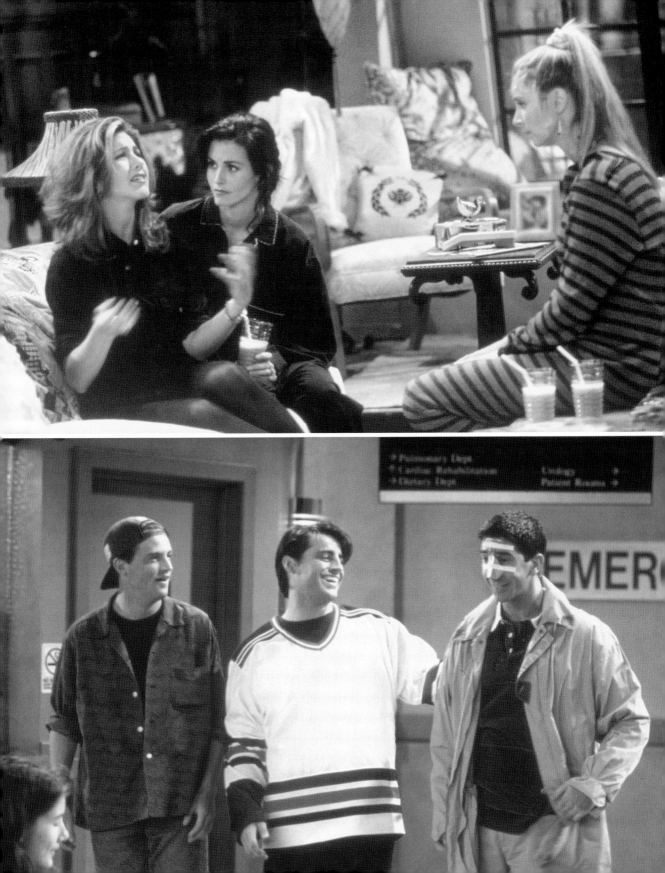

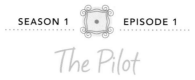
# The Pilot

WRITTEN BY • DIRECTED BY • ORIGINAL AIR DATE
David Crane & Marta Kauffman • James Burrows • September 22, 1994

In the *Friends* pilot—sometimes called "The One Where It All Began" or "The One Where Monica Gets a Roommate"—we see Monica Geller, Phoebe Buffay, Chandler Bing, and Joey Tribbiani sitting in Central Perk, discussing Monica's penchant for dysfunctional men and Chandler's naked dream, which involved an ill-placed phone and a call from his mother.

In walks Monica's brother, the morose Ross Geller ("This guy says hello, and I wanna kill myself," Joey quips). It turns out Ross's ex-wife, Carol, has come out as a lesbian and moved out of their apartment, officially ending Ross's marriage. After Ross admits he just wants to be married again, his old high school crush, Rachel Green, bursts into Central Perk, soaking wet and wearing a wedding dress. We learn she has left her fiancé, Barry (aka Mr. Potato Head), at the altar and has nowhere else to go.

Later, at Monica's apartment, Rachel has an existential crisis on the phone with her father: "What if I don't want to be a shoe? What if I want to be a purse?" She refuses to go back to Barry, and loses access to her father's fortune as a result. She then promptly begins hyperventilating into a paper bag.

• • • • • • • • • • • •

## "Welcome to the real world. It sucks. You're gonna love it."

### MONICA

• • • • • • • • • • • •

Monica, meanwhile, has a first date that night with Paul the Wine Guy (John Allen Nelson). At a restaurant, he confesses he hasn't been able to perform sexually in two years, since his ex cheated on him. Monica, touched by Paul's "fifth-date honesty" on the first date, sleeps with him. The next day, she is chatting with a fellow chef who reveals that she too slept with Paul and takes credit for putting back the "snap in his turtle." Monica realizes she's been conned.

Back at Ross's apartment, the guys try to cheer up Ross, telling him that divorce is the greatest thing ever to happen to him. Joey compares all the available women in the world to the many different varieties of ice cream and tells Ross to "grab a spoon!" But Ross can't even imagine loving another woman after Carol.

At the end of the episode, there is a ritualistic cutting of Rachel's credit cards ("Cut! Cut! Cut!") as she symbolically severs the ties to her old life. Monica, meanwhile, smashes Paul's watch on the floor, exacting the same revenge on him that he had on his ex. And Ross realizes—through a shared Oreo cookie moment with Rachel—that he might be ready to "grab a spoon" after all.

In the pilot, Rachel has left her fiancé, Barry, at the altar, trading in her old life for five new friends and a cup of joe.

**COMMENTARY** Even though the six characters have all interacted with each other in some capacity outside the pilot (Rachel, Ross, and Monica all went to Lincoln High together, and Joey mentions he and Chandler live across the hall from Monica), this is really the first time all six friends meet for the first time as a group, setting the stage for the next ten seasons.

Early character traits are already strong in the pilot episode. Monica tells her friends to move her table back to its original spot, an early indication of the obsessive tendencies that will surface later; the not-so-subtle hints that Ross and Rachel will eventually become a couple; Joey with a sandwich in hand as he unashamedly hits on Rachel on her wedding day; Phoebe alluding to her mother's suicide in her flighty, "oh by the way" voice; and finally Chandler—ever the Freudian funnyman—in a hysterical moment of physical comedy dancing after Joey and singing, "Once I was a wooden boy . . ." mocking Joey's stint in a production of *Pinocchio*.

Even in the very first episode (which brought in 21.5 million viewers), you can see what made *Friends* work so well: the quips, the timing, the strong character traits, and the clear chemistry on set. It's all there, percolating along with a cup of Central Perk's finest.

# The One with the Sonogram at the End

WRITTEN BY • DIRECTED BY • ORIGINAL AIR DATE
David Crane & Marta Kauffman • James Burrows • September 29, 1994

If the first episode was about things falling apart—from Rachel's wedding day to Ross's marriage—the second episode was about trying to fix it. Carol comes to see Ross at his job at the fictitious Museum of Prehistoric History and tells him that she's pregnant with his baby. He needs to decide if he's going to be a part of the pregnancy with Carol and her new partner, Susan.

Monica, meanwhile, is all "chaotic and twirly" (a Phoebe-ism) because her parents are visiting, and it's always hard work maintaining your status as the less-favored Geller child. When her father lovingly refers to her as his "Harmonica," you almost question Monica's parental hang-ups, until he continues, "And I read about these women trying to have it all, and I thank God our little Harmonica doesn't seem to have that problem!"

Rachel starts working at Central Perk and gets up the courage to go see her ex-fiancé, Barry, to return the ring. Instead of the "broken shell of a man" she was expecting, Barry looks incredible, aglow with an island tan and lush new hair plugs. Barry admits that he went to Aruba with Mindy—Rachel's maid-of-honor—and thanks Rachel for not going through with the wedding.

Ross shows up at Carol's ob-gyn appointment, and the trio—Carol, Susan, and Ross—awkwardly await the doctor's arrival. Ross pretends one of the gynecological instruments is a duck until Carol finally snaps, "Ross, that opens my cervix." They begin discussing potential baby names, and Carol reveals she and Susan have decided on "Marlon" for a boy and "Minnie" for a girl. Ross advocates for "Julia" instead and quickly shuts down "Helen" (Helen Geller!), but he almost storms out when the pair refuse to use "Geller-Willick-Bunch" as the baby's last name. He is nearly gone when something stops him in his tracks. It's his baby's heart beating, and the sound quells the fighting almost instantly.

> "I did have an imaginary friend that my parents actually preferred."
>
> CHANDLER

COMMENTARY This is an episode of significant firsts. We meet several characters who will have long-standing, beloved roles in the show, like Jack and Judy Geller. Christina Pickles's deadpan delivery of insults as Monica's mom still rings true for despairing daughters everywhere.

It's also the first time we meet Ross's ex-wife, Carol, but just like Ross, fans shouldn't get too attached. This "Carol"—played by actress Anita Barone—appears in only one episode. Barone quit the *Friends* gig for a more regular role; the actress most people recognize as "Carol Willick" is actually played by actress Jane Sibbett.

Finally, this is the first time we hear about everyone's favorite neighbor, "Ugly Naked Guy," who lives in the building across from Monica and is the proud owner of a new (gulp) ThighMaster.

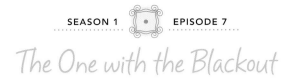

# The One with the Blackout

WRITTEN BY
Jeffrey Astrof & Mike Sikowitz
•
DIRECTED BY
James Burrows
•
ORIGINAL AIR DATE
November 3, 1994

Episode 7 opens with a citywide blackout leaving all six Friends—quite literally—in the dark. Monica, Ross, Joey, Phoebe, and Rachel are all in Monica's apartment, alight with fiery menorah candles and burning secret crushes (Ross). Chandler, meanwhile, hits the jackpot, getting stuck in the ATM vestibule of Emerson Bank with Victoria's Secret model Jill Goodacre.

Ross works up the courage to tell Rachel he has feelings for her, but Joey tells him it's too late because he's already in her "friend zone." Rachel heads out to the balcony, and Ross follows her to tell her how he feels. Just as he's about to confess, a random cat dives down from above and lands on his back, digging its claws in deep. While Phoebe, Monica, and Joey are all singing along to "Top of the World," campfire-style, in the living room, Ross is furiously running back and forth on the balcony behind them trying to wrench the cat from his back.

Phoebe and Rachel try to find the cat's owner, and they meet Mr. Heckles (Larry Hankin) for the first time. Heckles, the building's token misanthrope, pretends that "Bob Buttons" is his cat. When the cat runs off terrified, Heckles responds dryly, "You owe me a cat." As Rachel searches for the scared kitty, she nearly runs straight into the arms of Italian heartthrob Paolo (Cosimo Fusco). Turns out the cat is his, and Rachel leaps into his arms almost as fast as the cat does. Rachel brings Paolo back to the apartment to introduce him, and when the lights finally come back on, Paolo and Rachel are kissing, leaving Ross squarely back in the friend zone.

> "Gum would be perfection."
>
> CHANDLER

Meanwhile in the ATM vestibule, Chandler's trying to figure out how to talk to Jill when he starts choking on a piece of gum he picked off the counter. Jill performs the Heimlich maneuver and saves his life. Conversation becomes easier after you almost die, and when the lights finally come back on, Jill kisses his cheek and tells him she had a great blackout. After she leaves, Chandler—speaking directly to the bank's security camera—says, "Hi, I'm account number 7143457, and I don't know if you got any of that, but I would *really* like a copy of the tape."

COMMENTARY *Friends* wasn't the only show to feature a "blackout" episode on November 3, 1994. A blackout was written into the scripts of *Mad About You*, *Friends*, and *Madman of the People* as part of an NBC effort to cross-promote its notoriously strong Thursday night lineup. They tagged it "Comedy in the Dark" and it started with Helen Hunt's character, Jamie Buchanan (*Mad About You*), sparking a citywide blackout when she tries to procure cable television illegally on her rooftop. This episode continues to be a fan favorite (as well as Courteney Cox's favorite) in no small part due to Ross's cat dance on the balcony, as well as Chandler's hilarious interaction with model Jill Goodacre. Twenty-five years later and *Friends* fans are still responding to offers of gum the same way Chandler did back in 1994: "Gum would be perfection."

# The One with Mrs. Bing

WRITTEN BY • DIRECTED BY • ORIGINAL AIR DATE
Alexa Junge • James Burrows • January 5, 1995

The episode opens with Monica and Phoebe browsing through magazines at a newsstand, when Monica spots a hot guy (David Sederholm). As he walks away, Phoebe convinces Monica to catcall him. Hot guy turns around mid-street, and as he smiles in their direction, he gets hit by an ambulance. They go to see him while he's in a coma and begin to fantasize about what he might be like in real life, eventually compromising that he's clearly a lawyer who sculpts on the side. As he lies there unconscious and unresponsive, Monica says wistfully, "I wish all guys could be like him."

Chandler, meanwhile, discovers his mom is coming to New York after seeing her on *The Tonight Show with Jay Leno*. Nora Tyler Bing (Morgan Fairchild) is a bestselling romance author with a special fondness for men . . . and post-coitus Kung Pao Chicken. Chandler has been embarrassed of her since forever, especially after she proudly reveals on national television, "I bought my son his first condoms."

Mrs. Bing goes out to dinner with the gang (plus Paolo) at Mexican Village, a restaurant where the only thing more prominent than the mariachi music is the tequila. Ross, who is not usually a "shot-drinking kind of guy," begins pounding tequilas after Paolo and Rachel engage in several cringeworthy PDAs, including (ugh) hand-licking. When Nora spots a depressed, intoxicated Ross exiting the women's bathroom, she tries to console him but ends up kissing him. Joey catches them in the act: "You broke the code! You don't kiss your friend's mom! Sisters are okay, maybe a hot-looking aunt, but not a mom, never a mom!"

. . . . . . . . . . . . .

## "Please God don't let it be Kung Pao Chicken."

### CHANDLER

. . . . . . . . . . . . .

As hot guy lies unresponsive, Monica and Phoebe continue to visit him, bringing him gifts of Etch-a-Sketches and balloons. But as they grow more attached to the idea of hot guy, they start visiting him separately, jealously marking their territory in subtle ways. It all culminates when Phoebe catches Monica racing off to see him, and she follows her. When they arrive, hot guy emerges from the bathroom, out of his coma. After thanking them, he callously says, "So I guess I'll see you around." Monica and Phoebe get angry and start to leave when Phoebe turns to him: "You know what? We thought you were different, but I guess it was just the coma."

Chandler is infuriated when he finds out that Ross kissed his mom, calling him a "Mother-Kisser." Ross tells Chandler he should talk to his mother about how he feels, but Chandler doesn't think he can. But as Nora is about to leave, he finally fesses up. "You kissed my best Ross!" They have a big fight, but they part on a good note and Chandler forgives Ross with a simple "Hey."

Joey shows Ross a photo of his mom in an attempt to convince him she used to be a knockout.

**COMMENTARY** Some of the funniest parts of the episode are the creative outpourings of the women. First, Nora Bing's recipe for writing a romance novel: "You just start with a half a dozen European cities, throw in thirty euphemisms for male genitalia, and you've got yourself a book!"

Then there's Phoebe's song dedicated to the hot guy in a coma, "You don't have to be awake to be my man." And finally, Rachel picks up a "huge throbbing pens" and attempts to write her own romance novel called *A Woman Undone*.

"Heaving beasts," indeed.

# The One with the Boobies

WRITTEN BY • DIRECTED BY • ORIGINAL AIR DATE
Alexa Junge • Alan Myerson • January 19, 1995

Chandler accidentally walks in on Rachel emerging from the shower and sees her topless. When Ross finds out, Chandler exclaims, "It was an accident! It's not like I was across the street with a telescope and a box of donuts!"

Phoebe, meanwhile, dates a psychologist named Roger (Fisher Stevens) whose nuanced observations start to prickle each of the Friends. After suggesting Chandler uses humor as a defense mechanism, Roger calls him the "textbook" only child of divorced parents. He tells Ross that *maybe* he wanted his marriage to Carol to fail so the shortcomings of a sibling (Monica) might be overlooked by their parents. He reminds Monica to go easy on the cookies. Soon, everyone starts to "hate that guy."

Mr. Tribbiani (Robert Costanzo) comes to visit, and Joey accidentally discovers his father has been having a long-term affair with a pet mortician named Ronni (Lee Garlington). Ronni shows up at Joey's door, Cheese Nips—and his father's hairpiece—in hand. Joey gives his father an ultimatum: either break it off with Ronni or tell Mom the truth.

The next morning, Ronni asks to take a shower in Rachel and Monica's apartment, claiming that Chandler is occupying the one across the hall. Rachel sees an opportunity to exact revenge on Chandler. "Chandler Bing, it's time to see your thing . . ." She barges across the hall and throws open the bathroom door only to catch a glimpse of Joey soaping up instead.

After Ronni and his dad leave, Joey's mother (Brenda Vaccaro) turns up. She gives Joey a bag of groceries and a slap on the head for convincing his dad to "make things right." Turns out Mom knew the affair was going on the whole time and was totally fine with it. In a poignant moment with Joey, he tells her that she's ten times prettier than Ronni. She smiles at Joey's sincerity but then asks the more important question, "So. Could I take her?"

Phoebe tells Roger that her Friends don't like him. He gets all clinical at first claiming it's a "dysfunctional group dynamic" before launching into a pity party about the group. In the end, Phoebe agrees with her Friends, "I hate that guy!"

> "I hate that guy!"
>
> PHOEBE

## Let's break down who saw who naked in episode 13

Chandler ⸺ sees ⸺▸ **Rachel** naked

**Rachel** ⸺ sees ⸺▸ **Joey** naked

**Joey** ⸺ sees ⸺▸ **Monica** naked

**Monica** ⸺ sees ⸺▸ **Mr. Tribbiani** naked

**Mr. Tribbiani** ⸺ sees ⸺▸ **Ronni and Mrs. Tribbiani** naked

**Phoebe** ⸺ no longer sees ⸺▸ **Roger** naked

# The One Where the Monkey Gets Away

**WRITTEN BY** Jeffrey Astrof & Mike Sikowitz • **DIRECTED BY** Peter Bonerz • **ORIGINAL AIR DATE** March 9, 1995

Rachel discovers that Barry (her ex-fiancé) and Mindy (her former maid of honor) are engaged, courtesy of her mother's country club newsletter. She tells Ross she is ready to start dating again (post-Paolo) and end the self-imposed "penis embargo."

Ross asks Rachel to babysit his pet monkey, Marcel, and decides he is finally ready to tell her how he feels. The only problem? While watching the monkey, Rachel leaves the front door open and Marcel escapes. Monica, Phoebe, Joey, and Chandler go door-to-door to find him. When Ross finds out, he is furious with Rachel—especially when he discovers she notified animal control, and it's illegal to keep an exotic pet capuchin in NYC.

When animal control shows up, Luisa Gianetti (Megan Cavanagh)—armed with a tranquilizer gun and an alarming amount of khaki—reveals she went to Lincoln High with Monica and Rachel. As they all laugh at the incredible coincidence, Luisa says, "You have no idea who I am, do you?" Turns out the younger, overall-wearing Luisa was completely ignored by the pair in homeroom. She goes to find Marcel with vengeance in her eyes.

Monica and Phoebe discover Marcel in the basement right before Luisa shows up. As she loads up her tranquilizer gun and aims for Marcel, Phoebe dives in front of him, taking the hit for the monkey (who escapes). It's cantankerous downstairs neighbor Mr. Heckles who ends up being the smartest in Marcel's mangled rescue operation, leaving a banana outside his door. Marcel follows the trail right into Heckles' cluttered apartment.

Ross and Rachel spot a delivery guy carrying a box of bananas into the building, and they too follow the banana trail . . . straight to Mr. Heckles. Once inside, they find Marcel dolled up in a frilly pink dress. Mr. Heckles insists it's his monkey, "Patty." As Ross and Mr. Heckles try to get Marcel to come, Luisa arrives with a cage and captures him. Rachel has had it with Luisa at this point and threatens to call Luisa's supervisor about shooting Phoebe "in the ass with a dart," thus saving Marcel.

Just as Ross is about to tell Rachel how he feels over a bottle of wine, ex-fiancé Barry bursts into the apartment. He tells Rachel he can't marry Mindy because he's still in love with her.

> "I can't remember the last time I got a girl to take care of my monkey."
>
> CHANDLER

**COMMENTARY** Marcel—actually played by two monkeys named Katie and Monkey—was mischievous off the set too. Though Matt LeBlanc got along really well with Katie, she was often unpredictable and made filming difficult. Marcel was eventually written off the show, but don't worry—Katie has her own IMDb page and was last seen modeling with Kendall Jenner. She's probably making some decent capuchin cash for her mealworm treats. (Ew, seriously.)

# The One with the Evil Orthodontist

WRITTEN BY • DIRECTED BY • ORIGINAL AIR DATE

Doty Abrams • Peter Bonerz • April 6, 1995

Rachel starts seeing Barry again and the Friends see she's falling into old patterns. At Monica's urging, Rachel promises to end it. Flash forward: Rachel and Barry are lying together in his orthodontist chair, and Rachel has clearly had more than her gums cleaned.

Chandler goes on an amazing date with Danielle, and the girls convince him to leave a message on her machine, which he does, and then gets completely strung out when she doesn't call back. He realizes later that he accidentally shut off his phone. Meanwhile, the Friends try to figure out how to stop the creepy guy across the way from snooping on them through a telescope.

> "Oh please, during that second time you couldn't have picked her out of a lineup!"
>
> RACHEL

Mindy (Jennifer Grey) shows up at Central Perk and asks Rachel to be her maid-of-honor. Mindy confesses that she thinks Barry has been cheating on her with someone who wears Chanel perfume. They begin talking, and eventually they realize that Barry cheated on Rachel with Mindy when they first got engaged, and now he's cheating on Mindy with Rachel. The proof was all in the perfume.

Joey discovers the Peeping Tom's name (Sydney Marks) and calls to confront him, er, her. It turns out that Sydney is a woman. Joey yells at her, only to fall victim to her flattery.

Meanwhile, Rachel and Mindy confront Barry: "We are here to break up with you." Barry begs for forgiveness and—after a moment's hesitation—tells Mindy that it's always been her. Mindy tells Rachel she still wants to marry Barry even though (according to Rachel), "He's Satan in a smock!"

**COMMENTARY** In what could have been a ridiculous cat fight over an undeserving man, Rachel and Mindy instead experience a bonding moment when they discover Barry was playing both of them. Even in their determination to break up with him, Mindy (played by Jennifer Grey, post–*Dirty Dancing*) looks at Barry like he is a petulant child acting out of turn, and it's the moment you realize that "Mrs. Dr. Barry Farber, DDS" will be her sad legacy. If you don't remember Jennifer Grey playing Mindy, it could be because it was a short-lived role. Actress Jana Marie Hupp became Mindy for "The One with Barry and Mindy's Wedding." And Barry? He lost Rachel twice in a way. Actor Mitchell Whitfield revealed in a *Guardian* interview that he was originally brought in to read for the role of Ross before losing the role to David Schwimmer.

**OPPOSITE** In season 1, episode 21, "The One with the Fake Monica," Joey, Ross, and Chandler mimic . . . the "See no evil, hear no evil, speak no evil" monkeys after Ross tells the guys that he has to give away Marcel.

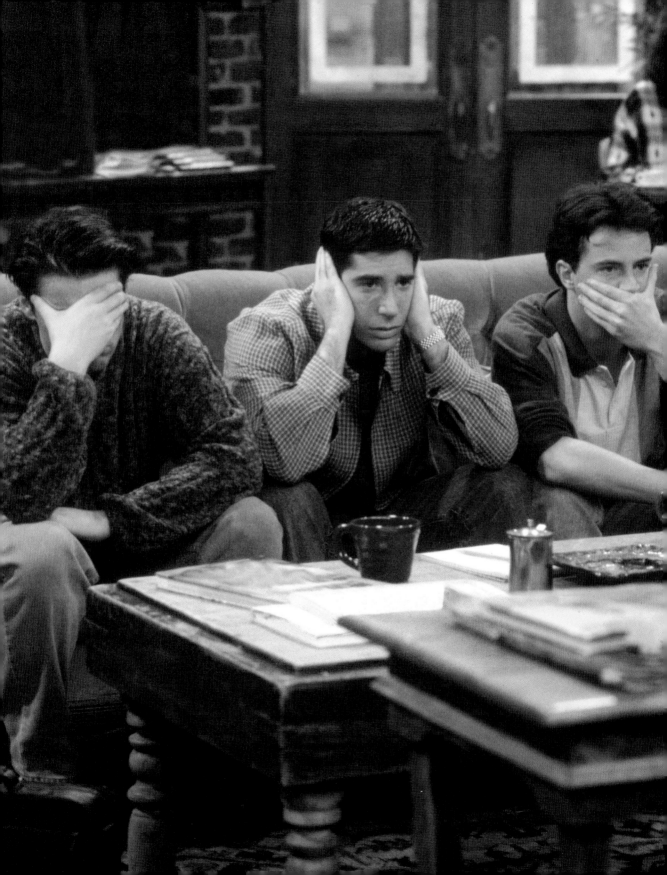

# The One with the Fake Monica

| WRITTEN BY | DIRECTED BY | ORIGINAL AIR DATE |
|---|---|---|
| Adam Chase & Ira Ungerleider | Gail Mancuso | April 27, 1995 |

Someone has stolen Monica's credit card, and she can't seem to stop examining the unusual charges. Between the art classes and the theater tickets, she realizes that "This woman's living my life . . . and she's doing it better than me!" Monica's fixation leads her to the tap class that her imposter has signed up for too.

While they look for the "fake Monica" in class, the dance teacher makes Monica, Rachel, and Phoebe put on tap shoes and participate. When they pair up and Monica is left without a partner, a woman runs in, apologizing for being so late. She pairs up with Monica, asking, "Who's the new tense girl?" and Monica realizes she is dancing with her credit-card-stealing doppelgänger (Claudia Shear). The real Monica introduces herself as "Monana," which she awkwardly claims is Pennsylvania Dutch.

The real Monica ends up adoring fake Monica. She is everything real Monica is not: a care-free spirit who loves to live life, even if it's on someone else's dime. Real Monica continues the charade of being "Monana" and gets kicked out of a hotel, auditions for *Cats*, ditches work and goes to the Big Apple circus . . . all with fake Monica. When she comes home drunk during the day, she sobers up quickly after the credit card company calls to tell her that the police have apprehended fake Monica.

Real Monica goes to see fake Monica in the correctional facility, and she tells her the truth. Fake Monica tells her not to worry about doing fun things like the circus anymore because, "You're going to go back to being exactly who you were, because that's who you are." Monica proves her wrong by going to the tap dance class on her own even if she did the entire routine wrong ("At least I'm doing it!").

> "Let's just say my Curious George doll is no longer curious."
>
> RACHEL

**COMMENTARY** This episode focuses closely on Monica's existential crisis as she—possibly for the first time—abandons her responsibilities as caretaker and problem solver. Courteney Cox admits that she responded to the character of Monica when she read the initial script and turned down the role of Rachel so she could play Monica instead. In an interview with *Off Camera with Sam Jones*, Cox said, "I related more to Monica . . . I'm very similar to her . . . I'm not as clean as Monica, but I am neat." Co-creator Marta Kauffman told the *Los Angeles Times*, "She has the neatest dressing room. She even cleans up the other actors' dressing rooms because she won't go in there if they are too messy."

This is the first time we see Drunk Monica in action, but don't worry, it's not the last. And even though she's a little sloppy (sticking her entire head under the kitchen sink faucet), it's a refreshing change to see "tense girl" loosen up for an episode.

# The One with the Birth

WRITTEN BY
David Crane & Marta Kauffman
•
DIRECTED BY
James Burrows
•
ORIGINAL AIR DATE
May 11, 1995

Carol is in labor, and everyone rushes to the hospital to see Ross become a father. Susan and Ross are arguing nonstop and competing over who gets to help Carol more. Rachel comes to help too but is distracted by Carol's young, handsome ob-gyn, Dr. Franzblau (Jonathan Silverman).

Joey is watching basketball in the waiting room when he starts arguing with the very pregnant Lydia (Leah Remini). She's a Celtics fan and doesn't think very highly of the Knicks. She begins having contractions, and when Joey sees that the baby's father isn't around, he helps Lydia to her hospital bed. As he coaches her through labor, he sounds alarmingly like a cheerleader.

Carol kicks Ross and Susan out of the room for arguing. Phoebe catches them fighting in the hallway and forces them into a nearby janitor's closet to talk. After lecturing them, Phoebe tries to storm out of the closet only to realize that they are locked inside.

> "Push 'em out, push 'em out...waaaay out!"
>
> JOEY

Dr. Franzblau blows his chances with Rachel when she realizes his work affects his personal life. Joey, meanwhile, returns to Lydia's room with balloons, but realizes the baby's father showed up while he was gone. Joey quietly leaves, hand in hand with a baby-bottle balloon.

As Ross and Susan argue, Phoebe points out how lucky the baby will be with so many people fighting to love it already. They decide to hoist Phoebe—clad in a janitor's uniform—up through the vent. Just as she heads up, the door opens, and the real janitor walks in. Ross and Susan run out just in time to make the birth, leaving Phoebe dangling from the ceiling. When it's time to decide on a name, Ross suggests "Ben," the name on Phoebe's janitor's uniform.

COMMENTARY Although this episode is primarily focused on the Ross and Carol baby plotline, it's a real moment of growth for Joey and the first time we see him as something other than the good-looking actor across the hall. He had great chemistry with Lydia, and he went from not wanting to know anything about birth at the beginning of the episode to being the resident expert by the end. The moment when he walks away from Lydia's room—a combination of happy and sad—was like looking into what Joey's future could have been. Actress Leah Remini actually auditioned for the role of Monica and nearly scored it: "I was devastated that I didn't get it. . . . We all knew it would be a huge hit. We just knew it."

June Gable (who plays Joey's agent Estelle Leonard in future episodes) makes her first appearance in this episode. Instead of being the cigarette-smoking, beehive-sporting agent of obscure talent, Gable plays the no-nonsense nurse who helps Carol during labor.

# The One Where Rachel Finds Out

WRITTEN BY • DIRECTED BY • ORIGINAL AIR DATE
Chris Brown • Kevin S. Bright • May 18, 1995

For extra money, Joey signs up for a fertility study at the NYU medical school, and that means he can't have sex outside his contributions to "the cup." His new girlfriend, Melanie, however, really wants to sleep with him. She owns a fruit basket company called "The Three Basketeers." Monica suggests that Joey put his pleasure on hold and just "be there for her." He doesn't get it at first, then eventually accepts Monica's suggestion.

Ross, meanwhile, must travel to China for a week for work. Before he leaves, he asks Chandler to give Rachel the birthday gift he bought. While Rachel unenthusiastically opens her presents later that day (travel Scrabble, a Dr. Seuss book), she is shocked when she opens Ross's present. It's a beautiful antique pin that Rachel had seen months earlier, and Ross had remembered she liked it. She is incredibly touched, and Chandler accidentally reveals the secret of all secrets. "Remember back in college, when he fell in love with Carol and bought her that ridiculously expensive crystal duck?" Everyone in the room gets incredibly uncomfortable, especially Chandler—once he realizes what he's done. He tries to downplay it, but the damage is done.

• • • • • • • • • • • • •

## "I don't think any of our lives are ever gonna be the same ever again."

PHOEBE

• • • • • • • • • • • • •

Rachel tries to catch up with Ross at the airport to talk about what Chandler said, but he is wearing headphones so he can practice speaking Chinese, and she misses her chance. While Ross is incommunicado in China, Rachel tells Monica it's not going to happen. There is just too much pressure for it to work. Then, while she's on a date with Carl (who is not against environmental issues *persay*), she starts imagining Ross is talking to her and asking her to "give us a chance." When imaginary Ross asks her if she's attracted to him, she tells him she's never looked at him that way before. He says, "Well, start looking," and then gives her a passionate kiss. That imaginary kiss clinches it for Rachel. She leaves Carl (actor Tommy Blaze) on her balcony with a bottle of wine and a grudge against Ed Begley Jr. and races to meet Ross at the airport.

Rachel arrives just in time, wearing her antique pin and holding flowers. But as Ross exits the plane, there's just one tiny problem. He's not alone. He's got his arm around a woman, and he says, "I can't wait for you to meet my friends."

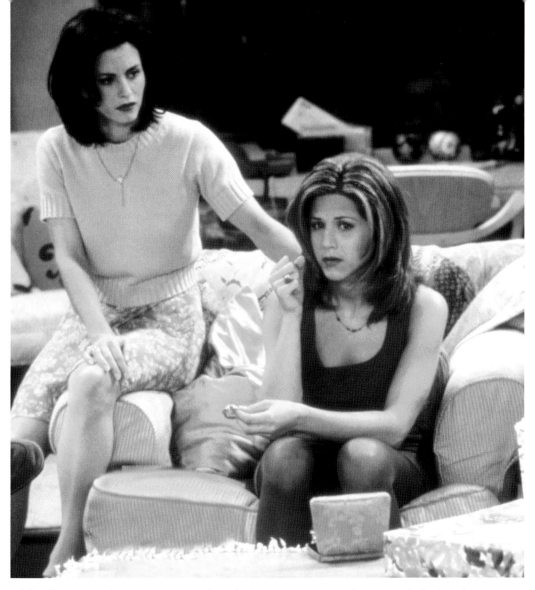

Well, it's no crystal duck, but the antique pin in her hand marks the moment Rachel discovers Ross is in love with her.

**COMMENTARY** This is the cliffhanger and final episode of season 1 (which probably should have been called "The One with the Crystal Duck"), setting up Rachel and Ross's legendary on-and-off romance. Season 1 producer Jeff Greenstein, in an interview with *Vulture*, explained how Ben's birth was originally supposed to be the season-ending cliffhanger, but director James Burrows said it should end with Ross and Rachel instead. Drawing from his wife's thesis on beloved writer Jane Austen, Greenstein suggested a rewrite inspired by how Austen wrote romance. The season 1 finale drew in 31.3 million viewers, an increase of more than 10 million viewers from the pilot episode.

# Season Two

Season 2 begins with a reversal as Rachel is now interested in Ross—who is dating Julie, a woman he met in grad school. Like Ross, Rachel fails at her attempts to tell Ross she likes him, then lets it slip out in a drunken phone message. Ross dumps Julie to pursue a relationship with Rachel. However, Rachel becomes furious when she finds out that Ross made a list comparing her to Julie, and breaks up with him. When an old video reveals that Ross intended to take Rachel to the prom, Rachel forgives Ross, and they begin a relationship that lasts into the following season.

The second season begins the maturing of another relationship: Chandler and Joey. The guys encounter their own missteps, including a time when Joey temporarily moves out and creepy Eddie moves in. Joey breaks into acting, earning a role in a fictional version of the soap opera *Days of Our Lives*. He loses the part and his character is killed off. Chandler eventually allows Joey to move back in.

Chandler also lets someone else back in: Janice. After unwittingly falling in love again over the internet, they decide to give things another try.

Tom Selleck begins his recurring guest role as Dr. Richard Burke, a friend of Monica and Ross's parents who is recently divorced—and twenty-one years older than Monica. Despite the age difference, they fall in love and date for half of the season.

**OPPOSITE** *Central Perk has never produced more steam than this moment!*

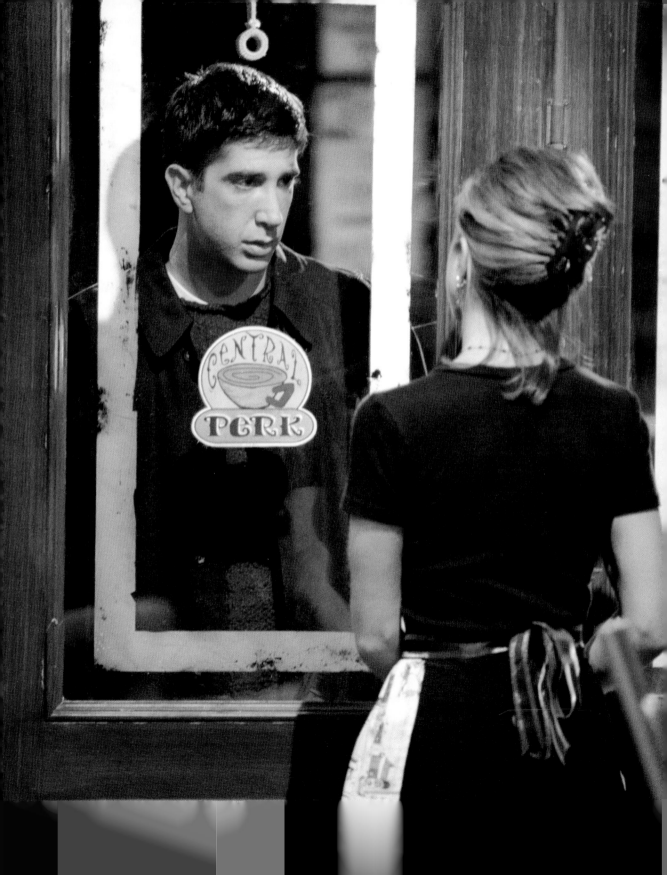

# The One with Ross's New Girlfriend

**WRITTEN BY**
*Jeffrey Astrof & Mike Sikowitz*   •   **DIRECTED BY**
*Michael Lembeck*   •   **ORIGINAL AIR DATE**
*September 21, 1995*

Season 2 picks up with Rachel waiting for Ross at the airport as he returns from China, where season 2 picks up. As Rachel stands in the airport with flowers and a nervous smile, Ross exits the plane—only he's not alone. Rachel tries to run away, but as she jumps over the seats and stumbles, Ross spots her and waves her down. Now Rachel is not only nervous, she's also bleeding after her foiled getaway. Ross introduces her to Julie (Lauren Tom), and Rachel—assuming Julie doesn't speak English—yells to Julie very slowly, "Welcome to our country!" Julie yells back, "Thank you. I'm from New York!"

At Monica's apartment, Ross introduces Julie to the gang. Turns out Julie and Ross went to grad school together, and when he arrived in China, Julie led the dig there. They start to tell the story of their crazy bus ride in China, but Rachel (now sporting a zebra-print Band-Aid on her forehead) cuts to the punch line before they even begin, "And the chicken poops in her lap!"

Ross and Julie act like teenagers on the phone, both refusing to hang up, making kissing noises. After Ross says, "No, you hang up!" for the umpteenth time, Rachel finally snatches the phone from his hand and hangs up on Julie herself. The following morning, she asks everyone to close their eyes because she "did a stupid thing." Turns out the stupid thing she did was Paolo, who emerges from her bedroom clad in boxers with a cheerful *"Buongiorno a tutti"* He almost immediately begins groping Phoebe.

Chandler, meanwhile, needs a tailor, and Joey recommends his lifelong tailor Frankie (Buck Kartalian). Chandler heads to Celestino Custom Tailor ("Where Tailoring is an Art") on Joey's recommendation, but is shocked when he realizes that Frankie the tailor is handsy with more than just hems. When he tells Joey what happened, Chandler struggles to describe the inappropriate touch. "There was definite . . . cupping," he says, but Joey insists they need to do that to get the measurement. Independent third-party Ross hears Joey's reasoning and agrees with him that tailors *do* need to touch you for the inseam, but only *"in prison!"*

> "Isn't that just kick-you-in-the-crotch, spit-on-your-neck fantastic?"
>
> RACHEL

Monica begs Phoebe to cut her hair. Phoebe refuses at first because Monica is a control freak, but eventually she relents. There's just one problem: Monica asks for Demi Moore's hair, but Phoebe thought "Demi Moore" was actually "Dudley Moore," and Monica ends up looking like a middle-aged British comedian.

Rachel tries to tell Ross how she feels on the balcony, but when he reveals how happy he is with Julie, she can't do it. Instead, when Phoebe agrees to cut Julie's hair like Andie MacDowell's, Rachel gets sweet revenge by telling Phoebe that Andie MacDowell is the actor in *Planet of the Apes*.

Rachel is ready for Ross to "hang up" his relationship with Julie.

**COMMENTARY** Actress Lauren Tom, who plays Julie and is known for her roles in *The Joy Luck Club*, *Pretty Little Liars*, and *Andi Mack*, claims her favorite *Friends* scene is the airport debacle in this episode, when Julie and Rachel meet for the first time. In an interview with *Entertainment Tonight*, Tom revealed that strangers constantly assume she doesn't speak English. When she told the *Friends* writers about it, they incorporated the line into the show. Tom revealed in a personal essay on *Fresh Yarn* that she had a crush on David Schwimmer before she took the role. But her favorite *Friends* actress? Lisa Kudrow, who she calls a "comic genius."

# The One with the List

WRITTEN BY
David Crane & Marta Kauffman
•
DIRECTED BY
Mary Kay Place
•
ORIGINAL AIR DATE
November 16, 1995

Although he is still with Julie, Ross and Rachel have finally kissed, and at the beginning of episode 8, Rachel prepares to describe the big moment to Monica and Phoebe. They shut off the phone, pour wine, and lean in to hear every single kiss detail from hand position to intensity level. Across the hall, Ross is doing almost the same thing with the guys. Their conversation, however, boils down to three words: "Tongue?" "Yeah." "Cool."

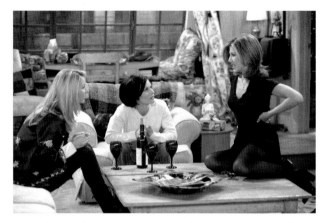

Rachel breaking down every single moment of her first kiss with Ross.

Monica interviews with Leon Rastatter (Michael McKean) who has developed "Mockolate," a synthetic chocolate. Monica tries to stay positive as she cautiously eats a piece, "I love how it crumbles." Rastatter needs a few chefs to create Mockolate-inspired recipes for Thanksgiving, and Monica—desperate for work—agrees to help. She creates Mockolate Pumpkin Pie and Mockolate Chip Cookies. Rachel and Phoebe each sample a synthetic treat, and both immediately spit it out.

Even though Ross has always loved Rachel, he is with Julie now and can't decide what to do. Chandler convinces him to make a list of the pros and cons, using his new computer. Against his better judgment, Ross agrees and says that Rachel can be spoiled, a little ditzy, and is "just a wait-ress." Joey adds his own two cents that Rachel has "chubby" ankles. When asked about Julie's cons, the only thing Ross can say is, "She's not Rachel."

> "Oh, sweet Lord, this is what evil must taste like!"
>
> PHOEBE

Ross finally breaks up with Julie and tells Rachel the good news with the heart-tugging, "It's always been you, Rach." While Ross goes to get her coat, Rachel spies Chandler's computer screen with the pro/con list in plain sight. She insists on seeing what he wrote, but Chandler refuses to let her see it, pretending it's a poorly written short story. She eventually snatches it from Joey's hands and reads her "cons." Angry and hurt, "Rachem" storms off.

Monica develops her Mockolate recipes with extremely low quantities of the imitation chocolate, but it turns out the FDA didn't approve the new product anyway. Rastatter is vague about the reason, mumbling something about "laboratory rats." On her way out, he asks her in a lighthearted voice, "Um, listen, you didn't eat a lot of it while you were cooking, did you?"

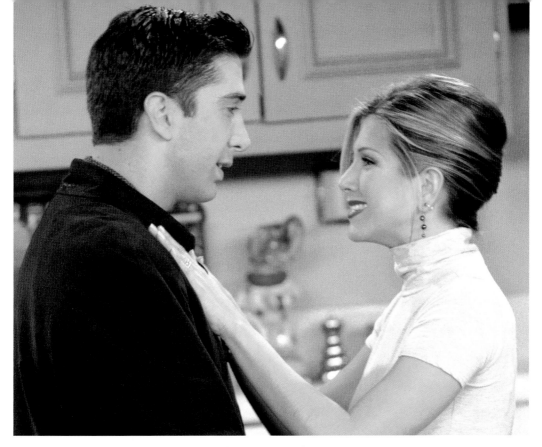

You can't see them here, but Rachel's "chubby ankles" almost spelled the end of Ross and Rachel forever.

Ross creates a pro list for Rachel and reads it to her while standing outside in the rain, but she doesn't want to hear it. When he tells her that no list would ever stop him from wanting to be with her, she replies sadly, "Well, then, I guess that's the difference between us. See, I'd never make a list." After he leaves, Ross calls up a radio show and dedicates U2's "With or Without You" to Rachel with an apology. When Rachel picks up the phone during Bono's lovelorn lyrics, it looks like she's finally resigned to calling Ross. In fact, Rachel just called the radio station to explain what he did, and the female DJ abruptly cuts off U2, exclaiming, "Ross, if you're listening, I don't want to play your song anymore."

**COMMENTARY** We could blame Ross. We could blame Chandler. Or perhaps *Friends* somehow predicted that technology would be splitting up couples in the years to come? Before Facebook and Instagram let you surreptitiously find old boyfriends and girlfriends online, Chandler's computer was doing some pretty heavy damage on the corner of Bedford and Grove. "All right, check out this bad boy. Twelve megabytes of RAM, 500 megabyte hard drive, built-in spreadsheet capabilities, and a modem that transmits at over 28,000 bps." Oh, Chandler. You've got to get better with computers (see page 220).

# The One with the Lesbian Wedding

**WRITTEN BY** · **DIRECTED BY** · **ORIGINAL AIR DATE**
Doty Abrams · Thomas Schlamme · January 18, 1996

One of Phoebe's clients—Mrs. Adelman—dies on the massage table, and Phoebe is convinced that when Mrs. Adelman's spirit left her body, it went into hers. After talking with Mr. Adelman (Phil Leeds), Phoebe asks him if Rose had any unfinished business on earth. He reveals that his wife wanted to see "everything" before she died. He also says that she wanted to sleep with him "one last time." Phoebe giggles because Mrs. Adelman is laughing inside her head. Phoebe takes Mrs. Adelman around the city, but she still won't leave Phoebe's body.

> "The world is my lesbian wedding."
> CHANDLER

Monica, who was asked to cater Susan and Carol's wedding, enlists the Friends to help, and everyone gets burned out by her orders. As they are cooking, Carol walks in looking like she's about to cry. She and Susan are calling off the wedding. Ross, for the first time in his life, thinks Susan is right about not caring what Carol's parents think and tells Carol to go get married. The wedding is saved.

In lieu of Carol's parents, Ross walks Carol down the aisle in an incredibly poignant scene—poignant, that is, until he refuses to let her go at the altar for a brief moment. Phoebe—crinkling butterscotch wrappers as Mrs. Adelman—realizes she is at the wedding of two women, and says, "Oh my God, *now* I've seen everything." With that, Mrs. Adelman leaves Phoebe's body.

Susan approaches Ross at the end and tells him, "You did a good thing today." They dance to "Strangers in the Night" as Carol watches—the two people who fell in love with her making their peace with each other.

**COMMENTARY** One of the gifts of *Friends* is the almost seamless integration of situation comedy with more serious topics. Between Lisa Kudrow's hysterical portrayal of Mrs. Adelman and Chandler trying to land a date at a lesbian wedding, the comedy could have easily taken over episode 11. But it doesn't. Carol and Susan's union was the first lesbian wedding portrayed on prime-time television, and Jane Sibbett was brilliant as a daughter struggling with her parents' refusal to accept her sexuality (even though Sibbett admitted to hating wearing that hat during the ceremony).

Gay marriage wasn't legal in most states in 1996, and there were some NBC affiliates in Ohio and parts of Texas that banned the wedding scene. If you missed the "I do's" the first time, keep your eyes open for Candace Gingrich, who plays the minister officiating the ceremony (yup, that's Newt's sister), and gay comic Lea DeLaria, who tries to pick up Phoebe. The wedding controversy didn't seem to bother *Friends* fans one bit, because as *Entertainment Weekly* reported, "The One with the Lesbian Wedding" was the most-watched show of the week back in 1996.

# The One After the Super Bowl, Part 1

| WRITTEN BY | DIRECTED BY | ORIGINAL AIR DATE |
| --- | --- | --- |
| Jeffrey Astrof & Mike Sikowitz | Michael Lembeck | January 28, 1996 |

Ross sees a monkey that looks like Marcel on the Monkeyshine beer commercial. He decides to visit his old capuchin comrade in the San Diego Zoo after attending a paleontology conference.

Phoebe is approached by Rob Donnen (Chris Isaak), who wants to book her as a children's act for local libraries. During her first gig, she sings about grandparents, letting kids in on the secret of what's really going on with grandma (spoiler alert: she's dead). Parents aren't too thrilled with her big reveal, so Rob asks her to tone it down and sing about barnyard animals instead. (Spoiler alert: they're murdered and eaten.)

> "I got my very own stalker!"
>
> JOEY

Joey gets his first piece of fan mail from Erika Ford. The letter addressed to "Dr. Drake Ramoray," was sent directly to Joey's apartment. Erika soon shows up unexpectedly at his apartment, and Joey and Chandler open the door expecting to die. Instead, they are greeted by Joey's gorgeous stalker (Brooke Shields). Joey agrees to have lunch with her even though she thinks he's *really* Dr. Drake Ramoray. Over lunch, Joey panics when Erika volunteers his services as a doctor to save a choking man.

Ross arrives at the zoo, but he can't find Marcel. The zoo administrator (Fred Willard) tells him that Marcel has died and gives him a few "zoo dollars" to make up for not notifying him. At closing time, the poetry-loving zookeeper (Dan Castellaneta) tells Ross, "Meet me in the nocturnal house in fifteen minutes." He has intel about Marcel. Turns out there was a robbery and Marcel was taken from the zoo. Seems his former pet has launched a new career in Hollywood. He doesn't just look like the Monkeyshine monkey. Marcel *is* the Monkeyshine monkey.

While the Friends all watch Joey on *Days of Our Lives*, Erika shows up demanding to know why Drake kissed Sabrina. She can't comprehend that it's a TV show, so Ross tells her that Joey isn't Drake Ramoray; he's Drake's evil twin brother, Hans Ramoray! Joey tells Erika to go to Salem to find the real Drake and then promptly slams the door in her face.

Ross finds Marcel in New York on the set of *Outbreak 2*. Marcel doesn't respond to his calls. But when he breaks out "The Lion Sleeps Tonight"—Joey chiming in with a surprisingly smooth soprano—Marcel runs over and takes back his old spot on Ross's shoulder.

COMMENTARY "The One After the Super Bowl," parts one and two, were the most-watched episodes of the entire ten-season series. Switching up their regular "Must See TV" slot on Thursday night, NBC execs collaborated to achieve the highest-grossing ad revenue day in history by scheduling their popular high-profile series after the Super Bowl instead of premiering a new show. This episode also had a high number of celebrity guest stars, including Brooke Shields, Jean-Claude Van Damme, Chris Isaak, Julia Roberts, and Fred Willard. Their plan worked, as 52.9 million viewers tuned in and created the highest-rated Super Bowl lead-out of all time.

# The One After the Super Bowl, Part 2

**WRITTEN BY**  •  **DIRECTED BY**  •  **ORIGINAL AIR DATE**
Michael Borkow     Michael Lembeck     January 28, 1996

Things heat up on the set of *Outbreak 2*. Chandler gets reacquainted with Susie Moss (Julia Roberts), a girl from elementary school that he once embarrassed in front of the whole school by lifting her skirt. Little Susie is now a gorgeous Hollywood makeup artist and asks Chandler, "So listen, how many times am I going to have to touch you on the arm before you ask me on a date?"

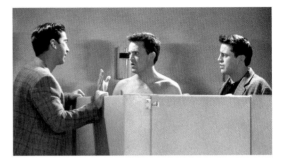

Remember that time Chandler used a bathroom stall door to cover his hot pink thong?

While Susie has clearly grown up, Monica has reverted to a love-struck teenager when she sees the Muscles from Brussels, Jean-Claude Van Damme, on set. Rachel approaches him on Monica's behalf, but Jean-Claude is more interested in Rachel than he is in Monica. Rachel tells her that Jean-Claude just wouldn't stop asking her out. Monica—assuming Rachel won't do it—reluctantly tells her she can go out with him if she wants. Rachel doesn't hesitate for a hot second and immediately accepts the date, leaving Monica feeling betrayed.

Phoebe tries to mediate the Van Damme debate, but things spiral out of control quickly. Monica thinks Rachel sold her out, and Rachel flicks Monica in the forehead to get her to stop talking. Monica flicks back. Before long, Rachel is on the floor while Monica hits her with a sock. Phoebe stands on the table yelling, "Happy thoughts! Happy thoughts!" until she can't take it anymore and finally says, "Okay, now I'm going to kick some ass!" She pulls both girls up by their ears. Monica tells Rachel she wants her to stop seeing Jean-Claude and she wants to go on a date with him instead. Rachel begrudgingly agrees.

Chandler and Susie go out with Ross and Joey to a restaurant called Marcel's. Susie asked Chandler to wear her underwear beneath his clothes. When she asks how he is doing, he's says, "I'm hanging in . . . and a little out." Susie tells Chandler to meet her in the bathroom, and she asks him to strip down to nothing but her underwear in a stall. While he stands there nearly naked, she grabs all his clothes and—in one of the greatest revenge plots of all time—leaves him naked in the bathroom. On her way out, she yells, "This is for the fourth grade!"

> ## "You know what, if we were in prison, you guys would be like my bitches."
>
> ### PHOEBE

Monica goes on her Van Damme date, but what she doesn't realize is that Rachel has told Jean-Claude that Monica is "dying to have a threesome" with him and Drew Barrymore. When she gets back to the apartment, Girl Slapfest 1996 begins, but Monica finds a better way to

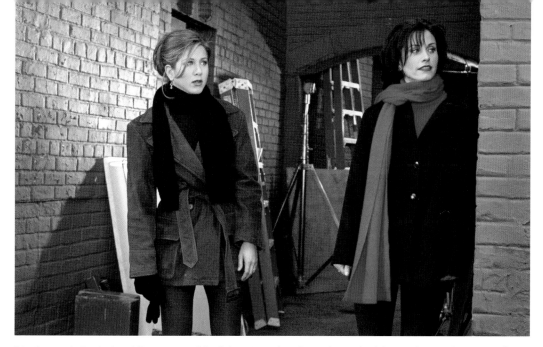

Monica and Rachel getting an eyeful of the Muscles from Brussels (Jean-Claude Van Damme).

get back at Rachel when she pulls the hem on her favorite "third date" sweater. But Rachel can play too and says, "You give me back my sweater or it's handbag marinara!" Neither one will apologize, and unfortunately, a sweater and a bag were harmed during the making of this episode.

Joey walks in the bathroom while naked Chandler is frantic in a stall. Ross follows shortly after. Chandler offers $50 for a pair of underwear so he can leave the restaurant. When Chandler yells at Joey for not wearing underwear, Joey replies, "Oh, I'm getting heat from the guy wearing a hot pink thong!" Chandler finally does the only thing he can do. He dismantles the bathroom stall door, uses it as a body shield, and walks out of the restaurant . . . head held high.

Once Marcel finishes shooting his movie scenes, he shows up at Central Perk, and spends his last day in New York with Ross.

**COMMENTARY** This two-part episode is chockablock with celebrity cameos, and this was no accident. What better way to lure in viewers post–Super Bowl than with celebrity street cred? First, singer Chris Isaak ("Wicked Game") romances Phoebe into a job as a children's singer. Then, Brooke Shields falls for Joey as a neurosurgeon. Jean-Claude Van Damme causes a "saucy" catfight between Rachel and Monica. And finally, Julia Roberts—who was reportedly incredibly nervous before filming the episode—fakes it with Chandler so she can show his best side to the world. Matthew Perry and Julia Roberts had real-life chemistry, as the pair dated for a brief time.

Across the hour, every Friend loses something. Phoebe loses her library gig; Rachel and Monica lose Jean-Claude Van Damme—and Drew Barrymore; Ross loses Marcel; Chandler loses his dignity; and Joey loses his big scene in *Outbreak 2*. The only thing the six friends didn't lose this week was ratings. According to Warren Littlefield (former head of NBC's Comedy Programs) on *The Story Behind Friends*, it was "the highest-rated hour in the history of television behind the Super Bowl."

# The One with the Prom Video

**WRITTEN BY** · **DIRECTED BY** · **ORIGINAL AIR DATE**
Alexa Junge · James Burrows · February 1, 1996

Now that Joey has a regular gig, he repays Chandler some of the money he owes him and buys him a gift: the gaudiest, chunkiest gold bracelet Chandler has ever seen. It's even inscribed with "To My Best Bud." Chandler immediately shoves it in a drawer, but Joey insists he wear it.

Monica interviews with a restaurant manager (Patrick Kerr) who asks her to make him a salad to show off her skills but has a request: "I want you to tell me *what* you're doing *while* you're doing it." Creepy manager tells her he likes the lettuce "dirty" and asks if the tomatoes have been "very, very bad." He almost loses it when she tells him she'll be doing the carrots "julienne." Monica realizes she doesn't need the job *that* badly and walks out.

When Monica can't make rent, Ross suggests she borrow money from their parents. Monica's parents come to visit, bringing boxes of her stuff because they've converted her room to a gym (Ross of course had too many awards and trophies in his room to change it).

Chandler loses a possible date after the bracelet makes an appearance, and complains to Phoebe: "Oh yeah, easy for you to say, you don't have to walk around sporting some reject from the Mr. T collection!" As Chandler commences his Mr. T impression, Joey walks in and hears the whole thing.

Phoebe tells Ross that she thinks that it will happen with Rachel because she's his "lobster," and lobsters mate for life. Ross tries to explain the whole crustacean concept to Rachel, but she tells him it's never going to happen and to just "accept it."

When Chandler loses the bracelet, he buys another one to replace it. Joey spies him with two bracelets after Gunther discovers the original, and Chandler tells Joey that the second one is for him. Joey, thrilled, immediately puts it on and says, "Check it out, we're bracelet buddies!"

Monica doesn't get the money from her parents, but "Cheapasaurus" Ross cuts her a check instead. Among the boxes her parents brought, they find Monica's old bathing suit ("I thought that's what they used to cover Connecticut!") and a VHS tape. When they play the tape, they realize they're

> · · · · · · · · · · · ·
> ## "See? He's her lobster!"
> ### PHOEBE
> · · · · · · · · · · · ·

watching their high school prom video. We meet a few new characters in the video: Rachel's old nose, Monica's former body, and Ross's hair. When it looks like Rachel's date, Chip Matthews, isn't going to show, Ross's parents convince him to put on a tux and take Rachel to the prom himself. As he descends from the staircase holding a bouquet, Monica and Rachel run out the door with Roy Gublik and a very tardy Chip. Jack Geller catches it all on his videocam, including Ross's devastated expression.

This is the first time Rachel and Monica have seen the prom video, so neither knew Ross did that for Rachel. Without so much as a word, Rachel walks over to the door and kisses Ross, ending Rachel's anger and Ross's anguish. Phoebe captures the moment perfectly with her quirky wisdom that no one ever sees coming. "See? He's her lobster!"

Chandler trying not to cringe as he reads the inscription on the flashy gold bracelet Joey just bought him.

**COMMENTARY** In the *Friends* reunion, Jennifer Aniston cited the flashback episodes as her favorites, and it's easy to see why. The flashbacks in the series were so perfectly portrayed and popular that they set the bar for the sitcom flashback technique used in later hit shows like *The Big Bang Theory*. But why did it work so well on *Friends*? Besides the 1980s clothes and vernacular ("Take a chill pill!"), the physical features that defined each Friend's childhood become almost separate characters in "The One with the Prom Video." Fat Monica is always a fan favorite, especially as she tries to defend her adolescent poundage: "The camera adds 10 pounds!" Rachel's sizeable nose makes Monica's mayonnaise sandwich look diminutive, and finally, there's Ross's hair. As he sits on the stairs working on "his music" (cue the Casio keyboard), it's hard not to feel sorry for him

and those impossibly tight curls. And though they all grew (or paid their way) out of their awkward adolescence, we see it in each of their personalities in every episode: Monica's rigidity about every part of her life, Ross's extreme vulnerability with Rachel, and Rachel's obliviousness about how things work because her problems were always miraculously "fixed."

In the powerful scene where Rachel walks across the room and kisses Ross, writer and co-executive producer Alexa Junge really wanted to illustrate the coming together of Ross and Rachel, and reveals she took inspiration from a powerful source: "The cross is directly from *Fiddler on the Roof*." Writer Greg Malins said that after watching the episode, "Jimmy Burrows called it the longest cross in sitcom history."

# The One Where Ross and Rachel . . . You Know

**WRITTEN BY**
Michael Curtis & Gregory S. Malins

**DIRECTED BY**
Michael Lembeck

**ORIGINAL AIR DATE**
February 8, 1996

A magical night under the stars (and over a juice box) for Ross and Rachel.

*Days of Our Lives* renewed Joey's option, and he splurges and buys matching leather recliners and a big-screen TV for the apartment. Once they kick back the recliners and turn on the tube, however, Chandler and Joey don't ever want to get up again. They even order pizzas and get them sent to Monica's apartment so they can stay seated.

Ross and Rachel have their first "official" date, but Rachel forgot she promised to waitress for Monica's catering gig. Phoebe steps in, and she and Monica show up at Dr. Richard Burke's (Tom Selleck) apartment to cater his party. Richard, a friend of her parents, doesn't recognize Monica because he only knew Fat Monica. Richard has divorced his wife, Barbara, and he sighs when Monica tilts her head and asks how he's doing. He jokes that people do the "head tilt" when they know about his divorce. He replies with the customary "head bob" that he's okay.

Richard spends the entire evening with Monica in the kitchen, claiming his friends are boring. After he leaves to go back to the party, Phoebe calls Monica a "smitten kitten" and says, "You two are totally into each other."

Ross and Rachel see a movie for their first date then head back to Rachel's apartment. They begin kissing and realize that Monica isn't home, but the evening doesn't go as planned. Rachel can't stop giggling. "Woah, Ross's hands are on my butt!" Even though she tries to get him back into it, he tells her "the moment's gone."

Monica goes to see Dr. Burke for an eye appointment because twenty-seven is apparently a "dangerous eye age." As he dims the lights and looks into her eyes, there's a moment when they nearly kiss. Richard gets nervous and quickly turns on the light, tells Monica her eyes look good, and gives her about fifty free bottles of eye drops to take home. He kisses her cheek goodbye, she kisses his cheek goodbye, and they start kissing each other right in the middle of his office.

Joey and Chandler take the term "La-Z-Boy" to a whole new level and Phoebe tells them to "go outside and be with the three-dimensional people," but she loses her focus (as anyone would) when *Xanadu* comes on.

Monica and Richard are looking at photos of his daughter and grandchild, and Monica suddenly realizes, "Oh . . . you're a grandpa." They discuss how strange it is for them be dating with a twenty-one-year age difference and agree to cool it. But just like at his office, the quick peck goodbye turns into a passionate kiss.

As Ross and Rachel get ready for their make-up date, he gets paged by the museum with an emergency. Rachel goes with him, hoping it will be a quick fix, but the exhibit is a mess. By the time he fixes it, all the restaurants are closed. Ross refuses to give up on the date and grabs a swatch of prehistoric fur and a couple of juice boxes, and takes Rachel to the planetarium. As they watch the stars and listen to Chris Isaak's "Wicked Game," they begin kissing, and Rachel suddenly feels something wet. She tells Ross not to worry about it—but he laughs and tells her she just rolled over on the juice box. She looks up at the fake stars and says, "Oh thank God!" When they wake up naked in each other's arms the next morning, they realize they have become the museum's star exhibit as a dozen of Catholic school kids stare at them, mouths agape.

> "It would really help when I'm kissing you if you didn't shout out my sister's name."
>
> ROSS

**COMMENTARY** While this episode is the first time Ross and Rachel, um, *you know* . . . this is also the first time that Tom Selleck appears on *Friends*. Originally signed up for only three episodes, he ended up doing nine because fans loved him, and he loved the show. In an interview with *AV Club*, Selleck reveals that some people told him not to take the role of Dr. Richard Burke because he was already an established film star, but he believed in taking risks and had already met Courteney Cox at a different screen test and liked her. And let's be honest, there aren't many actors that can make ophthalmology sexy.

# The One Where Joey Moves Out

**WRITTEN BY** · **DIRECTED BY** · **ORIGINAL AIR DATE**
Betsy Borns · Michael Lembeck · February 15, 1996

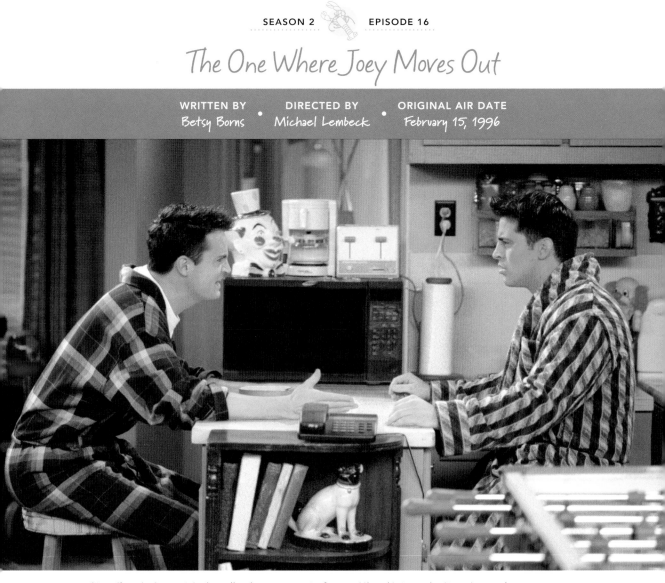

*Chandler just caught Joey licking a spoon before putting it back in the drawer!*

While Joey and Chandler discuss the precise location of Cap'n Crunch's eyebrows, Chandler notices that Joey licks his spoon and *puts it back in the drawer*. Further digging reveals that Joey apparently likes to share; he has also used Chandler's toothbrush to brush his teeth AND unclog the drain. "Oh GOD! Can open, worms everywhere!"

Phoebe and Rachel decide to get tattoos, even though Ross is against them. When they are in the tattoo parlor, Phoebe calls out Rachel on her seeming indecision: "Is this how this relationship's gonna work? Ross equals boss?"

Meanwhile, Monica, Richard, and Ross are all going to Jack Geller's birthday party, and Joey asks if Monica is going to tell their parents about Richard. Monica doesn't think it's a good idea. "Yeah, for my dad's birthday, I decided to give him a *stroke*."

At the party, Monica is helping her mother and her mother's friend in the kitchen when they start discussing the young "twinkie" Richard is dating. Monica's mother replies, "So, Richard's shopping in the Juniors section?" The men, meanwhile, try to pry for information on Richard's young new "speedster." Ross's father tells Richard he wants to live through him "vicariously." Ross assures him, "Dad, you really don't want to do that."

Joey and Chandler attend the party of a fellow *Days of Our Lives* cast member, and Joey falls in love with the guy's apartment. The guy says he's buying a bigger place, and Joey should buy his apartment, but Chandler gets jealous. "I saw the way you were checking out his moldings!"

During her father's party, Richard and Monica meet secretly in the bathroom. As Richard sneaks out of the bathroom first, Monica's mother walks up to go inside. Richard says loudly, "Judy, *going to the bathroom*, good for you!" In response, Monica promptly hides in the bathtub. Things get weird when Monica's dad joins her mom in the bathroom, and asks for a little birthday "present." Monica covers her ears, but not before her dad shares what Richard said about his new girlfriend. "He told Johnny that he thinks he's falling in love with her."

Rachel shows off her new heart tattoo to everyone but is nervous to show Ross. Phoebe, meanwhile, has chickened out. She is left with a tiny blue dot on her shoulder which she claims is how her mother sees her "from heaven." Rachel scoffs at her, "Your mother is up in heaven going, 'Where the hell is my lily, you wuss?'" When Ross gets home, he sees Rachel's tattoo but is surprisingly enamored by it.

Joey and Chandler make up, but Joey gets the new apartment anyway since he can finally afford to live on his own. Chandler is hurt and angry, and claims ownership of the foosball table, but Joey says he paid for half too. They decide to play each other for it. In the end, Joey wins and Chandler storms out.

In the perfect ending, Joey moves out but leaves Chandler the foosball table, telling him he "needs the practice." They say their goodbyes, but Joey runs back into the room one last time to give Chandler a hug goodbye.

> • • • • • • • • • • • •
>
> "Next time you take a shower, think about the *last* thing I wash, and the *first* thing you wash."
>
> JOEY
>
> • • • • • • • • • • • •

**COMMENTARY** In episode 16, the foosball table becomes a hot commodity, with Joey and Chandler both vying to hold on to its memories. Joey wins the table fair and square on the show, but the table meant just as much—if not more—to Matt LeBlanc in real life too. In an interview with Jimmy Fallon, LeBlanc revealed that one of the treasures he lifted from the set before the final episode was the actual foosball from the table.

Rachel gets a heart tattoo in this episode, and just like her character, Jennifer Aniston did not chicken out in real life either. Aniston's actual tattoo is on the inside of her right foot and reads simply, "Norman." It's a tribute to her beloved Welsh corgi-terrier that passed away in 2011.

# The One Where Dr. Ramoray Dies

| STORY BY | TELEPLAY BY | DIRECTED BY | ORIGINAL AIR DATE |
|---|---|---|---|
| Alexa Junge | Michael Borkow | Michael Lembeck | March 21, 1996 |

We first learn that there might be an issue with Chandler's new roommate when we hear Eddie (Adam Goldberg) is "not a big fan of foosball." Chandler quickly realizes that Eddie might be clinically insane. Eddie's spiral into "the abyss" is hastened when he accuses Chandler of having sex with his ex-girlfriend, Tilly (Mary Gallagher). Eddie's delusion goes even further when his fish, "Buddy," is missing from his tank and he thinks Chandler killed him.

Joey is living large as Dr. Drake Ramoray, but gets into hot water when he does an interview and claims he writes many of his own lines. Phoebe asks him if the writers will get mad at him for saying that. Joey "never really thought about the writers." Turns out they might have been a bit mad as one of them writes him right off the show.

Richard and Monica discuss the number of people that they've slept with. His number is shocking . . . it's a whopping two, including Monica. She becomes worried about his low number. Richard tells her he's only slept with people he loves, and that's when she realizes he loves her.

Monica and Rachel race to the bathroom to get a condom for their respective make-up sex, but there's only one left. They play rock-paper-scissors to see who gets it, and Rachel wins.

> ### "God, that is good TV."
>
> CHANDLER

When everyone gets together to watch *Days of Our Lives* the next day, they see Dr. Drake Ramoray fall down an elevator shaft, effectively killing off Joey's character. Joey is devastated. The soap opera was the greatest thing that ever happened to him.

And don't worry about Eddie. He replaces Buddy the fish with a Goldfish cracker at the end of the episode . . . and names him after Chandler.

**COMMENTARY** It was unheard of to show condoms on network TV back in 1996, and sitcom creator Marta Kauffman said, "We weren't even allowed to show the condom; it had to be in the box." While Monica and Rachel are gambling for condoms in the bathroom, Ross and Richard have an absolutely priceless moment of comedy in the living room. For starters, Richard in socks and boxers staring at Ross, who is growling to conjure his "animal" passion for Rachel. Ross—realizing for the first time that he has nothing in common with his father's friend—is visibly uncomfortable with the awkward silence. He begins asking Richard the only questions he can think of for a man twenty years his senior. Has your mustache always looked like that? (*Yes.*) How do you keep it neat? (*A little comb.*) What do you call it? (*A mustache comb.*) Were you in 'Nam? (Wait, what?) David Schwimmer and Tom Selleck play off each other brilliantly in this scene; Schwimmer's flawless timing (shifting uncomfortably with each lingering second that passes) and Selleck's deadpan expression are both exceptional. And in case you ever wondered, Richard was right about *Deer Hunter*. It was John Savage who lost both legs in the flick.

# The One with Barry and Mindy's Wedding

| STORY BY | TELEPLAY BY | DIRECTED BY | ORIGINAL AIR DATE |
|---|---|---|---|
| Ira Ungerleider | Brown Mandell | Michael Lembeck | May 16, 1996 |

White babysitting Ben, Monica asks Richard about their future. Richard says she *is* his future. But when she asks him about kids, he says, "I just don't want to be seventy when our kids go off to college and *our* life can finally start." Monica pretends to not be disappointed. They join Rachel and Ross at Barry and Mindy's wedding.

Chandler keeps chatting with his new online girlfriend when she reveals that she is married in real life. Though he doesn't want to talk to her anymore, Phoebe convinces him to meet her in person.

Meanwhile at the wedding, Rachel freaks out right before she walks down the aisle as Mindy's maid-of-honor, but Ross gives her a pep talk. Unfortunately, he *doesn't* tell her that the cotton-candy monstrosity she's wearing has gotten stuck in her underwear. The string of horrors brings Rachel back to eighth grade when she was supposed to sing "Copacabana" in front of the school and couldn't make it through.

When the best man makes fun of Rachel's ass, Ross tries to make it better by giving his own toast (cringe), and Rachel tries to ditch the whole thing around 9:45 pm. But she doesn't. Instead she gets up onstage and takes the microphone. She might have given up on getting through Barry's wedding with decorum, but this time, she will finish "Copacabana."

Richard and Monica slow dance together. As they realize that the pieces of their lives are not going to fit together anymore, Monica asks him what they do now. Richard says sadly, "I guess we just keep dancing."

In the final scene, Chandler is waiting at Central Perk to meet his married girlfriend in person. While his friends all tell him to relax and calm down, he stops listening as she walks in . . . and his mystery girlfriend is none other than Janice.

• • • • • • • • • • • • •

## "Oh . . . My . . . God."

### JANICE

• • • • • • • • • • • • •

**COMMENTARY** Barry and Mindy's wedding is a pivotal moment for Rachel. Exhibiting bravery, independence, and ridiculousness, she chooses to step onstage. Rather than have anyone make excuses for her or clean up her mess, she picks up the microphone, giving a speech—and performance—that would make Barry Manilow proud . . . at least the speech part.

Played by the brilliant Maggie Wheeler, Janice made her first appearance in season 1 and appeared in every subsequent season thereafter (although season 6 only featured her voice on a mixtape). Wheeler revealed in an interview on Oprah's *Where Are They Now?* that she never knew if she was coming back after an appearance. "Every time Janice came and went, the door was left a little bit open, but we never really knew." Wheeler created Janice's signature voice for the audition when she read the script, which called for a "fast-talking New Yorker." Fans loved the voice, and she is often asked to laugh like Janice or recite her famous catchphrases.

# Season Three

Season 3 refines what the first two seasons defined. Rachel meets Mark Robinson, who helps her get a job at Bloomingdale's. Ross becomes suspicious of Mark, convinced that he only helped Rachel get the job because he wants to pursue a relationship with her. Ross's jealousy pushes Rachel to the point where she tells him that she thinks they should take a break—a simple phrase that leads to a seismic event. Ross and Rachel get back together, only to break up again when Rachel discovers that Ross slept with Chloe, the girl from the copy shop. His insistence that they were "on a break" becomes a running joke through the remaining seasons. Throughout the second half of the season, Ross and Rachel display mutual animosity—until the cliffhanger ending suggests that the two might patch things up.

Phoebe becomes acquainted with her half brother, Frank Jr. In the season finale, she meets the birth mother she never knew she had.

Joey lands a role in a play and has a short-lived fling with his acting partner, Kate Miller, until she's offered an opportunity on a soap opera in Los Angeles.

Monica begins a relationship with Pete Becker, a millionaire who wins her heart. Monica is disappointed when Pete confides in her that he wants to become the Ultimate Fighting Champion. After watching him get beat up, she tells him he has to give it up. Since he won't, she breaks up with him.

OPPOSITE *"Could I BE wearing any more clothes?"*

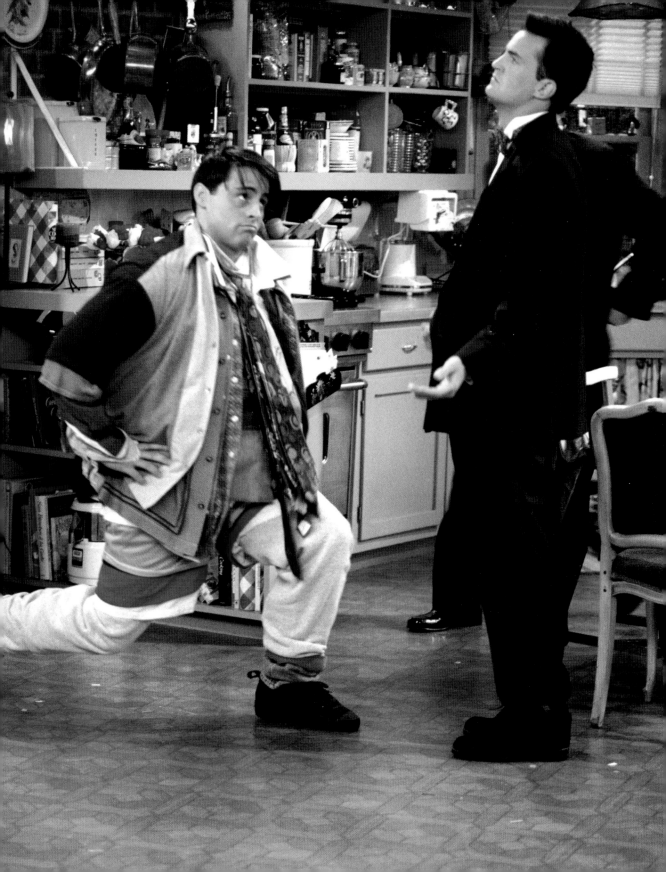

# The One with the Princess Leia Fantasy

WRITTEN BY
Michael Curtis & Gregory S. Malins

DIRECTED BY
Gail Mancuso

ORIGINAL AIR DATE
September 16, 1996

Monica and Richard are fresh off their breakup, and she hasn't slept in days. It's gotten so bad that when she finds Richard's hair in the bathroom drain, she doesn't want to part with it.

Chandler's back with Janice and he can't stop beaming. The only one unhappy in the apartment is Joey, who hates Janice. He tries to garner support to come up with a plan to get rid of her. Joey finally tells Chandler he doesn't like Janice. Chandler gets mad at him for not even trying.

While Rachel and Ross are lying in bed together, Rachel asks him if he has any fantasies. He goes on to describe the everyman fantasy of Princess Leia in the gold bikini.

Monica still isn't sleeping, so Phoebe tries to help her meditate and relax. But every time she tries to bring Monica to a "happy place," Monica perseverates about Richard, betting Phoebe that he's already over her.

Janice finds out that Joey hates her, and she suggests "Joey and Janice's Day of Fun" to fix their relationship. Joey is reluctant to spend the whole day together, but Janice insists it's necessary "because that's how long it takes to love me."

Rachel suggests that Ross share more things with his friends the way she does with Monica and Phoebe. Ross asks Chandler if he wants to share stuff, then describes his gold bikini fantasy. When it's Chandler's turn, he explains how his mom is one of his mental images while he's having sex, and once she's in there, he can't get rid of that image, so it's almost like . . . well, *you know*. The look of utter repulsion on Ross's face lets Chandler know they won't be bonding any time soon.

> "I said *share*, not *scare*!"
>
> ROSS

Monica's father comes to see her because he knows that she and Richard broke up. Monica asks him how Richard is doing, and he says, "The man is a mess." Almost immediately Monica falls asleep, secure in the knowledge that Richard is having a hard time too.

Rachel puts on the gold bikini to fulfill Ross's lifelong Princess Leia fantasy, except as she walks in, Ross gets a mental image of his own mother wearing the gold bikini instead. "I hate Chandler. The bastard ruined my life."

**COMMENTARY** The opening sequence of this episode is only fifteen seconds long, but it's one of the funniest in the show's run. All six Friends are talking as they enter a crowded Central Perk and are faced with the stark reality that six squatters (three guys and three girls) have taken over residence of their beloved couch. Unable to get a seat, Monica, Ross, Phoebe, Chandler, Rachel, and Joey stare blankly at the scene before Chandler says, "Huh." They all turn around and walk out.

This episode is also clearly an homage to Princess Leia, *Star Wars*, and adolescent fantasy worldwide. Interestingly, George Lucas called *The Phantom Menace* "Episode 1" in 1999 and the *Friends* "Gold Bikini" episode is also technically episode 1. Coincidence? Okay, probably.

## 10. Will's No-Good Pie
**Season 8 • The One with the Rumor**
Will Colbert, played by Brad Pitt, has lost 150 pounds, and to accommodate his special diet, he brings a no-sugar, no-fat, no-dairy pie that he claims is "no good." When he spies Rachel, he immediately starts hunting for cake, cookies, and his worst enemy: complex carbohydrates.

## 9. Monica's Grilled Cheese Sandwiches
**Season 1 • The One Where Underdog Gets Away**
Monica hosts her first Thanksgiving and is making three different kinds of potatoes. When the Friends all get locked out of the apartment, her dinner is ruined, and she ends up carving grilled cheese sandwiches instead.

## 8. Joey's Turkey Grease
**Season 10 • The One with the Late Thanksgiving**
Monica and Chandler lock out the other Friends after they show up late. They stick their heads in the door to see what's going on, and Joey gets his head stuck. In an attempt to slip him out, Monica pours turkey grease down the sides of his face, which he tries to lick off while he's wedged in.

## 7. Monica's Mockolate Chip Cookies
**Season 2 • The One with the List**
Desperate for work, Monica helps develop Thanksgiving recipes for a synthetic chocolate called "Mockolate," but it turns out the FDA doesn't entirely agree that the crumbly bits won't make it burn when you pee.

## 6. Chandler's Macaroni & Cheese
**Season 5 • The One with All the Thanksgivings**
It's Thanksgiving in 1987, and Fat Monica offers to make A Flock of Seagulls–Chandler inspired macaroni and cheese since he doesn't eat Thanksgiving food. He tells her it was so good she should become a chef, and she immediately says, "Okay!"

## 5. Joey's 19-pound Turkey
**Season 8 • The One with the Rumor**
When Monica refuses to make a turkey because not enough people are eating it, Joey insists he can finish it on his own (with a little help from Phoebe's maternity pants).

## 4. Monica's Carrots
**Season 5 • The One with All the Thanksgivings**
While trying to revenge-seduce Chandler during Thanksgiving 1988, Monica rubs carrots and a large knife against her body and then fumbles the (very sharp) knife onto Chandler's stylish sandal, severing his toe. They rush to the hospital, and Monica brings the toe so they can reattach it. The only problem? She brings a carrot on ice instead of the toe.

## 3. Joey and Monica's Turkey Heads
**Season 5 • The One with All the Thanksgivings**
While attempting to scare Chandler, Joey dons a raw turkey and gets it stuck on his head. Later, when Chandler gets mad at Monica for cutting off his toe all those years ago, she puts on the big turkey head and adds a fez and sunglasses to try to make him laugh.

## 2. Ross's Moistmaker
**Season 5 • The One with Ross's Sandwich**
While technically not a Thanksgiving episode, Ross's leftover Thanksgiving sandwich episode is one of the funniest in the series. Monica's secret to the perfect leftover turkey sandwich is the extra slice of gravy-soaked bread she puts in the middle of the sandwich. The "moistmaker" is enough to make Ross go "mental" and launches his cry heard 'round the world: "*MYYYY SANNNNDWICH!!!!!!!!*"

## 1. Rachel's Traditional English Trifle
**Season 6 • The One Where Ross Got High**
In a moment of brilliance, *Friends* writers have Rachel attempt a dessert doomed to failure when her magazine's pages stick together, blending two recipes. The funniest part of her English trifle-cum-shepherd's pie isn't even that it "tastes like feet." It's the fact that Joey likes it and eats his whole serving.

# The One with the Football

WRITTEN BY • DIRECTED BY • ORIGINAL AIR DATE
Ira Ungerleider • Kevin S. Bright • November 21, 1996

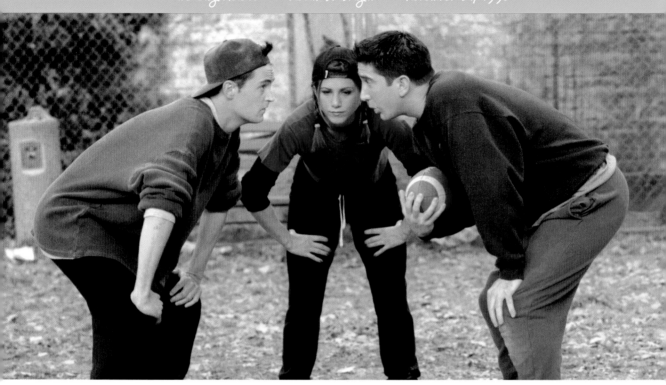

A friendly game of touch football becomes a battle of wills when the Geller Cup is at stake.

It's a Friendsgiving, and the girls are cooking while the guys watch football. At halftime, Joey suggests a friendly game of 3-on-3 touch football. Rachel and Phoebe are game, but Chandler says no. He's still depressed over the Janice breakup (season 3, episode 8). Joey says he needs to start getting over her and doing things again, but Chandler says, "I wanted to start drinking in the morning. Don't say that I don't have goals!"

When they ask Ross and Monica about playing, there's a moment of awkward silence before the siblings admit they are not allowed to play football because of the legendary "Geller Bowl." Every Thanksgiving they would play touch football, but it was in Geller Bowl XI that Monica "accidentally" broke Ross's nose, and their parents banned them from the sport. Ross insists the nose break wasn't an accident, and the game was called after Jack Geller threw the trophy—the highly coveted "Geller Cup"—into the lake. After a heated discussion, Monica and Ross decide that twelve years have passed, and *maybe* they can play again.

They pick teams and Rachel is the last one chosen. Chandler imagines the ball is Janice's head, while the Geller trash talk starts stinking up the park ("Cheater, cheater, compulsive eater!")

During a play, the football rolls away and it's stopped by a gorgeous Dutch woman named Margha. Chandler and Joey both want to ask her out, and that's when the real game is on.

Phoebe scores a touchdown at the basting buzzer, and Ross insists it doesn't count. Monica challenges him to continue the game after halftime and produces the long-lost Geller Cup: a water-logged Troll doll nailed to a block of wood. After its disappearance in the lake years ago, Monica furtively swam in to retrieve it while Ross was at the hospital nursing his nose. The temptation is too great, and Ross agrees to finish the game they started all those years ago.

Joey gets switched to Ross's team after Monica insists she doesn't need him to win. It's guys against girls. To get in good with the Dutch darling, Chandler asks Joey where Dutch people come from, mentioning that it might be somewhere near the Netherlands. Joey laughs and says, "The Netherlands is this make-believe place where Peter Pan and Tinkerbell come from." Ross can't deal with the team fighting over Margha, and he finally just asks her which guy she likes better. When she says she prefers Chandler, the only person more surprised than Joey is Chandler. After he does a mini-wave to congratulate himself, Margha realizes that Chandler's not so charming.

In what was supposed to be a simple game of touch football, the not-so-innocent Friends continue to get tackled, clotheslined, poked, pulled, pantsed, and flashed. With only a few seconds left on the clock, Rachel goes long. With literally no one else to throw the ball to, Monica throws it to her, and Rachel miraculously catches it. It would have been a touchdown, but she was five feet short. Realizing the ball is still in play, Ross and Monica jump on top of it, refusing to let go.

At the end of the episode, it's evening and Rachel, Phoebe, Joey, and Chandler are enjoying Thanksgiving dinner while Monica and Ross are still lying on top of the ball at the park, refusing to give up their deadly Geller grip.

> "Well, why don't we just bunny up?"
> MONICA

**COMMENTARY** Thanksgiving would not be complete without the Friends gift of the Geller Bowl. And if that's not enough, we also get a moldy Troll doll for the Geller Cup as the perfect symbol of sibling rivalry at its absolute worst. Glimpses into Monica and Ross's dysfunctional childhood never get old, and their stubborn refusal to give up the football closes out an almost perfect Friendsgiving episode. There is a deleted scene at the end of this episode where Monica and Ross agree to call it a tie and throw the Geller Cup down the garbage chute. After they shake on it and Ross leaves, Monica runs to the chute and calls down to Phoebe, who has secured the discarded trophy for Monica. While Phoebe is down there, Ross shows up to claim it too, thus cementing the continuation of the Geller Cup controversy and proving once and for all that you can't trust a Geller . . . at least not when Troll dolls are on the line.

*Friends* Thanksgiving episodes are legendary, and co-creator David Crane has cited them as his favorites in the series. In 2019 he said, "When you just have all six of them, that's generally where the magic happened, when we were not off doing separate stories. I suppose the same could be said about Christmas, but somehow Thanksgiving became the holiday for the show."

# The One Where Chandler Can't Remember Which Sister

**WRITTEN BY** · **DIRECTED BY** · **ORIGINAL AIR DATE**
Alexa Junge · Terry Hughes · January 9, 1997

Rachel and Monica have a noisy upstairs neighbor, but Monica insists the guy is so charming that she can't really yell at him. Phoebe thinks that is ridiculous and goes up there to yell at him herself. Instead, she too is charmed by him and agrees to a date.

It's an episode of crap jobs all around. Rachel is fetching coffee and sorting wire hangers at Fortunata Fashion and wants to quit. She complains to Monica, also in a crap job, sporting gravity-defying fake boobs as a waitress at the Moondance Diner (a real-life place!) Rachel is overheard complaining about her job by a handsome stranger named Mark (Steven Eckholdt), who happens to work at Bloomingdale's and might know of an open job. Rachel is ecstatic, but Ross thinks Mark is after something besides good karma.

It's Joey's birthday party, and Chandler (still reeling from a Janice sighting) discovers the Jell-O shots early on. He's completely intoxicated by the time all seven of Joey's sisters show up. After the party, Chandler is ridiculously hungover, and he admits to making out with one of Joey's sisters. And if that's not bad enough, he can't remember which one. Joey figures it out by telling Chandler his sister Mary Angela called him. "She told me you said you could really fall for her. Now is that true or are you just getting over Janice by groping my sister?" Chandler lies, saying he could really fall for her.

Charming upstairs neighbor scored with Phoebe, as Monica and Rachel can clearly hear, before they decide to get out of the apartment ASAP.

Ross tells Chandler he can't break it off with Mary Angela by letter; he needs to go to her house and let her down easy. When Chandler knocks on the door of the Tribbiani household, Joey answers. Chandler asks for Mary Angela, hoping that he can finally figure out which sister he groped. Joey leads him to the dining room where *everyone* is sitting down to dinner in a sea of big hair and red shirts. Joining them, Chandler directs his questions to Mary Angela, but Joey's *nonna* answers on her behalf, making it an impossible task. One of Joey's sisters tells Chandler to excuse himself from the table and go to the bathroom. On the way, she kisses him in the hallway, murmuring that Mary Angela wasn't kidding about his soft lips. Chandler realizes he's not kissing Mary Angela but Mary Therese. Mary Angela walks in on them and screams for Joey. All the sisters walk in and demand that Joey punch Chandler. He just tells Chandler to apologize to Mary Angela, but even in the sober light of day, Chandler still can't figure out which sister is Mary Angela. Joey finally lets Cookie punch Chandler.

Rachel gets the interview and is meeting with the buyer, Joanna, the following day. She asks for help deciding what to wear, and a jealous Ross doles out frumpy fashion advice. Monica tells Ross he's being crazy and to trust Rachel. He realizes she's right. He waits for Rachel after the interview the next day and apologizes. Just as they are about to leave, Mark gets off the elevator and tells Rachel she got the job. Excited, instead of hugging Ross, she hugs Mark.

> "You see what men do? Don't tell me men are nice. *This* is men."
>
> ROSS

That's the thing about New York apartments. You can hear EVERYTHING going on upstairs.

**COMMENTARY** This is the first time we meet all of Joey's sisters—Mary Angela, Mary Therese, Tina, Dina, Gina, Veronica, and Cookie. One of the funniest and most subtle exchanges happens between Cookie and Phoebe at the bar when Phoebe tells Cookie she's drinking a vodka and cranberry juice, and leather-clad Cookie replies, "No kidding? That is the exact same drink I made for myself after I shot my husband." Phoebe, who can talk to just about anyone, just looks at her and says, "Wow. Okay, I don't know how to talk to you." Cookie nods like she understands and moves on.

Though Chandler and Monica first get together in a later episode, Chandler actually kisses Monica (off-screen) in this episode. Along with Phoebe, Rachel, and, um, Ross.

# The One with All the Jealousy

| WRITTEN BY | DIRECTED BY | ORIGINAL AIR DATE |
|---|---|---|
| Doty Abrams | Robby Benson | January 16, 1997 |

*Um, three years of modern dance with Twyla Tharp? Oh, Joey.*

Rachel starts her new job at Bloomingdale's, and much to Ross's dismay, works in the same office as Mark. Mark takes Rachel to lunch and answers her phone, and Ross can't shake his crazy jealousy of the guy. Chandler, meanwhile, is going to a bachelor party for his cousin Albert and asks Ross to go with him. Chandler even calls a stripper named Miss Crystal Chandelier to hire her for the occasion. ("So would I have to provide the grapes?")

Joey scored an audition for *A Tale of Two Cities*. Everything is going great until the director tells him to bring his jazz shoes for the callback. Seems Joey fudged the dance portion of his résumé, and he has a better chance of meeting Charles Dickens than of Twyla Tharp ever recognizing him.

Monica is still working her chesty gig at the Moondance Diner, and she starts dating her fellow coworker, the Baudelaire-reading Julio, a wanna-be poet. They go out on a date and Julio stops a make-out session to compose a poem called "The Empty Vase." When Monica shows it to her friends, Phoebe realizes that Julio must be writing about Monica. ("She's the empty vase!")

Ross's jealousy escalates, and he begins sending outrageous gifts to Rachel's office. Mark

observes that Ross wants everyone to know that Rachel has a boyfriend, and Rachel is completely embarrassed. When she confronts Ross about it, he claims to be "hurt" and asks, "I mean, my God, can't a guy send a barbershop quartet to his girlfriend's office anymore?" Chandler and Joey tell him that Mark is becoming Rachel's confidante, and he needs to start making surprise visits to the office. Ross is skeptical of the advice, but he doesn't want to lose her.

On Ross's first surprise visit, he eavesdrops on Mark telling a girl (who looks alarmingly like Rachel) to kiss him. Ross—thinking it's Rachel—jumps in and tells him to cut it out, only to look like a complete idiot in front of Mark, Rachel, and Rachel's imposter. The real Rachel is, of course, furious.

Back on Broadway, the director asks Joey to teach all the dancers the combination since he is the most experienced dancer of the group. As the director shows him the steps, Joey pretends to know what he's talking about, but only seems to grasp the concept of "jazz hands." When the director returns, the group performs the moves as Joey taught them (completely wrong, minus the jazz hands). When he asks Joey to show them the dance again, the music begins, Joey takes a deep breath . . . and then runs out of the room, ditching the audition and his big shot at Broadway.

Ross apologies to Rachel for his ridiculous outburst at her office and explains how hard the Mark thing is for him. She lectures him about how there is no need to be jealous because they love and trust each other. All is well in Rachel-land until Ross reveals he has a playdate with the stripper from Chandler's cousin's bachelor party, and Rachel—trying to sound calm but furiously shaking a sugar packet—asks casually, "You have a playdate with a stripper?"

Monica confronts Julio about being the empty vase. He puts her at ease by telling her it's not about her until he adds, "It's about *all* women. Well, all *American* women." She is less than comforted. When Julio starts dating someone else, Monica sends in Ross's barbershop quartet with some of her own revenge "poetry." ("You are just a buttmunch. No one likes a buttmunch . . . and you're also bad in *bed!*")

> "I mean you might as well have just come in and peed all around my desk!"
>
> RACHEL

**COMMENTARY** It's a cringe-worthy episode for Ross as he attempts to lock down his relationship with Rachel with cheap Mylar balloons and a hysterically funny barbershop quartet. But it's worse to be Rachel, stuck between Desperado and Mark, who may or may not have landed her the job of a lifetime just because he wants to sleep with her. The only thing Rachel wants to do is get her fashion career started, but she can't see the path because it's blocked by an oversized greeting card with Ross's face plastered across it. Mark eventually peeks through the love foliage littering her desk and asks for a file on Ralph Lauren halfway through the episode, and it almost seems like foreshadowing, if the writers knew Rachel would work there by season 10.

Rachel isn't the only character who landed a job because of sexual attraction. Monica got an offer for her first restaurant from Pete Becker, who fell in love with her in "The One with the Chick and the Duck" (season 3), and Joey implies he got his *Days of Our Lives* gig by sleeping with the casting director in "The One with Russ" (season 2).

## Joey Tribbiani

*90 Bedford Street, Apartment 19*
*New York City, NY 10014*

Joey's fake résumé:

- Archery

- Horseback riding

- Fluent in French

- Can play the guitar

- Three years of modern dance with Twyla Tharp

- Five years with the American Ballet Theatre

- Was one of the original *Zoom* kids

Joey's real résumé:

- Can drink a gallon of milk in ten seconds

- Can pop open a bra just by looking at it

- Can eat a dinner for six, plus a whole birthday cake, by himself

- Will risk life to save a meatball sandwich

- Able to wear Chandler's entire wardrobe at the same time

- Can keep juicy secrets for an extended period of time

- Able to provide the perfect kiss or help you meet your soul mate

- Can eat a nineteen-pound turkey and still have room for pie

# The One Where Monica and Richard Are Just Friends

**WRITTEN BY**   Michael Borkow  •  **DIRECTED BY**   Robby Benson  •  **ORIGINAL AIR DATE**   January 30, 1997

Monica goes to the video store and runs into a mustache-free Richard. ("Wow, your lip went bald.") And after they catch up, he asks her out for a burger. She knows it's too soon but can't resist. When she tells her friends about it the next day, Monica insists she and Richard are just friends. Ross can't help but mumble, "Naked friends."

Phoebe meets a cute sporty-type guy named Robert in the park, and he offers to teach her rollerblading. There's just one problem: Robert only wears loose-fitting shorts, giving everyone a glimpse of what's underneath. As Chandler puts it, "The man is showing brain."

Rachel finds Joey's copy of *The Shining* in his freezer, where he puts the book when it gets scary. Joey insists *The Shining* is the best book, and Rachel thinks *Little Women* is, so they decide to swap. All goes well until Joey accidentally reveals a spoiler to Rachel. She, in turn, tells him Beth dies at the end of *Little Women*.

Robert's peek-a-boo problem gets worse, and Joey sees it too. Phoebe demands to know what's so funny. Ross tells her, "Calm down. There's no reason to get *testy.*" They finally tell her, and Phoebe sees it (literally) for herself. She buys Robert tight stretchy pants as a solution, but he won't wear them because he feels like he'd be "on display."

Monica teaches Richard to make lasagna, and he calls her afterward to thank her. She agrees that just being friends is difficult, but thinks it's for the best. While talking to him on the phone, there is a knock on her door. It's Richard on his phone standing in front of her. He says, "You really sure?" She drops the phone—along with her willpower—and kisses him. Monica wonders if they can be "exclusive" friends. They realize that they are right back where they started, with each of them wanting different things. They play one "last game of racquetball" before calling it quits.

At the end, Joey walks into Rachel's apartment with a copy of *Little Women*. He's gotten to the point where Beth gets very sick in the novel. Rachel asks him if he wants to put the book in the freezer, and he nods yes.

> "Put the mouse
> back in the house."
>
> GUNTHER

**COMMENTARY** In an interview with *Good Morning Britain*, James Michael Tyler (Gunther) revealed that his favorite Gunther line was in episode 13: "Hey, buddy, this is a family place. Put the mouse back in the house."

Joey and Rachel aren't the only characters reading in this episode. At Central Perk, Ross is reading *Race: How Blacks and Whites Think and Feel About the American Obsession* by Studs Terkel, a bestselling 1992 publication about race relations in America. There are tons of books (all selectively picked) throughout the series, ranging from Dostoevsky's *The Idiot* and Ayn Rand's *Anthem* to Dr. Seuss's *Oh, the Places You'll Go!* And don't forget the single encyclopedia volume "V" that Joey read!

# The One Where Ross and Rachel Take a Break

WRITTEN BY • DIRECTED BY • ORIGINAL AIR DATE
Michael Borkow • James Burrows • February 13, 1997

Phoebe scores a date with a diplomat named Sergei (Jim Pirri). The diplomat can't speak English, so everything they say goes through the diplomat's translator, Mischa (Stephen Kearney). Phoebe gets so frustrated by the lingering translator that she asks Monica to come with her next time to be Mischa's date.

Chandler has a crush on Chloe (Angela Featherstone), the cute girl with the belly button ring who works at the copy place. She invites Joey and Chandler to The Philly the following night because her coworker, Isaac, will be deejaying. She jokingly hints at a possible threesome with Chandler and Joey. They come up with ground rules just in case.

Rachel, meanwhile, has to work late on her anniversary date night with Ross. He is hurt, and even though she says not to come to the office, he shows up anyway with a furious pepper grinder and an open flame. After he sets fire to her flowers, she yells at him to go home. When they resume the fight at Rachel's apartment, Ross tells her it's "just a job" and that he's tired of having "a relationship with her answering machine." When he asks if this is about Mark, Rachel loses it. That's when she utters the breakup words that will echo around the world: "Look, maybe we should just take a break."

After Ross leaves, Rachel sits at home feeling upset. She waits for Ross to call, but the one who calls is Mark, who immediately senses trouble in paradise. He comes over with Chinese food. Ross heads to The Philly, and Joey and Chandler tell him to call Rachel to work it out. But when he calls, Mark can't keep his big mouth shut. Ross hears him through the phone, confirming all his insecurities and suspicions. He hangs up immediately.

. . . . . . . . . . . .

## "Look, maybe we should just take a break."

### RACHEL

. . . . . . . . . . . .

Turns out Monica and Mischa really hit it off, but not having an accessible translator means that Sergei and Phoebe can't have a conversation. Phoebe asks Monica to sit silently so the three of them can converse. Tensions run high, and as Mischa tells the touching story of his dog's death, Sergei gets mad at him for neglecting his translator duties. A fight ensues, and Mischa promptly quits and invites Monica to the Rainbow Room. Phoebe and Sergei are left staring blankly at each other.

Back at The Philly, Chloe—who clearly isn't interested in either Chandler or Joey—finally convinces Ross to dance to U2's "With or Without You." Chloe starts kissing Ross on the dance floor while Rachel continuously calls Ross's apartment.

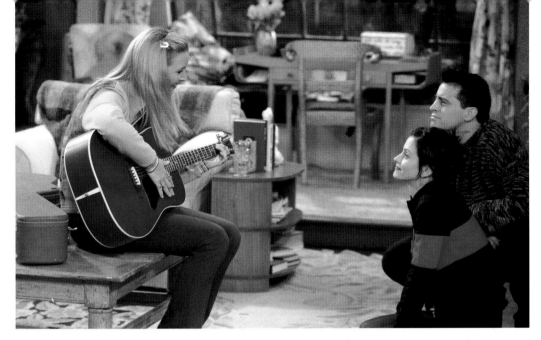

This scene is from the previous episode—season 3, episode 14, "The One with Phoebe's Ex-Partner"—where Phoebe gets back together with her ex-singing partner, only to break up again by the end of the episode.

**COMMENTARY** This of course is the episode that launched a thousand arguments: were Ross and Rachel on a break when he hooked up with Chloe? Whether you play for Team Rachel or Team Ross, it's twenty-five years later, and the jury's still out on whether or not Ross actually cheated. *Friends* executive producer and director Kevin S. Bright revealed to *Metro* that the "on a break" plot hook wasn't in the original plan, and it was a bold and brilliant decision for writers Marta Kauffman and David Crane to add it in, prolonging the "will they/won't they" saga for Ross and Rachel for seven more years. In an *Entertainment Weekly* online poll, nearly 75 percent of voters agree that Ross and Rachel were on a break during Chloegate 1997. However, when asked if it was acceptable for Ross to sleep with someone if they were on a break, only 39 percent thought it was okay. A YouGov poll in the UK yielded similar results, with 61 percent of viewers agreeing with Ross that they were, in fact, on a break. However, only 41 percent of voters believed it was okay for

an unmarried couple to sleep with someone else if they were "on a break."

As for cute-as-a-belly-button-ring Chloe, this won't be the last time she plays a mistake. Actress Angela Featherstone is almost unrecognizable as Chloe in Adam Sandler's 1998 hit movie *The Wedding Singer*. She plays Linda, Robbie's high-haired fiancé who ditches him at the altar only to come running back into his bed—and his Van Halen T-shirt.

With all the break/not a break controversy, it's easy to overlook the Phoebe-Sergei subplot in this episode. Actor Jim Pirri, who plays the dashing diplomat Sergei, is not actually speaking a recognizable foreign language. He seems to be speaking a Slavic-like language with made-up words. Perhaps it's not surprising that Pirri does this with so much ease since he has an amazing career as a voice actor too, having lent his vocal prowess to popular video games including *Final Fantasy XV*, *Lego DC Super-Villains*, *World of Warcraft: Battle for Azeroth*, and *God of War*.

# The One with the Morning After

WRITTEN BY
David Crane & Marta Kauffman

DIRECTED BY
James Burrows

ORIGINAL AIR DATE
February 20, 1997

It's the day after the apocalypse (Ross sleeping with Chloe), and—with Chloe still in his apartment—Ross realizes he's made a huge mistake, especially after hearing Rachel's message saying that she's going to stop by at 8:30. Just as Chloe is about to leave, he opens the door and Rachel is there. Chloe ducks behind the door while Ross and Rachel agree to make the relationship work.

Ross tells Chandler and Joey what happened with Chloe, and they advise strongly against telling Rachel the truth. It would only hurt her. Joey asks Ross, "Did you think about the trail?" He elaborates that you need to stop the trail of the woman you slept with, so it never gets back to the woman you don't want to find out. Chandler brilliantly figures out the trail, and Ross races out to stop the cheating trail back to Rachel.

Monica orders the hot new product "Waxine" from an infomercial, and Phoebe wants to try it too. Phoebe can't figure out how it removes hair painlessly, but Monica points out, "Hello! Organic substances recently discovered in the depths of the rain forest!" But when they apply the strips, they screech in pain after pulling them off.

Ross heads to the copy place to stop the trail. Chloe admits to taking his watch *and* to telling Isaac about their romantic escapade. Isaac sympathizes with Ross, telling him, "We're the same, you and me." Ross finally agrees to disagree and asks Isaac not to tell his sister Jasmine about Chloe, but it's too late. Jasmine already knows. Ross races to the massage place, where Jasmine promptly tells him, "You did a bad thing." He begs her not to tell Phoebe, and she agrees but warns him to let her roommate, Gunther, know. Gunther—who has been in love with Rachel since always—doesn't waste any time sabotaging Ross. The trail that Chandler couldn't imagine came to pass, and when Ross turns around in despair at Central Perk, he sees Rachel was watching him from the corner of the cafe as he desperately tried to cover up his infidelity trail with Gunther.

Joey and Chandler run into Monica's room when they hear them screaming post-Waxine. Joey

That moment when you've started eavesdropping and can't back out now.

> "You always have to think about the trail!"
>
> JOEY

thinks women just have a lower threshold for pain until Phoebe slaps some Waxine on his arm and tells him to pull it off, and he too experiences Waxine pain. At that moment, Ross and Rachel burst into the apartment, yelling at each other. The four Friends in the bedroom shut the door so they can eavesdrop in secret. Rachel asks how Chloe was in bed, and Ross stumbles and says, "Nobody likes change."

The fight continues for hours while Monica, Phoebe, Chandler, and Joey hide, and they start eating the Waxine to stave off hunger. Ross protests that he thought their relationship was dead, and Rachel snaps back, "Well, you sure had a hell of a time at the wake." They order a pizza but even after they polish it off, nothing has been resolved. And at 3 am, in an incredibly touching scene, Rachel and Ross are crying, but Rachel can't forgive him. "You're a totally different person to me now . . . it's just changed everything. Forever."

COMMENTARY The Ross and Rachel relationship kept audiences engaged for a decade. In a 2004 "Final Thoughts" interview produced by Christina Hacopian, creator Marta Kauffman said of the couple, "We didn't know this would be the central romance of the series. It was just chemistry just seeing two of them work together; something magical happened."

David Schwimmer said of the relationship, "It's a testament to the writers to be able to find hopefully grounded and organic ways to keep that relationship between Ross and Rachel evolving. You always feel a sense of history between these two and a sense of destiny that they belong together."

"I have a very special spot in my heart for Ross and Rachel," said Jennifer Aniston. And on the topic of "The One with the Morning After," she said, "The breakup—well, that was sort of the beginning of the end for them. Or the beginning of the beginnings of endings and beginnings. They've had so many starts and stops."

## The Presumed Trail

CHANDLER'S DIAGRAM ILLUSTRATING
ROSS'S INFIDELITY

···· Chloe
*the woman Ross slept with*

▶ Isaac ····
*works with Chloe*

Jasmine ◀····
*Isaac's sister*

▶ Phoebe ····
*works with Jasmine*

Rachel ◀····
*friends with Phoebe*

## The Actual Trail

THE ONE CHANDLER
DIDN'T THINK OF

···· Chloe
*the woman Ross slept with*

▶ Isaac ····
*works with Chloe*

Jasmine ◀····
*Isaac's sister*

▶ Gunther ····
*lives with Jasmine and in love with Rachel*

Rachel ◀····
*friends with Gunther*

# The One with the Hypnosis Tape

**WRITTEN BY** • **DIRECTED BY** • **ORIGINAL AIR DATE**
Seth Kurland • Robby Benson • March 13, 1997

Chandler's still smoking, so Rachel brings him a hypnosis tape to help him quit. The only problem is that the tapes are geared for women who smoke, so Chandler begins inadvertently exploring his more feminine side as he continues the hypnosis process.

Phoebe's little brother, Frank Jr. (Giovanni Ribisi), shows up at Central Perk with some big news. He's getting married. Phoebe is thrilled but changes her tune when she meets his fiancé: Mrs. Knight (Debra Jo Rupp), a middle-aged home economics teacher who calls Frank her "best student." They're getting married because they want to have kids right away. Free spirit Phoebe finds herself becoming a rigid conservative because she doesn't think Frank is ready for kids, and she plots to break them up, enlisting Joey and Chandler for help.

> ## "I'm practicing my fake laugh."
>
> ### JOEY

A random customer named Pete keeps asking Monica out at the Moondance Diner, but she turns him down. When Pete leaves her a $20,000 tip with his phone number on it, Chandler realizes where he's heard the name "Pete Becker" before. He opens a magazine and shows Monica a picture of Pete hugging Bill Clinton. Turns out Pete is an inventor—and a millionaire. After yelling at Pete for the insulting check gesture, she agrees to one meal with him. Little does she know, though, that the "little place" he knows for pizza is actually in Rome, and they fly there for a date on Pete's private jet.

Joey overhears Chandler listening to the hypnosis tapes at night and finally understands why Chandler has been acting so . . . sensitive lately. He gets a brilliant idea to replace the smoking cessation hypnosis tape with his own tape. ("Joey's your best friend. You want to make him a cheese sandwich every day . . .")

**COMMENTARY** After the heartbreaking split between Ross and Rachel, this episode brings with it a spring of new and unusual couples. Jon Favreau, who plays millionaire Pete Becker, was originally considered for the part of Chandler. And even though it's Monica rolling on skates and serving up food at the Moondance Diner, it was Friend David Schwimmer who was a roller-skating waiter back in Chicago. He told David Letterman that he used to make tips by "jumping over people."

Debra Jo Rupp was nervous to play Mrs. Knight, making out with a very young Giovanni Ribisi through the entire episode. But as she describes in *Friends of Friends*, Ribisi made it easy for her by saying, "All right, you know what we're going to do? I'm going to just throw you on the table and make out with you . . . we have to be committed." She admits, "I don't think I could have done it with anyone else."

Both Favreau and Ribisi admit that they still get stopped in the street (or shouted at from cars) for their memorable *Friends* characters, twenty-five years later.

# The One with Ross's Thing

WRITTEN BY
Ted Cohen & Andrew Reich • DIRECTED BY
Shelley Jensen • ORIGINAL AIR DATE
May 1, 1997

Ross finds a growth on his butt and asks Joey and Chandler to see if it's a mole or pimple. They don't come to a definitive conclusion, but Chandler confirms it's "fancier than a pimple."

Monica gets a message from Pete and is convinced he's breaking up with her. They all go to Pete's apartment to water his plants while he's away. Pete calls while they're there and tells Monica it's good news he wants to share. After Pete hangs up, Joey spots an entry in Pete's checkbook that says he wrote a check for $50,000 to Hugo Lindgren Ring Design. Rachel can't stop her excitement. "Monica's going to marry a millionaire!"

> "It's too wrinkly to be a mole."
>
> JOEY

Ross goes to Chandler's doctor but even he's stumped, and brings in more than a dozen doctors to look at Ross's butt. Phoebe recommends that Ross go see her herbal guy. Guru Saj looks at the skin abnormality and determines immediately that it is a "kundus." He applies a salve but then furiously tries to rub it off, saying, "We appear to have angered it!" The guru tells Ross he's going to need to use love to get rid of the growth, and begins waving his hands over Ross's butt. As he works his magic, Ross's skin growth gets caught in Saj's watch, removing the *kundus* instantly.

When Pete gets home from his trip, he tells Monica his big news: he wants to become the Ultimate Fighting Champion in an intense competition. He even had an octagonal ring designed for the training. Monica realizes the hefty check didn't go to her engagement ring.

Phoebe gets tired of dating two guys at the same time, and decides to break it off with Vince, the firefighter, despite his "burliness." She just finds Jason, the teacher, more sensitive. But as she breaks up with Vince, he starts to tear up and says he needs to go write in his journal, and Phoebe realizes that Vince is burly *and* sensitive. She decides to break up with Jason instead. But when she goes to break up with Jason, he is shirtless and muscled. With a body like that, she can't break up with him either. Phoebe finally admits to seeing them both. Instead of being mad, the guys seem fine with it until Jason notes they haven't slept together yet, and he realizes that she *has* slept with Vince. Phoebe tries to console Jason by reminding him about the candlelight dinner she made him in the park, but Jason doesn't care and walks out of Central Perk. She's left with Vince, who dumps her too when he realizes she brought an open flame to a wooded area.

# The One at the Beach

| STORY BY | TELEPLAY BY | DIRECTED BY | ORIGINAL AIR DATE |
|---|---|---|---|
| Pang-Ni Landrum & Mark Kunerth | Adam Chase | Pamela Fryman | May 15, 1997 |

*Mermaid Joey wasn't even the funniest part of the Montauk weekend!*

Phoebe discovers an old photograph of her mom with her mom's best friend, Phoebe. She realizes that this woman (her namesake) could be the key to learning more about her mom and dad. She invites everyone out to the beach at Montauk to see if she can find Other Phoebe, who lives there. Everyone can go except for Ross's new girlfriend, Bonnie (Christine Taylor), who has to work.

As they get ready for their trip, Monica feels like she'll never have a boyfriend again. Trying to make her feel better, Chandler says he'll be her boyfriend, and Monica laughs—a little too hard. When they arrive at the beach house (owned by Phoebe's hairy-backed client), it's pouring rain, and the place is filled with sand from prior flooding. Phoebe goes to see her mom's old friend right away. Other Phoebe (Teri Garr) pretends not to have seen her father, Frank Buffay, for years, but Phoebe swipes a photo from her fridge that says otherwise. She's going to dinner with Other Phoebe the following night, so she hopes to find out more.

Stuck in the sandy house during the storm, Rachel shamelessly flirts with Ross. Joey suggests they play strip poker to stave off boredom, but everyone says no. Phoebe says she'll spin around and point to someone who will get to choose what they do. Phoebe lands on Chandler, who echoes Joey's sentiment for strip poker, but the only cards in the house are in the *Happy Days* game, so strip *Happy Days* game it is. With margaritas flowing and the watchful eyes of Fonzie and Pinky Tuscadero on them, the Friends all gang up on Joey until he's down to his boxer shorts. Rachel is so happy until Bonnie walks in unexpectedly. When Bonnie hears they're playing strip *Happy Days* game, she jumps right in with, "Cool, I'll catch up," and promptly takes off her shirt.

The next morning, while Joey is asleep, they bury him in sand so he looks like a mermaid with an ample bosom. He wakes up and is initially shocked, but then seems to appreciate his sand breasts. Rachel, meanwhile, is reading when Bonnie returns from a dip in the water. Bonnie complains about the sand in her hair and wishes she was bald again. Rachel tells Bonnie she loved her look and tells her she should shave her head again.

Bonnie takes Rachel's advice to heart and comes downstairs shiny and bald. Everyone jumps back when they see her, and Bonnie makes a reluctant Ross touch it. "You can feel all the bones in your skull." Ross figures out that it was Rachel who encouraged Bonnie's razor rendezvous and confronts her. She admits she still loves him, and he admits he loves her too. They kiss and Rachel says she's going upstairs, implying Ross should join her.

When Other Phoebe cancels dinner because she's going out of town, Phoebe breaks into her house to find out something about her father. After crawling through the window, she starts flipping through Other Phoebe's address book. Just as she's getting started, Other Phoebe bursts in with a hanger. Phoebe lies and says, "I came to fill your ice cube tray," but she demands to know where her father is. But Phoebe learns a different secret, one that she never could have guessed: Other Phoebe is Phoebe's real mother.

Ross has to decide if he wants Bonnie or Rachel. He has finally moved on from Rachel and likes that Bonnie is fun and cool, but he wants to "finish that kiss." At the end of the episode—the season finale—Ross stands in front of two doors: one to Rachel's room and one to Bonnie's. He walks through a door (we don't know which one) and says, "Hi."

> ### "You balded my girlfriend!"
> ### ROSS

COMMENTARY In the opening sequence of this episode, Phoebe relates a story about her mother's "BFF," who was also named Phoebe. When the Friends raise an eyebrow at the acronym, she explains that it stands for "Best Friends Forever." It sounds odd now that she must explain a term so prevalent, however, according to the *New Oxford American Dictionary*, "BFF" originated in 1987. "The One at the Beach" aired in 1997, so it's distinctly possible that Phoebe Buffay popularized the world to BFF.

Actress Jennifer Aniston is known for her amazing hair, but as her character Rachel Green, she might be better known for "Revenge Hair." After all, "The One at the Beach" isn't the first time that Rachel has interfered with Ross's girlfriend's hair. Remember Julie's inspired haircut? (See page 60.)

# Season Four

The plots thicken. Ross breaks up with Bonnie to be with Rachel. Rachel is willing to take him back under one condition: Ross must accept responsibility for everything she accuses him of in a thirty-six-page letter. When he reads the letter and realizes he can't accept it, they break up. Again.

During the season, Lisa Kudrow became pregnant in real life. The writers creatively handled the pregnancy as Phoebe's surrogate pregnancy on behalf of her brother, Frank Jr., and his new wife. And Monica and Rachel lose their apartment to Joey and Chandler—a result of a bet they made.

The Ross/Rachel saga picks up again when Ross embarks on a whirlwind romance with Emily Waltham, which results in them deciding to get married in London. Ross decides to invite Rachel, but she declines, unable to bear the thought of Ross marrying someone else. The Friends, minus Rachel and Phoebe, travel to London to witness the wedding.

The rehearsal dinner is a disaster for everyone, and as a result of their frustration, Monica and Chandler end up in bed together, beginning a romance that would withstand the test of time—or at least the remainder of the series. Rachel rushes off to London to tell Ross that she still loves him. In the last scene of the season, Ross says, "I, Ross, take thee, Rachel," as he stands with Emily at the altar.

OPPOSITE A publicity photo for Friends, season 4.

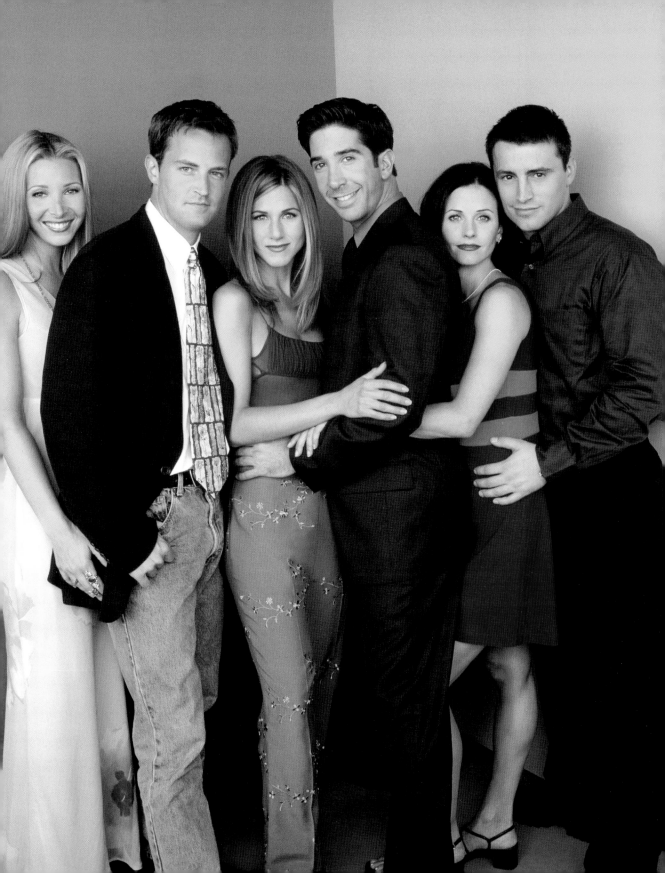

# The One with the Jellyfish

**WRITTEN BY** • **DIRECTED BY** • **ORIGINAL AIR DATE**
Wil Calhoun • Shelley Jensen • September 25, 1997

We ended season 3 with emotional turmoil at the beach house in Montauk. Ross is standing between two doors, each leading to a completely different life path. He opens Rachel's door, but both Rachel and Bonnie are in the room. Apparently, Bonnie forgot that a completely bald head requires additional sunscreen, so Rachel helps her out.

While Ross breaks up with Bonnie, Rachel composes an eighteen-page (front and back) tome for Ross to read before they get back together. But it's 5:30 in the morning, and Ross falls asleep before finishing the letter. When Rachel comes down, she asks him one question: "Does it?" Ross—having no idea what she is talking about—gambles on the correct answer when he replies, "I have decided that it . . . does." She gives him a big hug, and he knows he guessed right.

Chandler, Monica, and Joey, meanwhile, are at the beach. Monica gets stung by a jellyfish, but Joey knows how to make the pain stop: Someone has to pee on her; Chandler steps up to the plate.

Phoebe goes to see Ursula and tells her about their real birth mother—the other Phoebe—who is a "big fat abandoner." Ursula already knows about Other Phoebe from their mother's suicide note—a fact that Ursula never bothered to share with Phoebe.

Phoebe's birth mom turns up at Central Perk wanting to start fresh. Phoebe turns her down. Her mother admits they don't know each other well, but thinks they might have things in common. She brings up the most popular things in the world like pizza, puppies, and the Beatles, and Phoebe says she likes those too. They end up walking out together, laughing.

At the end of the episode, Rachel and Ross are lying in bed together, and Rachel brings up the letter. Ross tries to restrain himself, but when Rachel keeps talking about cheating, Ross can't stop himself from saying it, with emphasis: "WE WERE ON A BREAK!" As they fight about ownership of the breakup and misplaced apostrophes, Rachel yells, "You know, I can't believe I even thought about getting back together with you. We are *sooo* over." Ross pretends to get all weepy and choked up before yelling back, "Fine by me!"

> ● ● ● ● ● ● ● ● ● ● ● ● ● ●
> ## "I can still hear the screaming."
> ### CHANDLER
> ● ● ● ● ● ● ● ● ● ● ● ● ● ●

**COMMENTARY** This Ross and Rachel fight is legendary—and for good reason. They pull out all the stops, from Ross correcting Rachel's usage of "your" vs. "you're" in her letter to Rachel letting him know that "... it's not that common. It doesn't happen to every guy. And it *is* a big deal!" But Ross wins the verbal sparring match after Rachel alludes to Ross losing sleep over her, and he jabs back, "Don't you worry about me falling asleep . . . I STILL HAVE YOUR LETTER!"

This is Teri Garr's first appearance as Phoebe's birth mother. Garr mentioned she was cast in the role because of "similarities" between her and Lisa Kudrow, though each claims not to see it. Either way, Garr is happy for Kudrow to take on the role of the "ditz" and says, "I've passed the baton."

# The One with the Cat

WRITTEN BY • DIRECTED BY • ORIGINAL AIR DATE
Jill Condon & Amy Toomin • Shelley Jensen • October 2, 1997

After ripping his suit, Chandler insists that Joey sell the entertainment center, saying, "I'm tired of having to get a tetanus shot every time I get dressed!" Joey places an ad in the paper to sell it for a ridiculous $5,000.

Monica acts like a teenager after running into Rachel's high school boyfriend, Chip Matthews. He leaves Monica a message to ask her out, but when Rachel comes home, she assumes it's for her and brags to Ross, "I bet he sensed that I was ready to have sex with another guy." Ross tells her to call him, and as she talks to Chip and realizes he didn't call for her, Ross whispers over her shoulder, "Oh that's right . . . he called to ask out Monica."

Joey meets with a potential buyer for the entertainment center and tells him how a grown man can fit inside it. The guy says he doesn't believe him, and Joey says he'll knock five dollars off the asking price if he can't fit. But as soon as Joey gets inside, the guy wedges a mini hockey stick through the handles, trapping Joey inside. The guy then proceeds to steal everything from their apartment. Chandler finally comes home and lets Joey out of the entertainment center. Joey is furious and imagines meeting the thief again.

Phoebe believes the cat she is holding, Julio, possesses the spirit of her dead mother—and she won't let it go.

"Wow. A lipper from the Chipper."

MONICA

Monica goes on her big date with Chip, and they take his old motorcycle, the "Chipper." But as she's talking to him, she realizes that Chip still has his old job at the movie theater ("like I'd give up that job"), still lives with his parents, and still gives wedgies to grown men. Monica comes homes and tells Rachel about the terrible date, but she can now proudly say she "got to dump Chip Matthews."

**COMMENTARY** Almost all of Joey and Chandler's things are stolen in this episode, including food from the fridge. The Laurel and Hardy print on the wall and the white dog Joey purchased when he moved out of the apartment in season 2 are among the few items remaining. Though the dog is Joey's on the show and has been featured in several episodes (including the series finale), the sculptured canine belongs to Jennifer Aniston IRL. She received it as a good-luck present from a friend.

# The One with the Dirty Girl

| WRITTEN BY | DIRECTED BY | ORIGINAL AIR DATE |
|---|---|---|
| Shana Goldberg-Meehan & Scott Silveri | Shelley Jensen | November 6, 1997 |

Ross miraculously lands a second date with a hot doctoral candidate named Cheryl (Rebecca Romijn), but when they go back to her place, Ross finally realizes why she might be single. Her apartment is disgusting—food, clothes, and garbage are strewn everywhere. Cheryl starts throwing food on the floor to try to summon Mitzi, her hamster, whom she "hasn't seen in a while." Ross suggests going back to his place instead for some "Cinnamon Fruit Toasties," but Cheryl doesn't want to because his place has a "weird smell."

Chandler buys Joey's girlfriend, Kathy, a rare copy of her favorite book, *The Velveteen Rabbit*. Everyone tells him it will look bad for Joey, since he only bought her a pen clock from Office Max.

Monica has to turn down a catering gig for a funeral because she doesn't have the funds, but Phoebe lends her $500 so she can get her business started. Phoebe helps her with the funeral job, but Monica gets squeamish when it comes time to collect payment from the grieving widow. Phoebe finally steps in, interrupting the widow's sunny rendition of "Jeepers Creepers," and demands full payment for their services. The widow coughs up.

· · · · · · · · · · · ·

## "You can't give her that! Because she's not eleven, and it's not the seventh night of Hanukkah!"

### CHANDLER

· · · · · · · · · · · ·

Ross decides to give it another go with Cheryl, but the second venture into the apartment is worse than the first. They lie down on the couch and start making out, but Ross gets some black gunk on his hand and starts groaning in disgust. He pretends his moans are amorous ones, but when he hears the potato chip bag rustling on the table, he leaps up and starts hitting it with a soiled toilet brush. Cheryl—thinking it's her hamster—yells for him to stop, but she breathes a huge sigh of relief when she opens the bag and sees "it's just a rat."

At the end of the episode, Joey gives Kathy the book, and he tells Chandler to give Kathy the pen clock instead. Chandler doesn't want to, but he finally hands it to Kathy, saying, "Happy birthday. I'm sorry." She pretends to love it, but after Joey heads to the bedroom, she thanks Chandler for his real present: the book. She knows it wasn't really from Joey, and they stare at each other, letting the intimate gesture of the gift sit between them. When Kathy says he must really like Joey to "go to all that trouble for him," he realizes what she is asking, and he says, "He's my best friend."

Gunther's role began as an extra with no name, but his secret obsession with Rachel elevated it into one of the funniest side characters of the show.

**COMMENTARY** One of the funniest scenes in this episode comes courtesy of Gunther played by James Michael Tyler. After Rachel finally finishes a crossword puzzle entirely on her own, she looks around Central Perk to share it with someone, and says, "I did it all by myself! And there's nobody to hug." Suddenly we hear pots dropping and plates breaking as Gunther races from the kitchen, shoving patrons aside. He is beaming as he takes a flying leap to Rachel—his one chance at physical contact with her—just a few steps away. He misses and falls to the ground, empty arms reaching out to hug her, just as Monica and Phoebe walk in.

Tyler revealed in an interview that he was brought in initially as an extra. The writers finally gave him a name and his first line ("Yeah") halfway through the second season. And his signature white-blonde hair didn't come naturally; Tyler admits he had to dye it every week for ten years!

# The One with Chandler in a Box

| WRITTEN BY | • | DIRECTED BY | • | ORIGINAL AIR DATE |
|---|---|---|---|---|
| Michael Borkow | | Peter Bonerz | | November 20, 1997 |

You wouldn't break up with someone over text in 1997. Thank God for boxes.

Chandler kissed Kathy in episode 7, and now he's begging forgiveness from Joey, who won't speak to him. He even pretends to be a radio DJ calling Joey about a contest: "What is the name of your roommate who is very, very sorry and would do anything . . . ?"

It's another dysfunctional *Friends*giving, and Phoebe suggests doing a Secret Santa for Christmas this year since they are broke. While Monica is fetching food from the freezer, a piece of ice hits her eye, and then she can't open it. They call Richard's office and luckily there's an on-call doctor on duty (not Richard) who will see her.

Joey is returning all the guilt gifts that Chandler bought him when Ross walks in, and Joey informs him there's a "spot open" to be his new best friend. Ross tries to convince Joey to talk to Chandler, and he reluctantly agrees, but when he sees Kathy and Chandler kissing in Central Perk, he says *"Va fa Napoli!"* (Which is like the polite Italian way of saying "Go to hell.")

When he gets back to the apartment, Chandler sees that Joey has packed a bag. He is going

to stay at his parents' house while he looks for an apartment. Chandler is devastated and tries to do anything to get him to stay. Joey explains that when he was locked in the entertainment center for six hours during the robbery (see page 99), he kept thinking about how he had let Chandler down. Chandler quickly says he would do the same if they still had the entertainment unit. That's when Joey looks down, sees the shipping container, and says, "We got a box."

Even One-Eyed Monica can see true love between Chandler and Kathy. Ahoy, Matey!

When Monica arrives at Richard's office, she realizes she is seeing Dr. Burke. But it's not Richard Burke, it's his hot son, Dr. Timothy Burke. He examines Monica and tells her she scratched her cornea and needs to wear a patch ("Like a pirate?"). When Monica realizes Timothy is recently single and has nowhere to go on Thanksgiving, she invites him over. No one is happy about it when she shares the news, though, and Rachel says, "It's like inviting a Greek tragedy over for dinner!" (And yes, Monica has even blinded herself in one eye, which only adds to the Sophocles-inspired spectacle.)

Chandler is in the box, which has a three-fold meaning (the first is time to think, the second is to prove he cares, and the third, well, is because it hurts). But he keeps making jokes and talking while in the box, and Joey gets upset because he thinks Chandler isn't taking it seriously. He makes Chandler promise not to say another word.

Timothy shows up, and everyone is super awkward. While he's in the bathroom, Phoebe says to Monica, "Do you really want to be in a relationship where you can actually use the phrase 'That's not how your dad used to do it'?" Their attraction doesn't seem weird to Monica and Timothy though—until they kiss out on the balcony, and Monica is reminded of Richard. They are both completely repulsed by the idea of kissing like Richard, and the Timothy–Monica love connection will be shorter-lived than a cigar.

Kathy shows up, and she breaks up with Chandler through the box: "I don't want to be someone who comes between two best friends." She tells him she thinks their relationship could have been "really amazing," but this is for the best. Chandler, still unable to talk, lifts a single finger out of the box to wave goodbye to Kathy. Joey is so touched that he lets Chandler out of the box, saying, "Yeah, we're gonna be fine. Get out."

> ## "Va fa Napoli!"
> JOEY

# The One with the Embryos

WRITTEN BY
Jill Condon & Amy Toomin

DIRECTED BY
Kevin S. Bright

ORIGINAL AIR DATE
January 15, 1998

Rachel and Monica are awakened by Joey and Chandler's chick crowing at the break of dawn. When they ask what's going on, Chandler says, "The vet seems to think that she's becoming a rooster. We're getting a second opinion."

Joey and Chandler insist they know Rachel and Monica better than Rachel and Monica know them, and a contest begins when Chandler bets he can name every item in Rachel's shopping bag. After guessing apples, tortilla chips, yogurt, diet soda, and, miraculously, Scotch tape, he tells Monica she owes him ten bucks. Monica wants a rematch with higher stakes: a hundred dollars.

Phoebe goes to the fertility doctor and gets five of her brother's embryos implanted, which gives Phoebe only a 25 percent chance that one will attach. Shocked by the low success rate, Phoebe promises she'll do it again if needed. But Alice and Frank Jr. have spent all their money ($16,000) to do it just this one time. "Whoa. Okay, that's a lot of pressure on me and my uterus."

Ross makes up the questions for the contest between the guys and the girls. The categories—*Jeopardy*-style—are Fears & Pet Peeves, Ancient History, Literature, and It's All Relative. With answers ranging from *Lord of the Dance* to Miss Chanandler Bong and Viva Las Gaygas, the game is a tie and goes to a lightning round. Monica and Chandler up the stakes: if the guys lose, they have to get rid of the rooster. If the girls lose, they fork over their beloved, rent-controlled apartment. It's almost another tie, but Rachel and Monica can't figure out the answer to a major question: What is Chandler Bing's job? (See page 106 for the answer.) When time is up, the guys win and the girls have to move out.

> "Oh, oh, he's a transpons— transponster!!"
>
> RACHEL

Phoebe is nervous because this is Frank and Alice's only chance to have a baby: "They are like, literally, putting all their eggs in my basket." She lays down backward on a chair with her legs up to help gravity along. Monica keeps trying to make bets to win back the apartment, but the guys aren't biting. And Rachel just keeps refusing to move.

Alice and Frank come over and bring Phoebe a lollipop and a home pregnancy test, and Monica tells her, "Don't mix those up. You could really ruin that lollipop." Phoebe reluctantly goes to take the pregnancy test. While she's gone, Chandler and Joey roll into their new apartment on the white dog. A fight breaks out when Rachel refuses to move, and Monica blames her for getting a question wrong. As they are all yelling at each other, Phoebe emerges from the bathroom with the pregnancy test in her hand. She's pregnant. Everyone goes wild, and Frank raises both hands in the air and yells, "My sister's going to have my baby!"

At the end of the episode, Monica and Rachel have moved their stuff into the boys' apartment, and Chandler and Joey are raising up their recliners in the girls' apartment.

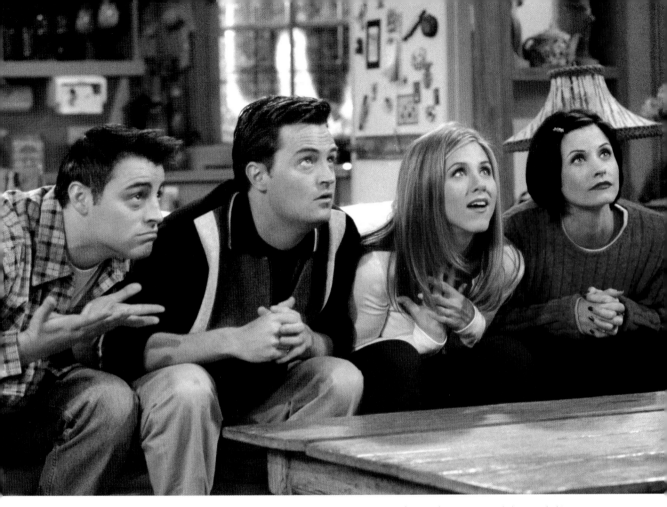

The girls lose the coin toss before the big trivia game, but that's nothing compared to what they lose at the end of it.

**COMMENTARY** This episode is a huge fan favorite due in no small part to the brilliant and entertaining trivia game, devised by Ross, in a high-stakes bet to see which pair of roommates knows the other better: Rachel and Monica or Chandler and Joey. When asked in 2019 about her insight as to why this episode left such an impression on viewers, Kauffman said, "It's a couple of things. It had a lot of stakes for everyone. It didn't start with a lot of stakes, but because of Monica's competitiveness, the stakes increased as the episode went on. Another thing is we had a group of them together playing this game. And

Phoebe's story was so emotional. It was such a counterbalance to the game.

"But I have to tell you a story about that game. There was one joke that I'm the only person who laughed at it. The category was literature and the question was about *TV Guide*. For some reason, that just slaughtered me. No one else laughed at it. That is one of my favorite episodes.

"Partly, it was because emotionally, the episode rung true and played really well . . . you got super-involved in the stakes of the game and super-involved in what Phoebe was going through. In that sense, it was very successful."

"The One with the Embryos" is a huge fan favorite due in no small part to the brilliant trivia game, devised by Ross, to see which pair of roommates knows the other better: Rachel and Monica or Chandler and Joey. Can you remember the answers to the "lightning round" questions that cost the girls the game?

1 • What was Monica's nickname when she was a field hockey goalie?

2 • What movie does Rachel claim is her favorite movie?

What is her actual favorite movie?

3 • Where did Monica get a pencil stuck when she was 14 years old?

4 • How many categories of towels does Monica have?

5 • What is Joey's favorite food?

6 • How old was Chandler when he first touched a girl's breast?

7 • Who was Joey's imaginary friend and what did he do?

8 • What is Chandler Bing's job?

1. Big Fat Goalie 2. *Dangerous Liasons*; *Weekend at Bernie's* 3. Her ear 4. Everyday use, Fancy, Guest, Fancy Guest . . . 11! 5. Sandwiches 6. 14? 19. 7. Maurice; Space Cowboy 8. Numbers, processing, carries a briefcase, transponding? Transponster!

# The One with Joey's Dirty Day

**WRITTEN BY** • **DIRECTED BY** • **ORIGINAL AIR DATE**
Wil Calhoun • Peter Bonerz • February 5, 1998

Rachel has a crush on one of her clients, Joshua, who invites her to the opening of a nightclub. However, she forgot she promised Mr. Waltham that she would take his niece, Emily (who is visiting from London), to see *Die Fledermaus*, so she convinces Ross to take Emily instead.

Chandler—currently in Phase One of recovery from his breakup with Kathy—is in a pair of sweatpants that look circa 1983. Joey, meanwhile, goes on a fishing trip with his dad. He falls asleep before he can take a shower and wakes up late to be on the set for his movie with Charlton Heston. He goes to the set smelling like a dead fish. When he learns that the licorice-loving Heston has a shower in his dressing room, he sneaks in to use it. Heston catches him mid-shower: "Put some pants on, kid, so I can kick your butt." Joey explains that he stunk, but Heston misunderstands and lectures him on how every actor thinks he stinks sometimes, a mistake that gets Joey off the hook.

Chandler, meanwhile, has taken off his sweats and put on pants, saying, "Where are the guys? I'm ready to get drunk and see some strippers," which is officially Phase Two. But Ross, as it turns out, had a blast with Emily, and they ran off to a bed-and-breakfast. Chandler immediately removes his pants, revealing his sweatpants underneath. Phoebe offers to go to the strip club with Chandler instead of the guys: "Would you just stop being such a wuss, and get those off, and you come with us and watch naked girls dance around!"

> "That's only Phase One."
>
> JOEY

The girls take Chandler to the strip club, but it's just not the same. Phoebe is pregnant and telling men to stop smoking, Monica convinces the cocktail waitress to become a third-grade teacher, and they don't realize that they must stop Chandler from calling Kathy (and Janice!) at all costs. Chandler doesn't think he'll ever achieve Phase Three: picturing himself with another woman. But when the girls start talking about which stripper they'd be most interested in, Phase Three comes a bit quicker than Chandler predicted.

**COMMENTARY** This is the first time we meet Emily, a character who will play a pivotal role in both Ross's and Rachel's lives. Actress Helen Baxendale turned down a reprisal of the role in the final season of *Friends* to focus on her family. In fact, Baxendale was pregnant at the time of the famous London wedding. Alterations were made to the wedding gown so no one could tell.

Baxendale wasn't the first choice for the role. It was originally offered to Patsy Kensit, a British actress and singer, who reportedly turned it down.

*Alternate Plot Alert!* Matthew Perry revealed to Andy Cohen that one of the plot suggestions for an episode was one in which Chandler went to a male strip club because "he really liked the sandwiches" they served.

# The One with the Free Porn

| STORY BY | TELEPLAY BY | DIRECTED BY | ORIGINAL AIR DATE |
|---|---|---|---|
| Mark Kunerth | Richard Goodman | Michael Lembeck | March 26, 1998 |

While Treeger snakes a drain in the bathroom, Joey flips a channel on the remote and miraculously stumbles on free porn. Treeger mentions that happened to him once, but he "made the mistake of turning off the TV." The guys are determined not to make the same mistake.

Phoebe's ob-gyn reveals that she hears "three separate heartbeats." When Phoebe tells Frank and Alice the news, Frank is thrilled, "I finally got my band!" They soon realize how much money they'll need to raise three kids, and Frank decides to quit refrigerator school to get a job. Phoebe tries to help by coming up with ways to make money like "The Relax-i Taxi," which would provide transportation *and* massages.

Ross goes to the airport to tell Emily that he loves her, but after the big reveal, she just says, "Thank you" in reply. He's mortified, and not just because he's holding an oversized Toblerone in the middle of the airport. He gets mad at Monica for the advice, but she convinces him to go home and wait for Emily's call. Monica is finally right about something, but it's not the "I love you" call that Ross was expecting. Emily apologizes for her chilly reply at the airport and tells him there is "someone else."

Even though Monica is 0 for 2, Ross listens to her again and decides to go to London to "fight for Emily." Joey and Chandler vehemently disagree: "Yeah, you already told her you loved her, and she didn't say it back. Then she called you, and told you there was another guy. So, yeah, go to London; that'll scare her." Ross flies to London but calls Monica from a phone booth to say that Emily hasn't been home all night and is clearly with the other guy. But she's not with the other guy. Emily is standing in Monica's New York apartment looking for him.

Emily takes a chance and rings her London flat. When the machine picks up, she talks to Ross over the answering machine. She tells him it's all over with Colin and that she loves him. Ross calls her back from the phone booth, and after she tells him she loves him, he reciprocates with a grateful "Thank you."

> ## "We have to turn off the porn."
> CHANDLER

**COMMENTARY** As the building's super, Mr. Treeger appeared throughout the series in small, sad ways, most notably as Joey's dance partner in "The One with the Ballroom Dancing," but also snaking drains and clearing pizza boxes from the garbage chute. In a *HuffPost Entertainment* interview, actor Michael G. Hagerty, who played Treeger, revealed that the super's apartment was designed to be "depressing." Hagerty's wife came up with the addition of the hot plate in Treeger's apartment, because she believed they are "some of the saddest things in the world."

**OPPOSITE** Joey and Chandler are up for a fake surprise party from season 4, episode 16, "The One with the Fake Party."

# The One with the Worst Best Man Ever

| STORY BY | TELEPLAY BY | DIRECTED BY | ORIGINAL AIR DATE |
|---|---|---|---|
| Seth Kurland | Gregory S. Malins & Michael Curtis | Peter Bonerz | April 30, 1998 |

Who needs a lousy engagement ring when you can have the GREATEST T-SHIRT EVER?

Ross is marrying Emily, and things get awkward when Joey asks about his best man, and Ross admits he already asked Chandler. Joey laments that he will never be a best man, and when Chandler says Joey can be *his* best man, Ross gets mad and makes Joey best man instead, giving him the ring for safekeeping.

Joey begins planning the bachelor party, and the girls are upset they're not invited. Phoebe is having some trouble managing her pregnancy hormones and screams, "Hey, get your ass back here, Tribbiani!" Monica tells Joey they don't care because they're having their own party: a baby shower for Phoebe. Phoebe is so excited she yells, "A party, yay!" and then immediately starts crying. Phoebe's baby shower ends up being a disaster, though, since Monica had the idea to give her presents that she can use *after* she gives birth, like leather pants and tequila.

Joey's bachelor party for Ross, in contrast, is a roaring success, despite the presence of all the

"dinosaur dudes." Joey even has T-shirts made for party favors with a photo of himself on the back. Chandler says Gunther is his new best man—that is, until Gunther quizzes Chandler on his last name, to which Chandler responds, "Central Perk." Gunther leaves, but not before expressing his gratitude to Ross in one of the funniest lines in the episode: "Thanks for not marrying Rachel."

After throwing out the museum geeks, Joey sleeps with the stripper. He's got more problems than glitter on his pillow though when he realizes that Ross's ring is gone the next morning . . . as is the stripper. Chandler can't help but gloat and calls Joey "the worst best man ever."

Monica and Rachel are scared to talk to Phoebe because of her mood swings. When she starts having false labor contractions, she asks them to bring her "the book" to see if they're real, and Rachel brings her the Bible. After the false labor, Phoebe admits that she is getting upset because "it's not going to be easy when, you know, these little babies have to go away." The girls help her come to terms with her new status as "Cool Aunt Phoebe."

Chandler figures out a way to get the ring back. Using the fake name "Gunther Central Perk," they call the stripper and have her come to Chandler's office to perform. When she gets there, Ross ignores Chandler's demand to "be cool" and immediately demands to know where she put his "dead grandmother's ring." The stripper denies stealing it, saying, "I make $1,600 a week doing what I do. Any of you guys make that?" As they try to figure out who took the ring, the duck comes in wildly flapping his wings, and the guys realize the culprit might be *fowler* than they thought.

As they sit at the vet, Joey gets nervous about the duck's well-being, and he flashes back to all the good times with Duck. Luckily, the little guy pulls through and the vet produces a ring. Ross is so excited until he makes the mistake of sniffing it. After he loses the ring, Joey gives up his best man responsibilities to Chandler. Ross decides, "I want both you guys," and they all get emotional in the vet's waiting room.

· · · · · · · · · · · · ·

# "So you might say it's a *magic* ring."

## CHANDLER

· · · · · · · · · · · · ·

COMMENTARY When Ross starts hysterically asking the stripper where his dead grandmother's wedding ring is, you can see Joey covering his mouth behind Ross, trying to control his laughter in what looks like an unscripted moment. And while the stripper made a decent clip for a week's work, by season 4, our favorite Friends had gone from making $22,500 per episode to $85,000 per episode, and they were negotiating as a group by this point, each actor refusing to earn more than another in an unprecedented move. Co-creator Marta Kauffman said in an interview, "We felt that that was absolutely the right thing to do. We didn't think it was right that they [the salaries] weren't the same." By the time seasons 9 and 10 rolled around, those paychecks had jumped to a million dollars an episode.

# The One with Ross's Wedding, Part 1

| STORY BY | TELEPLAY BY | DIRECTED BY | ORIGINAL AIR DATE |
|---|---|---|---|
| Michael Borkow | Shana Goldberg-Meehan & Scott Silveri | Kevin S. Bright | May 7, 1998 |

Monica, Chandler, and Joey head to London for Ross's wedding. Phoebe is too pregnant to go, and Rachel doesn't want to watch Ross get married. After they leave, Phoebe claims that Rachel is upset because she still loves Ross. Rachel denies it until she realizes she does still love him, saying, "Why didn't you tell me?" Phoebe replies, "We thought you knew!"

On arrival, Joey and Chandler hit London Town, but Joey can't read the map. He finally decides, "I'm gonna have to go into the map," and lays the paper map on the floor and steps on it. Joey annoys Chandler with his tourist routine until Joey finally tells him, "Man, you are Westminster Crabby." Joey buys a ridiculous Union Jack top hat from a street vendor (Richard Branson), and Chandler finally gives him an ultimatum. Joey chooses the hat.

Emily freaks out because the caterer switched up the menu, the florist is out of tulips, and the church has become a demolition site. Monica suggests postponing the wedding. Ross disagrees and Emily snaps at him. She walks out on him, suggesting they shouldn't get married at all.

When Joey returns later, Chandler admits he had a terrible day, but Joey didn't. He shows him a video of Fergie (Sarah Ferguson) telling Joey she finds his hat "dashing." Ross walks in and yells at Monica for convincing Emily to call off the wedding. Monica helps Ross see how insensitive he's being, and they decide to fix things. They line the half-demolished church with little white lights and show Emily how they can still get married there. Emily tells Ross, "It's perfect."

Meanwhile, back in America, Rachel has packed her bag to go to London to tell Ross she loves him.

## "London, baby!"

### JOEY

**COMMENTARY** A *Friends* wedding in London means a star-studded invitation list, complete with guest stars Richard Branson of Virgin Air fame (who sells Joey his Union Jack hat) and Sarah Ferguson, the Duchess of York, who does a video with Joey for Chandler. Part two of this episode features more British acting royalty from Hugh Laurie (the cynical passenger sitting next to Rachel on the plane) and Olivia Williams (bridesmaid Felicity) to Tom Conti (Emily's father), plus *Absolutely Fabulous* stars Jennifer Saunders (Emily's stepmother) and June Whitfield (the Waltham housekeeper).

Hats off to Lisa Kudrow, who won an Emmy for Outstanding Supporting Actress in a Comedy Series in 1998. Both Helen Baxendale and Lisa Kudrow were actually pregnant while taping this episode, Kudrow with her son, Julian Stern. In an interview with *People*, Kudrow said the cast members were so tight they even included Lisa's unborn son in their legendary pre-show "huddle" to have a good show.

Watch this episode until the credits, and you'll catch the show's co-creator Marta Kauffman along with writer and producer Adam Chase sitting behind Joey and Chandler on the double-decker tour bus, taking in the sights.

# The One with Ross's Wedding, Part 2

| STORY BY | TELEPLAY BY | DIRECTED BY | ORIGINAL AIR DATE |
|---|---|---|---|
| Jill Condon & Amy Toomin | Shana Goldberg-Meehan & Scott Silveri | Kevin S. Bright | May 7, 1998 |

At the rehearsal dinner, Jack and Judy Geller meet Emily's parents, Steven and Andrea Waltham (Tom Conti and Jennifer Saunders). The Gellers offer to pay for half the wedding, but when Jack gets the bill, he realizes Emily's parents are getting them to foot the bill on remodeling their house as well.

The rehearsal dinner is a disaster by several accounts: Chandler's best man speech is met with crickets, Joey can't stop being homesick, and a guest mistakes Monica for Ross's *mother*. Jack Geller gets the last word in with Mr. Waltham when he shouts, "I'm not paying for your wine cellar, you thieving, would-be-speaking-German-if-it-weren't-for-us, cheap little man!"

The next morning, Ross runs into Chandler's room, excited to be getting married. After he leaves—in one of the biggest surprises of the ten-year series—Monica pops up from under Chandler's covers and asks, "Do you think he knew I was here?"

Meanwhile, on the plane, Rachel unloads the Rachel-Ross saga to anyone who will listen, and is interrupted by the guy sitting next to her (Hugh Laurie) who says, "It seems perfectly clear you *were* on a break."

Joey neglects his promise to Phoebe to intercept Rachel and completely misses her storming into the church. He's too busy making out with Felicity (Olivia Williams), one of Emily's bridesmaids. When Rachel sees Ross kissing Emily before the wedding, she can't tell him she still loves him.

As the wedding commences, Mrs. Waltham—clad entirely in black—picks up her cell phone as she walks down the aisle with Joey. It's Phoebe again, wanting to make sure Rachel didn't ruin the wedding. Joey holds up the phone during the ceremony so Phoebe can listen. As Chandler and Monica walk down the aisle, they agree sleeping together was stupid, but Chandler says, "I'm coming over tonight, right?" and Monica immediately replies, "Oh, yeah, definitely."

After Emily recites her vows, the minister turns to Ross, but Ross begins, "I, Ross, take thee, Rachel . . ." There is a moment of shocked silence, and the minister asks if he should continue, ending the dramatic London season finale with a killer cliffhanger.

> "Do you think he knew I was here?"
>
> MONICA

**COMMENTARY** This episode was penned by Scott Silveri and his wife, Shana Goldberg-Meehan (along with the incredible team of *Friends* writers). Silveri revealed in an interview with *Vulture* that the chemistry between Monica and Chandler, particularly in season 2, episode 7, "The One Where Ross Finds Out," made a pairing seem like a good idea. It was pitched as a potential storyline in the third season, but they decided to wait to surprise fans. When the London audience saw the episode for the first time at the taping, Kauffman said at the ATX Television Festival, "We had to stop [taping] the show because people were screaming."

# Season Five

After the ceremony in London, Emily bolts. Still, Ross hopes Emily will show up to join him for their honeymoon to Greece. He runs into Rachel and invites her along since he can't find Emily. Emily shows up just as Ross is boarding the plane with Rachel. She runs off again, and Ross chases after her, leaving Rachel alone on the flight. Emily eventually agrees to give their marriage a chance, but makes two demands: Ross must move into a new apartment and cut Rachel out of his life. Ross agrees to move, but draws the line at cutting Rachel out of his life. Emily's inability to trust Ross results in her ending their marriage.

After sleeping together in London, Monica and Chandler establish a secret relationship, which each Friend discovers throughout the season. Ross is the last to know, finding out only when he sees the couple through the window of his new apartment, which once belonged to Ugly Naked Guy.

Joey lands a role in a movie filming in Las Vegas. The rest of the Friends decide to visit and discover that the movie has run out of funding and Joey is working as a gladiator character at a hotel and casino. Chandler and Monica begin to wonder if they are seeing signs telling them that they should get married. However, when they get to the chapel, Ross and Rachel run out, having just drunkenly tied the knot.

OPPOSITE Looks like it once gobbled, but that turkey on Joey's head was made out of foam and mesh.

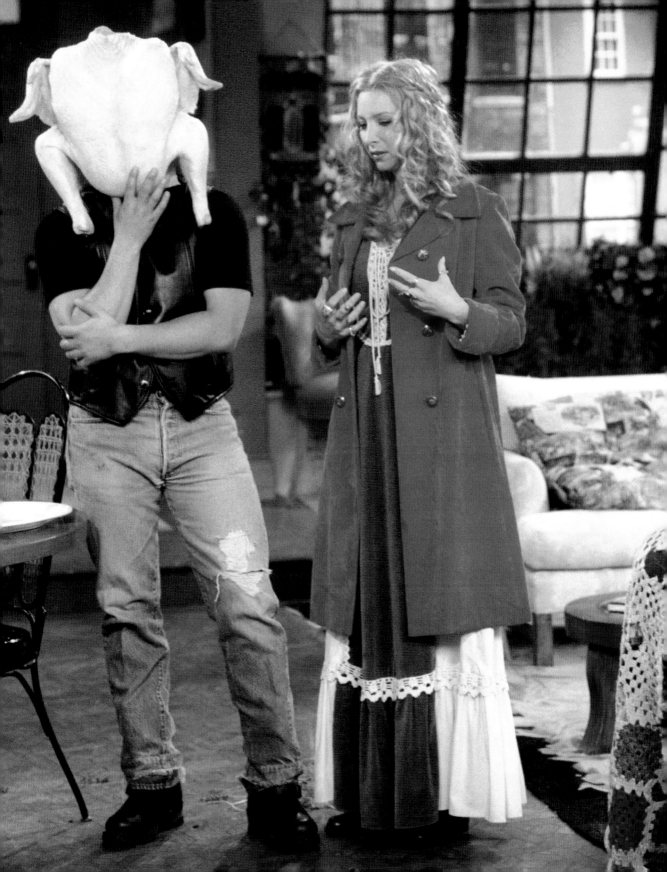

# The One After Ross Says Rachel

WRITTEN BY • DIRECTED BY • ORIGINAL AIR DATE
Seth Kurland • Kevin S. Bright • September 24, 1998

Ross has just said Rachel's name at the altar, and Emily gives the minister the okay to continue. They are married, and the rest of the ceremony is a chilly, awkward mess. After they get outside, Emily punches Ross in the stomach.

The reception isn't any better. Emily locks herself in the bathroom, screaming, "I hate you!" at Ross, Joey is eating a piece of steak out of his hand like it's a sandwich, Ross tells Rachel that saying her name doesn't mean anything, and Monica and Chandler can't pull off a quickie in the wine cellar. Rachel mentions that when she locked herself in the bathroom at her own wedding, it was because she was trying to escape out the window. Ross gets nervous and races into the bathroom where Emily's hiding, but she's gone.

The movie *My Giant* squashed Chandler's naked plans with Monica.

Chandler and Monica race from room to room trying to find an empty one to have sex in, but between Rachel's chronological breakdown of Ross's obsession with her to Phoebe, Joey's hook-up, and the movie *My Giant*, they are thwarted at every turn—until they finally get to Ross's honeymoon suite. Chandler insists that "the room expects sex," but unfortunately Ross turns up and plants himself in the room just in case Emily is looking for him.

> "This is worse than when he married the lesbian."
>
> JUDY GELLER

Emily's parents come for her things, and her mother makes a pass at Ross: "I think you're absolutely delicious." They tell Ross that Emily never wants to see him again. He makes them promise to let her know that he'll be at the airport waiting for her to join him for their honeymoon.

When they arrive back home, Chandler and Monica decide to part as friends. But after Chandler leaves the apartment, he bursts back in and says, "I'm still on London time. Does that count?" And just like that, their London relationship becomes a New York one too.

Ross is at the airport waiting for Emily to go to Greece, but she still hasn't shown up. He spots Rachel, who is waiting for a standby ticket back to New York. Rachel tells Ross to go by himself, and at the last minute he suggests Rachel come with him, saying, "God, I could use a friend." But just as they're about to board, Emily shows up and sees them together. She runs off and Ross chases after her. Rachel, meanwhile, sits on the flight to Athens all by herself.

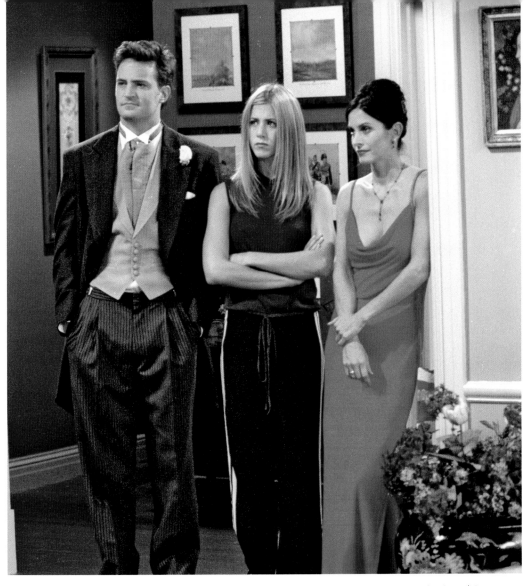

Mr. Geller was the only one brave enough to say what everyone else was thinking: "Boy, a bad time to say the wrong name, huh, Ross?"

COMMENTARY Well, it probably wasn't meant to be. After all, if you get angry at your ex-girlfriend for not coming to your destination wedding while forgetting to invite your own son (yup, producers reportedly forgot to include Ben on the invite list!), it doesn't seem like the best start, right? But the idea for Ross's big mix-up at the altar got its start in a different scene as revealed by writer Greg Malins in *The Story Behind Friends*. David Schwimmer messed up one of his lines—accidentally saying Rachel's name instead of Emily's—in a scene involving a cab. When Schwimmer did that, Malins was standing next to creator David Crane, and said to him, "That's it," and thus Ross's matrimonial "oops" moment was born.

# The One Hundredth

WRITTEN BY
David Crane & Marta Kauffman
•
DIRECTED BY
Kevin S. Bright
•
ORIGINAL AIR DATE
October 8, 1998

Phoebe's water broke in episode 2, so episode 3 begins at the hospital. But the problems start early when Phoebe's ob-gyn can't come due to a tragic shower accident, and a Dr. Harad arrives to deliver her triplets instead. But as it turns out, Dr. Harad is not only the head of the department, he's also obsessed with Fonzie from the TV show *Happy Days* ("Oh, you know, Fonzie *dated* triplets!"). Phoebe makes Ross get her another doctor.

While he's filming Phoebe on delivery day, Joey hurts his back. Phoebe thinks they're only sympathy pains, and Joey says under his breath, "I didn't know I cared that much." When the doctor X-rays his back, however, they discover that it's not sympathy pains at all: Joey has kidney stones.

Rachel gets a date with two hot nurses, and she insists that Monica go along with her. Chandler finds out and tells Monica to go since they're just "goofing around." Monica's feelings are hurt and she says she *will* go out with him. When they meet Dan, the nurse, Chandler tries to make fun of his job, calling it "girlie," but Dan shoots back, "It didn't feel so girlie during the Gulf War."

Ross brings back Dr. Oberman for Phoebe, but when she looks at his youthful face, she's not having it: "Go, go little boy, GO!" Frank laughs because she made the "Doogie" doctor cry, and Phoebe is forced to settle for the Fonzie fanatic. Phoebe also tells Rachel a little secret: she wants to keep one of the babies. Rachel moans, "Oh, I'm going to be on the news," before telling Phoebe it's an insane idea. But Phoebe begs Rachel to talk to Frank and "feel him out."

•  •  •  •  •  •  •  •  •  •  •  •  •

## "Chandler's a girl!"

### FRANK BUFFAY JR.

•  •  •  •  •  •  •  •  •  •  •  •  •

Phoebe's in her final stages of labor just as Joey is passing his kidney stones in a hilariously parallel storyline ("I want the drugs, Ross, I want the drugs!" he yells from a nearby room). When Phoebe is dilated to 10 centimeters, Dr. Harad puts on *Happy Days* and assures her, "It's a good one. Fonzie plays the bongos." Three babies are born: Frank Jr. Jr., Leslie, and Chandler. Baby Chandler was supposed to be a boy, though, so it's a big surprise when she comes out, and Frank Jr. exclaims: "Chandler's a girl! Chandler's a girl!" After recovering from kindergarten flashbacks, Chandler (the adult male) convinces Monica not to go out with Dan because he and Monica care about each other.

While she's holding one of the babies, Phoebe asks Rachel if she talked to Frank about keeping one, and Rachel tells her it's not going to happen. There's a moment of quiet sadness and Phoebe asks for a moment alone with the babies. She tells them she's had the "most fun" with them and then prepares to let them go to Frank and Alice: "Okay, I'll settle for being your favorite aunt."

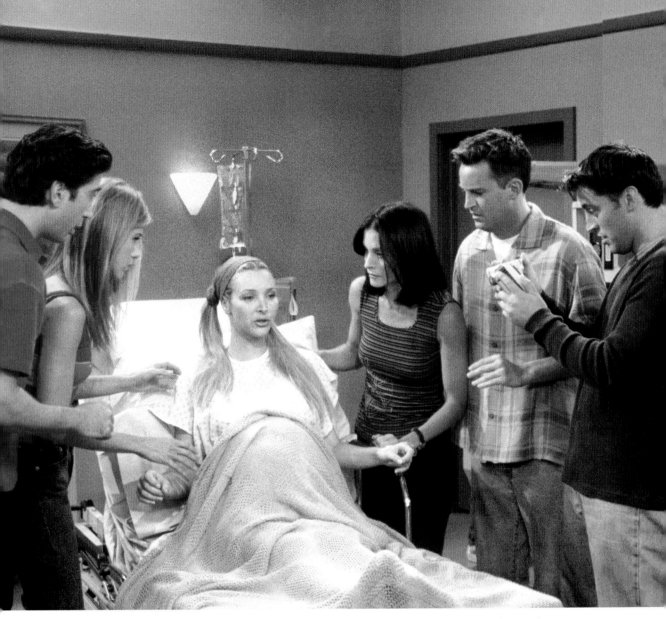

Phoebe considers keeping one of the triplets, but eventually lets them go to be with their new parents, Frank Jr. and Alice.

**COMMENTARY** In an interview, co-creators David Crane and Marta Kauffman said the roles of Chandler and Phoebe were originally going to be "secondary" to Monica, Joey, Ross, and Rachel. But once Lisa Kudrow auditioned, they changed their minds, saying she "nailed it." Funnily enough, Kudrow had no intentions of ever becoming an actor. She graduated Vassar with a degree in Biology, intending to be a doctor like her father. But after her real-life brother's friend, Jon Lovitz, landed a gig on *Saturday Night Live*, she decided to give acting a go.

# The One with the Yeti

**WRITTEN BY**
Alexa Junge

**DIRECTED BY**
Gary Halvorson

**ORIGINAL AIR DATE**
November 5, 1998

Ross is having a sale to get rid of all his stuff because Emily wants all new furniture when she moves to New York. He has already promised not to hang out with Rachel anymore just to get Emily to agree to come.

Monica and Rachel go into the storage room of their apartment building to find their little waffle maker, and Monica finds it next to a can of bug bomb. The light goes out and they are approached by a wild-haired man in the shadows brandishing what looks like a pickaxe. Rachel uses the bug bomb to fog the yeti-like creature, and they run out.

Phoebe's mother sends her a mink coat, and she doesn't know what to do with it because she is against fur. She tries giving it to Joey, but Chandler looks up at Joey's new look and says, "You're on in five, Ms. Minnelli." Ross walks in and announces he's moving apartments to Emily's cousin's place all the way uptown. Monica and Rachel follow in shortly after and tell everyone about the yeti in the storage room. Joey says, "Yeah, you fogged Danny."

As it turns out, Danny is a new neighbor who just got back from "a four-month trek in the Andes." Monica and Rachel go to apologize, but Danny is stony-faced and refuses to say anything beyond "okay" and shuts the door on them.

When Ross says he's not happy about moving, Joey sees his chance. "We all hate Emily!" The Friends say that's not true but do admit that Emily is being "unreasonable." Ross gets angry and says marriage is about compromise and this is "what grown-ups do."

Rachel runs into a cleanly shaven Danny downstairs and doesn't recognize him, thinking it's a cute new neighbor. Once she realizes it's Danny, she apologizes again, and he says, "Some people are just into appearances." She yells at him for making snap judgments until he interrupts and says, "I'm hungry. Want to get some pizza? You can keep yelling if there's more."

At the end of the episode, Monica makes dinner for everyone, and when Rachel comes home, Ross invites her to stay, even though Emily has forbidden him from hanging out with her. Ugly Naked Guy makes an appearance in the window across the way, and Monica realizes it might be the last time they are all hanging out together. The phone rings, and it's Emily. She asks to go on speaker phone so she can hear everyone there. Joey says, "I don't know about who's here, but I can tell you for damn sure who's not here, and that's Rachel!" Rachel gets upset, and Ross tells Emily the truth. Emily realizes she can't trust him. After he hangs up the phone, Ross makes a startling realization: "My marriage is over."

> "Yeah, I pulled the tab, and I just fogged his yeti ass!"
>
> RACHEL

"You're on in five, Ms. Minnelli."

**COMMENTARY** You might recognize George Newbern (the yeti) from his roles in *Father of the Bride* and *Scandal*. But his role as Danny on *Friends* wasn't the first experience Newbern had with the hit show. In an interview, he revealed that he was supposed to audition for the role of Ross (which went to, his old college buddy, David Schwimmer). Newbern took another sitcom role (*The Boys Are Back*, which ended up being cancelled) but he was thrilled to score a guest spot as Rachel and Monica's sometimes-hairy neighbor in three episodes.

# The One Where Ross Moves In

WRITTEN BY
Perry Rein & Gigi McCreery

DIRECTED BY
Gary Halvorson

ORIGINAL AIR DATE
November 12, 1998

Monica's restaurant gets examined by Larry (Gregory Sporeleder) the health inspector. Phoebe meets him and thinks he's cute. Larry asks her out, and she agrees because "you know all the clean places to eat." Phoebe is turned on by Larry's power, and when he spots ten health code violations at a restaurant on their first date, she says lustfully, "Shut it down."

Danny walks into Central Perk while Monica and Rachel are chatting, and he mentions he's having a housewarming party on Saturday but doesn't invite them. Danny hasn't called Rachel since their date, and Rachel thinks he's playing some kind of game. When he stops by later to invite them, Rachel makes up a "regatta gala" so it looks like she has plans.

After Ross and Emily decide to get divorced, Ross is kicked out of her cousin's apartment and has nowhere to stay until Joey and Chandler offer up their apartment. Ross moves in, and immediately changes the voicemail to Queen's "We Will Rock You," replacing the lyrics with "We will, we will . . . *call you back.*" Chandler and Joey aren't happy, but Joey has fun making a fort out of Ross's moving boxes. But when Chandler spots the air purifier, he is reminded of all of Ross's annoying habits in college. Tensions reach an all-time high when Ross starts constantly using an annoying hand gesture to ask them to keep it down.

Chandler and Joey find an apartment for Ross and convince him to go see it even though it's an expensive studio. The place is a closet, but they encourage him to take it anyway to get him out of their place. Ross realizes he's become a burden to his friends and sadly fills out an application.

> "Why don't you be a grown-up and come watch TV in the fort?"
>
> JOEY

Larry the health inspector's power trip is getting old fast for Phoebe. He's shutting down all of her favorite restaurants, and when he flashes his badge at Gunther, she realizes she has to stop him: "So where are we going to eat ever?" He agrees to give Central Perk just a warning.

Rachel shows up late to Danny's party, but when she gets there, Danny tries to set her up with his friend Tom. The audience knows Tom is not meant to be, however, the minute he says, "So you work at Bloomingdale's, huh? My mom calls it 'Bloomies.'"

When the landlord calls Chandler and Joey as a reference for Ross and his new place, Chandler sees an opportunity to make things right again. He tells the landlord that Ross is a "big tap-dancing pimp" so he doesn't get the apartment. Ross comes home and says he didn't get the new place, and says that he'll move in with Phoebe instead. The guys insist that he stay, and at the end of the episode, they're all in the fort, dressed up for a Wild West roundup, with Chandler as a bonnet-wearing lass, of course.

Thanksgiving isn't complete without turkey, carrots, and mac & cheese.
Hold the severed toe, please, from season 5, episode 8, "The One with All the Thanksgivings."

**COMMENTARY** In the blooper reel for this episode, when Chandler comes in and catches Ross and Joey playing in the fort, he asks, "What are you doing?" Joey and Ross say, "Nothing," as they simultaneously zip their flies.

The Magna Doodle in Joey and Chandler's apartment made its first appearance toward the end of season 3, and it has become a *Friends* legend, with fans around the globe deciphering its messages. In this episode, "No Girls Allowed" is scrawled on it: perhaps a nod to the three guys living together for the first (and last) time. Or perhaps the message is intended for Ross, fresh off the heels of yet another failed marriage. Chatting with Jimmy Fallon, Matt LeBlanc admits he swiped the infamous board after the final episode and gifted it to the electrician on the set who drew the messages on the board every week.

# The One with All the Resolutions

STORY BY · TELEPLAY BY · DIRECTED BY · ORIGINAL AIR DATE
Brian Boyle · Suzie V. Freeman · Joe Regalbuto · January 7, 1999

It's 1999 or, as Joey calls it, "The Year of Joey." Post-NYE party, the Friends make resolutions for the new year. Ross decides he's going to try something new every day. Phoebe wants to pilot a commercial jet. And when Chandler makes fun of Phoebe's resolution, Ross bets Chandler he can't *not* make fun of people for an entire week. Joey wants to learn guitar, and Phoebe offers to teach him. Monica suggests that Rachel gossip a little less for her resolution.

Phoebe gives her first guitar lesson to Joey, who quickly learns he's not allowed to touch the guitar. Phoebe names the chords things like "Old Lady" and "Bear Claw" based on how her hand looks when she's playing the chord. Joey accidentally says the real name of a chord while Phoebe is teaching him, and she realizes he's been studying behind her back. He tells her that he needs a real teacher. He later apologizes, asking her to be his teacher again. She thinks he is finally ready to hold a guitar, but as he tries to play his first chord, the instrument crashes to the ground.

Ross comes in, and he's definitely trying something new: snug leather pants. Chandler can't make fun of him, and it's killing him. Everyone pretends to like them, and Chandler storms out. Monica takes pictures and we learn her resolution is to take more photos of everyone together, but the only thing she ends up capturing is a bunch of failed resolutions.

> "You know what your nickname is, *Mr. Big* . . ."
>
> MONICA

Ross goes on a date with Elizabeth in the leather pants. It turns out that leather can make you sweat. His shirt is soaked, and his pants make fart sounds as they rub against the couch. He goes into Elizabeth's bathroom for a breather, pulls down the pants, and pats his legs with water to cool down—only now it's impossible for him to pull up his pants.

Rachel picks up the phone in her apartment and hears Monica talking on the line. She tells the other caller that she'll just tell Rachel she's doing laundry for a few hours. But the real surprise comes when Rachel hears it's Chandler, and he says, "Laundry? Huh. Is that my new nickname?" Rachel is shocked to realize that Monica and Chandler have been sneaking around. She runs to tell Joey (despite her no-gossip resolution), but he covers his ears because he doesn't want to be the keeper of secrets anymore.

Ross, meanwhile, is stranded in the bathroom. He calls Joey for help; Joey suggests baby powder. Ross tosses it by the handful onto his legs, but through tears, he says, "They're not coming on, man." Joey suggests Vaseline next, but Ross only has lotion. He slathers and squirts it onto his legs (and beyond), to no avail. "The lotion and powder have formed a paste!" Elizabeth freaks out when he finally emerges from her bathroom—sans pants, covered in the lotion–powder paste—saying simply, "I had a problem."

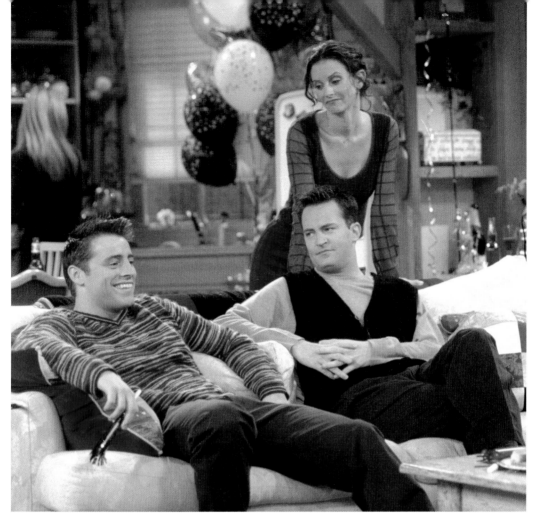

Y2K didn't come to fruition at the end of 1999, and neither did a single Friend's resolution.

**COMMENTARY** This might be "The One with All the Resolutions," but not a one of us is likely to ever call it that. This episode is clearly "The One with the Leather Pants." David Schwimmer fumbling around his date's bathroom in search of baby powder, Vaseline, and, finally, lotion to hitch up his leather pants is one of the funniest scenes in *Friends'* ten-year run, and may be one of the sharpest scenes of sitcom physical comedy ever. As he cries in desperation and accidentally smacks himself in the head with a lotion-slicked palm while trying to forcibly pull the leather over his sweaty calves, it's just laugh-out-loud hysterical.

When he finally gives up, slowly opening the door and walking out with his soiled pants in hand, he looks like a child nervous to tell his mother he had an accident. And paste pants? Thank you, Joey, for being you.

Costume designer Debra McGuire said in an interview with *The Telegraph* that the wardrobe changes for each *Friends* episode were extensive: "We had between 50 and 75 changes per episode." When co-creator Marta Kauffman requested jeans for the characters, McGuire refused, claiming, "I lived in New York for a long time, and I don't think I ever wore a pair of jeans." Perhaps leather pants?

# The One with Chandler's Work Laugh

WRITTEN BY · DIRECTED BY · ORIGINAL AIR DATE
Alicia Sky Varinaitis · Kevin S. Bright · January 21, 1999

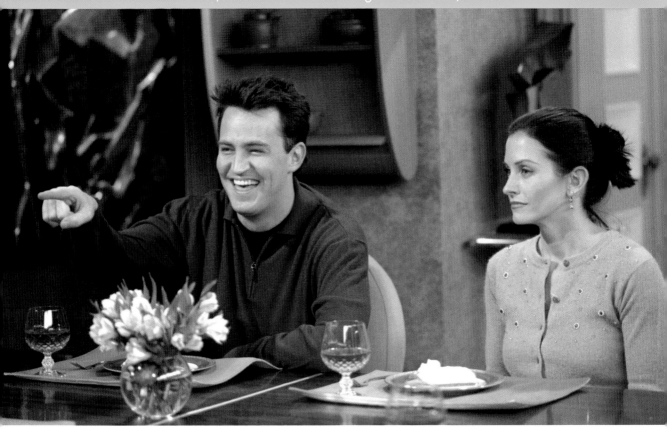

Turns out that Monica isn't the only one with an annoying habit in this relationship.

Chandler takes Monica as his date to a work party, but as Chandler schmoozes with his boss, Doug, he lets out a giant fake laugh at a bad joke. Monica asks him what he's doing, and he tells her it's his "work laugh." Doug asks Chandler and Monica to play doubles tennis with him and his wife.

Even though tennis with his boss seemed like a great opportunity, Chandler forgot about Monica's competitive streak, and she ruthlessly batters Kara with the mighty Geller backhand. Chandler can see he's doing damage with his boss and asks Monica to let them win one, but she refuses because she can see victory: "Look at them! He can't breathe and she's poppin' pills!" Chandler throws the game on purpose, prompting Monica to break Chandler's racquet, saying, "I don't like Work Chandler. The guy's a suck-up."

Rachel keeps trying to get information about the Monica/Chandler relationship, first from Joey "who knows nothing," and then from a tight-lipped Monica. When Rachel finally tells her she

knows about Chandler, Monica vehemently denies it, claiming she didn't call him Mr. Big, she called him Mr. *Bigot*.

The next morning, everyone is looking for Ross, who didn't come home the night before. He was upset about the news that Emily is getting married again. When he finally walks through the door, he is vague about his whereabouts until Joey says, "He hooked up!" Ross isn't divulging details about his mystery lady, but he doesn't have to, because Janice bursts through the front door and says, "Ross, you left your scarf . . ." And what's even more shocking than a Janice/Ross rendezvous is that Ross plans to see her again.

Dinner with Doug and Kara is a doozy, and Monica cannot stand Chandler's work personality anymore: "How does that laugh not give you a headache?" But when Chandler tries to stop the phoniness by not laughing at his boss's bad jokes, Doug gets offended. Monica swoops in to help him, a signal she is willing to live with it.

Rachel is fed up by Monica's lies and goes over to Chandler's to confront the couple. But when she arrives, she overhears Monica telling Chandler that she doesn't like lying to Rachel, because she's her "best friend." Rachel decides to let Monica tell her when she's ready, but she knocks over the lamp on the way out and Monica comes running out. As she fumbles with lies about a "new job," Rachel gives her a hug and congratulates her.

Janice, meanwhile, can't take Ross any longer, finally telling him he is too whiny. Ross is shocked: "Let me make sure I'm hearing this right . . . you're ending this with me because *I'm* too whiny?" All he can say in this complete and utter role reversal is, "OH. MY. GOD." On her way out, Janice stops Joey and says, "Well, I guess that's two out of three . . . *Joey!*"

. . . . . . . . . . . . .

"You're a very sweet person, Ross . . .
unfortunately I just don't think I can take
another second of your *whining*."

JANICE

. . . . . . . . . . . . .

**COMMENTARY** Maggie Wheeler, who plays everyone's favorite *Friends* girlfriend, sounds nothing like Janice in real life. "The laugh was born in the rehearsal," she says in an interview on *Friends of Friends.* Matthew Perry made her laugh during an early rehearsal scene (the one where he tries to break up with her), and because they were still in scene, her character had to laugh too, and thus, the Janice laugh was born, and our lives are now complete. For this episode, when Janice hooks up with Ross, she said, "The audience never suspected that it was going to be me." The live studio crowd went wild when she walked in, and Wheeler says, "It went on for five minutes." You'll notice Janice lifts the scarf to her face in that big reveal scene with Ross, and it's because Wheeler was about to lose it during the scene because of the incredible audience reaction.

# The One Where Everybody Finds Out

WRITTEN BY • DIRECTED BY • ORIGINAL AIR DATE
Alexa Junge • Michael Lembeck • February 11, 1999

Ugly Naked Guy is moving, and Ross thinks he should rent his apartment so he can be right across the street from everyone. Rachel, Phoebe, and Ross go check it out, and while Ross fills out an application, Phoebe goes to the window. She spots Chandler and Monica across the way undressing each other and begins screaming, experiencing temporary blindness from the shock.

Joey wants to let Monica and Chandler know that they all know, but Phoebe wants to mess with them first. She decides to start flirting with Chandler to see how he'll react. ("Oh, hello, Mr. Bicep.") Rachel plays her own game by giving Monica laundry to do when she's supposedly going to "do laundry" with Chandler.

Ross tries to get an edge on Ugly Naked Guy's apartment by sending him a basket of mini muffins, but unfortunately, his basket is the smallest of the gifts Ugly Naked Guy receives, as they observe through the window. On her way out of Monica's apartment, Phoebe pinches Chandler's butt, and this time, Monica notices too. Rather than assume Phoebe actually likes Chandler, Monica figures out the truth—"Oh my god, she knows about us!"—and decides to have a little fun of her own.

Chandler calls Phoebe and tells her he's been thinking about what she said and invites her over to "feel my bicep and maybe more." Rachel figures out that Chandler and Monica know they know. Phoebe decides to beat him at his own game and tells Chandler she'll be over that night.

Ross decides to "bond" with Ugly Naked Guy over common interests to secure the apartment. He shows up at Ugly Naked Guy's apartment, who predictably answers the door buck naked. Ross applauds him for his nudity and says, "That is how God intended it." While Ross is there, the gang all look out the window and Joey notices that Ugly Naked Guy has a naked friend. Rachel is the first to realize that it's "Naked Ross!"

To spy on the big date, Monica hides in the bathroom and Rachel listens at the door to the laugh-out-loud encounter between Phoebe and Chandler. The stakes get high when Phoebe says she wants Chandler to rub lotion all over her. He runs to the bathroom to get lotion and tells Monica it's getting out of hand. To speed things up for Phoebe, Joey gives her some advice, "Show him your bra. He's afraid of bras. Can't work 'em." Joey promptly rips open Phoebe's dress to expose her bra, without tearing off a single button. Phoebe walks up to Chandler with her bra out, they awkwardly move in for the first kiss, and Chandler is terrified. He cracks at the last second and says he can't have sex with her because "I'm in love with Monica."

> "They don't know that we know they know we know!"
>
> PHOEBE

At the end of the episode, Naked Ross sublets the apartment across the way. He invites his old boss to come see it, and Donald thinks Ross is ready to come back to work. Ross says, "That whole rage thing is definitely behind me." That is, until he sees Monica and Chandler going at it across the way and starts screaming out the window, *Get off my sister!*

The brief fling that was supposed to be Monica and Chandler's relationship led to the most stable couple on *Friends*.

**COMMENTARY** This is one of the funniest episodes in season 5, between Ugly Naked Guy, Naked Ross, and the sex standoff between Phoebe and Chandler. During the almost–sex scene, they look like they're struggling to keep straight faces throughout—especially Chandler, when Phoebe does her "dance."

But let's take a moment to pay tribute to Ugly Naked Guy here in his last appearance. For many years, no one knew his real identity, and many as-

sumed he was played by Michael Hagerty (who plays Treeger, the super). But *Huffington Post* journalist Todd Van Luling spent a painstaking year trying to uncover Ugly Naked Guy's real identity, and in 2016, his efforts paid off. Turns out the real actor—Jon Haugen—is *not* ugly and loved doing the show. Haugen confirmed that he and Ross weren't actually naked in the bonding scene. Both wore boxer shorts.

# The One with the Cop

STORY BY • TELEPLAY BY • DIRECTED BY • ORIGINAL AIR DATE

Alicia Sky Varinaitis • Gigi McCreery & Perry Rein • Andrew Tsao • February 25, 1999

Ross buys a couch. The delivery charge is so high that he decides to carry it the three blocks to his apartment and enlists Rachel to help. The salesman at the furniture store isn't surprised when he finds out they aren't a couple. "Something didn't quite add up there," he says, implying that Rachel is too hot for Ross. But Ross informs him that they went out and "did it . . . 298 times."

Joey has a dream about being in a relationship with Monica, and he starts acting all weird around Monica and Chandler, until he finally admits he's worried that he's in love with her. Chandler suggests that maybe "you're jealous that I've become the apartment stud." But Joey doesn't think so. "Kind of sounds like your dream, dude." Monica thinks Joey is ready for a close relationship, maybe with someone who is a friend first. Joey turns to Rachel and says, "How *you* doin'?"

Phoebe discovers a police badge under a cushion at Central Perk. She sees a woman put out a cigarette on a tree later that day, and she is so infuriated that she busts out the cop badge, forcing the woman to apologize to the tree. After performing more "good deeds" like that, she decides to take the badge back. The power is just too much.

Phoebe gets in real hot water though when she flashes the badge at a guy who has parked on the sidewalk in front of Central Perk. Turns out the guy is the cop who lost his badge. He quickly figures out Phoebe is a phony when she mentions the fellas in Vice that she works with, like "Sipowicz," whose partner died. Gary says, "I'm sure Sipowicz is going to be all right. I heard that kid from *Silver Spoons* is really good." Phoebe realizes the jig is up, throws the badge at him, and takes off.

## "PIVOT! . . . PIVOT! . . . PIVOT!"

### ROSS

Ross and Rachel can't get the couch up the stairs. She tries to get Joey to come help but ends up having to settle for Chandler. Ross isn't happy. The three try to maneuver the couch up the stairs, with Ross screaming "PIVOT! PIVOT! PIVOT!" until Chandler finally screams back, "SHUT UP, SHUT UP, SHUT UP!" The couch gets stuck in the stairwell, and the fire department has to saw it in half to get it down.

While everyone is at Monica's apartment, the NYPD comes to the door. It's Gary the cop looking for Phoebe. She thinks she's getting arrested, but it turns out Gary is looking for a date instead. "You're the prettiest fake undercover whore I've ever seen." Turns out Gary ran her fingerprints through the computer and that's how he found her. He saw her record, too, to which she responds, "Yeah, we'll talk at dinner."

David Schwimmer admitted to Conan O'Brien that the "Pivot!" couch scene is "the hardest I've laughed in my life, period."

Actor Michael Rapaport—who is no stranger to playing a cop—enjoyed his time as Phoebe's love interest, Gary, on *Friends*. But when asked on *PeopleTV's Couch Surfing* which one of the guys—Matthew Perry, Matt LeBlanc, or David Schwimmer—would make the better cop, he laughingly answered, "Oh, *none* of them would be good cops." Rapaport and Kudrow had terrific on-screen chemistry, so their breakup had to be over something really unforgiveable. Shooting innocent songbirds for sport, anyone?

As for taping the fan-favorite couch scene with Ross screaming "PIVOT!" in a hysterically exaggerated voice, Courteney Cox paid homage to Ross's furniture fail on Instagram in 2019. While moving a desk in her home, she can be heard yelling "PIVOT" in the background, and included the hashtag in the post.

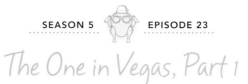
# The One in Vegas, Part 1

| WRITTEN BY | DIRECTED BY | ORIGINAL AIR DATE |
|---|---|---|
| Ted Cohen & Andrew Reich | Kevin S. Bright | May 20, 1999 |

*Chandler lays down the law in Vegas, telling Monica she can't ever see Richard again.*

Joey went to Vegas to film his big movie, but it gets shut down until they can get more financing. To make some money while he's waiting, he gets a gig at Caesars Palace as a gladiator and tells Chandler he forgives him just so Chandler won't come to Vegas and see he was right about the movie not being his "big break."

Monica buys Chandler tickets to Vegas for their one-year anniversary, and despite their protests, Phoebe says she's going too. Ross and Rachel decide to fly out later, and Rachel is happy to have the apartment to herself for one night. Phoebe assumes Rachel will be walking around naked in the empty apartment, but Rachel said she doesn't do that.

Even though Monica has asked her not to, on the plane, Phoebe accidentally reveals to

Chandler that Monica had lunch with Richard the day before. Chandler pretends to not be mad, but the palpable silence suggests otherwise. When they arrive in Vegas and see Joey dressed as a gladiator, he admits the movie is temporarily shut down. Chandler and Monica fight about Richard after he tells her she can't go out with him ever again. Just as she's about to go up and apologize to him, she spies a chip on the floor and starts gambling.

*Ross mistakenly thinks that Rachel is dancing naked just for him.*

Rachel, at home by herself, drops her robe for a little naked dance to Donna Summer's "Love to Love You Baby," but doesn't realize that Ross (across the way) can see her. He assumes she's trying to make a pass at him and heads over there immediately. He struts in and says he just wants to lay down some "ground rules" before anything happens. But Rachel laughs and says, "You actually thought I wanted to have sex with you?"

Ross and Rachel keep trying to out-embarrass each other on the plane to Vegas: Ross announcing to the plane that he's not joining the mile-high club with Rachel; Rachel kissing the back of a guy's head and pretending Ross did it. Spilled water, secret babies . . . the stakes keep going up. Ross gets the last laugh when he draws a mustache on a sleeping Rachel with his marker, and she walks off the plane not knowing a thing.

> ● ● ● ● ● ● ● ● ● ● ●
>
> ## "Love your condoms, my man."
>
> ### CHANDLER
>
> ● ● ● ● ● ● ● ● ● ● ●

Joey bets his $100 tip and loses it instantly, but he finds something even better: his identical hand twin. And Chandler, miserable about his fight with Monica, goes to the casino to make up, but when he finds her having the time of her life, he walks back to his room alone.

COMMENTARY Contrary to appearances, "The One in Vegas" was not recorded there. It was the first time the Central Perk set was broken down; in its place, they built a Las Vegas casino. In order to make the beloved cafe look the same when it was rebuilt for season 6, the set-dressing team used "continuity folders" with detailed photos of each section for reference. Not everything stayed the same, however; the team changed out the coffeehouse selections of teas and coffees every three or four episodes to keep things fresh, and changed the artwork regularly.

Joey's identical hand twin, a dealer played by Thomas Lennon, was later cast (funnily enough) not as a twin, but as Matthew Perry's polar opposite, Felix Unger, in a remake of TV's *The Odd Couple*.

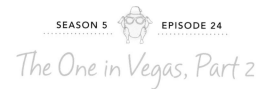
# The One in Vegas, Part 2

WRITTEN BY
Gregory S. Malins & Scott Silveri

DIRECTED BY
Kevin S. Bright

ORIGINAL AIR DATE
May 20, 1999

When they arrive at the casino, Phoebe thinks that Rachel is dressed up as Pancho Villa, and when Rachel pulls out a compact, she sees that Ross drew all over her. After going to the bathroom to clean up, she realizes it's not coming off. After a lot of staring and pointing from Vegas patrons, Rachel storms up to her room with Ross in tow, and she starts drinking mini liquors and eating macadamia nuts.

Phoebe is struggling with a "lurker" at the casino: one of those people who waits for you to give up on a slot machine before swooping in to steal your winnings. As she sees the old woman peeking around corners at her, she gets fed up. "You and me, outside!" But this cute little old lady isn't going down without a fight. "I wouldn't want to see you lose a chunk of that pretty blonde hair!"

Joey keeps thinking the identical hand twin phenomenon is going to make him a lot of money despite the overwhelming lack of enthusiasm from the other Friends.

Chandler tells Monica that he's going home, and she runs after him, apologizing about Richard. She insists that he means nothing to her. They forgive each other, and Monica realizes the bag he was taking home was actually empty. "Yeah, I wanted to make a dramatic scene, but I hate packing," Chandler admits.

They head back to the tables, where Monica is on the biggest winning streak of her life. Chandler keeps upping the ante every time she rolls the dice. First he tells her they'll get the biggest suite in Vegas, and then, if she rolls a hard eight . . . they get married in Vegas. But when she rolls, one is a four, and the other gets tossed off the table and lands halfway between four and five. Chandler looks at Monica and says, "It's a four."

Rachel and Ross get completely trashed. Joey comes up asking for help with his identical hand twin, and Ross falls to the floor trying to sit on an imaginary chair. Joey hits on Rachel with a "How you doin'?" and when she responds, "I'm doin' good, baby, how you doin," Joey promptly tells Ross not to let her drink any more booze. Ross tells Rachel he wants to leave the hotel room, and she agrees, provided she can draw on his face too.

Phoebe gets thrown out of the casino after playing the old lady's quarter and winning, and then Joey gets thrown out soon after for harassing his identical hand twin.

Chandler and Monica decide to get married and rush out to find something old, something new, something borrowed, and something blue. They head to the wedding chapel but must wait for the wedding in progress to end for their turn. And in the season's ultimate cliffhanger, the chapel doors open and Ross and Rachel drunkenly stumble out, saying, "Hello, Mrs. Ross!" And, "Well, hello, Mr. Rachel!"

Chandler's taxi prediction that Vegas wouldn't be Joey's big break ended up coming true . . . unless you count his identical hand twin!

· · · · · · · · · · ·

## "Hello, Vegas? Yeah, we would like some more alcohol, and you know what else? We would like some more beers."

### RACHEL

· · · · · · · · · ·

**COMMENTARY** James Burrows—the genius TV director behind *Friends* (as well as *Cheers*, *Taxi*, and so many more of our favorites)—famously took the six relatively unknown actors to Caesars Palace in Las Vegas before they started taping. In 2019, when Courteney Cox shared a photo of the trip on Instagram, many people thought it was a nod to the Vegas *Friends* episode, but the photo was taken before the series even went on the air. In this episode, Monica was the gambling genius, but it's actually David Schwimmer who has been described as a card shark in real life.

# Season Six

**M**onica and Chandler decide to live together in Monica's apartment, resulting in Rachel moving in with Ross, but when she discovers they're still married, she moves in with Phoebe. Phoebe's apartment catches fire, forcing Phoebe to move in with Chandler and Monica, and Rachel to move in with Joey.

Chandler wants to propose to Monica. In his effort to keep the proposal a surprise, he tells Monica that he opposes marriage. Frustrated, Monica considers going back to Richard, who admits that he still loves her and is now willing to have children with her. But when she learns that Chandler has been planning on proposing all along, Monica decides to stay with him, and even attempts to propose. When she breaks down in tears and cannot get the words out, Chandler asks Monica to marry him, and the show ends with celebration.

This season sees some of the series' favorite guest stars, including Bruce Willis and Elle Macpherson arcs, a Reese Witherspoon two-parter, and Tom Selleck's return.

**OPPOSITE** Ross takes teeth whitening too far in episode 8, "The One with Ross's Teeth," and Monica can't find a color to match his crazy.

# The One After Vegas

WRITTEN BY · DIRECTED BY · ORIGINAL AIR DATE
Adam Chase · Kevin S. Bright · September 23, 1999

Yup, it's hangover day, and Ross and Rachel wake up in bed together. Ross doesn't know why he's naked, and neither of them can recall the events of the night before. Rachel says, "I'm just glad we didn't do anything stupid," just as Ross gets out of bed with "Just Married" scrawled on his back in the same black marker that is still all over their faces.

When Ross and Rachel join their friends at the breakfast buffet, they still have no idea what happened the night before until Chandler finally tells them they got married. They tell him it's impossible until—at the same time—they turn to each other, shocked, the memories flooding back. Ross insists that they don't have to get divorced; they can just get an annulment. Joey does not agree: "Ross, I don't think surgery's the answer here."

· · · · · · · · · · · · ·

## "This is *not* a marriage.
## This is the world's worst *hangover!*"

### RACHEL

· · · · · · · · · · · · ·

Chandler and Monica don't think they're ready to get married, but neither wants to be the one to say it. They decide to leave it to fate: if Monica rolls an eight, they'll get married. But after she rolls the eight, she insists it doesn't count because it wasn't a "hard eight." But the signs don't stop: the elevator doors open, and a minister stands before them, open Bible in hand; Chandler carries Monica over the threshold after a plane altercation involving a stolen snack; Monica accidentally catches a bouquet.

Joey and Phoebe drive her cab back to New York, but Joey is so tired that he picks up a hitchhiker to do his shift while Phoebe is asleep. When she wakes up, Phoebe is furious, but after verbally confirming with the hitchhiker that he is not a rapist or a killer, they play the license plate game together, without Joey. Phoebe exchanges info with the grifter before he leaves, and Joey begs her forgiveness. She finally relents after his rendition of David Bowie's "Space Oddity."

Monica and Chandler decide not to get married because they both agree it's too soon. After she yells at him to unpack, he comes back and says, "You know, I was thinking, what if I unpack here?" Monica doesn't get it at first, but she eventually realizes he's asking her if they should live together, and she says yes.

Ross tries to convince Rachel to forego the annulment and stay married because he doesn't want to be "*that* guy." Despite the promise of registry gifts, Rachel refuses and Ross relents and agrees to the annulment. He pretends to get it done, but after Rachel leaves, he confesses to Phoebe, "We're still married. Don't tell Rachel. See you later."

Joey is mad that he wasn't the best man at Chandler's near-wedding the night before.

**COMMENTARY** Fifty-two takes, fourteen scenes, seven rewrites. According to *The One Behind the Scenes*, that's how it long it took to get the Vegas finale right. *Friends* was considered a democratic set where everyone had input, including the audience. In this episode, they went to the audience to make sure they understood the implication that Phoebe had been married in Vegas at one time and didn't realize it was a valid wedding (they did). They also collaborated with the actors for help. When a joke fell flat, they consulted Matthew Perry, who wrote a joke on the spot, which you can see in the uncut episode: "Well, I don't think they are as much dating as they are two bottles of vodka walking around in human form."

# The One Where Ross Hugs Rachel

**WRITTEN BY**
Shana Goldberg-Meehan

**DIRECTED BY**
Gail Mancuso

**ORIGINAL AIR DATE**
September 30, 1999

Monica and Chandler have to break the news to Rachel and Joey that they're moving in together. Chandler gets to Joey first, and Joey is clearly upset. He tries to tell Monica what a bad roommate Chandler is, but he can't come up with anything. When Monica finally tells Rachel, Rachel is thrilled, but it's because she assumes she'll still be living with them à la *Three's Company*. Monica doesn't have the heart to tell her the truth.

Ross asks Phoebe to keep his fake annulment a secret, and she reluctantly agrees. But not before she polls three random women in Central Perk to see if they would marry Ross despite his divorce history. The first woman says yes, but not while he's still married. The second woman has emotional baggage and isn't dating now, and Phoebe moves on to the third woman. She says the divorces don't bother her, but she thinks he's clearly still in love with "this Rachel girl." Ross gets so frustrated by her response that he decides to go get the marriage annulled.

Monica tells Rachel the truth about the apartment, and brings tissues and cookies for her just in case there are tears. But Rachel seems fine with moving out and expresses no emotion whatsoever. As Monica presses, Rachel admits that she doesn't think Monica and Chandler will actually move in together. When she realizes that Monica is serious, she finally starts crying.

> ### "You got married *again?*"
> #### ROSS'S DIVORCE LAWYER

Ross goes to his divorce lawyer, who suggests that Ross investigate therapy. Ross can get the annulment, but he'll need Rachel to testify before a judge. That means Ross will have to tell Rachel that he lied to her when he said he already took care of it. When he goes to see Rachel, she's crying about Chandler and Monica. Ross comforts her with a hug, and as she is in his arms, he seems to suddenly realize something.

**COMMENTARY** At the end of the episode, Joey asks if Phoebe wants to "hook up." She says they will eventually, and (spoiler) even though that never comes to pass in ten seasons of *Friends* (besides the perfect kiss Joey delivers for her thirtieth birthday), Lisa Kudrow and Matt LeBlanc tried to get the writers on board with it at one point. LeBlanc told *People*, "We actually pitched the idea that Joey and Phoebe had been having casual sex the entire time. We'd go back and shoot all the historical scenes and just before a moment that everyone recognizes, there's Joey and Phoebe coming out of a broom closet together." Ingenious!

**OPPOSITE** The moment in season 6 when Phoebe sees that Ross loves Rachel again.

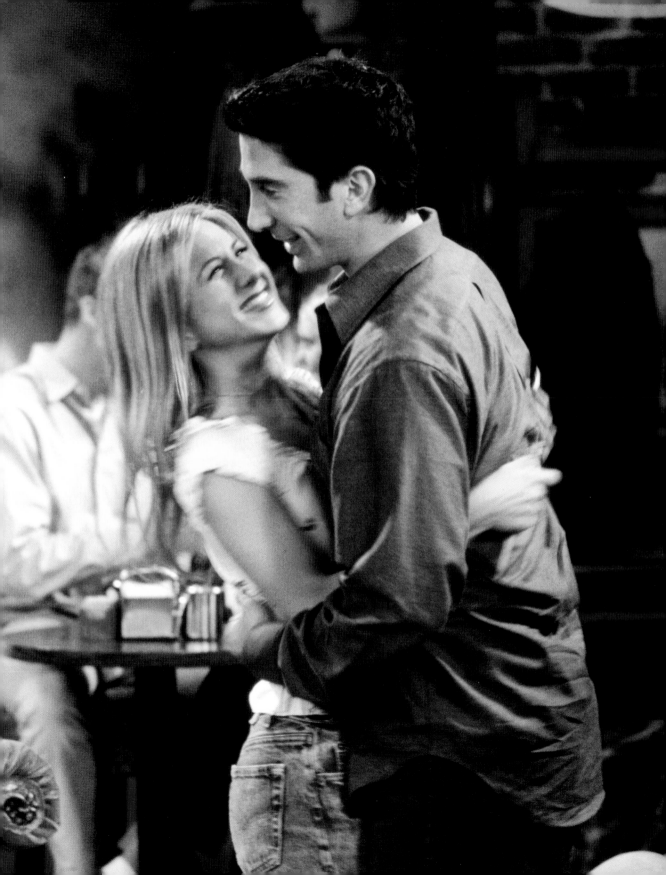

# The One on the Last Night

WRITTEN BY · DIRECTED BY · ORIGINAL AIR DATE
Scott Silveri · David Schwimmer · November 4, 1999

Chandler is moving in with Monica, but he's worried that Joey can't afford to live in their old apartment by himself. He wants to give him $1,500 to cover expenses, but Joey won't accept charity, so Chandler decides to challenge him to a game of foosball to get Joey the money another way.

Rachel presents her gift to Monica: packing up her entire room.

The movers are coming to pick up Rachel's stuff soon, but she hasn't even started packing. So instead of going to dinner with the girls, she pretends she is giving Monica the "gift" of packing. Phoebe warns the guys that Monica is going to enlist their help, so they come up with lies to get out of it, including Ross's whopper that he is picking up Ben.

Monica and Rachel are so sad not to be roommates anymore that Phoebe suggests they list all the things they *won't* miss about each other. Rachel says never being allowed to move the phone pen. Monica complains about not getting her messages. The complaints begin to escalate.

While Chandler casually eats his Chinese food—barely watching the foosball game—Joey accidentally scores in his own goal and loses five hundred bucks. So Chandler invents a new game—one that Joey can't lose—called "Cups" (a "full cup" is a four and a nine, two cards that Joey conveniently has in his hand). Ross, meanwhile, has fashioned a "fake Ben" by putting a hat and shirt on a pumpkin in his apartment.

- - - - - - - - - - - -

## "Damn, I am good at Cups!"

### JOEY

- - - - - - - - - - - -

Rachel and Monica are at each other's throats now. Monica imitates Rachel, "Oh my god, I love Ross. *I hate Ross.*" But Rachel has a stash of grievances too. "I'm Monica. I wash the toilet seventeen times a day, even if people are on it." Rachel decides she's not moving, and they get in a big, explosive fight. Phoebe then decides she doesn't want to live with Rachel after all because she doesn't want to hate her. Monica insists, "Phoebe, you gotta take her." She starts recounting all the good things about Rachel, like how she writes little notes on the mirror when Monica takes a shower. Finally, in tears, she tells Rachel how supportive she has been about her moving in with Chandler, " . . . and now you have to leave, and I have to live with a *booooy!*"

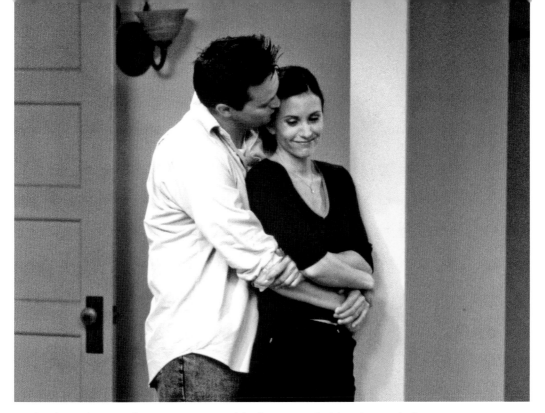

Monica looks in Rachel's empty room nostalgically, acknowledging the end of an era.

Monica looks across the way and sees a headless Ben through Ross's window, courtesy of a fallen pumpkin. She calls Ross, who says, "Yeah, it's a pumpkin. I'll come pack." Joey helps Ross pack up the girls, but then he loses all the money he won from Chandler to Ross in the fake game of Cups.

Joey tells Chandler he will miss *him*, not his money, and gives him the big white dog for his new place. After Rachel returns her key and leaves for Phoebe's, Monica walks into Rachel's empty room, sad that her friend is gone. Sad, that is, until she spots the big white dog in the living room: "What the hell is that dog doing here?"

COMMENTARY "The One on the Last Night" is particularly special because it's the first of ten *Friends* episodes directed by David Schwimmer. He went on to direct movies, including *Run, Fatboy, Run* in 2007 and *Trust* in 2010. It also features one of the writers' made-up games, Cups.

When asked about how they came up with fictional games in the series, Kauffman recalls an instance from season 5, episode 21, "The One with the Ball," where Joey, Ross, Monica, and Chandler try to keep the ball in the air. Kauffman says, "There was a game we used to play in the writers' room called Tippy Catchy, I think we named it. It was this Nerf football with a tail, and we used to bat it across the table to each other. You weren't allowed to stand up. You had to stay in your wheelie chair. We were trying to keep it in the air as long as we could. That's where that one came from." Sadly, Tippy Catchy never made it into an episode.

## As far as we can tell, here are the basics:

1 • Shuffle the cards.
2 • Give each player two cards and put the rest of the deck down.
3 • Players show cards at the same time.
4 • Person with highest rate wins.
5 • Put away used cards.
6 • Repeat steps 2 through 5 until all cards are used. The player with most high rates wins the game (and the money).

## From highest to lowest, here are the combinations ratings:

- 2 of clubs
- 3 and 6
- 4 and 9
- 4
- 9
- 2 (not clubs)
- 3
- 5
- 6
- 7
- 8
- 10
- Jack
- Queen
- King

Cups is a game of luck consisting of a series of two-card tricks. The game is played just by taking two cards, and whoever has highest-rated combination or, if there are no combinations, highest-rated card, wins. Since Joey takes only one card and it is a two of clubs, and Chandler says that he has automatically won, we know that two of clubs is the highest-rated card in the deck.

There are two combinations that beat any cards: the full cup (4 and 9) and the D-cup (3 and 6). The D-cup is the highest of those two. Joey mentioned a half-cup, but you can't divide 13 (9 + 4). That means that a 4 or 9 card are half cups—and are rated higher than other cards . . . except, of course, the 2 of clubs. Basically, the lower the card, the higher the rate.

If one player wins $700, the other player automatically has to double it. After you receive the doubling bonus, you receive one card, and that one card could be worth $100, which will bring $1,400 to an even $1,500—if the card drawn is the 2 of clubs—and the player won't lose any money if it's the wrong card.

# The One with the Apothecary Table

| STORY BY | TELEPLAY BY | DIRECTED BY | ORIGINAL AIR DATE |
|---|---|---|---|
| Zachary Rosenblatt | Brian Boyle | Kevin S. Bright | January 6, 2000 |

Rachel, now living with Phoebe, orders an "apothecary" table from Pottery Barn but doesn't realize that Phoebe hates the store and its "mass-produced" stuff. She decides to pretend the table is an antique, so she won't have to return it.

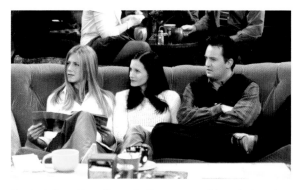

Rachel thumbing through the pages of her beloved Pottery Barn catalogue.

After lusting after Janine, his hot dancer roommate, Joey finally kisses her. They began dating, and Monica and Chandler are thrilled they have a new couple to go out with. Unfortunately, Janine hates Chandler, who is "blah," and Monica, who is "loud." Joey tries to lie to Monica and Chandler about why Janine can't come to dinner the next day, but fails miserably.

Phoebe loves their new apothecary table, and when she asks Rachel what time period it was from, she says, "Uh, it's from yore." Ross, unfortunately, purchases the exact same table, and Rachel makes him cover it up with a sheet when Phoebe comes over.

While Phoebe, Rachel, and Ross watch a movie, Phoebe accidentally spills wine all over Ross's new sheet-covered apothecary table. He freaks out and takes off the sheet, exposing his Pottery Barn purchase. Rachel tells Phoebe that Pottery Barn has copied their apothecary table, and Phoebe believes her. When Ross goes to visit their apartment, he tells Rachel her place looks like "page 72" of the Pottery Barn catalogue. Rachel has told Phoebe that all the pieces she keeps buying are from a "colonial flea market." While Phoebe and Rachel are out walking, they pass a Pottery Barn, storefront and Phoebe sees their entire living room in the front window. Luckily for Rachel, Phoebe falls in love with the Barn and ends up buying a matching lamp.

> "Uh, it's from yore."
>
> RACHEL

**COMMENTARY** In an interview with *Elle*, supermodel Elle Macpherson admitted to not really knowing *Friends* very well when she was offered the role of Joey's girlfriend/roommate, Janine. She agreed to the role, but got nervous once she finally watched the show. "These guys are brilliant. I don't think I can do this. I'm not a comedian." Turns out the experience wasn't a bad one; after all, she has mentioned that Matt LeBlanc is a "good kisser."

# The One with the Joke

| STORY BY | TELEPLAY BY | DIRECTED BY | ORIGINAL AIR DATE |
|---|---|---|---|
| Shana Goldberg-Meehan | Andrew Reich & Ted Cohen | Gary Halvorson | January 13, 2000 |

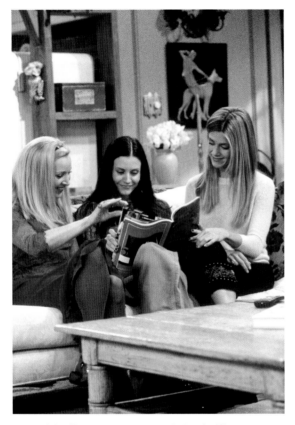

*The girls flip through a copy of Ross's Playboy.*

Ross is thrilled when *Playboy* prints a joke he submitted, but after reading it, Chandler insists that the joke is his. When they each try to convince Joey, he is incredulous. "Jokes? You guys know they have naked chicks in there, right?" The girls swipe the *Playboy* to check it out. Rachel mentions that she would date one of the "outdoorsy" girls featured, and they start discussing who they would date if they had to choose between each other. Rachel and Monica both say they don't know, but Phoebe decides she would date Rachel, and Monica is *not* happy about it.

Chandler can't let go of Ross stealing his joke, and Monica can't let go of the fact that Phoebe picked Rachel in their imaginary gay dating world. She confronts Phoebe, who admits that Monica is "kind of high-maintenance." And then Phoebe adds that Rachel is so easygoing that *she's* a pushover. Rachel and Monica disinvite Phoebe from lunch, and afterward they tell Phoebe that's *she's* flaky. Phoebe wholeheartedly agrees.

Joey's low on funds, so when Gunther offers him a job, he takes it to cover expenses. He tries to hide his job as a waiter at Central Perk, but it's impossible. When Joey gets a call for an audition and asks Gunther to cover his shift, Gunther refuses. After Gunther leaves, Joey kicks everyone out, telling them it's to "keep the kids off drugs," and goes to the audition anyway. Joey doesn't get the part, and he loses his job at Central Perk for closing the cafe in the middle of the day. Rachel—in a very non-pushover move—demands that Gunther give Joey his job back. She readies herself to argue with him, but Gunther, perpetually smitten, immediately acquiesces.

Ross and Chandler cannot settle the joke debate, and they ask Monica to intervene. She hears both sides of their stories, and then says, "You shouldn't be arguing over who

## "I'm Dr. Monkey!"

### ROSS

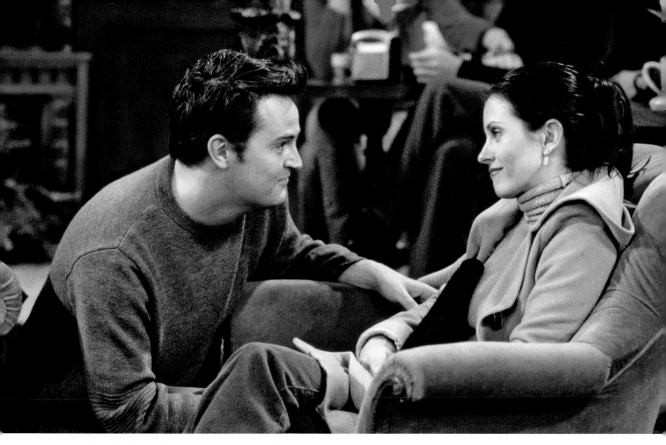

*Chandler finally admits here that Monica is high-maintenance but he loves all of her. Aw, these two.*

gets credit, you should be arguing over who gets *blamed* for inflicting this horrible joke upon the world." Neither of them claim ownership to the monkey joke after that.

Monica ropes Chandler into describing to Rachel and Phoebe how *un*–high-maintenance she is, and succeeds only in looking *more* high-maintenance. Rachel is impressed, "That is the best fake speech I think I've ever heard." Chandler finally tells Monica that she *is* a little high-maintenance, but he likes "maintaining her." Phoebe now finds Monica a little more attractive.

At the end of the episode, Rachel and Monica tell Phoebe they would definitely pick her to go out with, when secretly they would really pick each other. When they ask the guys to choose, Ross and Joey refuse to answer, but Chandler immediately says, "Joey."

**COMMENTARY** By season 6, the Friends evolved and writers played into the actors' strengths, incorporating their quirks. In a 2019 interview, show creator David Crane said, "The actors were capable of anything. It was evident that they could play anything we wrote, so it was all on us. Obviously, Matthew Perry had a certain way of speaking that we took advantage of and even made fun of . . . Over time, you learn things David was brilliant at doing, or Lisa. The trap is once you know those things, not to overplay that. The danger of any long-running show is how do you do it where you don't ultimately become a parody of your original show."

# The One with Rachel's Sister

| STORY BY | TELEPLAY BY | DIRECTED BY | ORIGINAL AIR DATE |
|---|---|---|---|
| Seth Kurland | Sherry Bilsing & Ellen Plummer | Gary Halvorson | February 3, 2000 |

Monica is sent home from work for being sick, but she refuses to accept her weakened state ("I'm fine-d"). Someone knocks on the door, and the Friends are confused because all six of them are already there. It's Rachel's sister Jill (Reese Witherspoon). Turns out Daddy cut her off because she bought a boat for a friend. Rachel offers to let Jill stay with her and Phoebe while she looks for a job and an apartment.

Gunther starts charging Joey for all the free food he's been giving away to pretty girls, telling him they only give away free food for birthdays. Jill comes into Central Perk with loads of bags after a shopping expedition, and she lies to Rachel and pretends that Phoebe and Ross went shopping, not her. They play along, and Phoebe shows Rachel her new "apartment pants," which Rachel thinks is a brilliant idea and pitches to her boss at Ralph Lauren. But the game is up when Ross tries to pass off buying a pashmina, which he thinks is "a rug." Rachel confiscates everything but Jill's Tiffany bag, and Jill starts flirting with Ross. "Were you this cute in high school?" Phoebe finally just inserts herself between them.

- - - - - - - - - - - - - -

## "Boy, did we make friends with the wrong sister."

### CHANDLER

- - - - - - - - - - - - - -

Monica is trying to seduce Chandler, but it turns out that phlegm isn't funny or sexy. She calls "Dr. Bing to the bed," but Chandler isn't having it, especially when Monica starts shivering: "You know what's sexy? Layers." But Monica finally discovers Chandler's kryptonite: VapoRub. She starts rubbing it on her chest, and he can't resist. Ignoring his rule not to sleep with sick people, he claims, "That was before all the . . . vaporizing action."

Phoebe tells Rachel that she saw a "spark" between Ross and Jill, and Rachel can't believe it. "Isn't that like incest or something?" She starts imagining the worst possible scenarios. Rachel checks in with Jill and asks if she is going to go out with Ross. Jill says he's not her type. "You know, he's just a little bookish." Rachel takes offense and starts defending Ross to the point where she actually convinces Jill to ask him out.

Ross and Jill go out, and Rachel is freaking out as she spies on them from Monica's window: "Oh, she *is* a slut." Monica tells her nothing is going to happen because it's a first date, until Ross closes the curtains to his apartment, blocking the view. Will Ross sleep with Jill? We don't find out until the next episode . . .

Sick Monica tries to seduce Chandler. Hmm, if only there were some VapoRub handy . . .

**COMMENTARY** Though the part of Jill wasn't initially written with Reese Witherspoon in mind, producers were beyond thrilled that she expressed interest in the role. Witherspoon was obsessed with *Friends* and couldn't wait to be a part of the popular series in her two-episode arc. She also admitted to having a "girl crush" on Jennifer Aniston on *Conan O'Brien*: "Doesn't everybody have a crush on Jennifer Aniston?" This was Witherspoon's first foray in television though, and she wasn't prepared for a live audience. "I panicked. I totally froze," she admits at an *Elle* event in 2011. Luckily, Aniston was there to talk her through it!

# The One Where Chandler Can't Cry

**WRITTEN BY**
Andrew Reich & Ted Cohen

**DIRECTED BY**
Kevin S. Bright

**ORIGINAL AIR DATE**
February 10, 2000

Joey reveals that the forgiveness time frame for sister-kissing is ten years. Which means Chandler still has five more to go.

Rachel finds Ross at the coffeehouse and asks him about his big date with Jill, and she feels better when she realizes that Ross closed the drapes to show Jill slides of his favorite fossils. "So *really* nothing happened!" Ross tells her that Jill asked him out for Valentine's Day, and Rachel finally just tells Ross she doesn't want him to date her sister anymore because it's too weird. He agrees.

While they are watching the movie *E.T.*, Monica, Phoebe, and Joey all start crying. Chandler says, "I'm not a crying kind of guy." Monica becomes determined to set those tears a-rollin'. She breaks out pictures from Chandler's childhood, including a photo of Chandler with the janitor on parents' day (since his own parents didn't want to go). When Chandler still can't produce tears, Joey looks at him and says, "You're dead inside!"

Phoebe is approached by her "biggest fan" at the coffeehouse and signs an autograph for

him. When Joey serves him, though, he realizes the guy thinks Phoebe Buffay is a porn star whose hits include *Lawrence of Alabia* and *Inspect Her Gadget*. Joey rents some of "Phoebe's" videos and brings them back to the apartment. Everyone but Joey starts to watch *Buffay the Vampire Layer*, and Rachel spots the ankle tattoo and figures out that it's Ursula in the porn, not Phoebe. Joey immediately begins watching and Phoebe walks in and yells when she sees herself naked on TV.

Jill is upset when Ross blows her off and she blames herself, saying, "I'm just this incredibly pretty, stupid girl." Rachel tries to set her up with her coworker Bob in Human Resources, but Jill is uninterested. Rachel finally tells her the truth—that Ross broke up with her because she asked him to do it. Jill is furious: "You had me doubting my fashion sense!" She storms off, claiming that Rachel is jealous of her.

Jill shows up at Ross's place upset about her fight with Rachel. She asks him to show her more of his "super cool slides," and while he's getting them, Jill sees Rachel in the window across the way, smiles, and promptly closes Ross's curtains. Rachel immediately calls Ross to tell him that Jill is just using him to get back at her, but Ross asks, "It couldn't have anything to do with the fact that maybe I'm a good listener and I put on a great slide show?" But as he hangs up the phone with Rachel, Jill kisses him.

Monica is still trying to get Chandler to cry by talking about their wedding one day, their baby, their empty nest after their child goes to college, and then eventually her death, but nothing is working: "You can't shed a tear for your *dead wife*?"

Phoebe, meanwhile, goes to her sister Ursula's place to confront her about the pornos. She tells Phoebe, "You know, twin stuff is always a real big seller." Phoebe refuses and orders Ursula to stop using her name. Phoebe exacts the best revenge though by picking up all the checks for "Phoebe Buffay" at the porn company and then giving them her own home address for any future payments.

When Ross tells Rachel about the kiss between him and Jill, she is instantly angry. That is, until he tells her that he stopped the kiss because he knew nothing could ever happen with Rachel if he kept kissing Jill: "I don't want to know that it never could." The touching moment isn't lost on Chandler, who now finally starts crying, saying, "I just don't see why those two can't work things out!"

> "Phoebe's a porn star!"
>
> JOEY

COMMENTARY Ursula was the first twin born (according to Phoebe), so she is technically a minute older, and that mimics the creation of their characters too. Ursula was a character originally created for the show *Mad About You*. When they cast Lisa Kudrow as a character in *Friends*, the writers needed to develop a story to explain why she was on two different Thursday night sitcoms.

That's how Phoebe Buffay, the "good twin," came to be created. In an interview with the Television Academy Foundation, Lisa Kudrow explained that she was surprised when she read how mean Ursula was in the *Friends* scripts. "I saw Ursula as this nice person . . . really nice, just didn't pay attention to anything."

# The One with Unagi

| STORY BY | TELEPLAY BY | DIRECTED BY | ORIGINAL AIR DATE |
|---|---|---|---|
| Zachary Rosenblatt | Adam Chase | Gary Halvorson | February 24, 2000 |

Rachel and Phoebe take a self-defense class, but Ross doesn't believe they can defend themselves since they don't have *unagi*, the Japanese art of total awareness. Phoebe tells Ross that unagi is freshwater eel, and Rachel starts craving a salmon skin roll. Chandler comes in needing help with a "homemade" gift for Monica. Joey suggests crotchless panties while Phoebe offers up her homemade sock bunnies.

Later, Ross hides in the hallway near Monica's apartment, and jumps out and yells, "Danger!" when Phoebe and Rachel come home, teaching them the importance of unagi. After scaring them half to death, he says, "At what point during those girlish screams would you have begun to 'kick my ass'?" But Rachel and Phoebe aren't convinced of Ross's "total awareness" either. They hide behind curtains in his apartment, and when they jump out to scare him, he shrieks. Imitating Ross's smug remarks, Rachel places two fingers by her temples and says, "Ah, salmon skin roll."

At the last second, Chandler finds an old mixtape and gives it to Monica for his Valentine's gift. In return, Monica gives him one of Phoebe's sock bunnies and pretends it's because she called him "bunny" once. She finally admits it's from Phoebe, and she feels so badly that she promises to "*cook* anything you want in here" (pointing to the kitchen) and "*do* anything you want in there" (pointing to the bedroom).

Things go south for Chandler when Monica plays the mixtape before her romantic dinner of mac and cheese with cut-up hot dogs for him. As "The Way You Look Tonight" plays softly in the background, Janice's voice comes loud and clear over the speaker: "I love the way *you* look every night, Chandler!" Monica realizes she's been conned and Chandler realizes he can't stop getting screwed by Janice.

> **"Ah, salmon skin roll."**
>
> RACHEL

Joey needs some extra money and tries to participate in a study at the medical center, but the only available study is for identical twins, and it pays $2,000. When he meets a dim-witted guy named Carl at his audition who looks vaguely Italian, he decides to pass him off as his twin to collect the cash. But even after he trains Carl, when they show up at the study, the doctor can tell instantaneously that they're not identical. Joey blames Carl entirely: "Damn it, Carl!"

After Phoebe and Rachel catch Ross trying to scare them again, they pin him to the floor, and Ross can't escape. He goes to their self-defense instructor and unsuccessfully asks for advice on how an attacker can get free from a woman trying to *stop* an attack. Then he spots Phoebe and Rachel outside Central Perk and tries to fake-attack them there. Except Phoebe and Rachel are already inside, and Ross has attacked two look-alike strangers instead. He spots the real Phoebe and Rachel as he runs screaming past the window of Central Perk.

"Ooh, you know what? If we made reservations, we could have unagi in about a half hour."

**COMMENTARY** *Parade* cited this as the best episode in season 6, and it's hard to disagree. Ross's ridiculous over-pronunciation of the word "unagi," combined with his insistent gesticulation on each utterance, is enough to make you laugh through the whole episode. Louis Mandylor, who plays Joey's "twin," Carl, is not Italian, but Greek, *and* he was born in Australia. You might recognize him as Toula's brother in the *My Big Fat Greek Wedding* film franchise. And we know you hate to be wrong, Dr. Geller, but unagi is not a state of total awareness. Phoebe called it—it's freshwater eel, a delicacy served in Japanese dishes. You might need to go back to those karat-*ay* lessons.

User advisory: A sock bunny might have been physically and emotionally scarred during the making of this episode.

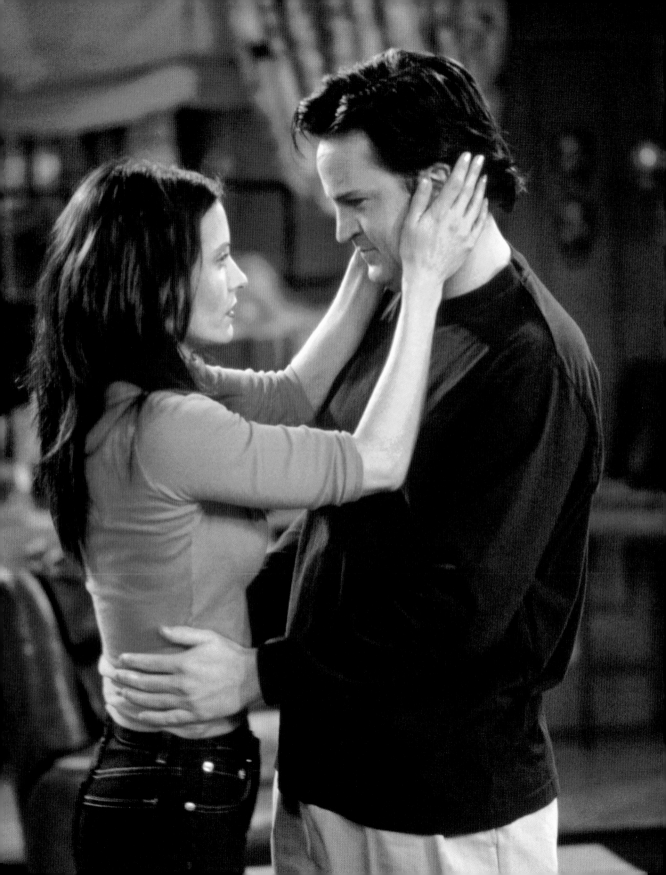

# The One with the Proposal, Part 1

WRITTEN BY  •  DIRECTED BY  •  ORIGINAL AIR DATE

Shana Goldberg-Meehan & Scott Silveri  •  Kevin S. Bright  •  May 18, 2000

Chandler wants to propose to Monica, and has planned a romantic dinner so he can pop the big question. When they get to the restaurant, Richard walks in with a date. Monica calls him over, and the waiter ends up seating Richard and Lisa at the table next to theirs, ruining proposal night.

Rachel brings Phoebe and Joey to a silent auction, a charity event being hosted by her job, and realizes quickly that she brought the wrong Friends. Phoebe gets completely loaded at the open bar, while Joey "guesses" the correct cost ($20,000) of a boat, not realizing he has to buy it.

Ross is still dating Elizabeth (Alexandra Holden), a beautiful former student with a scary father (Bruce Willis), but he starts feeling the pinch of their twelve-year age difference when he gets caught in the middle of a Kamikaze-fueled water balloon fight. He decides to break up with her, but after it's over, he second-guesses the decision. Elizabeth calls his name from her open dorm window as he's leaving, and he's about to tell her he made a mistake when she launches water balloons at him, telling him he sucks. Ross gives her a thumbs-up and confirms, "Breakup's still on."

Phoebe asks to see Monica's hand when she gets home, and Chandler becomes convinced that Monica knows he is going to propose. He decides to throw her off track by pretending he never wants to get married, claiming marriage is just a government conspiracy to keep "tabs on you." Joey (waiting for the delivery of his boat) echoes his sentiment, "Huh, Big Brother." But Chandler's timing couldn't be worse because Richard shows up at Monica's restaurant the next day and tells her he's still in love with her, and part one ends on that note.

> "I'm Chandler. I make jokes when I'm uncomfortable."
>
> CHANDLER

**COMMENTARY** Alexandra Holden plays the role of Elizabeth, the Kamikaze-loving college student with the scariest father. Her best memory of David Schwimmer is when he told her that Bruce Willis would play her father. "He was like a little kid who just found out some amazing thing . . . it was absolutely endearing." Willis reportedly lost a bet to Matthew Perry while filming *The Whole Nine Yards*, and as a result, became Elizabeth's father on *Friends*. Holden told *The Guardian* that it's "surreal" being a part of such a cultural phenomenon, and adds, "I don't know if there will ever be another show as successful as *Friends*."

*Alternate Plot Alert!* Elizabeth's character was originally going to get pregnant at the end of season 6 as part of the cliffhanger finale. It ultimately wasn't going to be Ross's baby, but the creators ended up having them break up instead since (spoiler) Rachel was going to get pregnant next year on the show.

**OPPOSITE** *Joke's on Monica . . . she thinks Chandler is terrified of getting married, but he's a man with a plan.*

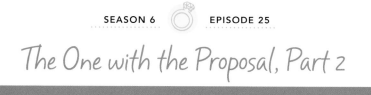

# The One with the Proposal, Part 2

WRITTEN BY
Andrew Reich & Ted Cohen

DIRECTED BY
Kevin S. Bright

ORIGINAL AIR DATE
May 18, 2000

Standing in the kitchen of Monica's restaurant, Richard tells her he wants it all with her: marriage, kids. He asks her if it's too late, and she says it is, but hesitates because Chandler just told her he doesn't believe in marriage. She has lunch with Chandler and asks him frankly about it, and—still determined to keep his plan a surprise—he tells her he will never get married, citing the mating habits of pigs as an example. Monica walks out on him and runs into Joey, who confirms what Chandler said.

Rachel and Phoebe admit that they are a *little* jealous of Chandler proposing to Monica and realize they need a "backup" in case they don't find love. Phoebe claims to have already "locked in" Joey, so Rachel heads to Ross's place to secure her own backup. But when Rachel asks Ross the big question, he tells her that Phoebe is already his backup. Phoebe later admits, "It's just good sense to back up your backup!" But Ross and Joey aren't happy and demand that Phoebe choose. They end up picking out of a hat: Rachel gets Joey and Phoebe gets Ross. After an uncomfortable silence, Rachel says, "We should just switch."

• • • • • • • • • • • • •

## "Chandler is a complex fellow; one who is unlikely to take a wife."

### JOEY

• • • • • • • • • • • • •

Monica goes to Richard's apartment, claiming she doesn't why know she's there. Richard senses Chandler trouble and offers her a scotch on the rocks with a twist. She tells Richard that getting over him was the "hardest thing I've ever had to do." They almost kiss, but Monica tells him she needs to figure things out first. After she leaves, Chandler shows up. Joey had told him about Richard's proposal, and he's looking for Monica. He blames Richard for everything, calling him a "big tree" and yelling at him for making his girlfriend "think." When Chandler tells Richard he was going to propose, Richard looks resigned. He tells Chandler to go get her and not to let her go.

When Chandler arrives home, Joey is waiting and tells him that Monica left to go to her parents' house because she needed to think things over. Chandler is devastated, but as he walks into his apartment, it's completely alight with candles, and Monica is waiting for him. She gets down on one knee to propose, but in the end, it's Chandler who does the asking. After she accepts, all the Friends—except for Ross—come in to celebrate.

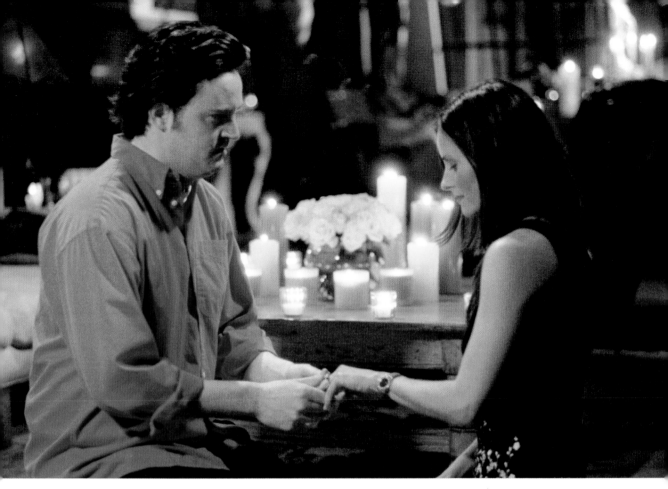

Monica turns the tables on Chandler, surprising him with a proposal (or trying to).

**COMMENTARY** One of the best parts of the finale is that you miraculously don't hate Richard or Chandler at any point during the hour-long show, even though Richard is trying to steal Monica, and Chandler is acting like a jerk. This was done intentionally, and it was no easy feat for the writers. Co-creator David Crane said that Tom Selleck had input on the script too. When Richard advises Chandler not to let Monica go ("trust me"), it's a genuinely touching moment, and the audience is just as sad to see Richard go as they are happy for Chandler to be with Monica.

The reason Ross isn't in the final proposal celebration is that David Schwimmer was in London at the time, shooting HBO's *Band of Brothers*. Luckily Ross "the Divorcer" jokes never get old, and as Rachel puts it, "Oh hell, he's done this three times . . . he knows what it's about!"

And speaking of Rachel's hair (okay, we weren't), she was filming *Rock Star* with Mark Wahlberg at the time of this episode, which accounts for her long hair, courtesy of extensions.

*Alternate Plot Alert!* The writers originally considered having both Chandler and Richard down on one knee proposing to Monica at the end of the episode for a more comedic ending, with a cliffhanger where she would need to choose. Don't worry, though, the idea didn't go to waste . . . they used it in season 10 with Phoebe's fellas.

# Season Seven

Season 7 begins with the newly engaged Monica and Chandler on cloud nine. As the happy couple attempts to plan their wedding, Monica discovers that her parents have spent her wedding fund. Additional missteps along the way cause Monica to worry that Chandler will leave her.

The guest star one-offs and return visits this season keep fans on their toes, wondering who could possibly show up next with stars such as Kristen Davis, Kathleen Turner, Jason Alexander, Susan Sarandon, Denise Richards, Winona Ryder, and Gabrielle Union appearing. Eddie Cahill as Tag is the only real guest character plot arc of the season—serving as a mediocre relationship for Rachel, one she'll eventually end.

Some highlights: Monica has trouble finding the perfect wedding dress, Joey discovers something of Rachel's he shouldn't, Phoebe finds out something unexpected about her grandmother's secret cookie recipe, Rachel is promoted and hires a handsome young assistant, Chandler confesses he hates dogs, Ross tries to introduce Ben to Hanukkah in a very strange way, and Rachel and Chandler both seem to break Joey's favorite chair.

As the season draws to a close, Chandler gets nervous about marrying Monica, but ultimately the season concludes with one of the show's best cliffhangers—a huge bombshell, dropped at the altar.

OPPOSITE Joey is definitely mad at Ross for still carrying around his "holiday weight," from season 7, episode 12, "The One Where They're Up All Night."

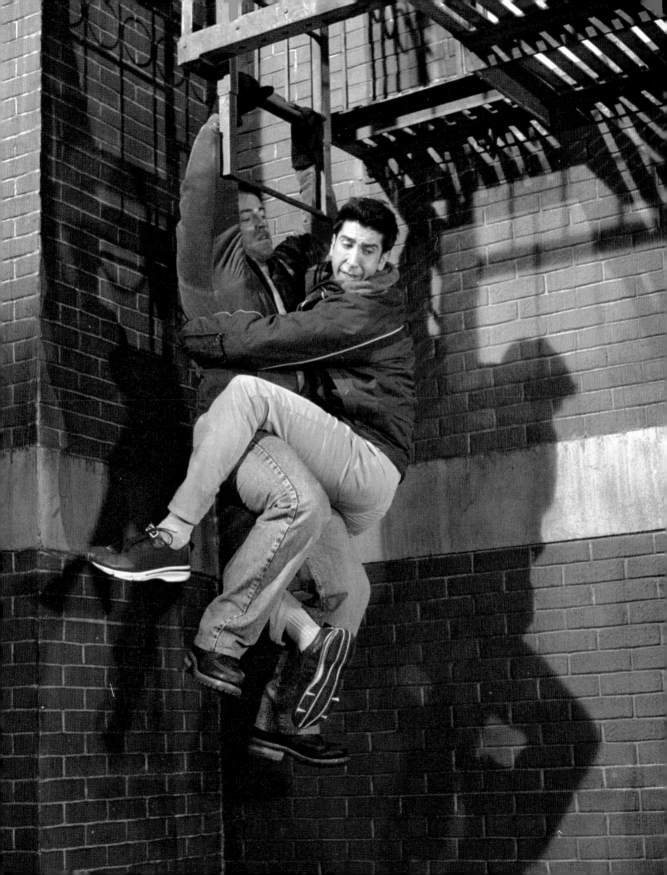

# The One with Monica's Thunder

| STORY BY | TELEPLAY BY | DIRECTED BY | ORIGINAL AIR DATE |
|---|---|---|---|
| Wil Calhoun | David Crane & Marta Kauffman | Kevin S. Bright | October 12, 2000 |

The season opens with Ross entering apartment 20 to find the group raising a champagne toast to Monica and Chandler's engagement. We see Monica through the window, but Ross wonders where she is. Then we cut to Monica on the balcony shouting her news to the street below.

Later Monica suggests they dress up and go celebrate at The Plaza. Joey won't be able to stay late because he has an audition the next day to play the part of a nineteen-year-old.

While getting changed in the bedroom, Chandler's plan for a pre-Plaza quickie is derailed by a surprising turn of events, or lack thereof. Monica consoles him on his "failure to launch," blaming fatigue and champagne. While Phoebe plays guitar for Monica, hoping to be the wedding entertainment, Rachel meets Ross in the hall, where they wish each other "Happy Monica's Night." Rachel wonders about their (separate) futures and reminisces about their relationship, telling Ross he was good at "the stuff" and in particular that she "really liked [his] hands."

Monica opens her door to find Rachel and Ross kissing and accuses them of "stealing her thunder." Although events have conspired to distract from Monica's Night, Chandler springs into action during a honeymoon-in-Paris inspired fantasy, but soon the couple is thwarted again.

> "Apparently, I've opened the door to the past."
>
> MONICA

When Monica accuses Rachel of a previous "thunder-stealing" episode at her Sweet Sixteen, Rachel is forced to admit her feelings about "Monica's Night." She's sad that she is nowhere near a wedding herself. Fear she might never get married sent her running to Ross's arms. In the end, Rachel and Monica make up, and Monica is particularly apologetic: "I'm so sorry I almost made you sleep with Ross."

**COMMENTARY** We see the cast at quite a few hotels over the years, from London to Barbados to whatever hotel Chandler and Monica get married in, but the gang never makes it to The Plaza to celebrate Monica's Night. If they'd been able to raise a glass at the legendary hotel on Fifth Avenue, they could've had a view of Central *Park*, instead of Central Perk.

Rachel's final revelation in this season opener recalls the season 4 finale when Monica, worried she would never get married, found herself in Chandler's bed. On the brink of a new decade, it's clear this is not the same group of young adults it once was. They have a past, and they can't escape it, but they can't return there, either.

Ross refers to himself as Dr. Monkey in season 6, episode 12, and it's definitely not the first time a Friend has tried out a new name (or been christened with one by someone else). Can you match the correct Friend associated with a name below?

1.  Joseph Stalin
2.  Princess Consuela Bananahammock
3.  Clifford Alvarez
4.  Gene
5.  The Divorcer
6.  Big Daddy
7.  Emma
8.  Big Fat Goalie
9.  Ron
10. Monana
11. Bea
12. Ray Ray
13. John Markson
14. Professor McNails His Students
15. Ross-a-Tron
16. Wet Head
17. Vunda

18. Clint
19. Red Ross
20. Miss Chanandler Bong
21. Regina Phalange
22. Harmonica
23. Toby
24. Candy Lady
25. Mario
26. Skid Mark
27. Flameboy
28. Ken Adams
29. Ikea
30. Mr. Big
31. Roland Chang
32. Mark Johnson
33. Valerie

1. Joey 2. Phoebe 3. Ross 4. Chandler 5. Ross 6. Joey 7. Phoebe 8. Monica 9. Ross 10. Monica 11. Ross 12. Rachel 13. Chandler 14. Ross 15. Ross 16. Ross 17. Phoebe 18. Chandler 19. Ross 20. Chandler 21. Phoebe 22. Phoebe 23. Monica 24. Chandler 25. Monica 26. Joey 27. Joey 28. Joey 29. Phoebe 30. Phoebe 31. Chandler 32. Chandler 33. Phoebe

# The One with Rachel's Book

**WRITTEN BY** • **DIRECTED BY** • **ORIGINAL AIR DATE**
Andrew Reich & Ted Cohen • Michael Lembeck • October 12, 2000

The bedroom farce continues as the wedding planning begins. Monica gets out her fabled "wedding book" that she has been filling since childhood so she and Rachel can start planning for the big day. Ross has some advice for Chandler, who is clearly not allowed to have a say in any of the planning: "Take it from me, as the groom, all you have to do is show up and try to say the right name."

The duck got sick on the couch after eating Rachel's face cream and, desperate for a nap, Joey settles into Rachel's bed, where he finds a book of erotic fiction. He teases Rachel about it throughout the rest of the show ("Where are you going? The vicar won't be home for hours."), but she defends her "healthy expression of female sexuality."

Ross becomes annoyed when Phoebe sets up a massage table in his living room. [Quick apartment-hop recap: A fire forced Phoebe and Rachel out of their apartment into Joey's (Phoebe) and Monica's (Rachel). The discovery that Rachel—not Phoebe—was responsible for the fire led to an apartment swap, landing Phoebe at Monica's, but the engagement news prompted Phoebe to move out to give the couple some privacy.] Ross tries to turn the situation to his advantage when a beautiful female massage client arrives at his door. Ross pretends to be a masseur, but the client ends up being the woman's elderly father. The hands Ross hoped would once again satisfy Rachel in the last episode are put to a very different purpose. (He ultimately uses salad spoons, chopsticks, a mop, and, according to Phoebe, Tonka Trucks to avoid actually touching the old man.)

"Get those clothes off . . . but I would keep that helmet on, because you're in for a ROUGH RIDE!"

"What the hell did the damn duck do now?"

RACHEL

Is Monica kissing Chandler because they can afford Wedding Scenario A or because she wants to save for the future?

Monica is devastated to find out the "Monica Wedding Fund" has become her parents' beach house, but is relieved to learn Chandler has enough money saved for "Wedding Scenario A." That would mean he wouldn't have any money left for the future, though. After some back-and-forth, Chandler agrees to spend it all on the wedding, but his description of their future life raising children outside the city persuades Monica to change her mind. That's the life she wants, not "a big, fancy wedding."

**COMMENTARY** Trespassing abounds! Phoebe interrupts a class Ross is teaching then invades his apartment with her massage table. Ross usurps Phoebe's role as masseur. Joey invades Rachel's room and her private life. Although they're far from considering each other relationship material, the chemistry between Joey and Rachel gets a bit of airtime, dramatized through the story of Zelda and the chimney sweep. Fans still argue about the legitimacy of their romance, but Jennifer Aniston has a clear opinion. In 2017 she told *Elle*, "I just don't think Joey and Rachel could have made it," she says. "I think it was more physical than emotional with them."

# The One with the Engagement Picture

STORY BY
Earl Davis
•
TELEPLAY BY
Patty Lin
•
DIRECTED BY
Gary Halvorson
•
ORIGINAL AIR DATE
November 2, 2000

Monica's mother wants to announce Monica and Chandler's engagement in the local paper, but Chandler's camera smile isn't ready for prime time, or really, any time. Meanwhile, Phoebe can't help but smile when she finds out cute "Coffeehouse Guy" Kyle (David Sutcliffe), also known as "Hums While He Pees," is getting divorced, leaving her an opening. When Ross helps out by distracting Kyle's ex-wife, Whitney (Julia Campbell), he ends up falling for the soon-to-be divorcée. As they start dating the exes, Phoebe and Ross begin fighting with each other, reenacting the rage of their new love interests.

Rachel has a love interest of her own, her assistant, Tag (Eddie Cahill). Although she practically moans, "Oh, I could just spread him on a cracker," she knows he's off-limits. That doesn't stop her from creepily smelling his sweatshirt, paying for Joey to spend an evening with Tag to keep him from a lusting female coworker, or bribing Joey to drop Tag as a partner-in-crime when her plan backfires.

Ross and Phoebe are simultaneously dumped when Kyle and Whitney announce they're getting back together, while Rachel awkwardly agrees to go out with Tag who, rather than asking her out, was announcing a plan to reunite with his ex-girlfriend.

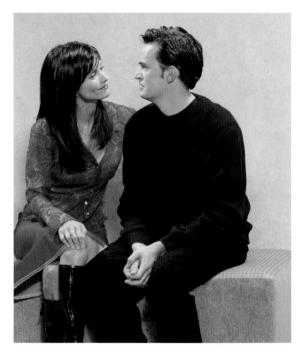

*Just shut up and smile, Chandler!*

• • • • • • • • • • • •

"You know he hums while he does other stuff too."

PHOEBE

• • • • • • • • • • • •

The Friends are cut loose as other people's broken relationships get repaired but at least a beautiful engagement photo finally gets published—of the wrong couple (Monica and Joey)!

Hmm, Chandler's bedroom eyes or his serial killer stare for the photo? Decisions, decisions . . .

**COMMENTARY** If nothing else, *Friends* believes in second chances, and the reunion of bitter exes Kyle and Whitney is no exception. Given all the entertainment value inherent in breakups, breaks (or not), and getting back together, one might have predicted that the relative stability of Monica and Chandler's relationship would have undermined the show's momentum. Instead, it seems the opposite happened. Executive producer Scott Silveri believes Monica and Chandler's secure relationship was largely responsible for the show's long run. Photographic proof of their happy engagement proves elusive, but it turns out they're just fine without it.

And while it was Joey who took Tag out and showed him New York in this episode, in real life it was David Schwimmer who called actor Eddie Cahill when he first came to L.A. and took him out because he was new in town. Cahill recalled, "That was highly unexpected and very cool."

# The One with Ross's Library Book

WRITTEN BY • DIRECTED BY • ORIGINAL AIR DATE
Scott Silveri • David Schwimmer • November 16, 2000

Rachel is startled to find a strange woman (Kristin Davis) wrapped in a towel in the bathroom. Erin has clearly spent the night, but Joey asks Rachel to let Erin know he's not interested in a relationship. Rachel and Phoebe become fast friends with Erin instead.

Meanwhile, Ross is proud to show off his dissertation on the fifth floor of the college library but is horrified to learn of a campus tradition of couples hooking up in the dusty, rarely used section. That is, until Ross joins the fun after meeting his biggest fan, a gorgeous woman. Turns out fossils aren't the only thing that makes his heart race. Rachel and Phoebe plead with Joey to give Erin a chance, tricking him into a second date, but roles are reversed when Joey ends up falling for Erin, who reports to Rachel and Phoebe that she doesn't "see this having a future."

It's the past that haunts Monica when a cranky customer turns out to be Chandler's ex, Janice, who traps Monica into issuing her a wedding invitation. Chandler is horrified, but various attempts to renege on the invite only make things worse until Janice shows up at Chandler and Monica's apartment asking to spend the night. While Rachel has to let Joey down easy, Monica figures out a way to do the same with Janice, although we haven't seen the last of her yet.

> "People are doing it in front of my book!"
>
> ROSS

**COMMENTARY** Among the many surprise appearances in this episode, perhaps the most surprising is Joey's rare moment of vulnerability, falling for a woman who doesn't feel the same way. Viewers would most likely have recognized Erin (played by Kristin Davis) from her role as Charlotte on HBO's *Sex and the City*, which began airing in 1998.

Joey is also behind one of the funniest scenes in this episode, without saying a word. When Janice shows up at Monica's apartment, she's standing in the doorway when Joey walks behind her to go into his place. He catches sight of Janice from behind, jumps in terror, then runs back downstairs in the opposite direction.

Janice's character was so popular, actress Maggie Wheeler told *Digital Spy*, that producers had to keep her appearances a secret. "Whenever Janice appeared on the show, I was always kept a secret up until the last moment, so they would put screens up and hide me. The audience had no idea until I actually walked through the door."

**OPPOSITE** Ross teaches Phoebe how to overcome her fear and ride a bike in season 7, episode 9, "The One with All the Candy."

# The One with the Holiday Armadillo

| WRITTEN BY | DIRECTED BY | ORIGINAL AIR DATE |
|---|---|---|
| Gregory S. Malins | Gary Halvorson | December 14, 2000 |

Santa and the Holiday Armadillo battle it out to win the holidays for Ross's son, Ben.

As the seventh season hurtles along toward Monica and Chandler's impending wedding day, Chandler's bungling attempts at bribery, starting with an effort to "be smooth" and slip money to an unamused maître d' to avoid a long wait for a table, provide a silly visual through-line for the episode. But the focus is on Phoebe and Ross, who are navigating new paths through the accumulated loss of their pasts.

When Phoebe worries Rachel might rather stay in Joey's apartment than move back in with her, she sends a drum set and later a tarantula to apartment 19, hoping to send Rachel running. No such luck. Rachel has a natural beat and fond memories of a childhood pet tarantula. It doesn't matter, though, because she always intended to honor the deal and is excited to go with Phoebe

to check out the renovated apartment. The only problem is that it's been made back into a one-bedroom; in the end, they agree Phoebe will live there alone and Rachel will stay with Joey.

Having little luck getting his Jingle Bells–singing son Ben excited about Hanukkah, Ross finally caves to the idea of getting a Santa Claus outfit so Ben can have a visit. Turns out Santa outfits are hard to come by on December 23, which is why a desperate Ross becomes a Holiday Armadillo, a "friend of Santa's." Ross continues to hope for a Hanukkah miracle, even though he's interrupted while telling the story of the Maccabees by a well-meaning Santa-Chandler, followed by a tarantula-terrified Superman-Joey. The final shot embraces cultural hybridity along with absurdity—the group lights the menorah by the Christmas tree in a scene Rachel describes as the "Easter Bunny's funeral."

Superman stopped by and described that time he "flew all of the Jews out of Egypt."

**COMMENTARY** Fans have often wondered who on *Friends* is supposed to be Jewish. Clearly Ross and Monica have some Jewish heritage. Ross tells his son he is "part Jewish" but doesn't elaborate on his genealogy. Show co-creator Marta Kauffman explains that Monica and Ross are half-Jewish (via their father, Jack) but only Rachel is fully Jewish. In real life, David Schwimmer and Lisa Kudrow are both Jewish, as are co-creators Marta Kauffman and David Crane. When Crane spoke with *The Jewish News of Northern California*, he clarified that they did not set out to tell Jewish stories in particular, but "Ross emerged out of a room where a lot of the people had a Jewish background. So his Jewish plotline was probably informed by that." Besides the Holiday Armadillo telling the story of the Maccabees, in the lead-up to Monica and Chandler's wedding we find out Ross rapped at Monica's bat mitzvah. And who can forget his Hanukkah Menoreos (with coconut!) from "The One Where Rachel Quits"?

Although he loved doing "The One with the Blackout," David Schwimmer has a special place in his heart for "The One with the Holiday Armadillo" too, telling *Glamour*, "I hope to one day show my daughter that episode."

# The One with All the Cheesecakes

WRITTEN BY
Shana Goldberg-Meehan

DIRECTED BY
Gary Halvorson

ORIGINAL AIR DATE
January 4, 2001

Joey doesn't hesitate to break plans with Phoebe for a date, while a mis-delivered cheesecake leads to a habit Chandler and Rachel can't break. Phoebe confronts Joey (aka "Big Daddy" a "nickname we were trying out"), emphatically disagreeing with his code of conduct, which states: "You can cancel plans with friends if there's a possibility for sex." That is, until she's in the same position the following night. At Central Perk, Phoebe spots "David the scientist guy, David that I was in love with, David who went to Russia and broke my heart David!" who has only a few hours left in New York before heading back to Minsk. She tries to double-book, rushing through dinner with Joey to get to David, but Joey is on to her, and she ends up abandoning him in the restaurant.

Meanwhile, Monica is upset when she's left out of her cousin's wedding, and crashes as Ross's date—meaning he has to cancel on linguistics professor Joan Tudeski, who may or may not be "broad-backed." Monica wondered what she "could have possibly done" to offend the bride, but, upon recognizing the groom, Stuart, as a former boyfriend, Ross clarifies the situation: "So it's really a question of *who* you could have possibly done."

In the final scenes, Joey is there for a tearful Phoebe, who has to say goodbye to David once again. He is rewarded with a hallway cheesecake feast, for which he whips out a fork from his pocket, undisturbed by the fact that Rachel and Chandler are eating it right off the floor.

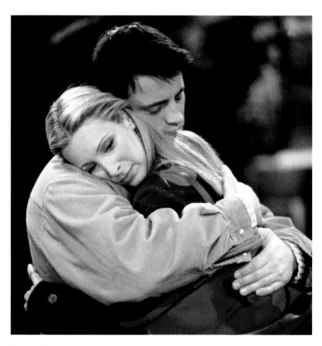

Sometimes you just need a friend when your soul mate flies back to Minsk.

"Oh, I have dinner plans with Joey. We get together about once a month to discuss the rest of you guys."

PHOEBE

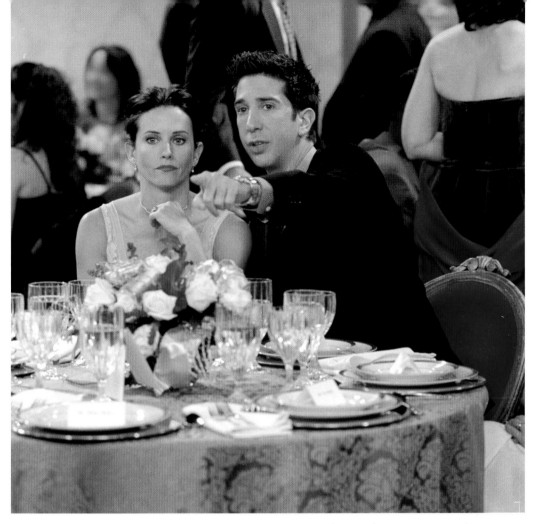

Monica's out for blood when Ross gets invited to their cousin's wedding and she doesn't.

**COMMENTARY** Episode 11 is a light morality play asking: "When is it wrong to cancel plans with friends? When it is okay not to invite your cousin to your wedding? And if a cheesecake belongs to your downstairs neighbor Mrs. Braverman but has 'a buttery, crumbly, graham cracker crust, with a very rich, yet light, cream cheese filling,' is it wrong to eat it?" On National Cheesecake Day in 2016, *E!* online celebrated this episode as ". . . the best Cheesecake moment in Pop Culture History."

David the scientist, played by the ridiculously talented Hank Azaria of *Simpsons* fame, told the Television Academy Foundation that he knew *Friends* was going to be a hit even before it aired particularly because of the sharp dialogue between the characters: "They talk how we talk."

Fans might not know that the character David wasn't the original role Azaria was hoping to land. "I went and auditioned for Joey . . . didn't get it obviously, then went back." He insisted on reading for Joey's part one more time, and while he still didn't get it, he did make us all happy by putting Minsk on the map (yes, it's a real city in Belarus) and making geeky look gorgeous.

# The One Where They All Turn Thirty

| STORY BY | TELEPLAY BY | DIRECTED BY | ORIGINAL AIR DATE |
|---|---|---|---|
| Vanessa McCarthy | Ellen Plummer & Sherry Bilsing | Ben Weiss | February 8, 2001 |

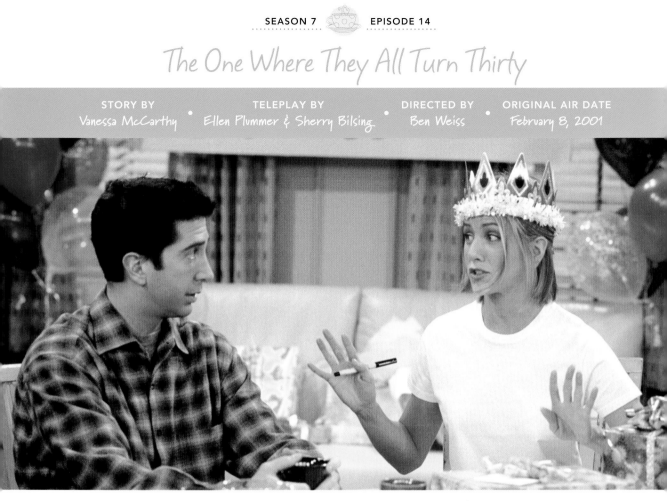

Rachel faces an existential crisis when she turns thirty and realizes she's not even close to having a family yet.

The gang tries to cheer Rachel up, telling her about their own thirtieth birthdays. We are told in a series of flashbacks about each one's experience, cut with present-day scenes of Rachel's existential crisis. First, we see Joey in Monica and Chandler's place. He's devastated, screaming, "Why God? Why?" as he seemed to believe he had a "deal" with God that was not honored. In Chandler's flashback, Joey again takes center stage, lamenting Chandler's passing youth, in addition to his own.

In another flashback, we see Phoebe hop her way across the finish line to thirty, accomplishing everything she wanted to by that time—all except repair her relationship with her sister.

Rachel's not up for doing anything on her birthday. Monica thinks ". . . doing nothing on your thirtieth is better than doing something stupid, like Ross," and with that, we cut to Ross in a sports car, which he claims was a "practical purchase." He doesn't seem to know anything about the car, but thinks it makes him look "hot." He tries to give Phoebe a ride, but can't get out of a tight spot. Back in the present, Monica compliments Rachel on how she's dealing, assuring her "no one handles this well."

"Least of all you," quips Phoebe, and we soon see why. Monica's thirtieth birthday celebration was a surprise party, but the biggest surprise was the guest of honor showing up completely wasted. "That's right, Mom and Dad, your little Harmonica is hammered!" Phoebe tried to help by getting "twice as drunk" as Monica to distract everyone, but in the end, Monica stops hiding from her parents, and, before collapsing, fully owns her drunken state.

Flipping back to Phoebe's story, we see her visiting her twin sister. Ursula's none too friendly, but she does give Phoebe some essential, if upsetting, information: they're not thirty, they're thirty-one. She knows from her birth certificate.

Drunk Monica makes an appearance for her surprise thirtieth birthday party. Could Chandler BE any more upset?

Later, at Central Perk, Phoebe tries to process her lost year. She's upset because she had three things she wanted to do by the time she was thirty-one, and she hasn't done any of them. Outside, Joey gives her an impassioned kiss. "Maybe that's one thing you can cross off your list," he tells her.

In the present day, following Monica's cue (sort of?), Rachel decides to be an adult too. When her plan for having kids shows she needs to "already be with the guy" she'll marry, it's clear she has to break things off with Tag, who is distraught over turning twenty-five. Seeing him race a scooter down the hallway makes her decision that much easier.

> "Ross, a sports car? Wouldn't it have been cheaper to just stuff a sock down there?"
>
> CHANDLER

COMMENTARY Superfans will be surprised to hear Rachel say she's an Aquarius (although Jennifer Aniston is one in real life). In the fifth episode of season 4, "The One with Joey's New Girlfriend," she told Gunther her birthday was May 5. Aquarius would have a birthday in January or February. Then again, maybe fans will be too thrilled by the reprise of Drunk Monica (see page 54) to be worried about the inconsistency. When it comes to characters' ages, they'll have to overlook quite a few irregularities in the series' decade-long run. Joey was the youngest friend in season 1, but Rachel's the last one to turn thirty. And then there are those three seasons when Ross doesn't age at all.

Eddie Cahill, who plays Rachel's younger, backpack-wearing boyfriend, Tag Jones, revealed in an interview that he spent the last of his money getting a flight to L.A. to audition for *Friends* and was terrified throughout the audition. He even borrowed a phone to call his mom as soon as he heard he got the part. Cahill reveals, "On my tombstone I think will be 'That Guy from *Friends*.'"

# The One with the Truth About London

| STORY BY | TELEPLAY BY | DIRECTED BY | ORIGINAL AIR DATE |
|---|---|---|---|
| Brian Buckner & Sebastian Jones | Zachary Rosenblatt | David Schwimmer | February 22, 2001 |

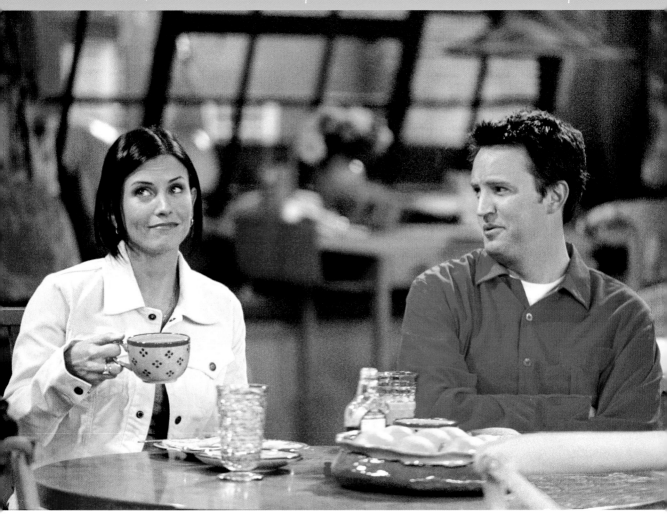

*Monica doesn't seem a hundred percent sure that Joey should be the minister at their wedding.*

With no luck finding a member of the clergy for the wedding—Chandler draws the line at "Horny-for-Monica Minister"—and Joey eager to officiate after he verifies that "Internet ministers can still have sex," the sermon-writing begins. But when Joey's early drafts get caught in a repetitive loop of "giving and receiving," Chandler suggests taking a more personal approach. Joey is on board with delving into how ". . . you two hooked up!" and the episode makes good on its name, cutting to Chandler's hotel room in London at Ross's wedding from the end of season 4.

Chandler "wasn't exactly expecting company after . . . (with a glance at his watch) 9:15." But company he has, and suddenly he and Monica have kissed, gotten undressed, gone under the covers, and come up for air. Chandler's comment—"it's safe to say that our friendship is effectively ruined"—doesn't bother Monica, who says they "weren't that close anyway."

Back in the present, all agree the relationship was "meant to be." Phoebe gets caught up in the moment, urging Monica to reveal her original plan that night—a "meaningless" hookup with Joey. Crushed, Chandler doesn't want Joey to officiate the wedding, but later, moved by Joey's eloquent observations about Chandler and Monica's relationship, he changes his mind.

While Chandler finds out more truth about London than he ever meant to, Rachel's lessons in practical joking have a bigger effect on Ben than she intended. Rachel loves becoming "Fun Aunt Rachel" to Ben, after an initially extremely awkward stretch alone together. She wins him over by teaching him pranks, but when he gets carried away, Ross wants her to put an end to it. Rachel loved being "Fun Aunt Rachel" but agrees not to teach Ben any more pranks as long as he's learned one thing: she and Ross were not "on a break." In the end, it looks like she may have created a monster. She's horrified when Ben throws Ross down a flight of stairs. But it's not Ross—it's a dummy. The father-son pair are in on it together. The joke's on her.

- - - - - - - - - - - - -

"And the love that they give and have is shared and received."

JOEY

- - - - - - - - - - - - -

**COMMENTARY** Monica and Chandler may have been "meant to be," but the episode asks us to momentarily consider an alternate reality, one the show's creators initially considered more viable: Joey and Monica. Chandler begins the episode running from the specter of sexual chemistry with a minister, but substituting a best friend in the role magnifies rather than negates the complexity of interrelationship chemistries. Plot B—Rachel's apprenticeship of Ben—is mostly silly, but the "What if?" question that it poses serves to illuminate the uncertainty at the heart of the main plotline. The awkwardness between Rachel and Ben arose from the fact that she and Ross broke up; after all, she spent a great deal of time with Ben when he was a baby. If not for the break/not a break moment, if not for Chandler answering the door rather than Joey, how different might things be?

For the actor who played Ben, things are quite different in real life than on the show. Rachel thinks she has to teach Ben some jokes because he doesn't have brothers or sisters to teach him. In real life, Cole Sprouse, the actor who played Ben, has an identical twin, Dylan. Disney Channel fans may recognize the brothers as the title characters from *The Suite Life of Zack & Cody*. In an interview with *The New York Post*, Sprouse revealed, "I had a really, really hard time working with Aniston because I was so in love with her. I was infatuated. I was speechless . . . It was so difficult." Sprouse, of course, went on to star as Jughead Jones on the popular CW teen drama *Riverdale*, but fans still sometimes recognize him as his former *Friends* character. "People call me 'Ben' on the street, and I will turn around. It's a funny little process."

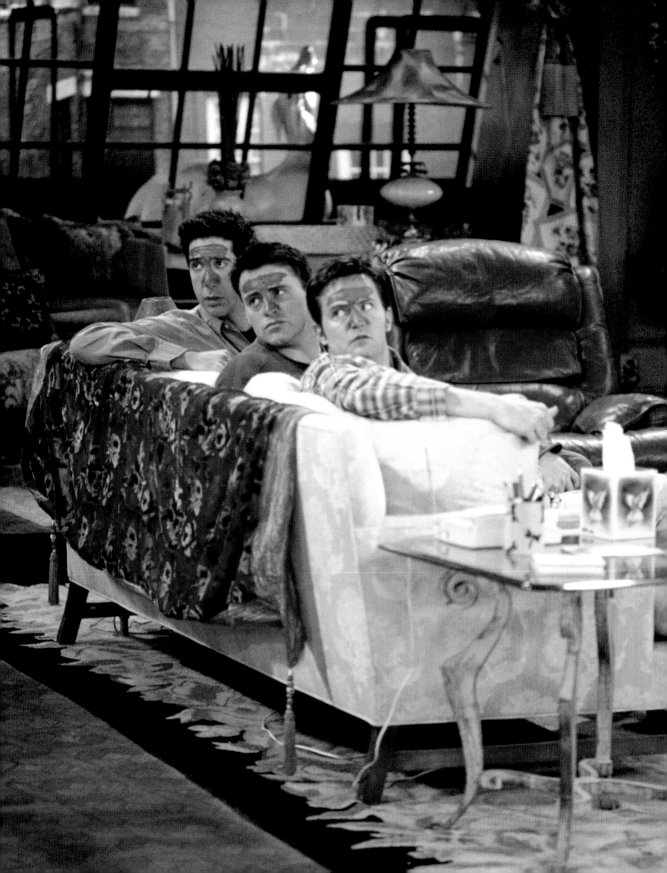

# The One with Monica and Chandler's Wedding, Part 1

**WRITTEN BY** • **DIRECTED BY** • **ORIGINAL AIR DATE**
Gregory S. Malins • Kevin S. Bright • May 17, 2001

It's the day before the wedding, and Monica's at breakfast with Rachel and Phoebe, "making a list of all the things that are most likely to go wrong," when Joey bursts in saying he got a part in a World War I movie shooting that day and will be finished in time for the rehearsal dinner.

Later, Monica tempts fate when she thanks Chandler for staying calm. She had been "waiting for something to flip [him] out," but so far nothing has. Nothing, that is, until minutes later when he hears Monica's voice on the answering machine referring to the couple as "The Bings." Chandler smiles at first, but the weight of the new couple name sinks in; he pulls at his collar as if he suddenly can't breathe. He manages to get through the rehearsal dinner, even introductions between the Gellers and his mother, Nora (Morgan Fairchild), and father, Charles (Kathleen Turner). But a toast "to the Bings" sends him back into a panic.

Back at the apartments, Joey's heading to a late-night rehearsal, wearing sunglasses to protect him from co-star Richard Crosby's (Gary Oldman) uncontrolled spitting. Ross looks for Chandler only to discover that he has disappeared and left a note that simply says, "Tell Monica I'm sorry." Ross, Rachel, and Phoebe agree to keep it secret. Feeling sorry for Monica, Rachel starts to cry. There are no tissues around and Phoebe, digging for a clean-ish tissue from the trash, finds a positive pregnancy test buried there. It looks like Monica is the one with something to hide.

**COMMENTARY** Episode 22, "The One with Chandler's Dad," appeared to depict Charles Bing as a gay drag queen performing as Helena Handbasket in Viva Las Gaygas. Yet in the wedding episodes, Charles seems to be a transgender woman, and "transgender" is the word series co-creator Marta Kauffman uses. A show produced now might be more precise on this topic. While some are critical of *Friends'* treatment of gender and sexuality issues, others view the imperfections in the context of their times, which was very different from our current climate.

Morgan Fairchild, who played Nora Bing, revealed in *Friends of Friends* that she was thrilled she got to work with Kathleen Turner on the show. "Kathleen and I both frequently are cast for exactly the same purpose . . . it's the sort of deep voiced, sex symbol, gravely seductress." Turner spoke with *Digital Spy* about how she decided to take the role as Chandler Bing's father. "How they approached me with it was, 'Would you like to be the first woman playing a man playing a woman?' I said yes, because there weren't many drag/trans people on television at the time."

**OPPOSITE** Oily T-Zones, eleven o'clock, from season 7, episode 17, "The One with the Cheap Wedding Dress." **ABOVE** Chandler and Monica finally say "I do" in episode 24, "The One with Monica and Chandler's Wedding, Part 2."

# The One with Monica and Chandler's Wedding, Part 2

| WRITTEN BY | DIRECTED BY | ORIGINAL AIR DATE |
| --- | --- | --- |
| David Crane & Marta Kauffman | Kevin S. Bright | May 17, 2001 |

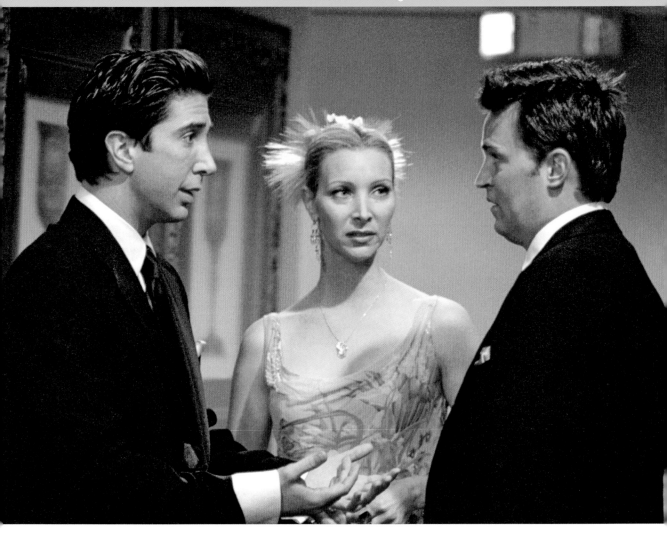

Chandler tells Ross that Monica is pregnant, narrowly escaping that "ass-kicking" from Ross.

It's the moment we've been waiting for all season. The bedroom farce format returns for the finale, with the hotel providing the perfect setting for lots of opening and closing of doors, overheard conversations, and rearranged pairings. The groom's got cold feet, there's a mysterious positive pregnancy test in the trash (Phoebe assumes it belongs to Monica), and Joey—set to officiate the wedding—is on set with a drunk Richard Crosby (Gary Oldman) with less than an hour before

the wedding is supposed to start. Ross hunts for Chandler; Rachel tries to stall Monica. Chandler, smoking a cigarette in the hall, ducks behind a door when he hears someone approach, and overhears a conversation about the baby—*his* baby. Instead of running for the hills, he embraces the news, even buying a newborn onesie to demonstrate.

Ready for the next step(s), the groom gets to the church/hotel function room on time, but Joey's still not there. A Greek Orthodox minister will have to take over the ceremony, but as he addresses the "dearly beloved" crowd, a triumphant Joey shows up (in World War I uniform) to let everyone know, "That's my line!" The happy couple says, "I do," and all is well until Chandler tells Monica he knows "about the baby." Turns out it's not hers. While Monica began the season shouting her big engagement news from the balcony, Rachel's last, anxious face in this season's closing shot makes it clear she'd rather keep her news to herself.

· · · · · · · · · · · · ·

"Why would you play
hide-and-seek with someone
you know is a flight risk?"

PHOEBE

· · · · · · · · · · · · ·

COMMENTARY He almost kept Joey from getting to marry Monica and Chandler, but that didn't stop Gary Oldman (who played Richard Crosby) from receiving a nomination for Outstanding Guest Actor in a Comedy Series in the Primetime Emmy Awards. (Derek Jacobi playing Jackson Hedley on *Frasier* took that year's prize.)

When Rachel is searching for a minister in this episode, she comes upon a wedding ceremony that's just ending. The sign out front says *Anastassakis Papasifakis Wedding*, and Rachel grabs their Greek Orthodox priest for Monica and Chandler's wedding. But the writers grabbed her real family name first. Jennifer's father, John Aniston, was born Anastassakis (Αναστασάκης).

When Chandler tells Monica, "Any surprises that come our way it's okay, because I will always love you," he's referring to the baby he thinks belongs to them. We find out seconds later it's not their baby, but perhaps the biggest surprise about the wedding episode came long after the show ended, when Marta Kauffman confessed that the creators never expected the Monica/Chandler relationship to last beyond the initial fling. But the audience loved the couple together and so they stayed.

Monica's thunder could have been stolen once again with the positive pregnancy test, but we only find out it's not hers in the show's final moments, leaving a big mystery for the start of season 8.

# Season Eight

Remember the juicy cliffhanger from last season? Season 8 begins with everyone speculating about who's pregnant—and who the father is. If you guessed Rachel and Ross, you would be correct! And if you guessed that they would seamlessly move into a traditional loving parenting relationship, you would be so very wrong.

The soon-to-be-parents' argument over who came on to whom evolves into a slow reveal when Ross discovers videotaped evidence. Rachel declares that she plans to date other men while she's pregnant. Joey becomes fixated on having Rachel and the baby live with him. He also makes unexpected gestures toward Phoebe and Rachel. Rachel soon realizes that she doesn't know how to care for a baby, which leads to the terrifying possibility of her mother moving in with her and Ross.

Along the way, Phoebe and Joey cause trouble during Monica and Chandler's honeymoon, Chandler mistakes a birthing video for porn, Monica's restaurant receives a horrible review, and Joey gets upset with Chandler when he falls asleep during the premiere of the movie that Joey is starring in.

In the season finale, with Rachel in labor, her friends get up to all sorts of mischief elsewhere in the hospital. After her daughter, Emma, is born—despite a kiss between her and Ross—Rachel mistakenly thinks that Joey is proposing to her . . . and she accepts!

**OPPOSITE** Take it from Chandler, if you have to choose between a pink bunny costume or no bunny at all, the answer is always, "no bunny at all!"

# The One After "I Do"

| WRITTEN BY | • | DIRECTED BY | • | ORIGINAL AIR DATE |
| --- | --- | --- | --- | --- |
| David Crane & Marta Kauffman | | Kevin S. Bright | | September 27, 2001 |

The Greek Orthodox priest who almost married Monica and Chandler had just performed the Anastassakis Papasifakis wedding. Writers got the name from Jennifer's father, John Aniston, who was born Anastassakis (Αναστασάκης).

As the season opens, the wedding ceremony has just ended and Ross is congratulating Monica on a baby. But she doesn't have a baby. The audience knows it's Rachel's, but she's not ready to share the news. Phoebe loyally steps in, pretending she's the one who's pregnant and that the father is James Brolin. (His was one of only two names she could think of on the spot.)

Chandler's slippery shoes make it impossible for him to show off his dancing lessons as he'd hoped, while Joey has gone years without anyone noticing how "freakishly tiny" his feet actually are. ("The rest of me is good. I'll show you!") Ross, on the other hand, takes over the dance floor, but not in the way he envisioned. He ends up letting a stream of young girls stand on his feet as he sashays around, hoping to impress Monica's gorgeous friend Mona (Bonnie Somerville).

Chandler's mother brings Dennis Phillips (Jim Piddock) along as her date. When Joey, dressed in a ridiculous tennis outfit he bought in the hotel shop (it was that or the World War I soldier uniform), learns Dennis is directing a Broadway play, he tries his best to impress him with an outrageously simplistic and histrionic wedding toast.

Rachel can't even have champagne to help her wrestle with the big questions about her future. When she forgets that she's not supposed to drink and spits out a mouthful of bubbly, it's enough of a tell for Monica to guess her secret. The mystery of the father remains, but Rachel agrees to a second pregnancy test. When Phoebe plays "a risky little game," pretending at first the test is negative, she tricks Rachel into revealing her true feelings about the baby. She can still hide the father, but she can't hide her excitement.

Secret's out . . . it wasn't Monica's positive pregnancy test.

. . . . . . . . . . . .

# "How small are your feet?!"

## ROSS

. . . . . . . . . . . .

**COMMENTARY** The season 8 opener—the first episode to air after 9/11—was dedicated to "The People of New York City."

Rachel, Phoebe, and Monica wait for the pregnancy test, but the real chemistry takes place between the three actresses. Jane Sibbett, who played Carol, Ross's first ex-wife, recounted a story about returning from lunch once to see Jennifer, Lisa, and Courteney playing in a puddle near the soundstage. Sibbett describes the scene: "They were just falling around laughing with one another. That was the lightning in the bottle because they captured that joy of being friends, and that playfulness, and it was magic." Their joy and playfulness carry over to their onscreen interactions, and the viewers couldn't get enough. "The One After 'I Do'" was the eleventh-most-watched

*Friends* episode, with 31.7 million viewers.

Early on, director James Burrows urged the cast to spend time together off-set as friends. At NBC's *A Tribute to James Burrows* in February 2016, Jennifer Aniston commented on the famous dynamic between the cast. "In the beginning, it was not a hard thing, we really just wanted to hang out with each other. It was not a 'we have to do this, ugh.' We really just fell in love and adored each other instantly." I'll be there for you indeed.

Soon there would be another member of this tight-knit group, but she didn't come as soon as viewers might have expected. Given Monica and Chandler's mid-May wedding date, and Rachel's four-week pregnancy, Rachel's due date should have been mid-January, not the following May, as later episodes indicate.

# The One with the Red Sweater

| WRITTEN BY | DIRECTED BY | ORIGINAL AIR DATE |
|---|---|---|
| Dana Klein | David Schwimmer | October 4, 2001 |

The wedding is over, and Monica slumps into "post-wedding letdown" until Chandler reminds her about the disposable cameras at the tables. The fun isn't over yet. Chandler will get those photos developed while Monica goes back to the apartment and waits for him to return to open the wedding gifts. Only she can't wait to open the gifts, and he can't find the disposable cameras. Their desperate solutions lead to trouble, but in the end they "call it even."

> "Who are you, Ansel Adams? Get out of here."
>
> CHANDLER

While Monica rushes to open gifts and Chandler rushes to make up for the lost film, Rachel's not in any rush at all to open up about the baby's father. A red sweater left behind in Joey and Rachel's apartment provides the only clue, but it turns out to be a red herring when Phoebe leads Rachel to meet Tag at Central Perk, believing she's solved the puzzle. Tag is indeed the owner of a red sweater, but he is not the father. Meanwhile, the wedding photos Chandler brings home show him kissing a bride, but it's not Monica. He and Ross hoped no one would notice they swapped one wedding for another. "This is the same ballroom. There's a band. There's gonna be plenty of dressed-up people," said Ross, before the two slipped back into their tuxes and did their best to capture the spirit of the day, albeit the wrong day.

The revelations come fast and furious when Joey finds out Rachel's baby news, and watches Ross claims the mystery red sweater, completely innocent as to how much he's revealing when he says he's "been looking for [it] for like a month." It takes a minute, but even Joey makes the connection. Ross is the father.

**COMMENTARY** Discretion saved her from stealing Monica's thunder on the wedding day, but Rachel's narrative arc drives the action this season, just as it did for the pilot, seven years earlier. It's her past (the reunion with Ross) that launches us into the action of season 8. In season 1, it was her flight from her own wedding that brought Rachel to Central Perk and introduced us to the story as a whole. As the story of the sweater unravels, Rachel seems to gather herself together, showing that she is quite capable of embracing single motherhood. Meanwhile, Joey may have ordered porn and Mashuga Nuts to other people's hotel rooms at the wedding, but he steps into an adult role himself in this episode, asking Phoebe to marry him when he thinks she's pregnant and later asking Rachel when he finds out it's really her. For now, he's just being a good friend. By the end of the season, we'll see him on his knees again.

**OPPOSITE** Phoebe conveniently forgets to tell Joey that she isn't the one who's pregnant after his impromptu proposal.

# The One Where Rachel Tells . . .

| WRITTEN BY | DIRECTED BY | ORIGINAL AIR DATE |
| --- | --- | --- |
| Sherry Bilsing & Ellen Plummer | Sheldon Epps | October 11, 2001 |

The newlyweds are packing for their honeymoon and Rachel plans to tell the father, and then the others, her news, but the word is already out to everyone but Chandler (who is definitely not packing any kind of Speedo in his suitcase). After saying goodbye to Monica and Chandler (who is swiftly let in on the baby news), Joey and Phoebe sit across from each other in apartment 19, seemingly left behind. Neither has a key to apartment 20, but they desperately need to get to Phoebe's guitar and the chicken parm Monica left in the fridge. Meanwhile, the Bings are bummed because the couple in front of them gets a bump to first class and later nabs the honeymoon suite, only because they were one spot ahead of Monica and Chandler in both lines.

> ## "I'm in love too!"
> ### MONICA

Joey and Phoebe go to the extreme of getting the door to Monica and Chandler's apartment knocked down, just as Rachel breaks the barricade between her and Ross, finally letting him in on the paternity secret. Soon enough, as a father-to-be at the ob-gyn office, he's as gentle and loving as ever. Rachel, oddly comfortable with her feet in the stirrups, doesn't want Ross to talk to her too close due to her "al fresco situation" but she's quick to lean into him for support—and for help seeing the fetus in the blurry sonogram image.

**COMMENTARY** The honeymoon subplot originally contained scenes where Chandler was brought into questioning at the airport for joking in response to a sign that said, "Federal Law Prohibits any Joking Regarding Aircraft Hijacking or Bombing." The scenes for the episode, which aired in October of 2001, were removed in response to the deadly terrorist attacks of September 11, 2001. When the scenes were released on DVD in the UK in 2004, the creators included these deleted scenes, explaining, "As part of the history of the show, we hope that the scenes can now be viewed in the spirit which they were originally intended."

As Maitri Suhas wrote in *Bustle* in 2015, "*Friends* was a show that took place in a universe where you could chase the love of your life to the gate at the airport, and I think that's the spirit that this scene was meant to have."

**OPPOSITE** Rachel pretending to see her baby on a sonogram.

# The One with the Stripper

| WRITTEN BY | DIRECTED BY | ORIGINAL AIR DATE |
|---|---|---|
| Andrew Reich & Ted Cohen | David Schwimmer | November 15, 2001 |

Joey wants Chandler to pretend he's not married yet so the bachelor party is more fun.

Monica and Chandler had agreed to forego bachelor and bachelorette parties, but when Phoebe spots the stripper from Monica's "secret bachelorette party," Chandler's upset and Monica has to think fast. She dreams up a post-wedding bachelor party for Chandler and hires a stripper. Despite the beers and shiny hats, it's a sad little affair, but it takes a turn for the worse when the stripper makes herself way too comfortable in the bedroom and turns out to have a different transaction in mind. ("You hired your husband a *hooker?*")

Meanwhile, Phoebe joins Rachel for dinner with scary dad Dr. Leonard Green (Ron Leibman). It's not easy for Rachel to break the news about the baby to her father, and she gets backed into a corner, painting Ross in an unflattering light to try to escape her father's wrath about a baby born out of wedlock.

Despite a broken tchotchke, Ross is happily making out with Mona when Dr. Green comes flying into his apartment. Ross knew he needed to let Mona know about the baby, but Rachel's father does that for him. Rachel, via her father, comes between Ross and Mona, but she's also the one to help them patch things back up. Monica has a romantic plan of her own—she snaps on the music and becomes the stripper Chandler never got.

• • • • • • • • • • • •

## "Yup, that's one naked hooker!"

### JOEY

• • • • • • • • • • • •

**COMMENTARY** The episode offers a rare opportunity for tightly wound Monica to loosen up when she presents a striptease to Chandler at the episode's end. He could do without her narration—"These tennis shoes are so tight"—but he nevertheless looks pretty pleased as he sits back to enjoy the show. The real thrust of the episode is still Rachel, while Mona is one of the many pretty detours on the winding road that is the love story of Rachel and Ross. In real life, the actress who plays Mona (Bonnie Somerville) said that she loved working with David Schwimmer. "He's just so talented. I learned a lot from watching him . . . he's the best at facial expressions." Bonus fact: Somerville also had a song, "Winding Road," on the soundtrack to Zach Braff's *Garden State*. The film came out in the summer of 2004, two months after the last episode of *Friends*, and the soundtrack won a Grammy the following year.

During its ten-year run, *Friends* showcased many a celebrity, from Kathleen Turner playing Chandler's dad (see page 177), to Danny DeVito, the crying stripper (see page 235), to Julia Roberts playing Susie Moss, who gets revenge on Chandler for a fourth-grade prank (see page 66). Here are more of the best celebrity sightings around Bedford and Grove.

### Siblings with an Agenda

- **Christina Applegate**
  *Rachel's sister Amy wants a straightener*
- **Reese Witherspoon**
  *Rachel's sister Jill wants Ross*
- **Winona Ryder**
  *Rachel's sorority sister, Melissa Warburton, wants Rachel*
- **Lisa Kudrow**
  *Phoebe's identical twin, Ursula, wants nothing to do with her*
- **Giovanni Ribisi**
  *Phoebe's brother, Frank Jr., wants Phoebe to give birth to his children*

### Dysfunctional Parents

- **Morgan Fairchild**
  *Nora Tyler Bing, Chandler's sexually liberated mother*
- **Kathleen Turner**
  *Charles Bing/Helena Handbasket, Chandler's trans father*
- **Bob Balaban**
  *Frank Buffay Sr., family abandoner and Phoebe's father*
- **Teri Garr**
  *Phoebe Abbott, Phoebe's real birth mother and namesake*
- **Christina Pickles**
  *Judy Geller, Ross and Monica's über-critical mother*
- **Elliott Gould**
  *Jack Geller, the Porsche-driving, condensed milk-drinking, secret smoker dad of Ross and Monica*
- **Marlo Thomas**
  *Sandra Green, Rachel's mom, wants to try marijuana*
- **Ron Liebman**
  *Dr. Leonard Green, Rachel's dad, might have some anger issues*
- **Robert Costanzo**
  *Joseph Tribbiani Sr., Joey's two-timing father*
- **Brenda Vaccaro**
  *Gloria Tribbiani, Joey's "look the other way" mother*

### Men Who Cry

- **Bruce Willis**
  *Paul Stevens, Ross's young girlfriend's scary father*
- **Jon Lovitz**
  *Steve, Rachel's "bad" blind date*
- **Freddie Prinze Jr.**
  *Sandy, Emma's nanny*
- **Robin Williams**
  *Tomas, the Central Perk couch invader with the cheating wife*
- **Danny DeVito**
  *Phoebe's over-the-hill stripper*

### Crossover Cameos

- **Helen Hunt**
  *Jamie Buchman from Mad About You*
- **Lea Thompson**
  *Caroline Duffy from Caroline in the City*

### The Mistakes

- **Alec Baldwin**
  *Parker, Phoebe's overzealous date*
- **Soleil Moon Frye**
  *Katie, the girl who hits Joey*
- **Jennifer Grey**
  *Mindy, Barry's new fiancé*
- **David Sutcliffe**
  *aka "Hums While He Pees"*

### Intriguing Doctors and Scientists

- **Tom Selleck**
  *Dr. Richard Burke*
- **Hank Azaria**
  *David the Scientist*
- **George Clooney**
  *Dr. Michael Mitchell*
- **Noah Wyle**
  *Dr. Jeffrey Rosen*
- **Michael Vartan**
  *Dr. Timothy Burke*
- **Jonathan Silverman**
  *Dr. Franzblau*
- **Billy Crystal**
  *Tim the gynecologist*
- **Greg Kinnear**
  *Dr. Benjamin Hobart*
- **Iqbal Theba**
  *Joey's kidney stone doctor*

### Men in Uniform

- **Michael Rapaport**
  *Phoebe's cop boyfriend*
- **Charlie Sheen**
  *Ryan the submarine guy*
- **Mark Consuelos**
  *the cop Rachel flirts with to get out of a ticket*

### Actors Playing Actors (Playing Actors)

- **Susan Sarandon**
  *Cecilia Monroe playing Jessica Lockhart on Days of Our Lives*
- **Gary Oldman**
  *Richard Crosby*
- **Jeff Goldblum**
  *Leonard Hayes*
- **Dina Meyer**
  *Kate Miller, the actress Joey falls in love with*
- **Alison Sweeney**
  *Jessica Ashley on Days of Our Lives*

### Friends Who Date More than One Friend

- **Gabrielle Union**
  *Kirsten Lang, dated Ross & Joey*
- **Sean Penn**
  *Ursula's sensitive fiancé Eric*
- **David Arquette**
  *dated Phoebe and stalked Ursula*
- **Aisha Tyler**
  *dated Joey & Ross*

### The Less than Enthused

- **Craig Robinson**
  *the clerk who changes Phoebe's name to Princess Consuela Bananahammock*
- **Thomas Lennon**
  *Randall, Joey's identical hand twin*
- **"Snaro" aka David Schwimmer**
  *Russ, Ross's look-alike, dates Rachel*
- **Joanna Gleason**
  *Kim Clozzi, Rachel's boss*

### Revenge Friends

- **Julia Roberts**
  *Susie Moss, aka "Susie Underpants"*
- **Brad Pitt**
  *Will Colbert, co-president of the "I Hate Rachel Green" club*

# "Come on, what's a little midlife crisis between friends?"

## JACK GELLER

### Potential Baby Makers

- **John Stamos**
  *Zack, Chandler's colleague with unbelievably good DNA*
- **Anna Faris**
  *Erica, biological mom to Monica and Chander's twins*

### Duplicitous Friends

- **Selma Blair**
  *Wendy from Oklahoma, tries to steal Chandler*
- **Dermot Mulroney**
  *Gavin Mitchell, tries to steal Rachel's job*
- **Steve Zahn**
  *Phoebe's ex-husband, lied about being gay*
- **Fred Willard**
  *San Diego zoo administrator, lied about Marcel dying*

### Friends with Accents

- **Elle Macpherson**
  *Janine Lacroix*
- **Helen Baxendale**
  *Emily, the name Ross should have said at the altar*
- **Richard Branson**
  *London street vendor*
- **Olivia Williams**
  *Emily's bridesmaid*
- **June Whitfield**
  *Emily's mother's housekeeper*
- **Jennifer Saunders**
  *Andrea Waltham, Emily's narcissistic mother*
- **Tom Conti**
  *Stephen Waltham, Emily's cheap father*
- **Jennifer Coolidge**
  *Monica and Phoebe's former building-mate Amanda Buffamonteezi, sports a fake British accent*

### Naked Friends

- **Jon Haugen**
  *Ugly Naked Guy*
- **Kristin Davis**
  *Erin, Joey's almost girlfriend*
- **Christine Taylor**
  *Bonnie, Ross's bald girlfriend*

### Anger Management Issues

- **Ben Stiller**
  *Tommy, Rachel's date who yells*
- **Sherri Shepherd**
  *Rhonda, wears a blue blazer at Ross's museum*
- **Debi Mazar**
  *the "Evil Bitch" in labor next to Rachel in the hospital*
- **Alex Borstein**
  *star of a bitter one-woman show, Why Don't You Like Me?*
- **Chris Parnell**
  *calls Chandler "Toby," trashes his desk*
- **Leah Remini**
  *Lydia, the pregnant woman Joey helps at the hospital*

### Kids Who've Been Corrupted

- **Cole Sprouse**
  *Ben, Ross's son*
- **Daryl Sabara**
  *Owen, the kid who didn't know he was adopted (cue Chandler)*
- **Mae Whitman**
  *Sarah Tuttle, the Brown Bird who enlists Ross's help to sell cookies*
- **Dakota Fanning**
  *Mackenzie, the 8-year-old girl living in Monica and Chandler's house*

### Friends with Money

- **Jon Favreau**
  *Pete Becker, Monica's millionaire boyfriend*
- **Paul Rudd**
  *Phoebe's blue-blooded boyfriend turned husband*

### Friends Looking for Money

- **Penn Jillette**
  *encyclopedia salesman, convinces Joey to buy volume "V"*
- **Jane Lynch**
  *Monica and Chandler's real estate agent*
- **Michael McKean**
  *Mr. Rastatter looking for "Mockolate" recipes from Monica*
- **Harry Shearer**
  *tries to convince Ross to put Marcel in an animal fight club*

### Actors Who Play Themselves

- Isabella Rossellini
- Jean-Claude Van Damme
- Jill Goodacre
- Ralph Lauren
- Sarah Ferguson, the Duchess of York
- Jay Leno
- Charlton Heston
- Gary Collins
- Dick Clark
- McKenzie Westmore
- Donny Osmond
- Trudie Styler
- Ben Shephard
- Matthew Ashford

### Can't Date 'Em

- **Brooke Shields**
  *Erika Ford, thinks Joey is really a neurosurgeon*
- **Jason Alexander**
  *Earl, the suicidal office manager*
- **Rebecca Romijn**
  *Cheryl, the very dirty girl*
- **Ellen Pompeo**
  *Missy Goldberg, the college friend Chandler & Ross made a pact not to date*
- **Denise Richards**
  *Ross and Monica's hot, off-limits cousin*
- **Adam Goldberg**
  *Eddie Menuek, Chandler's roommate from hell*
- **Missi Pyle**
  *Hillary, the chef with a blacklight*

### The Music Makers

- **Chris Isaak**
  *Rob Donnen, books Phoebe for library gigs in the city*
- **Chrissie Hynde**
  *Stephanie Schiffer, plays at Central Perk*

### Men Who Got Stuck Sitting Next to Rachel on a Plane

- **Hugh Laurie**
  *thinks Ross and Rachel were definitely on a break*
- **Jim Rash**
  *departs the plane headed to Paris because of the missing "phalange"*

# The One Where Chandler Takes a Bath

| WRITTEN BY | DIRECTED BY | ORIGINAL AIR DATE |
|---|---|---|
| Vanessa McCarthy | Ben Weiss | January 17, 2002 |

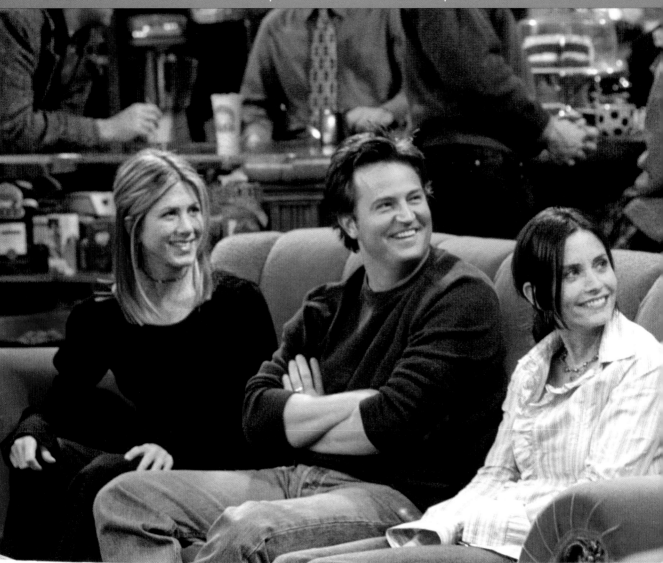

Perhaps Ross is suggesting baby names worse than Sandrine, Rain, Darwin, and Thatcher?

The wedding planning for Monica and Chandler from season 7 has given way to baby planning for Ross and Rachel. For a second it looks like the parents-to-be might have a name they both like (James) . . . that is until Rachel adds "only if it's a girl," which makes it an automatic veto for Ross. (After initially suggesting "Phoebe" for a girl, and "Phoebo" for a boy, Phoebe grows to like the name "Veto.") Rachel hates the name Ruth at first; when she later warms up to it, Ross thinks he's being double-crossed somehow and says, "Ruth is off the table." He finds out they're having a girl, telling Rachel the sex because he thinks she already knew. (She didn't.) Even so, the news touches both of them.

Poor Joey's still struggling with feelings for Rachel, while Chandler, newly won over to the joys of the relaxing, candle-lit bath, isn't struggling with much beyond tepid water, undissolved salts, and later, keeping his toy navy ship strategically placed. A misinterpretation leads Monica to tell Phoebe *she's* the object of Joey's affection, but a conversation with Joey makes it immediately clear that's not the case. "It's Rachel, for God's sakes!" In the end, they all wind up in the bathroom, circled around a naked Chandler, who *was* relaxed at one point. Ross and Rachel share their news about the baby girl. Chandler takes a rain check on the group hug.

- - - - - - - - - - - - -

# "That's a really pretty name for an industrial solvent."

## ROSS

- - - - - - - - - - - - -

COMMENTARY Although indecision and confusion are trademarks of the show, the elevated levels of both in this episode may have been fueled by the uncertainty surrounding the show's future. Co-creator David Crane says the production team didn't know until midway through the eighth season whether or not it would be the last. That made it hard for the producers to know where to take the storyline. In this episode, the mix-ups eventually bring everyone into the same (tiny) room. When the whole group crowds into the bathroom, fans of the Marx Brothers will likely be reminded of the famous Stateroom Scene when fifteen people managed to crowd into one ocean liner cabin in *The Night at the Opera*. ("We're all in here and we'd love for you to join us!" Chandler calls out to Ross, the last one to enter.) The six look surprisingly relaxed in such close quarters, but when the Joey/Rachel story arc starts picking up momentum, the lack of space might become a little too close for comfort. In *Digital Spy*, director Kevin S. Bright described Matt LeBlanc's initial reaction to the plot twist. "He was very firmly against it, saying that he's Ross's friend, and that the type of friend that Joey is would never go and take someone else's girlfriend." Maybe Ross persuaded Matt LeBlanc along with Joey in "The One Where Joey Tells Rachel."

# The One with the Secret Closet

**WRITTEN BY**
Brian Buckner & Sebastian Jones

**DIRECTED BY**
Kevin S. Bright

**ORIGINAL AIR DATE**
January 31, 2002

Phoebe's feelings are hurt when she finds out Monica's been secretly seeing another masseuse for three years, and she convinces Monica to give her a chance. Things start off okay, but the porn star sound effects Monica makes during the massage make it clear the two might be better off not mixing business and pleasure.

Ross is feeling a bit left out of his baby's world, as it's Joey who feels the kicks and even gets mistaken for the father at the hospital. Joey nobly suggests maybe Ross and Rachel should be the ones living together. Ross is eager to try, and they agree to give it a shot.

Monica has a lot of secrets, and Phoebe's about to find out just how loud one of them is.

Meanwhile, Chandler feels left out too—from the locked closet Monica absolutely will not let him open. Turns out Alexandra's massages are not the only thing Monica's hiding. It all started when they were looking for a place to hide a hideous punch bowl from Bob and Faye Bing. But what is in there? Most outrageous suggestion goes to Joey: "I bet it's Richard." Chandler's desperate to find out and, when the credit card and bobby pin trick don't work, he finally stoops to removing the door. The skeleton in the closet turns out to be a giant pile of junk.

"You make sex noises when you get massaged!"

PHOEBE

The baby just kicked, and Commando Joey gets to be a part of it too.

**COMMENTARY** When it comes to secrets, a Ross and Rachel relationship-relapse, Rachel's hidden pregnancy, and Joey's forbidden attraction, Monica's secret closet seems to pale in comparison. Yet the revelation that the tightly wound, hyper-organized Monica not only makes sex noises during massage sessions but has a closet full of junk shows the multidimensionality of her character. It also sets viewers up for the season finale, "The One Where Rachel Has a Baby," where Monica—certain she will "freak out Chandler" by mentioning having a baby themselves—turns out to be the one who freaks out. As co-creator David Crane put it, Monica has always wanted a baby. "To finally put it to the test," he says, "and have her freak out about it seemed really fun and a nice other color for the character."

Production designer John Shaffner enjoyed allowing a bit of mystery about the closet door for the first seven seasons. They didn't have a fixed idea in mind for what was behind it when they put the door on the set originally. In his words, he said, "Why don't we just wait and see where the stories take us." Enter an unwanted punch bowl wedding gift, and here we are.

# The One with the Birthing Video

WRITTEN BY • DIRECTED BY • ORIGINAL AIR DATE
Dana Klein • Kevin S. Bright • February 7, 2002

*Phoebe has never tried saltwater taffy before, so Ross offers her one on Valentine's Day.*

Valentine's Day is not easy for Joey, who is still pining after Rachel. Watching her leave Central Perk, he comments, "That is one lucky to-go cup of coffee." Phoebe tries to cheer him up, even offering for him to look down her top. When Gunther comes to take his order, he has a rather tall one: "I want to be with the woman I love on Valentine's Day." Gunther offers red bagels. Joey says okay.

Ross needs to tell Mona that he and Rachel are living together but says he's not worried because Mona's "been so supportive." Phoebe wants Rachel to see a "video of [her] friend giving birth."

Monica's dressing up in something "a little less comfortable" for Chandler, who mistakes the left-behind "Candy & Cookie" birthing video (named after the mother and daughter in the video) for girl-on-girl porn. Across the hall, Phoebe brings Joey "a real, live furry playmate." But even the happiest dog in the world can't cheer him up, and Joey winds up making the dog depressed.

Chandler can't wait to pop in the "Candy & Cookie" video, but the pushing and grunting is not what he had in mind. It ends up killing the mood, even though Monica is dressed to the nines in sexy red lingerie. Chandler is outraged that Monica bought this video for him. He describes the traumatizing moments on the video. When Monica questions why he was watching it, he says, "I

thought you got me porn for Valentine's Day." In fact, she did. She picks up another VHS tape.

Mona's back from Atlantic City and brought Ross a present—saltwater taffy, apparently a favorite. "It's actually made with salted freshwater," Ross explains, a factoid that delights them both. Ross doesn't have any luck telling Mona that his "pregnant ex-girlfriend is living with [him]." He decides to take her to a romantic Valentine's dinner and "butter her up first." But he never gets the chance, because Mona surprises him by showing up at his apartment . . . and Rachel's, as she comes to find out. Mona finally confronts a pajama-wearing Rachel privately, asking her to respect "some boundaries" and return to her own home, only to find out Rachel lives there now, with Ross. Rachel has to "escape from all the yelling" of Ross getting dumped by Mona.

"It's ironic how footage of someone being born can make you want to kill yourself," says Chandler, but he, Rachel, and Monica agree to watch it together. "Oh, look at those little fingers and toes," says Monica, and Rachel's almost convinced of the sweetness of the scene, until she remembers she's the one who actually has to go through the horror.

Later, a just-dumped Ross gives Joey good advice about pursuing a woman he likes, not knowing he's talking about Rachel. In the last frame of the episode, Joey utters her name.

> • • • • • • • • • • • • •
>
> ## "What the mother of crap is up with this stuff?"
>
> PHOEBE
>
> • • • • • • • • • • • • •

**COMMENTARY** Monica tries to warn him against it, but Ross insists on butting into her lingerie selection for Valentine's Day. She relents, holding up the two equally risqué options. "All right, big brother. Which of these do you think would make your little sister look hotter, so your best friend would want to do her?" Ross actually has an opinion—"the red one." (*Ew.*) But the sometimes-inappropriate sibling exchanges don't stop here. In "The One Where Joey Tells Rachel," Ross actually says that Joey and Rachel going out would be "like you (Monica) and me going out, only weirder!" Monica is repulsed that Ross even put that thought into words. But then again, when Rachel kisses Ross for the first time, Monica wants to know every single detail. (Um, gross.) There's full sibling participation in strip *Happy Days* and we also find out in "The One Where the Stripper Cries" that Ross was Monica's first kiss (albeit not on purpose). Finally, no sister has ever sat on her brother's lap as they do throughout the series.

And they're not the only inappropriate siblings on the show. Rachel broke up with Yeti Danny after seeing a little too much closeness between him and his sister in "The One with the Inappropriate Sister" (season 5, episode 10).

While Monica's plan is foiled by the "Candy & Cookie" video, Ross, and later Phoebe, enjoy some actual candy. Despite the insight he offers Joey, Ross is clearly no relationship expert, but he is right about the saltwater taffy. It isn't made with seawater after all. Legend has it the origin of the name comes from a flood that happened in the late nineteenth century along the Atlantic City boardwalk. The resulting drenched taffy in a candy store wasn't destroyed but reborn as something new: saltwater taffy.

While Ross has a fondness for taffy and maple candy on the show, in real life Courteney Cox was the one with the sweet tooth. She reportedly kept "Courteney's Cabinet" for her on-set stash which included one of her faves: Bit-o-Honey candy bars.

# The One Where Joey Tells Rachel

**WRITTEN BY**
Andrew Reich & Ted Cohen
•
**DIRECTED BY**
Ben Weiss
•
**ORIGINAL AIR DATE**
February 28, 2002

Ross flips out over Joey's news that the woman keeping him up at night is Rachel. We see him mouthing her name in disbelief as he leaves Central Perk. Even if they haven't been a couple for years, we can't get Ross's confession to Rachel from season 2 out of our heads: "It's always been you, Rach." It looks like he might still feel that way.

Meanwhile, Phoebe has a soul mate question of her own. Perched at Central Perk, she asks Chandler and Rachel whether they believe in them, and is relieved when Chandler says he does not, since Phoebe believes she has just met Monica's.

Don (Harry Van Gorkum) is older, British, and in the food business. Monica and Don meet, and indeed hit it off, connecting over disdain for sundried tomatoes and a high regard for smelly cheese. It turns out Don loves "this great little place, Alessandro's," which just happens to be Monica's restaurant. Chandler gets jealous, but there is no need, as Monica doesn't believe in soul mates either.

Ross comes to accept Joey's feelings and gives his blessing to Joey to tell Rachel. Joey asks her to dinner, and when he tells her he is falling in love with her, she's not sure how to respond, trying everything she can to let it be a joke.

Joey finally tells Rachel the truth—that he's in love with her.

"Cheese. It's smelly. You must smell a lot of the time, too."

CHANDLER

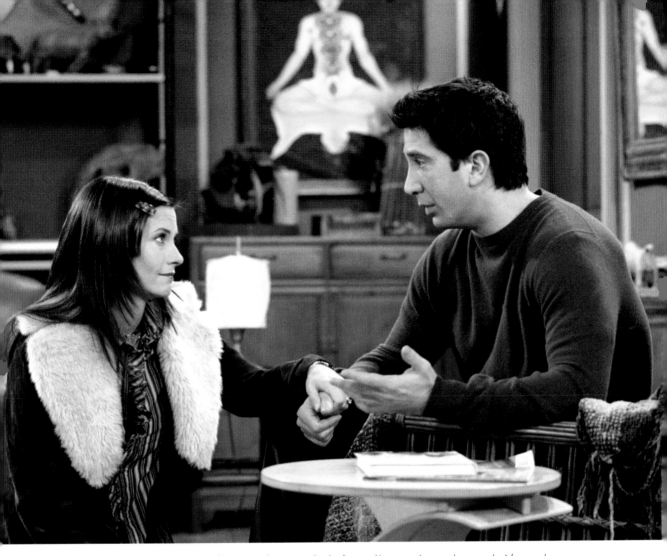

Monica tells Ross that Joey is so upset he wants to leave the country and move to Vermont.

**COMMENTARY** When Phoebe asks Rachel and Chandler if they believe in soul mates, Rachel says she does. "I believe that there is one perfect person out there for everyone," she says, before explaining that you just have to wait. In real life, fans have followed Jennifer Aniston's love life, including her relationships with Brad Pitt, Vince Vaughn, and Justin Theroux, with intense interest. In the 2019 June/July issue of *Harper's Bazaar*, Aniston offers an original take on the soul mate question: "I think we have many soul mates. I don't think there's one and one only. I think we have soul clusters."

To this day, fans are divided as to whether Joey and Rachel should have ever had a relationship. Some see it as a forced storyline, unnaturally suspending the Ross/Rachel denouement, while others saw chemistry. Either way, producer/director Kevin S. Bright saw a potential love triangle, with Joey hanging over the birth of Rachel's baby, as a strong cliffhanger for the end of season 8.

# The One Where Rachel Has a Baby, Parts 1 and 2

| WRITTEN BY | DIRECTED BY | ORIGINAL AIR DATE |
|---|---|---|
| Scott Silveri • David Crane & Marta Kauffman | Kevin S. Bright | May 16, 2002 |

We watched Rachel struggle with her secret pregnancy in the early episodes of the season. Now the baby is ready to come out. But not *that* ready. While she suffers through contractions, Rachel's semiprivate hospital room is invaded by a stream of outrageous couples. First, the boundary-crossing couple where the expectant mom—on her third pregnancy—offers for Ross to feel her cervix in comparison to Rachel's. Next come Sick Bastard and Evil Bitch, whose names speak for themselves. Then there's the couple with a mom-to-be whose contractions are the world's tiniest (and most annoying). Just when you think it can't get worse, pregnant Janice rolls in with her husband, Sid, who considers himself "the luckiest guy in the world." Even Janice gets wheeled to delivery before Rachel, but not before Chandler has a momentary scare that she is somehow, the laws of physics be damned, carrying his baby.

In between, Mrs. Geller interrupts to pull Ross into the hall to try to convince him to marry Rachel, who "isn't just some girl you picked up in a bar and humped" and insists he take his grandmother's engagement ring. He reluctantly agrees, finally putting the ring in his coat pocket.

The other Friends, with nothing to do but wait, find ways to entertain themselves. Phoebe meets a cute guy with a broken leg but loses him to the shutting elevator doors before she can catch his name. Monica and Chandler, after a bit of back and forth and "period math," decide to try to have a baby. Some may think a hospital wouldn't be the most romantic locale, but the cleanliness makes Monica happy and, as Chandler points out, there are plenty of beds.

Joey transforms into Dr. Drake Ramoray to help Phoebe find the mystery man (Cliff, played by Eddie McClintock). It works, at first, even though Cliff seems a bit suspicious about the personal nature of Dr. Ramoray's questions. Phoebe and Cliff hit it off, so comfortable together Phoebe uses a spoon to scratch his itchy foot under the cast and later uses the same spoon to eat. But when Cliff recognizes Dr. Ramoray on *Days of Our Lives* playing on the television in his room, and Joey enters as himself minutes later, it looks like Phoebe's hopes for hospital romance are ruined.

Finally, the baby—breech, which means the delivery will be even harder—comes out, and the group swoons. Monica sacrifices the baby name she's wanted to give her own daughter since she was fourteen—Emma—and Rachel tries to adjust to the idea of motherhood on her own. In the last shots of the season, however, it looks like she'll be far from alone. In a recapitulation of the moment in season 7 when she accepted a date for which Tag wasn't asking her, Rachel accepts a proposal that Joey did not mean to give. Meanwhile, Ross, flowers in hand, is coming down the hall toward Rachel's room, looking like he's ready for a proposal of his own.

> "I have a very wide pelvis. You remember, Chandler."
>
> JANICE

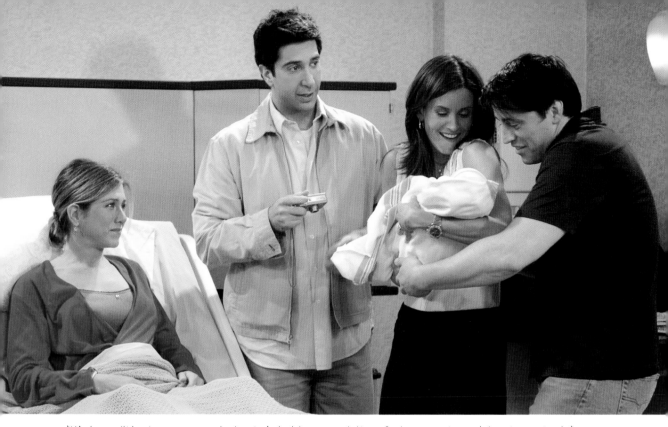

*"It's incredible, I mean, one minute she's inside you and then forty-seven hours later, here she is."*

**COMMENTARY** We get a chance to find out if Ross's wishes and predictions about children from season 2 are correct. In episode 2, "The One with the Baby on the Bus," he hoped one day Ben would have a little sister. Later in the season, in episode 20, "The One Where Old Yeller Dies," Ross tells Rachel he would like them to have two kids and "hopefully the girl will come first so Ben here won't feel too competitive." He also said the name "Emily" appealed to him (though the name "Emily" takes a negative connotation after his failed marriage to the British "chippie"). Turns out they do have a girl, whose name, Emma, turns out to be a gift from Monica. The names Emily and Emma sound similar and are both Germanic, but their meanings differ—Emily means "industrious," while Emma means "universal." Since 2013, Emma has reigned as the most popular baby name for a girl in United States.

Marta Kauffman says writing about the birth of Rachel's baby took elements from the New York birth of her first child, when she had five roommates during the hospital stay, two of whom couldn't get to the delivery room fast enough. "I had nightmare roommates," says Kauffman of that experience. "She [Rachel] had even worse ones."

An actual nurse was used as an extra for the delivery. Director Kevin S. Bright felt it was important to have someone medically trained on set given that there was a real baby on set, too (a premature one, presumably so that it would be old enough to "perform," but look more like a newborn).

We leave the *Friends* cast at the end of season 8 before Rachel takes the baby home, but at the 2002 Emmy Awards, *Friends* finally took home Best Comedy Series—the only time the beloved show captured this elusive award.

# Season Nine

Rachel and Joey clear up the misguided proposal, and the season follows Ross and Rachel living together and learning how to parent baby Emma. But wait—there's more. After a fight, Rachel moves back in with Joey and discovers that she has feelings for him, and Ross finds a love interest in his colleague, Charlie, played by Aisha Tyler. Before too long, Ross and Rachel look for other people to kiss at a rooftop party. It will take some time to work out who belongs with each Friend this season.

Monica and Chandler decide to have a baby of their own this season, and after trying for a while, end up seeking medical advice, only to discover that it's likely that they will be unable to conceive naturally. They decide to engage in the adoption process.

Things heat up significantly for Phoebe with the appearance of boyfriend Paul Rudd as Mike Hannigan. However, the situation soon gets complicated when Mike tells Phoebe he never wants to marry again. Meanwhile, David, played by Hank Azaria, returns, and she ends up with two marriage proposals.

The finale is none other than the famous Barbados episode, where the group goes to hear Ross give a keynote speech at a paleontology conference and we discover that Monica's hair takes on a whole new dimension in humidity.

OPPOSITE *Monica and Phoebe, from season 9, episode 19, "The One with Rachel's Dream."*

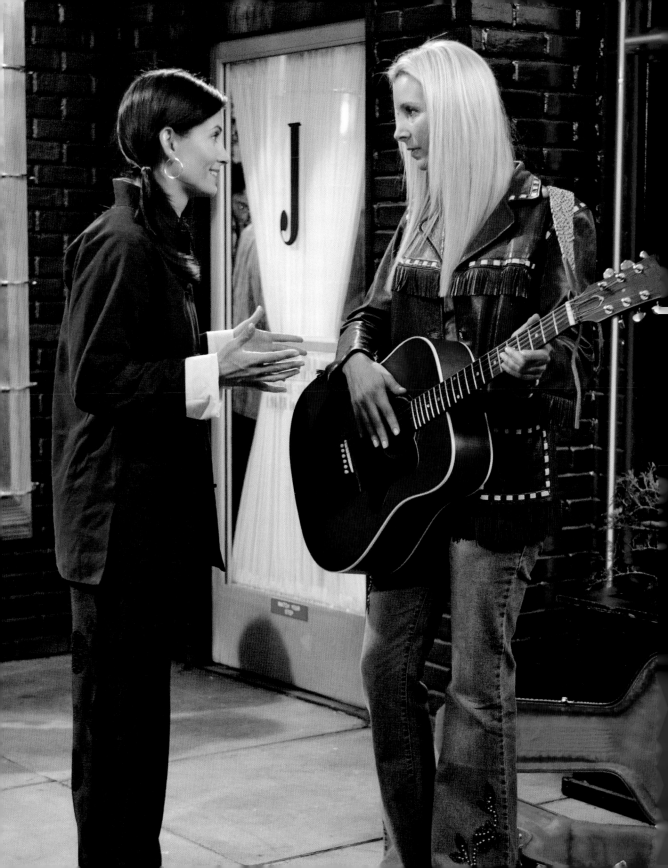

# The One Where No One Proposes

WRITTEN BY
Sherry Bilsing & Ellen Plummer
•
DIRECTED BY
Kevin S. Bright
•
ORIGINAL AIR DATE
September 26, 2002

At the end of season 8, Joey finds Ross's grandmother's wedding ring in Rachel's hospital room. As he turns around to show it to Rachel, he's still kneeling on the floor, and Rachel thinks he's proposing. She is scared about raising the baby alone and says yes. Joey doesn't know what to do. He doesn't want to hurt Rachel, and knows Ross is going to kill him. Rachel tells Phoebe the news, though she isn't sure she made the right choice by saying yes. Phoebe—thinking that Rachel is talking about Ross—tells her that they were meant to be together.

Phoebe congratulates Ross, but he insists he never proposed to Rachel. Seeing the ring on a sleeping Rachel after forty hours of no sleep, "Ross the Divorce Force" wonders if he did propose: "It does sound like something I would do." Joey tries to explain to Rachel what happened, but a nurse walks in to help Rachel breastfeed, and the impromptu peep show nearly does him in.

Monica and Chandler are trying to get pregnant, and they end up having sex in a closet at the hospital because Monica is ovulating. The only problem is that Monica's dad can hear someone having sex in the closet and decides to "peek." He is mortified at first, but then when he realizes they're trying to conceive, he's thrilled and (gulp) ready to help.

Joey, Ross, and Rachel finally clear up the mistake. Rachel successfully gets Emma to latch on, and Joey leaves Ross and Rachel in peace to be with their baby. Ross tells Rachel he has been having some feelings, and Rachel says, "I've been feeling . . ." It appears they might be on the verge of getting back together, but Ross notices the engagement ring on Rachel's hand. He asks her in disbelief if she said yes when she thought Joey was proposing. The episode ends with Rachel sporting a guilty expression.

> "Man, that kid is going to town!"
>
> JOEY

COMMENTARY Going into season 9, the *Friends* writers thought it would be the last season, Kevin S. Bright told *Digital Spy*. It's visible even in this opening episode, where you can see the Friends trying to figure out their futures: Monica and Chandler trying to get pregnant, Rachel having Ross's baby, Joey . . . well . . . Joey unable to avoid looking at Rachel breastfeeding.

Elliot Gould, who plays Jack Geller, has a funny moment when he looks down at Emma and says, "Look at her. My first grandchild." Ross points out that Emma is *not* his first grandchild. Turns out Jack forgot Ben, although how can we blame him?

The last time we saw Ben was in "The One Where Joey Dates Rachel," and the line could easily be a nod to the fact that Ben didn't even attend Ross's wedding. But we won't forget Mr. Geller anytime soon. According to casting director Ellie Kanner on A&E's *Friends* episode of *Biography*, "I had to call Elliot Gould directly . . . to convince him that this was going to be a great part for him." And she was right. Taylor Swift is reportedly a huge *Friends* fan and ran up to Gould, saying, "You're Mr. Geller!" As he puts it, "People just know me now from being Mr. Geller on *Friends*."

# The One Where Emma Cries

WRITTEN BY • DIRECTED BY • ORIGINAL AIR DATE
Dana Klein • Sheldon Epps • October 3, 2002

Ross is still mad that Rachel agreed to marry Joey after his non-proposal, but she's got more important things to worry about. When she gets home from the hospital, she wakes Emma from a nap and can't get her to stop crying. Joey confronts Ross and apologizes, but Ross is still mad. Joey finally convinces Ross to hit him, but when he does, Joey ducks, and Ross slams his hand into a metal pole. Ross is in agony, and Gunther—still reeling at him for impregnating Rachel—is beaming. Turns out Ross's thumb is broken, as is Joey's understanding of air quotes.

Chandler falls asleep during a divisional meeting at his office and after he wakes up, he has unknowingly agreed to run the Tulsa office.

Rachel gives up on quieting the baby, as does Phoebe. But in the arms of Aunt Monica, who does a sort of swing-bounce with her, Emma falls fast asleep. Rachel tells Monica her new job is to come over whenever Emma starts crying. Chandler walks in while Emma is sleeping, and whispers to Monica, "We're moving to Tulsa."

Ross comes home with his broken thumb, and when Rachel tells him she never really wanted to marry Joey, he accepts it. He offers to get Emma when she starts crying, but Rachel says it's okay and calls for Monica, who comes running to get her.

Ross isn't happy after Joey questions his punching technique.

- - - - - - - - - - - -

"This just proves no good can come from having sex with Ross!"

PHOEBE

- - - - - - - - - - - -

**COMMENTARY** Neither the cast nor the audience were fond of the Joey/Rachel romance. In a 2019 interview, David Crane said of the arc, "We got a lot of pushback from all the actors. We fought for it. I still love it. Is it wrong? Absolutely, but that's part of what's exciting about it to me, is people making mistakes. It was dangerous and wrong. I remember when Marta and I pitched that arc to both of them and they were like, 'But, she's like my sister.' And we were like, 'Right.' They're like, 'She should be with Ross.' 'Exactly.' But who hasn't, at some point or another, had feelings they shouldn't have? What became clear was it wasn't that kind of love. Joey cares about her so deeply. I know people still resist it, but I loved it."

Crane added, "[Besides], Matt had been doing so many dumb jokes. It gave him the chance to break our hearts a little bit."

# The One with the Sharks

**WRITTEN BY**
Andrew Reich & Ted Cohen
•
**DIRECTED BY**
Ben Weiss
•
**ORIGINAL AIR DATE**
October 17, 2002

After Joey sets Phoebe up on a blind date with a complete stranger, who just happened to be named "Mike," in "The One with the Pediatrician," things could have gone horribly wrong, but surprisingly don't. Phoebe ends up liking the handsome piano player and is just about to go on a date with Mike (Paul Rudd) when Ross mentions how much he envies Phoebe's ability to go "from guy to guy" without it ever getting too serious. Surprised by his comment, Phoebe tries to think of a long-term relationship that she's had, but when she can't, she becomes upset and starts crying, "What's wrong with me?" Her date with Mike ends up being a flop because she can't stop sobbing.

Joey asks out a girl at the coffee shop, and everything is going great until he goes back to her place and realizes that he's been in her apartment before. He remembers the scary painting, the prickly cactus, he even remembers having sex on the big couch and the chair . . . but he can't remember his date. When he tells Rachel and Monica about it, he becomes angry that the girl didn't seem to recognize him either. Rachel doesn't see a problem though: "You're both so slutty, you don't even remember who you slept with . . . you're made for each other!"

• • • • • • • • • • • • •

## "Do you want me to fast forward to something . . . toothier?"

### MONICA

• • • • • • • • • • • • •

Ross tries to fix his mistake—making Phoebe cry on her date—by going to see Mike and explaining what had happened, and asks him not to "blow her off." Mike says they're going out again tomorrow night, but he is concerned that Phoebe has never had a serious relationship. He asks Ross, "Is that true, what you said, that Phoebe's never had a serious relationship?" Ross lies, "Of course she has. If she's never had a serious relationship, you think I'd go around broadcasting it like some kind of unstoppable moron?"

Desperate not to screw this up any more than he already has, Ross tries to cover up by saying Phoebe hasn't had a serious relationship since Vikram ("That's a real name!" Ross insists). When

Phoebe finds out what he did, she becomes furious. She decides to tell Mike the truth—she was not in a relationship with the Oprah-dating, kite-designing, glue-sniffing Vikram. But when Mike shows up, she caves and goes along with the lie.

Monica decides to surprise Chandler in Tulsa by flying there for the weekend. When she walks into his hotel room, he quickly changes the pay-per-view porn he's been watching to a random show about shark attacks. Monica freaks out, thinking he's "molesting himself" to sharks, not women. When he comes home, she decides to be supportive and rents him a shark attack video so she can be a part of it too. "Do you want me to get into the tub and thrash?" Chandler tells her that he had been watching regular porn, not shark porn, and Monica has never been happier.

Joey goes on a second date with Hayley, and he confronts her about not remembering him. She's insulted, but the mystery is solved when Hayley's roommate comes home, and Joey realizes he slept with the roommate and not Hayley. Turns out three's a crowd, and he is quick to say goodnight.

After attempting to spin a tall tale about the lonely Vikram, Phoebe decides just to tell Mike the truth: that she's never been in a serious long-term relationship before. He seems a little worried but kisses her anyway. And she is a little worried about his Magic Marker–sniffing past, but kisses him back. The romantic moment is killed, though, when Ross leaves a message on her answering machine pretending to be the elusive "Vikram."

COMMENTARY So, is Vikram a real name? Of course! It's a fairly popular name for boys in India, and according to Nameberry.com, the name means "valorous." It can be argued that Ross was trying to act with valor when he went to meet Mike, a virtual stranger, to explain to him why Phoebe was so upset.

Though *Friends* is an American sitcom, its popularity is a global phenomenon. According to the Broadcast Audience Research Council, it was the most-watched English-language show in India through the first half of 2016, and it has long resided at the top of the list in the country. The UK also has a massive *Friends* fan base, with the *BBC* reporting that *Friends* is still "the favorite TV program for young people in the UK." And this is in 2019! Of course, most are watching on their phones and laptops rather than their televisions these days. Comedy Central UK even hosts *FriendsFest*, an immersive event to celebrate all that is *Friends,* featuring Monica's and Joey's apartments, series memorabilia, and the opportunity to re-create the infamous "Pivot" scene (see page 130) yourself! The series is also tops for Netflix in Jordan, Latvia, Lebanon, Nauru, Nepal, and Ukraine, according to an analysis by HighSpeedInternet.com in 2017, which ranks *Friends* as number two worldwide for Netflix. And if that's not enough, Kaplan International Colleges performed an international study that revealed the series is "the most popular television show for helping people learn English." So . . . how *you* doin'?

# The One with Phoebe's Birthday Dinner

**WRITTEN BY** · **DIRECTED BY** · **ORIGINAL AIR DATE**
Scott Silveri · David Schwimmer · October 31, 2002

*That moment when you realize you've locked your key AND your baby in the apartment.*

Chandler's office in Tulsa allows smoking, and every single person on his team lights up during their first meeting. He holds out for about three minutes and then starts smoking again too, even though he quit years ago. Monica smells smoke on him the minute he gets home, and they get in a huge fight where she "forbids" him from ever smoking again.

It's Phoebe's birthday, and everyone is going to dinner together, even Ross and Rachel, who have roped Ross's mom into babysitting Emma. But things start falling apart quickly. Joey and Phoebe are at the restaurant, but everyone else is ridiculously late. Rachel doesn't want to leave Emma,

> "I suppose Monica will have the manipulative shrew."
>
> CHANDLER

but Ross insists she go to the restaurant while he waits for his mom. But as he pushes her out the door—closing it behind him—Rachel realizes she left her keys inside, leaving Emma locked inside the apartment alone. Rachel freaks out, and when she finally gets back in, she won't leave Emma. As a compromise, Judy brings the baby to the restaurant so Rachel can join the dinner without being far from her daughter. Monica is ovulating, so she pretends to not be angry about Chandler's smoking to trick him into having sex. Right after they're done though, Monica makes it clear she's still mad, and Chandler realizes he's been conned. ("I feel so used.")

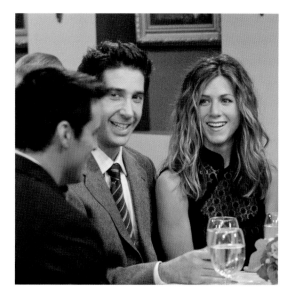

Joey might hurt Ross if he doesn't order dinner soon.

All six Friends—plus Emma and Judy, who park themselves at the bar—are finally settled at the restaurant, over an hour late. Phoebe is furious, especially when Rachel tries to make a toast but gets distracted by Emma's fallen sock from across the room. Phoebe loses it and screams to Judy across the restaurant: "Pick up the sock, pick up the sock, PICK UP THE SOCK!" When Mike calls, saying he got off work early, she takes off to be with him. Ross and Rachel take Emma home, and Chandler and Monica go home to have sex one more time after reconciling. Joey is left with six dinners all to himself, telling the waiters as he tucks in his napkin, "Well, you boys are about to see something really special."

COMMENTARY Judy Geller—played by the brilliant actress Christina Pickles, who viewers also might recognize as Bridget Jones's mother in the hit films—wins for the funniest bit in this episode as she shares with Rachel the story of Ross's separation anxiety as a child. "One time, I was about to leave Ross to go to the beauty parlor, and he got so upset, he took off all his clothes, tucked his willy between his legs, and cried out, 'Mommy, I'm a girl. Take me with you!'"

Despite Judy Geller's obsession with Ross, it was Jennifer Aniston who first caught Pickles's eye as she told *The Guardian*: "I knew Jennifer Aniston would be a huge success from the moment I saw her in rehearsals . . . I just knew I was witnessing a really special actor at work." Pickles's favorite episode is the one where she has a "quickie" in the bathroom with Jack at his birthday party while Monica hides in the tub (see page 73). Those Gellers are kinkier than we initially thought. After all, each of them has made a sex tape at some point during the ten-year run: Monica made one with Richard (see page 210); Ross and Rachel's accidental sex tape generated a whole episode as well as a baby. And finally, Jack and Judy Geller probably didn't intend for their daughter to view their sex tape, which was partially recorded over with the infamous prom video (page 68).

# The One with Ross's Inappropriate Song

WRITTEN BY • DIRECTED BY • ORIGINAL AIR DATE
Robert Carlock • Gary Halvorson • November 14, 2002

Ross gets Emma to laugh for the first time by singing "Baby Got Back" by Sir Mix-a-Lot, and he realizes he's a terrible father. Rachel isn't happy. "You sang to our baby daughter a song about a guy who likes to have sex with women with giant asses?" She tries her hand at making Emma laugh, but nothing works. Rachel finally asks her, "Well, so is it only offensive novelty rap?"

Joey wants to invest some of his *Days of Our Lives* money. After he briefly considers emus, Monica gets him to consider buying real estate instead, and she mentions that Richard is selling his apartment. Joey goes with Chandler to check it out, and while they are there, Chandler spots a tape with Monica's name on it, and they realize it's probably a sex tape. Chandler swipes it from the apartment, and they hightail it out of there.

Phoebe is going to meet Mike's parents—a Park Avenue couple who live on the Upper East Side—for the first time, and Rachel agrees that "she can't be herself." When she meets Theodore and Bitsy, Phoebe puts on an accent that she thinks sounds rich, but Mike tells her to act natural. Unfortunately, Phoebe's real self is not Park Avenue–friendly, and after revealing that she's had hepatitis, been homeless, had a pimp spit in her mouth, and that her mother committed suicide, Theodore and Bitsy are less than impressed. It gets worse when she jokingly punches Theodore in the stomach, and he bowls over from pain since he recently had surgery. "How could you know? Why *wouldn't* you punch me in the stomach?"

• • • • • • • • • •

"When he gets going,
he can rattle a headboard
like a sailor on leave!"

PHOEBE

• • • • • • • • • • • •

Chandler makes Joey watch the videotape of Monica and Richard, and it's so explicit that Joey jumps on Chandler to make sure he doesn't see it. Monica walks in during the middle of it, and she's furious that they stole the tape, claiming it's "sad" that Richard still has it. The tables are turned, however, when Chandler references her "cowboy boots" in the video, and she realizes that the girl on the video is not her. "That bastard taped over me!"

Mike's mom serves veal for dinner, forgetting that Phoebe is a vegetarian. Phoebe tries to eat it, but she ends up throwing up in the coat closet. Mike's parents try to encourage him to date someone else, but he tells them that he loves Phoebe, and she overhears. Phoebe emerges and tells Mike she loves him too.

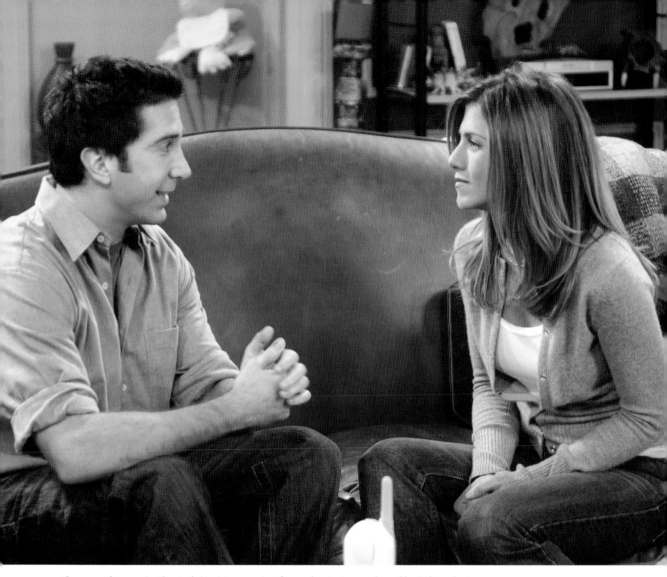

Ross confesses to Rachel that he made Emma laugh by rapping Sir Mix-a-Lot.

**COMMENTARY** Paul Rudd, who plays Phoebe's boyfriend Mike, says in *Friends of Friends,* "Probably one of my favorite [episodes] that I got to do in regard to Lisa . . . was where she meets my parents." Between Phoebe's vocal intonations and the parents' clear discomfort, the episode was an instant classic. And it's obvious why Rudd likes it so much: "There's just nothing funnier to me than awkwardness."

When asked in an interview where he thinks Phoebe and Mike would be today, Paul Rudd answered honestly, "I could see Phoebe and Mike going strong . . . we'd have a family band!" Awesome news from Ant-Man!

An interesting goof in this episode: Monica says that Chandler is jealous of Richard because Richard has a mustache and Chandler can't grow one. However, Chandler had a goatee earlier in the series—seen in both a flashback and in a season 2 episode. Oops!

# The One with Rachel's Other Sister

| WRITTEN BY | DIRECTED BY | ORIGINAL AIR DATE |
| --- | --- | --- |
| Shana Goldberg-Meehan | Kevin S. Bright | November 21, 2002 |

Friendsgiving is here, and Chandler asks Monica to use their wedding china for the occasion. She hesitates because she doesn't want it to break but eventually agrees. While they get dinner ready, Joey sees the *Days of Our Lives* float go by at the parade, and realizes he totally forgot he was supposed to be there and needs to come up with a good excuse.

Rachel's "favorite" sister Amy (Christina Applegate) shows up while they're getting ready. She is in dire need of a hair straightener to use before meeting her boyfriend for Thanksgiving dinner. But when she gets a call that her boyfriend's wife has returned home, Rachel and Ross are stuck with her. They bring her to Monica's, where she begins insulting everyone: calling Phoebe "Emma" (and thinking the name "Phoebe" is just a noise that Phoebe makes), telling Joey that they must put a lot of makeup on him for the show. But she gets really insulted when Ross and Rachel ask Chandler and Monica to be Emma's godparents, claiming *she* should be the one to care for Emma if they die. She looks at Chandler and says, "This guy? Seriously?"

The touching moment for Monica and Chandler ends quickly when Ross explains that if Monica dies, Emma would go to his parents, hinting that Chandler wouldn't be capable of raising her alone. Chandler is reminded of all his own fears about raising a child.

- - - - - - - - - - - - -

## "I want you to know that if I die, you don't get Joey."

### CHANDLER

- - - - - - - - - - - -

Things come to a head between the sisters when Amy finds out that Rachel gets a 45 percent discount at Ralph Lauren while Amy is still paying full retail prices. Amy gets the ultimate revenge when she says, "Your baby isn't even that cute." Rachel demands that she take it back, and when she doesn't, they start fighting in Monica's kitchen, right next to the expensive china. They're slapping each other and messing up each other's hair. Monica screams, "Forget the bubble wrap, there isn't time!" as they quickly put the dishes away, and Joey suggests throwing Jell-O on the fighting girls. Once Rachel breaks a plate, Chandler puts his foot down. He makes them apologize to Monica and to each other, proving that he *can* be a good father figure.

As a compromise, Rachel lets Amy use her Ralph Lauren discount, and they are on good terms again. Chandler, meanwhile, gets the diaper bag to change Emma—empowered by his new "Dad" confidence—but knocks over the entire box of china in the process.

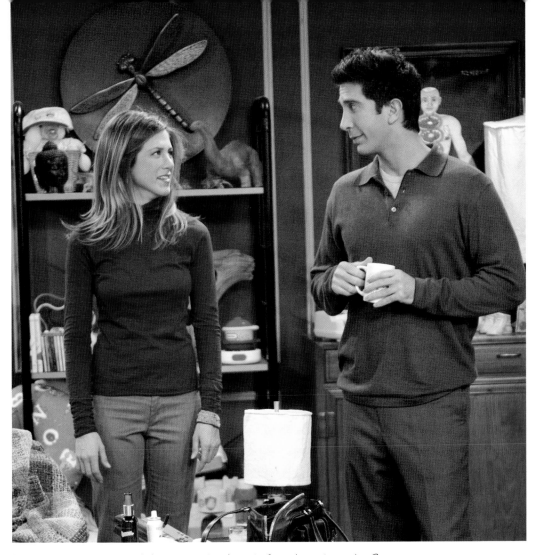

Do you remember when things were happier—before Amy showed up?

**COMMENTARY** Christina Applegate won an Emmy for her performance in *Friends* as Rachel's sister Amy. She was so nervous for the role that she almost fainted right as she was getting ready to knock on Ross and Rachel's apartment door at the beginning of the episode. The famous catfight between Rachel and Amy was really "the highlight of the episode" according to Applegate, and she said they did it again and again until it was perfect.

*Days of Our Lives* plays into a subplot of this episode when Joey forgets he's supposed to be riding the parade float on Thanksgiving Day. But Joey's not the only one on the show with connections to *Days*. Christina Applegate appeared on the soap opera when she was just three months old with her mom, Nancy Priddy, who acted on the show, and Jennifer Aniston's father, John Aniston, is well known for playing the character Victor Kiriakis (since 1985!) on the popular daytime drama.

# The One Where Rachel Goes Back to Work

STORY BY • TELEPLAY BY • DIRECTED BY • ORIGINAL AIR DATE
Judd Rubin • Peter Tibbals • Gary Halvorson • January 9, 2003

Chandler is unemployed after quitting his Tulsa gig in the last episode, and he's looking for a brand new career path. Monica helps him, creating file folders and career suggestions for him to browse through. But it's her first suggestion—advertising—that makes perfect sense for Chandler, and he thinks he can do it. Monica calls one of her friends who works in the field to help him out, and they offer Chandler an unpaid internship.

Maternity leave is cut short when Rachel meets her replacement.

Phoebe is short on cash and Joey offers her a job as an extra on *Days of Our Lives*. Phoebe is excited until she gets on set and is too nervous to do the scene as a nurse. Joey finally tells her she's not an actor, but a nurse who has to save a life. Phoebe buys into becoming the character and nails it, but when they ask her to then play a waitress, she thinks her "fans will be confused." Joey creates an elaborate backstory where she is a single mom with two kids so she can finish the scene. As this waitress, she is fighting with Dr. Drake Ramoray because he slept with her once and never called. When they start to shoot the scene, Phoebe takes the backstory too seriously and slaps Drake Ramoray in the head for being a jerk.

> "Pants off, Bing!"
>
> MONICA

Rachel stops into her office to show off Emma before she returns to work in two weeks. But when she arrives, she finds a guy named Gavin Mitchell (Dermot Mulroney) who has been brought in while Rachel was on her maternity "vacation." Gavin is clearly angling for her job, and Rachel panics. She tells Mr. Zelner (Steve Ireland) she's coming back that day. Gavin is getting ready for a big presentation the next day, and Rachel insists on being a part of it. She gets in early the day of the presentation with Emma in tow to get everything done, but Ralph Lauren moves the meeting so it's in ten minutes. Rachel has Emma for another hour so she can't do the presentation, and she's incredibly upset, thinking she will be forgotten. Gavin, in a moment of empathy, offers to let Rachel do the presentation while he watches Emma. Rachel is touched and starts crying. Gavin tells her crying women make him uncomfortable, and she tells him, "Well, you're not going to like what's coming!"

Chandler needs to tell Monica that he thinks they should postpone having a baby until he gets a little more settled in his career, but she is so focused on having sex that he fakes an orgasm with her until they can have a conversation. Monica is shocked when she finds out that guys can fake it: "Unbelievable. The one thing that's ours!" She convinces Chandler that there will never be a good time to have a baby, and they decide to keep trying.

Phoebe becomes convinced that Joey is jealous of her acting abilities as an extra on *Days of Our Lives*.

**COMMENTARY** This is an important episode for one major reason: we find out what Chandler used to do in his old job. Back in season 4 (see page 104), the girls actually lost their apartment in a bet because neither Monica nor Rachel could identify what Chandler did for a living. Turns out it is the extremely important "statistical analysis and data reconfiguration." Um, could that *be* any more boring? Transponster sounds better.

Dermot Mulroney played Gavin Mitchell, and though he reportedly forgot his character's name until younger fans started to recognize "Gavin" in recent years, he told Fox News that he definitely hasn't forgotten his work on the show, including the steamy balcony scene with Rachel (see page 216).

Phoebe has always had a sketchy relationship with law enforcement, and that's no exception in this episode. In fact, the security guard who tossed her off the *Days of Our Lives* set is played by the same actor who threw her out of the Las Vegas casino (see page 134).

# The One Where Monica Sings

STORY BY
Sherry Bilsing & Ellen Plummer

TELEPLAY BY
Steven Rosenhaus

DIRECTED BY
Gary Halvorson

ORIGINAL AIR DATE
January 30, 2003

Ross sees Rachel kiss Gavin on the balcony and thinks she has moved on without him. He decides to start hitting on women, but he keeps striking out. Rachel, meanwhile, doesn't know what to do. Gavin is a coworker, and she just had a baby with Ross. She calls in sick to avoid Gavin, but he comes to her apartment with soup. She explains to him that there is so much history with her and Ross, and Gavin thinks she needs to be open with Ross.

Joey is getting new headshots and decides to get his eyebrows shaped. Fearing it's too feminine, he uses Chandler's name for the appointment. But as the technician starts to pluck, he freaks out. He ends up getting only one eyebrow waxed, and now "they don't match!" Luckily Chandler used to tweeze his dad's eyebrows for his allowance as a kid, so he's an expert.

Phoebe enlists Monica to support Mike at his gig at the karaoke piano bar. Monica feigns not wanting to sing, but already has her song—"Delta Dawn"—planned for her onstage debut. The audience goes crazy, and Monica is fueled by the boisterous crowd. What she doesn't realize is that the guys are not applauding her song but her see-through shirt, and, as Mike puts it, "bad day not to wear a bra."

> "Single white male,
> divorced three times,
> two illegitimate children . . .
> the personal ad writes itself!"
>
> CHANDLER

A woman walks into Central Perk crying to her friend about not being loved, and Ross sniffs out a date opportunity. He brings her back to his apartment because she has trouble going to the bathroom in public places ("the doody parasites"), and he realizes almost instantly he's made a mistake. She's crazy. Rachel comes home and wants to talk to Ross but stops when she hears a stranger flushing in the bathroom.

Chandler—all finished curling Joey's eyelashes—shows up at the piano bar just in time to see Monica's rendition of "I'm So Excited" by The Pointer Sisters. As Chandler watches her, he turns to Phoebe to confirm, "Are those my wife's nipples?" He jumps up to tell Monica the "naked" truth, but she doesn't seem to care and finishes her encore performance.

Rachel meets Ross's new girlfriend and can see immediately she's not of sound mind. Rachel and Ross then fight about it all: the Gavin kiss on the balcony, the girl in the apartment. But when Ross brings up the "guy at the bar" who called looking for her a month earlier, Rachel gets very quiet. She realizes that Ross not only took the message but never told her. They decide that living together isn't working anymore, and Rachel and Emma move in with Joey for a while.

Monica's karaoke numbers are "sheer" joy for everyone except Chandler.

**COMMENTARY** While Monica can belt out "Delta Dawn" for sure, the show had a few brushes with more iconic musicians over the years. Pretenders singer Chrissie Hynde appeared in season 2 with Phoebe as Stephanie, a fellow musician in Central Perk. Singer Chris Isaak also appeared with Phoebe in "The One After the Super Bowl, Part 1." Casting director Leslie Litt also approached Paul McCartney to play Emily's father. Unfortunately, he was too busy at the time to do it, but he did respond personally to the invitation. And Justin Timberlake reportedly wanted to do an episode of *Friends*, but Marta Kauffman and David Crane couldn't come up with the right role for him. And does Jon Lovitz count as a singer? He appeared twice on the series. While he technically didn't sing on the show, none of us can forget his rendition of "Ladies Night" in Adam Sandler's *The Wedding Singer*, and he's been known to *Sing Your Face Off* as Elton John and Pavarotti in the NBC show. And he can sure play the piano!

And as for the most famous song in the series? Lisa Kudrow revealed in an interview that the lyrics for "Smelly Cat" were penned by the brilliant *Friends* writers, but she came up with the tune for it . . . as well as all of Phoebe's songs through the years.

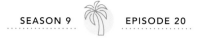

# The One with the Soap Opera Party

STORY BY • TELEPLAY BY • DIRECTED BY • ORIGINAL AIR DATE

Shana Goldberg-Meehan • Andrew Reich & Ted Cohen • Sheldon Epps • April 24, 2003

Joey hooks up his friends with tickets to a one-woman play called *Why Don't You Like Me? A Bitter Woman's Journey Through Life*, but says he can't go because he has to be at work early the next day. The truth, however, is that Joey is hosting his annual *Days of Our Lives* party on the rooftop, and he's too embarrassed to have his friends attend.

Rachel admits she has a crush on Joey after a dream she had, but Monica tells her it's a terrible idea to pursue anything. Rachel listens to a message from a *Days of Our Lives* actor who reveals that Joey is having a party that night. She begs him to invite her, and he agrees but makes her promise not to tell the others.

Ross is dreading having to show two new professors around campus because he thinks they're going to be "old windbags," so he's more than pleasantly surprised when the stunning Professor Charlotte Wheeler (Aisha Tyler) shows up. He tries to leave without the other professor, but Professor Spafford (Ken Lerner) shows up, and he's the exact kind of windbag that Ross was expecting. After listening to a detailed breakdown of his allergies, Charlie finally suggests they ditch him.

> "Oh man, if I had known I was coming to this party, I never would have gotten married!"
>
> MONICA

Rachel pretends to be sick to get out of going to the play so she can go to the soap opera party, but Monica opens Rachel's robe and sees she's all dressed up. Rachel tells them the truth about the party, and when Joey comes over, Monica says, "The game's over. Take off your robe." Unfortunately, Joey was *not* dressed for the party, and everyone sees his (ahem) one-man show.

Almost all of the Friends end up going to the party, but Monica gets so excited that she forgets to tell Chandler about it, and he ends up at the play by himself. Before he can get out of there, the play begins with "Chapter 1. My First Period." Chandler's in the first row and there is no intermission. He's completely stuck.

While Monica gets her bra signed by soap stars, and Rachel collects phone numbers, Ross figures out that Charlie only dates "geniuses and Nobel Prize winners." He thinks she's out of his league, but Phoebe points out that Charlie might be ready to "slum it with some average Joe PhD." Ross goes to find Charlie to ask her out just as Rachel decides she wants to kiss Joey. They both find the objects of their affections kissing each other in a dark corner of the rooftop.

Chandler gets his revenge on Monica and Phoebe by buying them tickets to the one-woman play, citing how much he loved it. He accompanies them into the theater, but just as "Chapter 1" begins, he says, "I can't believe you guys bought that. Enjoy your slow death!" as he races out.

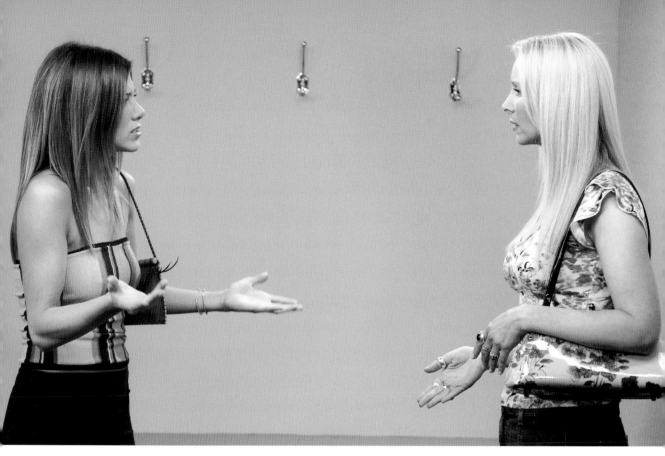

Rachel doesn't understand why her crush on Joey is such a big deal in season 9, episode 22, "The One with the Donor."

**COMMENTARY** This is the episode where we meet Charlie Wheeler, played by the incredible Aisha Tyler. Tyler might not know anything about dinosaurs, but she is a published author in her own right and has a degree in government from Dartmouth. She told *InStyle* that right before she went onstage for the first time, Matthew Perry said to her, "Get ready for your life to change," and she admits he was right. Her appearance made *Friends* history, since Tyler was the first black woman cast in a recurring role (nine episodes) on the series. She also noted that "the role wasn't written as woman of color," and when she auditioned, she "read against women of every ethnic background."

Want the scoop on what Joey looks like naked? In *Friends of Friends*, Tyler uncovered the truth: when Matt LeBlanc opened his robe in that . . . er . . . *revealing* scene early in the episode, he was actually wearing boxer briefs with a headshot of David Schwimmer taped to the front, which gave everyone in the audience—as well as the cast—a huge laugh.

If you are a fan of *The Marvelous Mrs. Maisel*, you might recognize the star of the one-woman play, *Why Don't You Like Me?* Emmy-award winning actress Alex Borstein also plays Midge's agent, Susie Myerson, on the hit show, and she's the voice of Lois Griffin on *Family Guy*.

# The One in Barbados, Part 1

**WRITTEN BY**
Shana Goldberg-Meehan & Scott Silveri
•
**DIRECTED BY**
Kevin S. Bright
•
**ORIGINAL AIR DATE**
May 15, 2003

The whole gang, including Charlie and David, goes to Barbados to see Ross give his keynote speech at a paleontology conference. David has returned from Minsk to stay, and the timing is perfect because Phoebe and Mike have broken up. David and Phoebe start seeing each other again, but she keeps accidentally calling David "Mike," and David is desperate to help her forget about her ex. When Chandler inadvertently gives David advice telling him to let Phoebe know he's "open to marriage," David misconstrues it, and decides to propose. Monica figures out a way to fix Chandler's "bad advice" and calls Mike to tell him about David.

Ross reads his keynote speech to Charlie, who tells him he's

*Joey is blown away when he realizes that Rachel might be into him.*

going to be the "hit of the conference," but when Chandler tries to open naked pictures of Anna Kournikova on Ross's computer, he accidentally deletes the entire speech. Ross is furious, and not just about the speech. "Nude pictures of Anna Kournikova? She's never even won a major tournament!" Charlie offers to help rewrite the speech, and the chemistry between them is palpable. For the first time in a while, both Ross and Rachel are lusting after people (Charlie and Joey) that aren't each other.

At dinner, David is just about to propose to Phoebe when Mike walks in. Mike proposes to Phoebe before David can, but she says no. She loves him, but she never "needed" a proposal. They are back together, and David makes his graceful departure: "Perhaps if I hadn't gone to Minsk, things would have worked out for us, and I wouldn't have ruined my career, or lost that toe to frostbite."

> "You don't own a TV? What's all your furniture pointed at?"
>
> JOEY

Monica's love for Chandler knows no bounds. And apparently, neither does her hair.

**COMMENTARY** David almost has his shining moment in this episode after a dreary eight years in Minsk, but he loses to Mike in the end. Turns out the original plan was for Phoebe and David to end up together, as Hank Azaria revealed in an interview with *Huffington Post*. "No, I didn't know that was the end of David. The plan always was kind of to bring him back." Azaria was admittedly "sort of sad" but says that Rudd "certainly has gone on to prove that he was comedically deserving of Phoebe's love." Azaria isn't at all bitter, though, adding, "He shouldn't really be allowed to be that handsome." Turns out Rudd and Azaria are pals in real life, and in an interview with the Television Academy Foundation, Azaria says, "I'm friends with Paul Rudd, and I still give him shit about that." Don't worry, Hank, when Lisa Kudrow was asked which of her boyfriends on *Friends* was her "personal favorite," she said she'll always have a "soft spot" for David.

# The One in Barbados, Part 2

WRITTEN BY • DIRECTED BY • ORIGINAL AIR DATE
David Crane & Marta Kauffman • Kevin S. Bright • May 15, 2003

The sun is finally out for a brief moment, but no one can enjoy it because Ross is giving his keynote speech this morning in Barbados. He is indeed the hit of the conference as predicted, and even manages to find a more-than-adoring fan in Jarvis Oberblau (John Balma), who looks dreamily at Ross even as he introduces him to his wife.

Monica's hair is "inexplicable," as Chandler describes it, and there is more than one reference to Diana Ross. But it gets even worse when they head down to the game room to play ping-pong despite Chandler's protests: "You know how competitive you get, and while I say it's cute, others disagree, and I'm lying!" But in a surprising character reveal, it turns out Phoebe landed herself a competitive fella in Mike: "Oh, by the way, um, I'm awesome." Game on.

Charlie and Joey realize that they have had fun on the trip, and Charlie wonders, "Is it weird that it's not with each other?" They decide to break up. But all is not lost for Joey, because when he tells Rachel about the breakup, she coyly reveals, "Maybe you're *not* always going after the wrong girl." It takes Joey a few minutes to figure out who Rachel is talking about, but he finally does and tells her he's "as curious as . . . George," but he can't have a relationship with her because of Ross.

> "You agreed to take me in sickness and in health . . . Well, this is my sickness!"
>
> MONICA

The only thing higher than Monica's hair are the stakes in the ping-pong game. With a tie score, next game wins; Mike is holding his own, but he needs to work on his trash talk. "Better comebacks, Mike, better comebacks!" Monica injures her hand and can't finish the game, but

COMMENTARY Chandler stepped in to take over Monica's "sickness" by playing the final game point, but his character isn't the only ringer. As Kevin S. Bright notes in the DVD commentary, "Matthew Perry used to be an amateur tennis player as a teenager. He was really good and actually is the only ringer here as far as being a good paddle tennis player." There were professional table tennis players on set to help Courteney Cox and Paul Rudd learn the proper moves, but the other episode challenge came from writing Ross's keynote speech. "We know nothing about paleontology," says co-creator Marta Kauffman. "Nothing!"

The ending scene where Joey walks very thoughtfully to Rachel's room was intentionally shot on the soundstage without a live studio audience, according to co-creator David Crane. "We wanted it to be a sexy moment." Even the song selected for the scene, Interpol's "Untitled," seems to match the loaded moment perfectly. Bright notes, "The music I think does what the scene does. It sends a little bit of a chill."

Chandler steps in for her and wins the game point. After calling Mike "Loser!" Monica suggests she and Chandler enter doubles tournaments.

Charlie tells Ross that she broke up with Joey and admits she has feelings for him instead. Their conversation is interrupted by the pasty paleontologists who want to honor the tradition of throwing the keynote speaker in the pool. Ross and Charlie run and hide, and while they huddle behind a potted plant, they kiss. Joey catches sight of them, and without another word, he goes back to Rachel's room and kisses her, to which she responds, "Oh."

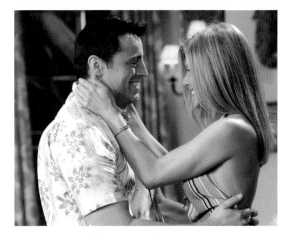

*Joey and Charlie broke up!*

## The Crush Tracker

A visual diagram of the progression of love interests in this episode:

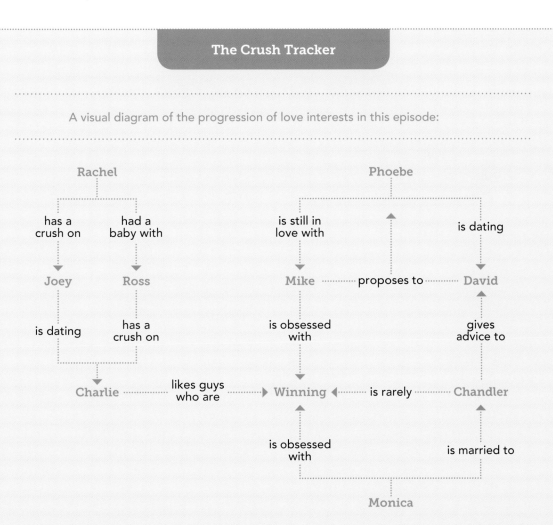

Rachel
- has a crush on → Joey
- had a baby with → Ross

Phoebe
- is still in love with → Mike
- is dating → David

Mike ·········· proposes to ·········· David

Joey
- is dating → Charlie

Ross
- has a crush on → Charlie

Mike
- is obsessed with → Winning

David
- gives advice to → Chandler

Charlie ·········· likes guys who are → Winning ◄ is rarely ·········· Chandler

Winning ← is obsessed with — Monica

Chandler ← is married to — Monica

# Season Ten

In the final season, Joey and Rachel decide to remain friends after considering something . . . more. Ross's girlfriend, Charlie, realizes she is still in love with her ex, and they break up.

As for other love stories, Phoebe and Mike get married. And Monica and Chandler, still working to start their own family through adoption, meet Erica, who gives birth to twins in the series finale. Joey ends up single—but with his own spin-off show, *Joey*, where he will find more than enough romantic encounters to help him get over Rachel.

Rachel accepts a job offer and decides to move to Paris, without even saying goodbye to Ross. In his upset, he confronts Rachel and . . . they end up in bed together. Again. This doesn't deter her from moving to Paris, and she gets on the plane anyway.

Soon after, Rachel appears at Ross's apartment door, telling him she still loves him, and they share their final onscreen kiss, leaving fans breathing a sigh of relief and feeling complete.

**ABOVE** From season 10, episode 8, "The One with the Late Thanksgiving."

**OPPOSITE** Season 10 marks the beginning of the end. After all, this is a year that we will see Chandler become a father, from episode 17, "The Last One, Part 1."

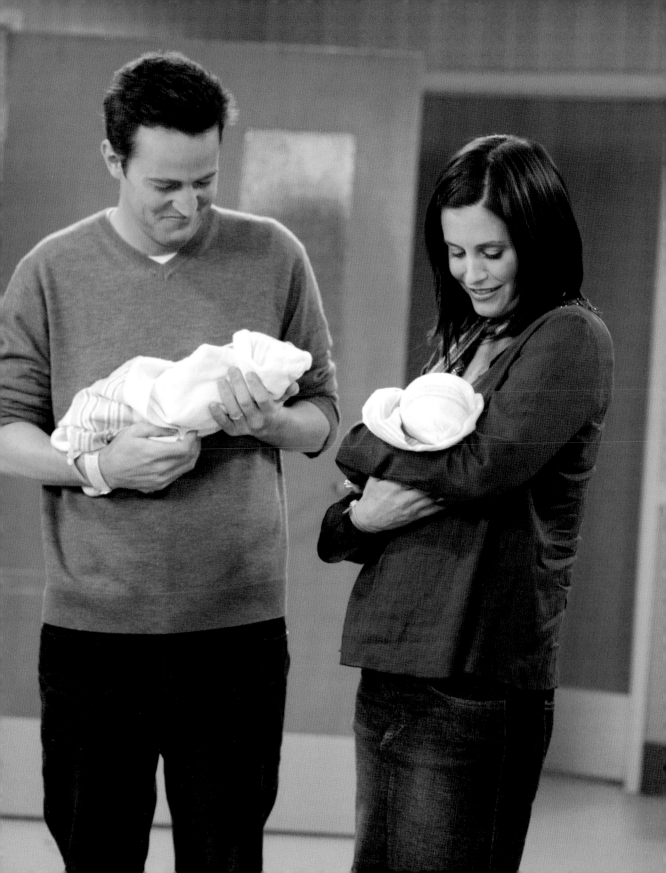

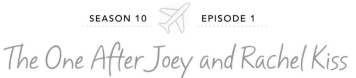
# The One After Joey and Rachel Kiss

**WRITTEN BY**
Andrew Reich & Ted Cohen

**DIRECTED BY**
Kevin S. Bright

**ORIGINAL AIR DATE**
September 25, 2003

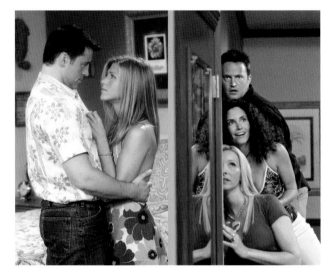

*Turns out there was no privacy before smartphones either.*

Season 10 opens in Barbados with Monica, Chandler, and Phoebe in Monica and Chandler's hotel room. Although Monica's frizzy hair hasn't changed, almost everything else has. The three overhear Ross and Charlie kissing in the room next door and think Charlie's cheating on Joey. Phoebe takes the moral high ground, "I'm not going to eavesdrop on my friend," until she hears Rachel and Joey from the room on the opposite side. They take turns "manning" the two walls, with all of them clearly enjoying the "free porn," as Phoebe calls it.

Ross, unaware that Joey is making out with Rachel, wants to make sure Joey is okay about what's happening between him and Charlie. He goes off in search of his friend. Charlie starts watching a movie, which Chandler recognizes as *Miss Congeniality*. Monica takes him down: "Honey, if you know it through a wall, you know it too well."

Chandler, Monica, and Phoebe must pretend not to know anything about Joey and Rachel when Ross comes into the room looking for Joey. "He's probably in his room with this current girlfriend, Charlie," says Chandler. "That's the situation as we know it."

Ross can't find Joey, but he finds Rachel (who also suddenly can't find Joey) and fills her in. When Ross leaves, Joey comes in from where he'd been hiding in the next room, along with the three eavesdroppers. Phoebe asks what's going on. A frustrated Rachel lets them know, "We kissed for ten minutes and now we're talking to our friends about it, so I guess this is sixth grade."

When they shake their audience loose, Rachel and Joey try kissing again, but each envisions Ross in the other's face. Before the group leaves Barbados, Monica gets her frizzy hair tamed into cornrows and Ross enjoys dirty talk from Charlie, in the form of calling him "Dr." and "PhD."

On the plane, Mike tells Phoebe he has a girlfriend and "can't do anything tonight" until he breaks up with her. Ross and Joey are finally supposed to talk as well. Ross lets Joey know about Charlie, and thanks Joey for being so honorable and generous in his reaction. Joey revels in the praise and

> "So I guess this is sixth grade."
>
> RACHEL

*Don't you hate it when your braids get caught in the shower curtain?*

passes up his opportunity to tell Ross about Rachel. Rachel thinks it's done, which leads to momentary confusion when she runs into a beaming Ross and wants to make sure he's okay. "Are you kidding?" he responds. "I have had some very dirty dreams about this."

Over at Ross's apartment, Rachel tries to tell Ross about her and Joey, but a "major shampoo explosion" interferes. Phoebe's lighting candles as she waits for Mike in his apartment, when his girlfriend, Precious (Anne Dudek), pays a visit. She tells Precious what happened with her and Mike, including his proposal. When Mike walks in, Precious slaps him, tells him she doesn't need him, and high tails it out. Phoebe says, "You're welcome."

Rachel and Joey resign themselves to one more night without being together, but in the end they can't resist the attraction, and lose themselves in a passionate kiss. Suddenly, Ross is at the door, horrified at what he sees.

COMMENTARY As season 10 began, the creators and producers knew it would be the last. They also knew Rachel and Ross would end up together. As co-creator David Crane put it, "We had dicked the audience around for ten years with their 'will they or won't they,' and we didn't see any advantage in frustrating them."

Marta Kauffman told *Entertainment Tonight* about the widespread interest in a Ross and Rachel relationship reunion. "My rabbi would stop me when I would drop my kids off at Hebrew school saying, 'When are they going to get together?'"

Beginning season 10 still in Barbados, with Rachel in Joey's arms in one room and Ross in Charlie's arms in another, they had only eighteen episodes to get them back into each other's.

Kauffman says the idea for the great, overarching love story between Ross and Rachel hadn't been there from the beginning. "Ross used to have a crush on Rachel. We didn't know that was going to be the central romance of the series. It was just chemistry. It was just seeing the two of them work together and just something magical happened."

# The One Where Ross Is Fine

**WRITTEN BY**
Sherry Bilsing & Ellen Plummer
·
**DIRECTED BY**
Ben Weiss
·
**ORIGINAL AIR DATE**
October 2, 2003

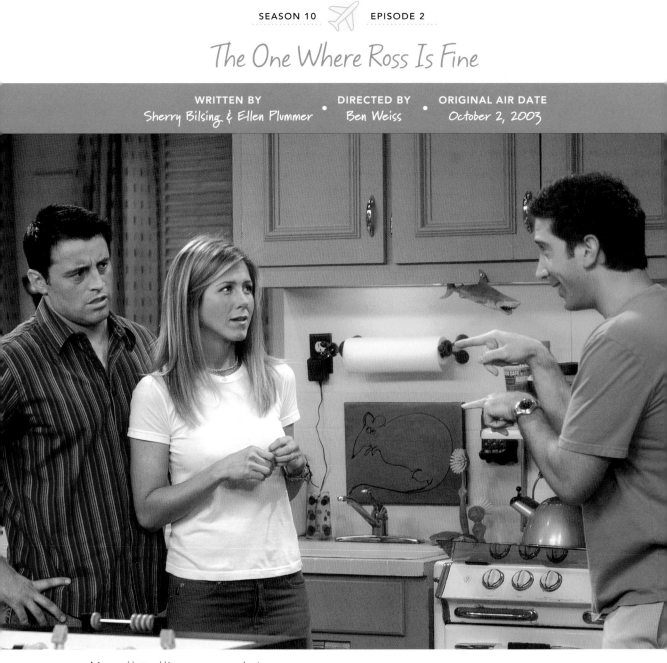

Margaritas with your ex = not okay.

We pick up where we left off, in Joey and Rachel's apartment, where the new couple has just been exposed by Ross. But Ross is completely *fine*. He's even going to make fajitas for a double date with Rachel and Joey, him and Charlie. That won't be the least bit awkward. At the dinner party, Ross hugs Charlie and Joey, then tells Joey, "Oh, you're gonna have to introduce me to your new girlfriend. Just kidding; I know Rachel, I know . . ."

Meanwhile, Monica and Chandler are working on their adoption at Central Perk. Or rather, Monica is working on it: "There's so many ways to go. This is like the biggest decision of our lives." Phoebe says she can connect them with her friends Bill and Colleen, who adopted a child and might be able to offer guidance. Phoebe's brother, Frank Jr., comes into Central Perk with the triplets, Frank Jr. Jr., Chandler, and Leslie. He looks about as "fine" as Ross is, and says he "hasn't slept in four years." He wonders if Phoebe could take one of the triplets for him.

At Bill and Colleen's house, Colleen gives Monica a cross-referenced, color-coded notebook to help guide them through the adoption process. Monica is so thrilled with the book she won't let Chandler touch it without washing his hands first. But things take a disastrous turn when Chandler runs into the couple's child, Owen. They're having a lively conversation in the hall until Chandler says he should get back to the conversation with Owen's parents about "how they adopted you." Owen didn't know he was adopted, and Chandler's "got nothing." (He also later ruins Santa Claus for the boy, and tells the triplets Phoebe gave birth to them.)

Could we *be* any more uncomfortable? Apparently, yes, because there's Ross, drinking a pitcher of margaritas by himself, who says, "There's no weirdness, no tension . . ." Rachel adds, "No awareness." Enter Ross carrying a plate straight from the oven without oven mitts. Later, Ross decides, "Everyone would feel better if we had some FLAN." Charlie and Rachel leave, separately, one immediately after the other. Joey decides to stay the night. It's clear Ross is anything but fine, and Joey understands why: "You're Ross and Rachel." Ross is more realistic: "Except we're not." But after a little thought, he comes around to embracing change: "Maybe it's time we all moved on."

. . . . . . . . . . . . . . .
# "I think I just had a tiny orgasm."
## MONICA
. . . . . . . . . . . . . . .

**COMMENTARY** Fajitas, family secrets, and triplets—oh my!

When it comes to women, Joey makes a lot of things look easy, but falling for Rachel wasn't easy for actor Matt LeBlanc. Kevin S. Bright comments on the challenge of this arc. "When you go out with your best friend's ex-girlfriend, it's really a tough place for a guy to be. I think he made that identifiable and gave it some honor. It could've been very sleazy in the hands of another actor." As Matt LeBlanc imbues Joey with honor, the audience gets to see his character growing up. Other cast members had embraced adulthood to varying degrees already, but when Joey starts acting like a grown-up, you know you've really entered a new phase. And that beginning is also

an end. Co-creator Marta Kauffman explains, "This is part of why the show had to end. This was no longer that time in your life when your friends are your family. You're starting your own family."

Except we know Ross and Rachel won't be going separate ways. Would Rachel and Ross have departed from where we leave them at the end of season 10? In a 2012 interview for the *Hollywood Reporter*, Jennifer Aniston posited where she thinks Rachel and Ross would be eight years on from the end of the show. "They're absolutely, 100 percent together. They have more kids!"

What about Monica and Chandler? Bright muses, "I imagine that after they had the surrogate twins, Monica did get pregnant after all, and they had a third child, so they have a wonderful family."

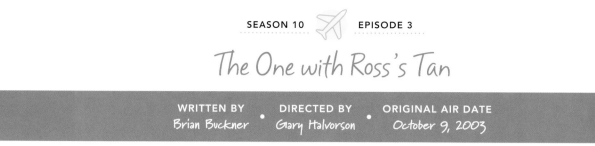
# The One with Ross's Tan

**WRITTEN BY** • **DIRECTED BY** • **ORIGINAL AIR DATE**
Brian Buckner • Gary Halvorson • October 9, 2003

Episode 3 opens with Joey telling Chandler about his plans for the evening. He has his "first official date" with Rachel. Chandler marvels at the confidence Joey has with women. "What must it be like not to be crippled by fear and self-loathing?"

Meanwhile, in Central Perk, #AwkwardSiblingMoment alert when Ross is caught staring at Monica's legs. But what catches his attention is her tan. Monica gives him her salon card so he can get sprayed too. Ross's experience at the tanning salon is one of the all-time greatest scenes in *Friends* history. When asked what shade Ross wants (one, two, or three), Ross picks two. Sounds reasonable. The problems start when Ross counts to five Mississippi-style, which is too long, and he gets sprayed twice on the front, and not at all on the back. ("I'm a four?")

An old friend who was never actually a friend, Amanda (Jennifer Coolidge), is back in town with a fake British accent, making her even more insufferable. Monica tries dodging her, but ultimately agrees to meet her along with Phoebe at Central Perk because she "can't say no twice." She comes up with an escape plan. She'll get a fake phone call and say Chandler and Mike got into a car accident.

At Central Perk, Monica and Phoebe have to touch Amanda's abs and smell her neck. "It's not perfume," Amanda says, absolutely dazzled by herself. "It's me." When Amanda says she's happy "you two are friends again," she exposes a time Monica never knew about when Phoebe was "kinda" gonna cut her out. Amanda says she feels "like a perfect arse." Phoebe has the perfect response: "Well, in America, you're just an ass." A hurt Monica follows through with the plan about the accident, except she leaves Mike out of it, sticking Phoebe alone with Amanda. Monica and Phoebe make up later in a private moment in the hallway. Phoebe admires the "scrappy" way Monica "clawed her way" back into Phoebe's life.

Rachel and Joey aren't having any more luck than anyone else this episode. They try kissing, but Rachel keeps (involuntarily) slapping Joey away. Joey can't unclasp her bra, even though he's an expert. Monica gives Rachel a little pep talk, and Rachel decides to try again with Joey. They will "power through." They've got champagne and candles, and Rachel takes her own bra off. Things are going okay, with Rachel on top of Joey on the BarcaLounger, until she accidentally knees him "in [his] misters."

Rachel and Joey sit next to each other on the couch, wondering why they can't be like Chandler and Monica, transitioning from friends to lovers. Joey offers a moving explanation: "I guess they weren't as good friends as we are."

> "Did you count
> Mississipily?"
>
> ROSS

A bromance characterized by beer, Baywatch, and BarcaLoungers . . . oh and foosball, of course.

**COMMENTARY** The tanning scenes are classic Ross: arrogance on full display, met with a swift comeuppance. "Well, I have a PhD, so . . ." he says in reply to the attendant's offhand, "You catch on quick." Yet, as soon as he's in the booth, this PhD who so self-assuredly summarized the instructions moments earlier—"Spray, count, pat, then turn, spray, count and pat"—can't manage to follow them. The scenes are not only classic Ross, but also classic humor, where, according to some philosophers, we laugh when we are made to feel superior to others. Ross is indignant when he realizes he was supposed to count somewhat rapidly to five, not wait five full seconds (which is what would happen when inserting the word "Mississippi.") "Mississippilessly?" he sputters to the attendant before going back in to even things out. Again, he fails miserably, and comes out with four twos on his front. "I'm an eight!" he shrieks.

Yet, the PhD—or "Miss Hawaiian Tropic"—hasn't learned his lesson. He returns to even out his tan (his front may be an "eight," but his back is as pale as ever), and when a different attendant starts giving him instructions, he has the nerve to cut her off. "I'm going to stop you right there, Glenda. Okay? Does it look like this is my first time?" Once again, Ross's overconfidence is met with comic justice when he's put in a different room with two sets of nozzles and, amazingly, manages to get two more twos on his face and chest. Was he wrong about evolution?

About David Schwimmer's physical humor, Kevin S. Bright reported, "The thing that appealed to us about David was his quirkiness in terms of his timing." He decided to give David more physical comedy after the pilot when Ross fumbles with his umbrella after talking to Rachel for the first time in years.

As for Rachel and Joey, the touching moment side-by-side on the couch at the end of the episode calls to mind a comment Matthew Perry made about "The One with the Proposal." "This show isn't afraid of going for emotional moments," Perry recalls, of the proposal itself. The statement applies equally well to Rachel and Joey, failed lovers but as close as ever in this emotional moment.

# The One with the Birth Mother

WRITTEN BY
Scott Silveri
•
DIRECTED BY
David Schwimmer
•
ORIGINAL AIR DATE
January 8, 2004

Monica and Chandler are off to Ohio to meet a possible birth mother, Erica (Anna Faris). She knows them only by an anonymous number and apparently has the wrong file, mistaking them for another couple—a doctor and a reverend. Monica and Chandler decide to pretend they're a doctor (Chandler) and reverend (Monica) in the hopes of being chosen. Monica's thrilled when Erica does choose them, but Chandler's not comfortable with the con. "This woman is giving away her child. She deserves to know who it's going to." After a bit of persuading, Monica agrees, but she's still sad. "Why couldn't I have been a reverend?" she asks. Chandler's response is, "You're Jewish," which she dismisses as a "technicality."

Presenting Dr. Chandler and Rev. Monica Bing.

Meanwhile, Phoebe agrees to give Joey the number of her friend Sarah, persuaded by Rachel's testimony that, based on the week she and Joey dated, he has grown up and is no longer immature with women. Sarah and Joey go out to eat and things take a nightmare turn when Sarah grabs a few fries off Joey's plate. To say he's outraged is an understatement. Later, when discussing the incident, Rachel says she knows "Joey doesn't share food." He apparently wouldn't even let baby Emma have a grape from his plate. Phoebe comes up with the plan of ordering some extra food next time, a "sharing buffer," as Joey calls it.

Rachel and Phoebe take Ross shopping so he will look "cool" for an upcoming date, but nothing in the store appeals to him. Rachel gets Ross to "trust her" and let her pick out some outfits. A bag gets switched, but Ross doesn't notice and dons an outfit Rachel had bought for herself. When he swaggers into Central Perk, he's met with an odd reaction from Joey. "Someone's afraid of a little competition with the ladies," quips Ross. "Looks like someone *is* the ladies," says Joey. Later, Ross and his date are wearing identical outfits; only then does he realize what's happened. They call it off.

> ● ● ● ● ● ● ● ● ● ● ●
>
> ## "JOEY DOESN'T SHARE FOOD!"
>
> ### JOEY
>
> ● ● ● ● ● ● ● ● ● ● ●

Joey tries another dinner with Sarah, this time ordering extra fries for the table. Sarah takes a fry, but seems especially drawn to Joey's stuffed clams. When she reaches for one, Joey intercepts her hand. Trying to keep his plate out of reach, he ends up dumping the entire meal on the floor. His food rules do *not* preclude eating food that fell on the floor.

Chandler and Monica return to the birth mother, and Chandler tells her the truth. Erica is upset with the cha-

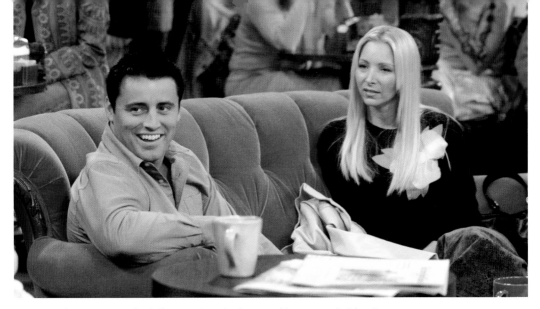

Joey convinces a skeptical Phoebe to set him up with her hot friend.

rade and decides the deal is over, but Chandler follows her and makes a heartfelt plea. "I love my wife more than anything in this world. And it . . . it kills me that I can't give her a baby." If that isn't tear-jerking enough, he goes on, "She's a mother . . . without a baby." Erica changes her mind, and Chandler returns to tell Monica the good news.

At Central Perk, Joey and Ross, both unlucky in love (or maybe just in food and clothing), share a muffin. Scratch that, because "Joey doesn't share food!"

**COMMENTARY** "The One with the Birth Mother" is a prime example of serving up not only a dish of extra fries but also the mix of absurdity and poignancy *Friends* fans love best.

Once again, Ross, the expert who corrects others with extreme condescension, is totally unaware of his own reality. He knew that *Homo habilis* wouldn't use clay pots, but he doesn't know when a male *Homo sapien* is wearing clothes meant for the other gender. Even when Joey openly ridicules him, Ross mistakes mockery for jealousy. It takes something as blatant as his own date wearing the identical outfit for him to recognize what's going on.

When Phoebe is skeptical about setting Joey up with another friend (things hadn't gone well in the past), Rachel assures her he's more mature now. We never get a chance to see if that's true

when it comes to loyalty in a relationship, because we can't get past the food plundering scenes. ("Food is a passion of his as much as women," says Matt LeBlanc of Joey's character.)

But the main story arc of the episode shows that the characters are in fact growing up and getting ready to move on. Although Monica and Chandler won't return from Ohio actually carrying a baby, as Joey expected, they are definitely beginning a new stage in life. The young adult era is coming to an end, and with it, the series as a whole, given that it was conceived as a show about that specific time in life. "Everybody was growing up," co-creator Marta Kauffman told *Entertainment Weekly* about bringing *Friends* to a natural end. This is also the last of ten episodes directed by David Schwimmer.

# The One Where the Stripper Cries

**WRITTEN BY**
David Crane & Marta Kauffman
•
**DIRECTED BY**
Kevin S. Bright
•
**ORIGINAL AIR DATE**
February 5, 2004

Joey's going to be a celebrity guest on *Pyramid*, one of Ross and Monica's favorite game shows from childhood, but no one can go watch. The ladies will be busy with Phoebe's bachelorette party, and Chandler and Ross have a "stupid college alumni thing."

At the Class of 1991 reunion, Chandler and Ross spot the lovely Missy Goldberg (Ellen Pompeo). Ross wonders if he should ask her out, which means breaking "the pact." We flash back to 1987, when Chandler and Ross (both with unbelievably unflattering eighties hair) each express interest in Missy, whom they invite to come see their band, "Way! No Way!" They

*The members of 1987's hit band "Way! No Way!" make a pact.*

"make a pact" that Missy is off-limits to both, thus securing their friendship. At his reunion party, however, Ross and Missy arrange a date, and the conversation is going well until Ross finds out Chandler broke the pact—in the science lab!—back in college.

On the set of *Pyramid*, Donny Osmond introduces the contestants. Joey can't seem to stop saying the words he's supposed to get his partner to say; the buzzer lets us know he's messing up big time. When Joey's in the opposite position, he fares no better. Not sure "Paper, snow, a ghost!" are things most people put their coffee. And the "earth" is a resounding no. Joey's third round is the worst yet, but somehow, he's advanced on to the winner's circle.

Phoebe's disappointed with the elegant bachelorette tea party at Monica and Chandler's place. She'd been picturing "pee-pees flying about." After trying to convince Phoebe the flowers and tea really are the whole party, Rachel caves and pretends there really is some kind of dirty entertainment on the way.

The last-minute entertainment, Officer Goodbody (Roy), is of course Danny DeVito, coughing from exhaustion as he enters the apartment from the stairs. His was the first name they found in the phone book. Roy starts thrusting, but not without a warning that he has a "concealed weapon." He starts his music and begins to dance, but catches a cringe on Phoebe's face and connects it with an insulting comment she made earlier. He says he'll leave, he just wants his $300. Rachel's happy to pay, but Phoebe doesn't think it's right given that he "didn't

> "Yeah, sorry boys, this ride's closing."
>
> PHOEBE

do anything." Phoebe's stuck on his age, wondering if he actually means "old man" when he says, "all man," referring to his crotch. Roy is devastated. "The hunk of beef has feelings."

Ross confronts Chandler about the broken pact, and we flash back again, this time to a party Rachel and Monica attended. Apparently, Ross had broken the pact too, with Adrienne Turner. Ross thinks they're even, but Chandler has another big reveal. He was hurt the night he caught Ross with Adrienne, and wanted to get back at Ross, with his favorite person. That night, he and Rachel kissed.

Roy the stripper realizes it's time for him to move on, but Monica, Rachel, and Phoebe all feel for him, and ask him for one last dance. It may have been a bit too much for him (he ends up needing to go to the hospital), but the most disturbing moment of the show is finding out that Ross and Monica kissed the night of the party in 1987, Ross thinking he was kissing Rachel "for the very first time" and Monica only knowing the guy as "Midnight Mystery Kisser."

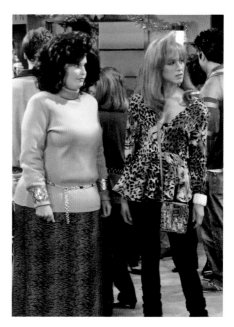

*First college party for these two high school hotties!*

**COMMENTARY** A killer celebrity guest star, Joey shouting out answers that could not be more wrong, and amazing flashbacks full of "unfortunate hair"—this episode has so much of what fans love about *Friends*. But it may have had a little less of Danny DeVito than the legendary actor would have liked. Apparently when he played stripper Roy (Officer Goodbody)—the "long arm of the law"—he had hoped to show a little bit more of that length.

When Jennifer Aniston appeared on the cover of *GQ's* March 2009 issue wearing only a necktie, she referred to the incident as "a Danny DeVito moment." Only she wasn't referring to DeVito's striptease. Instead she was admitting to drinking during the shoot, referring to DeVito's unusual appearance on *The View* in 2007. The actor showed up apparently hungover from a wild night with George Clooney. "I knew it was the last seven Limoncellos that was going to get me," he told Barbara Walters and the others.

Besides DeVito, "The One Where the Stripper Cries" has another famous face now. Though she starred in the 2002 film *Moonlight Mile*, and had other roles on screen and film, most fans watching Ross and Chandler's college reunion probably did not recognize Ellen Pompeo, who played Missy Goldberg. (She's the one who made out with Chandler back in college, despite the infamous pact.) A year after *Friends* ended, in the spring of 2005, ABC premiered a mid-season replacement, a little medical drama known as *Grey's Anatomy*, starring Pompeo. The rest is history. (Actually, it's not history yet, but renewed in May of 2019 for another two seasons.)

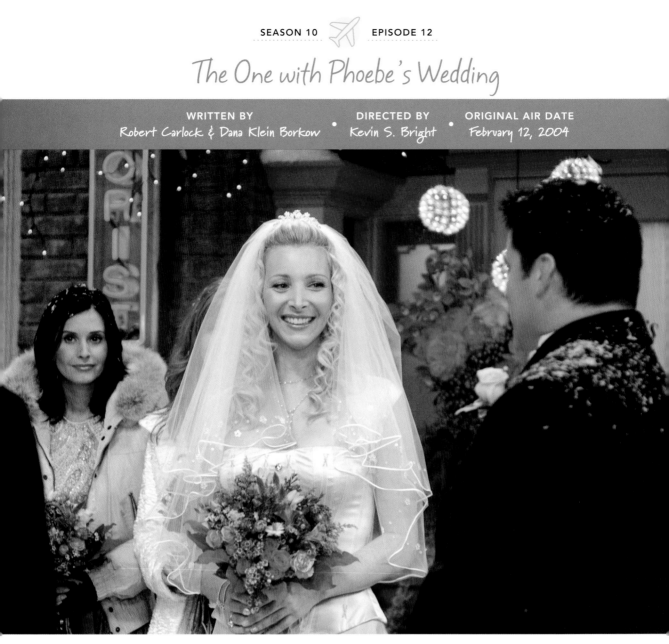
# The One with Phoebe's Wedding

| WRITTEN BY | DIRECTED BY | ORIGINAL AIR DATE |
|---|---|---|
| Robert Carlock & Dana Klein Borkow | Kevin S. Bright | February 12, 2004 |

Even though the cold has spread to his "special place," Joey still marries Phoebe and Mike during a New York City blizzard.

Everyone helps Phoebe get ready for her big day. Since her stepfather stabbed someone in prison and can't walk her down the aisle, Joey agrees to step in. Monica helps too, redefining what it means to be a Type A psychotic wedding planner. Chandler has promised "no stupid jokes."

Ross and Chandler are bummed they weren't asked to be groomsmen, but when one of Mike's friends drops out, they compete for the open spot. Phoebe asks Rachel to choose. Ross convinces her to pick him, but then Chandler busts out a sob story ("Make *groom* for Chandler"), and she

chooses Chandler. She flip-flops between both friends and ultimately can't decide, and Mike finally decides to have his family dog, Chappy, fill in for the missing groomsman.

Monica, meanwhile, is taking her compulsive, controlling behavior to a whole new level at the rehearsal dinner. She's dropped vegetarian dishes from the menu (informing Phoebe by fax), cuts bathroom breaks ("Pee on your own time, Mike!"), and interrupts Phoebe's own wedding toast. Phoebe loses it, and screams, "You're fired!" before adding "Cheers!" to close out the dysfunctional toast. A hurt Monica hands the entire wedding over to Phoebe, who is quickly overwhelmed by mounting disasters: an orchid crisis, a mis-delivered ice sculpture, no food, and a missing bartender. Phoebe finally breaks down and begs Monica, "I want you to be crazy bitch again." Monica is touched by her words.

A wedding day blizzard effectively shuts down the city, and Rachel suggests that Phoebe and Mike just get married outside in the snow, giving Phoebe the simple ceremony she always wanted. Drill sergeant Monica gets the whole affair in order, but when the minister gets snowed in, Joey steps in to officiate the ceremony even when he claims the "cold has spread to my special place," and Chandler is left to give Phoebe away. Ross gets to walk Rachel down the aisle, but he has to carry a stinky Chappy with him. Mike and Phoebe exchange their own vows in a beautiful ceremony at the end of which Phoebe says gleefully, "I got married! Could someone get me a coat? I'm frigging freezing!"

> . . . . . . . . . . . . . .
>
> ### "I just wanted a simple wedding where my fiancé can go to the bathroom *ANYTIME he wants!*"
>
> PHOEBE
>
> . . . . . . . . . . . . . .

**COMMENTARY** The snowy wedding was a dream, and so was the fashion. The bridesmaids, including Rachel and Monica, wore Michael Kors dresses, and Phoebe wore a stunning lavender St. Pucchi gown designed by Rani Totman and purchased in Westwood. The truly original piece was Phoebe's embroidered coat that she wore right before she walked down the aisle. Debra McGuire was the costume designer on *Friends* for most of the series. When she first got started, she even made many of the clothes herself, though time didn't allow it as the series continued. She was thrilled to be able to make Phoebe's coat though, and in an interview with *Racked*, she describes the piece. "I had the fabric made in India—it was gorgeous—and it's lined in faux fur. The colors are just amazing . . . and it really showed her personality. It's just so Phoebe!"

Lisa Kudrow, for her part, loved working with both Hank Azaria and Paul Rudd as her vying love interests. And when Phoebe finally tied the knot, Kudrow was thrilled. "It makes me happy that Phoebe is really wrapping up in such a nice, normal way—finally, for the first time in her life, she's kind of normal."

# The One Where Joey Speaks French

**WRITTEN BY** • **DIRECTED BY** • **ORIGINAL AIR DATE**
Sherry Bilsing & Ellen Plummer • Gary Halvorson • February 19, 2004

Phoebe is back from a constipated honeymoon with Mike, and Joey asks her to help him learn French for an upcoming audition. But when Phoebe tries to get him to recite a simple sentence, he fails miserably. She loses her patience and walks out on him, only to come back the next day and try again. Joey has spent the day practicing with a French tape and feels he has mastered it. Turns out he's not even close. Phoebe shows up at Joey's audition, and she tells the director (in French) that Joey is her brother and a "little retarded." The director humors him and tells him his French is good.

Phoebe's about to lose it listening to Joey "speak French."

Pregnant Erica comes to visit New York City before she has the baby because she wants to see all the sights. During the visit, Monica and Chandler ask Erica questions about the baby's father, and she admits it can be one of two guys: a cute football player who got a college scholarship or a guy who went to prison for killing his father with a shovel. Monica and Chandler are petrified about the dud DNA they might be getting: "Honey it's us; of course it's the shovel killer!" But after a heart-to-heart with Erica, Monica realizes the scholarship guy is the father because the kind of sex Erica had with the prison guy ("the thing we *never* do" as Chandler eloquently put it) made pregnancy a physical impossibility.

Meanwhile, Rachel's father has had a heart attack, and Ross and Rachel go to Long Island Hospital to see him. Afterward, they spend the night in her childhood home, and Ross feels like a high school rock star when he's in "Rachel Green's room" among posters of Shaun Cassidy, stuffed animals, and a bubblegum pink telephone. Rachel claims she doesn't "want to be alone tonight," and tries to kiss Ross. He refuses, thinking he'd be taking advantage of her vulnerability.

> ### *"Ja blub la! Me la pee! Oom blah! Poo."*
>
> JOEY

The next day, however, she is angry about it. "In the future when a girl asks for some ill-advised sympathy sex, just do it!" They fight in the hospital and Ross tells her "Sex is off the table!" just as Mr. Green walks out of his hospital room. Later that night, Rachel recounts an amazing sexual encounter they had awhile back, and Ross suddenly seems more interested in sex. She tells him, "With us, it's never off the table."

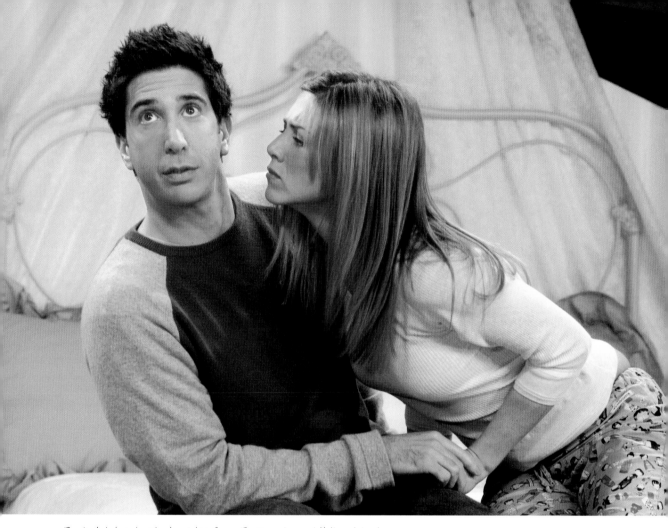

Rachel tries to steal a kiss from Ross on her childhood bed.

**COMMENTARY** Anna Faris joined the *Friends* cast for five episodes in the final season, and in an interview with *MediaVillage*, she noted that her episodes don't run a lot in syndication. "I think that's because [those episodes] give the impression that it's ending, and no one wants the show to end." Faris became the star of her own hit show, *Mom*, and is herself mother to Jack, born in 2012 with ex-husband Chris Pratt.

And speaking of ex-husbands, Ron Liebman played Rachel's cantankerous father, Dr. Leonard Green, who divorces Rachel's mom (Marlo Thomas) during the series run. The Tony and Emmy award-winning actor said in an interview with *The AV Club* that he almost turned down the role of Dr. Green. "The thing I can say about that is I had never seen the show when they asked me to do it. I'm not a big television watcher . . . and my daughter, then, who was of that age, said, 'No, you have to do it, you have to do it!'" Liebman loved the "nasty" part of his character on the show. "I loved that he was difficult, particularly to the Ross character, David Schwimmer's character. Most of my stuff was with Jennifer and David, which was terrific, because I really like them both."

# The One with Rachel's Going Away Party

WRITTEN BY
Andrew Reich & Ted Cohen

DIRECTED BY
Gary Halvorson

ORIGINAL AIR DATE
April 29, 2004

We're closing in on the end of an era in more ways than one. Rachel is leaving for her big new fashion job in Paris tomorrow, and Chandler says they want to throw her a little going-away party that night. Monica and Chandler are packing up their apartment too, getting ready to move to a new home in the 'burbs so they're ready for the arrival of the baby. The boys are packing, but get distracted by the wonders of Bubble Wrap around Joey's head, which means it doesn't hurt when he gets punched. It's all fun and games until Ross suggests, "Let's put Styrofoam peanuts down his pants and kick him!" Turns out the Styrofoam isn't quite as good a barrier, as Joey will discover with Phoebe at the end of the episode.

Chandler unearths fur-lined handcuffs in the guest room closet and is upset that Monica never used them with him. After all, he "once did a naked dance for her . . . *with scarves.*" Monica finds them, and an upset Chandler says, "I decided to leave those out for you in case Richard stops by and you want to engage in a little light bondage and mustache play!" Monica and Rachel tell him the cuffs aren't theirs, and Phoebe is almost insulted when Chandler asks her about them. "These are not mine. Look how flimsy they are, come on!" Chandler discovers the real owner when he finds some kinky photos of Monica's grandmother.

· · · · · · · · · · · · ·

## "Nana liked it rough!"

### MONICA

· · · · · · · · · · · · ·

Rachel starts saying tearful goodbyes to each Friend individually, and Ross gets nervous for his upcoming turn. "Oh no, she took down Monica. And I'm the crier in the family!" Chandler is so touched he can't stop making fart jokes to cover his discomfort after a heartfelt goodbye, and Joey starts to climb up on the balcony ledge, presumably unable to deal with Rachel's impending departure. But when it's Ross's turn, Rachel skips out early, and Ross realizes, "I DON'T GET A GOODBYE?" He storms out to confront her, and Rachel follows him to his apartment. She tells him the reason she didn't say goodbye is because it's too "damn hard" and ". . . if you think that I didn't say goodbye to you because you don't mean as much to me as everybody else, you're wrong. It's because you mean *more* to me." Ross looks overcome with emotion and he walks up to Rachel and kisses her.

Erica comes back after eating cheeseburgers, and she complains about stomachaches that keep coming and going "every few minutes." Monica realizes that she's in labor, and they head out to the hospital.

Joey tries to convince Rachel not to move to Paris by flipping a coin.

**COMMENTARY** This isn't the first time that a Geller has been frustrated by a lack of emotional response Rachel Green. In season 6, Monica feels she deserved a few tears when it was time for Rachel to move out (see page 142); in this episode, near the end of the season and series, it's Ross who doesn't understand why Rachel won't say goodbye to him. It's a poignant buildup to the series finale. We already know that Monica and Chandler are going to the hospital with Erica for the birth, and Rachel and Ross end the episode kissing passionately. We'll soon see Chandler and Monica as parents and find out whether Rachel will really go to Paris and leave Ross.

One of the real-life parallels in the last two seasons was Courteney Cox's fertility struggle, which mirrored her character's. Cox went through several miscarriages and eventually IVF treatments to eventually give birth to daughter Coco, who was born shortly after the series finale.

Kevin S. Bright—who directed more than fifty *Friends* episodes, including the series finale— revealed how difficult it was for everyone in those final episodes. In an interview with *Digital Spy*, he said, "Almost all of the actors broke down and cried in one scene or another. So there was a lot of stopping to mop up, and get the redness out of the eyes!" Most of the *Friends* seasons had twenty-three or twenty-four episodes, but season 10 has an even eighteen, which was the highest number all the stars could commit to at that point, with everyone growing up and ready to move on.

# The Last One, Part 1

| WRITTEN BY | DIRECTED BY | ORIGINAL AIR DATE |
|---|---|---|
| David Crane & Marta Kauffman | Kevin S. Bright | May 6, 2004 |

Phoebe and Joey tell Ross that he's about to be an uncle.

"The Last One" opens in the hospital room where Erica is in labor, and while Monica is in the bathroom, Chandler handles the awkwardness by asking Erica's opinion on which hurts more: going through labor or getting kicked in the nuts. She looks at him like he's crazy, and then as she's about to deliver the baby, she yells, "I think it's time to kick you in the nuts and see which is worse!"

After Erica delivers the baby, Monica is ecstatic, telling the baby boy, "I am going to love you so much that no woman is ever going to be good enough for you!" They name the boy Jack, after Monica's dad. Moments later, the doctor says that the second baby is on the way, and Monica insists, "We only ordered one!" Chandler is panicked and only wants one, but Monica tells him, "We are taking them home because they are our children." When the second baby comes, it's a girl, and Chandler finally gets on board. "Well, now we have one of each!" They decide to name the baby, Erica, after her birth mom.

Ross tells Joey and Phoebe about Rachel—before he realizes that he wants to be with her, long-term. But when Rachel wakes up and sees him, she smiles and tells him, "It was just the perfect way to say goodbye." Phoebe and Joey tell Ross he has to tell Rachel how he feels. Just as he's about to tell her, Gunther steps ahead of him and steals Ross's thunder, telling Rachel that *he* loves her. After Rachel shoots him down, Ross gets gun-shy, and decides not to say anything.

Joey buys Chandler and Monica a house-warming gift: a baby chick and a duckling, and Monica couldn't be more thrilled: "Oh great, just want you want for a new house with infants . . . bird feces." But the baby birds have gotten themselves trapped in the foosball table, and the only way to get them out is to break the table. When Joey and Chandler can't bring themselves to do it, Monica happily offers to oblige.

Just as Rachel's car arrives for the airport, Monica and Chandler come home with the twins, shocking everyone. Mike and Phoebe decide to have a baby too: "We can be like the Von Trapp family! Only without the Nazis." After Rachel leaves for her flight, Ross realizes, "I don't want to get over her." Phoebe drives him to JFK in her "death cab," but upon arrival, Ross can't find Rachel's flight on the board. When he calls Monica, she tells him that Rachel is at Newark Airport, not JFK.

Rachel tells Ross that spending the night together was the perfect way to say goodbye.

• • • • • • • • • • • •

## "I don't want to get over her."

### ROSS

• • • • • • • • • • • •

COMMENTARY There were a lot of expectations for "The Last One." When asked recently what she recalled about the atmosphere on set and that last day of taping, creator Marta Kauffman said, "It's funny because 'The Last One' was in two parts. We tore down the coffeehouse at the end of the first part. When we took it down, the only thing that was left was the flats and one piece of furniture. We had an impromptu party. We ordered in pizza. We all sat in this space. It's like any-thing when you are doing the last of it. I did our last table read. I had my last bagel at a table read. 'Oh, it's the last chili at craft services.' Everything was a little bit of a last."

She continued, "It was an extremely emotional night. *Extremely* emotional. My heart was pounding the whole time. At the end, I just sobbed. Not that it wasn't time, because I felt it was time, but it was the end of an era for me personally."

# The Last One, Part 2

| WRITTEN BY | • | DIRECTED BY | • | ORIGINAL AIR DATE |
|---|---|---|---|---|
| David Crane & Marta Kauffman | | Kevin S. Bright | | May 6, 2004 |

A teary-eyed Ross tells Rachel not to go to Paris because he's in love with her.

Joey and Chandler rescue the birds after Monica decimates the table, and Chandler tells Joey to keep the birds. They do a "lame, cool guy handshake" and finally just hug it out.

Phoebe and Ross get back in the death cab and speed their way to Newark. Ross thinks they are never going to make it, so Phoebe calls Rachel and tells her to get off the plane because "something is wrong with the left phalange." Rachel doesn't buy her premonition, but the rest of the passengers do. Everyone gets off, and Rachel—all alone—gets off too. Ross and Phoebe arrive just as Rachel re-boards—the "phalange" supposedly fixed—and Phoebe screams to get

The chick and the duck are stuck in the table, and Monica happily volunteers to break it open.

her off, telling Ross, "Okay you're on." Ross finally tells Rachel the truth, "I love you. Do not get on this plane." Rachel says she's sorry but boards the plane anyway. In tears, Ross turns to Phoebe saying, "I really thought she'd stay."

Ross goes back to his apartment and checks his messages. Rachel left a message just as she boarded the plane. She tells him she loves him, but even as she says the words, she seems surprised to hear them, "What am I doing? I love you. I gotta see you. I gotta get off this plane."

Ross hears her arguing with the flight attendant, and he starts screaming, "Let her off the plane!" The message ends, and he has no idea if she got off. He starts fumbling with the answering machine to figure out if she got off the plane, until he hears her behind him, suddenly in the apartment. "I got off the plane." They kiss, and Rachel says, "It's you and me, all right? This is it." Ross wholeheartedly agrees but jokingly adds, "Unless we're on a break."

> "I got off the plane."
>
> RACHEL

In the final scene, the movers come and take away all of Monica and Chandler's stuff, leaving an empty purple apartment, which surprises Joey. "Has it always been purple?" They realize that all of them have lived in the apartment at one time or another, including during Ross's stint as a dancer many years ago. Monica and Chandler leave their keys for Treeger, and then each of the Friends produces a key too. Monica tears up, saying, "This is harder than I thought it would be." Everyone is crying, but in a perfect ending, they decide to go get coffee, and the final line is Chandler's: "Sure. Where?"

**COMMENTARY** There is a fair amount of symbolism in parts 1 and 2 of "The Last One": The destruction of the foosball table, the symbol of Joey and Chandler's bachelor life together, only to be supplanted by new life with the birth of the twins and Chick Jr. and Duck Jr. The poignant moment when they all leave their keys to Monica's apartment for Treeger, trading in their old lives for new ones. And just like life, there is the circular appearance of the airport throughout the series. Way back in season 2, Rachel is racing to the airport to tell Ross that she loves him (only to discover him with Julie); she races to London in season 4 to do the same thing; and finally, now it's Ross's turn to do the running.

Everyone is growing up too. High-strung Monica remains calm upon learning that she is going to mother twins (maybe because Cox was pregnant in real life too); Mike and Phoebe discuss having children; and Joey, who is rarely the voice of reason, tells Ross that he can finally get over Rachel after all these years.

Co-creators Marta Kauffman and David Crane watched some of their favorite sitcom finales for inspiration, including *Newhart*, *M\*A\*S\*H*, and *The Mary Tyler Moore Show*. Crane has also said the hardest episodes to write every season were "the first one and the last one," although there was one thing they always knew for sure about the finale: Rachel and Ross would end up together. Actress Jennifer Aniston agreed. "I have a very special spot in my heart for Ross and Rachel."

And it somehow feels appropriate that Matthew Perry utters the last line in the series. After all, his fellow Friends have noted for years that he always likes to have the last joke. Paget Brewster, who played his girlfriend Kathy in season 4, told *Vogue Australia*, "If it was the end of the scene, he would constantly pitch something.

They'd make fun of him for literally always wanting to have the last laugh."

"Your family is your family, and that does not ever change or go away," Crane shared with *Glamour* in 2016. Perhaps that's why 52.5 million people tuned in to watch their Friends say goodbye, and companies paid $2 million for a thirty-second commercial spot during the finale, a record-breaking price tag for a sitcom. Or why Netflix paid $100 million for fans to continue streaming all 236 episodes of the beloved series through 2019.

If the music sounds familiar as Rachel boards the plane to Paris, you're likely a Pearl Jam fan. In their song, "Yellow Ledbetter," it was the first time the band ever gave permission for this song to be used on television. It's a song that never appeared on a studio album, and it's a perfect match for the finale, given that it is usually played last at Pearl Jam concerts as well.

Two hundred and fifty people attended the final taping. Hank Azaria (David the scientist), Maggie Wheeler (Janice), and David Arquette (Courteney Cox's then-husband and Ursula's stalker in season 3), were all in attendance. Maggie Wheeler told *People*, "The tears were flowing and the entire cast had to go back and have their makeup redone before starting."

Stage 24 was blessed with a new name following the end, and is now known as the "*Friends* Stage," and each cast member was presented with a piece of the sidewalk outside Central Perk. Perhaps separately those pieces don't mean that much, but they create something magical when they're together. For as David Schwimmer noted in *Friends Final Thoughts*, "Not one of us could have been traded. It was like the six of us were the perfect pieces of this puzzle."

**OPPOSITE** Joey and Chandler say goodbye to their beloved foosball table, individually high-fiving each little player with, "Good game."

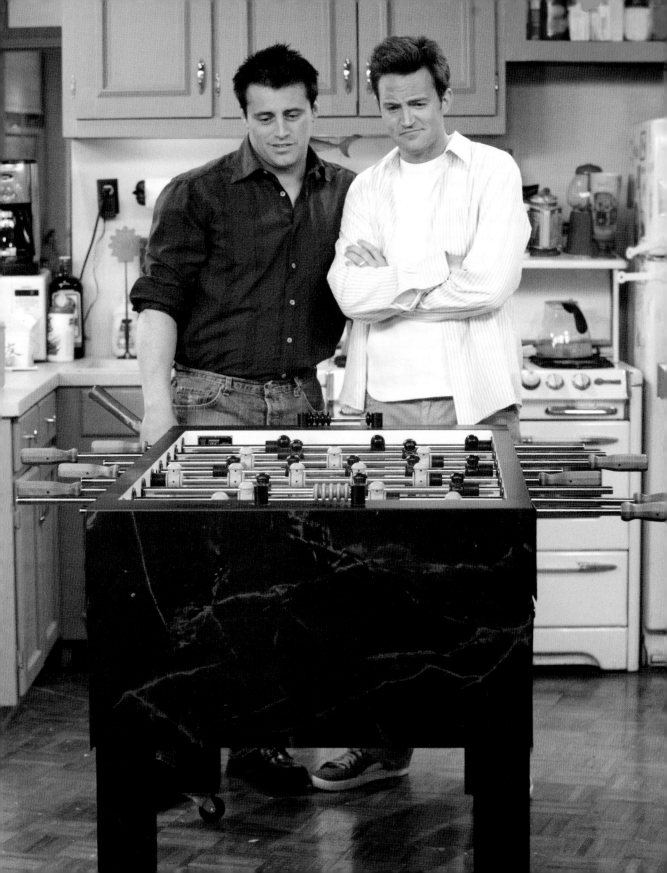

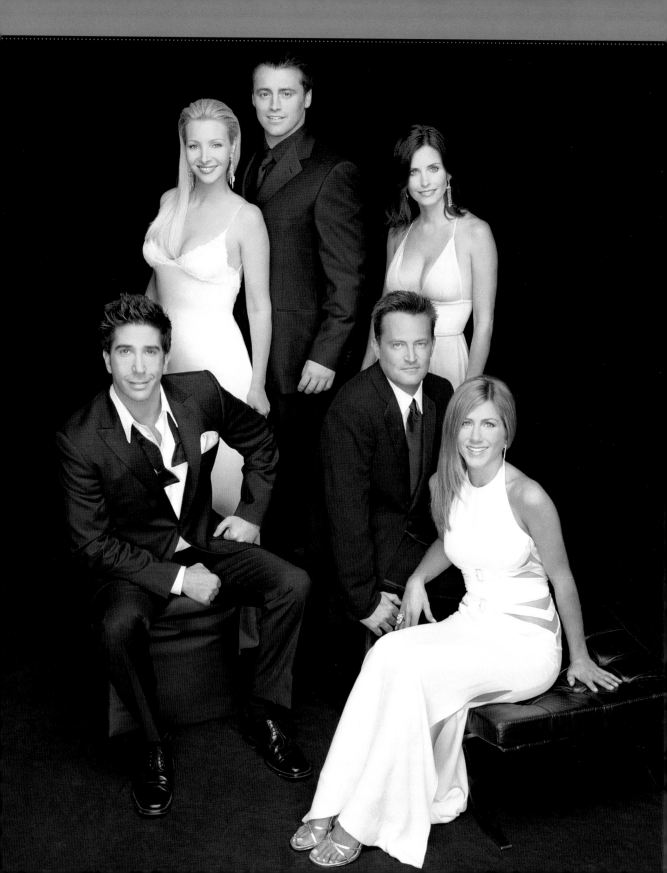

# The One Where We Bring It All Together

## HOW *FRIENDS* INFLUENCED
## AN ENTIRE GENERATION

• • •

Not many comedies have the kind of growth, season after season, of *Friends*. "It's why the show had to end," said Kauffman. "They went from a time in their lives where their friends were their family to a time in their lives where they had their own family. That changes everything. Since the show is about the time in your life when your friends are your family, once the change started happening and they grew up, we had to say goodbye."

If it seems like *Friends* has never left the cultural stage, that's because it hasn't. Since the series ended in 2004, it's still been available to watch at the click of a button, in syndicated reruns on television, on DVD and Blu-ray, or streaming on Netflix. You can binge-watch the entire series with the ease of Joey gorging himself on Thanksgiving turkey.

When asked if there were any guest stars in particular who truly elevated the material, Kauffman said, "Honestly, we had a lot of guest stars who did that. Christina Applegate. Reese Witherspoon. Brad Pitt. And he's very good in it. Tom Selleck. His presence elevated that storyline. Bruce Willis was great. The other one was Candace Gingrich. She performed the lesbian wedding. Just the fact that it was Newt Gingrich's sister added an element to it."

Occasionally, guest stars offered their own improvisations, which sometimes made the cut. Kauffman said, "Our deal was: we'll see any pitch that you want to pitch to us, as long as we see the material we worked on. Sometimes, their pitches

would make it even funnier and we'd keep that. But it was a collaboration where we would get to see the words that we worked so hard on at least once."

No wonder the influence of *Friends* has been all-encompassing. It's been most apparent on TV, where networks have tried countless times to clone *Friends*, with varying degrees of success. Some faux *Friends*, like *The Single Guy*, were quickly forgotten. Others, like Fox's *New Girl* and ABC's *Happy Endings*, became modest hits. And a few, like CBS's *How I Met Your Mother* (think *Friends* without a Phoebe) and *The Big Bang Theory* (think *Friends* if all the guys and two of the gals were Ross), were long-running successes in their own right. Even HBO's landmark comedy *Sex and the City*, with its four gal pals hanging out in Manhattan and discussing their dating woes, owed at least a small debt to *Friends*. As did HBO's *Girls*, a decade later, with its struggling, self-absorbed, sex-fixated twentysomethings across the river in Brooklyn.

The laughs came easier on *Episodes* (2011–17), a Showtime series co-created by David Crane, on which LeBlanc also played a version of himself—a foul-mouthed, womanizing, insensitive, yet charming version—who is also desperate to return to TV stardom and winds up on a hacky sitcom, and then an even hackier game show. As *Episodes* went into its final season, the real-life LeBlanc landed a starring role as a goofy dad on Showtime sibling CBS's family comedy *Man with a Plan*.

In 2015, Kauffman co-created for Netflix the sitcom *Grace and Frankie*, about a couple of

A bittersweet moment as the cast of *Friends* says goodbye, following the series finale, season 10, episode 18, "The Last One," which aired on May 6, 2004.

newly divorced gals rooming together—one an uptight control freak (Jane Fonda), one a ditzy flower child (Lily Tomlin). It was easy to think of them as Monica and Phoebe fifty years older—especially in season 5, when Tomlin's Frankie briefly moved out and was replaced as Grace's housemate by a flaky hairdresser played by . . . Lisa Kudrow.

And of course, there have been countless references to *Friends* on such shows as *The Simpsons*, *King of the Hill*, *Family Guy*, *Broad City*, *South Park*, *30 Rock*, and *Unbreakable Kimmy Schmidt*. And those are just the American shows.

But the influence has gone far beyond television and into the real world. Central Perk–inspired coffeehouses have opened in Pakistan, India, Dubai, China, and Singapore. A pop-up Central Perk, with actual *Friends* props, opened in London in 2009 to coincide with the show's fifteenth anniversary; for the twentieth

anniversary, a similar pop-up Perk appeared in Manhattan. Comedy Central UK, which airs *Friends* reruns across the pond, began staging touring events in England called *FriendsFest*, where visitors can walk through re-creations of the show's sets and sit on the Central Perk sofa or in Joey and Chandler's matching recliners. And of course, you can always visit the "real" (air quotes) Central Perk on the Warner Bros. studio tour.

*Friends* has influenced the way we talk. University of Toronto sociolinguist Sali Tagliamonte did an exhaustive study of the show's dialogue in 2004 and determined that the gang's use of "so" as an intensifier modifying adjectives (they said it more often than "very" or "really") may have helped popularize similar usage among fans in everyday conversation. Kauffman said in 2004 that she believed viewers picked up from Chandler the habit of letting unfinished sentences

hang, in order to make a snarky point. And don't forget: it was Joey who coined a useful and now common phrase to describe being trapped in a platonic relationship with someone you'd rather date. Aptly, that's the "friend zone."

On a practical level, *Friends* changed the TV industry in many ways. In terms of content, it expanded the creative freedom of network shows airing in what used to be called the "family hour" (the first hour of prime-time) to explore adult concerns. During the first two seasons, NBC received flak for the show's candid (for the era) references to sexual behavior. Carol and Susan's wedding was an envelope-pushing episode, as was the one where Monica and Rachel battle over which of them gets to use the last condom with her respective boyfriend. (Even then, NBC's Standards and Practices department wouldn't let *Friends* show the condom, only the box it was packed in. But at least *Friends* got to generate laughs while taking a stand for safe sex.) Today's network shows that air between 8 and 9 p.m. goes a lot further with their frank talk, but *Friends* got there first and opened the door.

As a standard-setter in terms of quality and popularity, *Friends* served as the anchor of NBC's "Must See TV" lineup of critically acclaimed and ratings-grabbing shows airing on Thursday nights. The promotional tag predated *Friends* by a year, but with *Friends* airing at 8 p.m. from 1995 to 2004 (and with *ER* airing at 10 p.m. from 1994 to 2009), the Thursday night slate really seemed to live up to the slogan's hype. The ninety minutes between *Friends* and *ER* were home, over the years, to TV landmarks such as *Seinfeld*, *Frasier*, and *Will & Grace*, not to mention fondly remembered shows such as *Just Shoot Me*, *Scrubs*, and the Kauffman/Crane/Bright's production *Veronica's Closet*. The slogan, and NBC's Thursday schedule, lost much of their luster after *Friends* ended in 2004.

When it came to business practices, *Friends* was practically revolutionary. The changes started with the way the actors negotiated their salaries.

In the first season, they were earning $22,500 each per episode. By season 3, WBTV wanted to pay Aniston and Schwimmer more than the others, due to the popularity of the Ross-and-Rachel storyline. Schwimmer thought that seemed unfair, since he felt the cast was still a true ensemble, all of them doing equal work. He convinced the other five to negotiate as a group to make sure they all got paid the same. As a result, the sextet earned $75,000 each per episode in season 3. The next year, they got $85,000 each. The stars each earned $100,000 per episode in season 5, bumped up to $125,000 the following year.

By then, the show had generated enough episodes to go into syndication, and the money really started rolling in. Salaries made a giant leap to $750,000 per episode for each star in seasons 7 and 8. In the final two seasons, each Friend earned a cool $1 million per episode, making them the highest-paid TV actors ever up to that time. Plus, they negotiated for a share of syndication profits—reportedly 2 percent each. That means, for the $1 billion or so that Warner Bros. claims *Friends* generates every year to this day—yes, billion with a "b"—each Friend gets another $20 million, about as much as each actor made per year when they were shooting the final two seasons.

Today, it's common for casts of long-running ensemble shows (like *The Big Bang Theory*) to negotiate as a group for equal salaries. But the Central Perk gang did it first.

Speaking of syndication, that's long been where the real money is for TV production companies. By the ninth season of *Friends*, between the cast's salaries and all other production expenses, it cost WBTV $9 or $10 million to make each episode. NBC was paying a few million less per episode in licensing fees. With a deal like that, WBTV should have been hemorrhaging money. But it made up all the difference and then some by licensing the reruns to television networks around the world. More money would flow to WBTV from DVD and Blu-ray sales.

In 2015, all 236 episodes of *Friends* became available to binge-watch on Netflix, offering a new revenue stream undreamed of when the show went off the air 11 years earlier. *Friends* soon became one of the streaming service's most popular offerings. At the end of 2018, Netflix paid WBTV a staggering $100 million just to keep *Friends* for one more year. Even at that price, the deal made sense for both parties. For Netflix, *Friends* continued to serve as a driver of paid subscriptions. For Warner Bros., it was cash flow until the company could launch its own subscription streaming service. This was scheduled to launch in spring 2020, at which time, *Friends* is expected to be the chief subscription draw for WarnerMedia's direct-to-consumer streaming service, HBO Max. Indeed, as the major old-media companies (including Warner Bros., Disney/Fox, Comcast/NBC/Universal) ramp up their own streaming platforms to compete with Netflix, Amazon Prime, and Apple, billions of dollars are on the line in a shifting media landscape that holds few certainties. One certainty is that a lucrative piece of that future will be a catalogue of 236 episodes of episodes of *Friends*.

Among the *Friends* breakthroughs was TV's first lesbian wedding. When asked in 2019 if there was anything that other shows imitated that she believe they did first—and maybe best—Kauffman said, "I do feel the lesbian wedding was a big deal in its time. There were a lot of concerns about how the network was going to get phone calls and they were going to get a lot of complaints. They put extra operators on. I think they got four phone calls that night. It wasn't as disturbing as people feared it would be.

> "I just don't think we can beat what we've done. And isn't it better to have people wanting than to be disappointed?"

"On the other hand, I have an opposite story to tell you where after *Seinfeld* did the masturbation episode, the following year things became more restrictive. We had an episode where Monica and Rachel were fighting over the last condom. Because it was such a reactionary period, we weren't permitted to show the foil wrapper. It had to be in the box."

## STILL FRIENDS TODAY
• • •

A decade or so after the series ended, Matt LeBlanc was hosting the British automotive show *Top Gear*, and the production took him and the crew to the Atlas Mountains in Morocco. "I mean, we were far away from civilization. And these people were wearing robes, and they live in caves and stuff," he recalled. "They called me Joey and said, 'How you doin'?' in a really butchered accent. It was like, 'Oh wow. Did not see that one coming.'" LeBlanc's point? No matter how far removed in time and space we are from *Friends*, "the show is everywhere. It still holds up."

How well does it hold up? In 2015, when it first became possible to watch the entire series in one massive Netflix binge, critics started reexamining the show and decided it was far from woke. So much about the cultural politics of *Friends* hadn't aged well. Think of all the fat-shaming Monica endured. Think of all the unflattering Jewish-princess stereotypes that the younger Rachel embodied, or the similarly disparaging stereotypes of Jewish masculinity that characterized nerdy, half-Jewish Ross. (These elements were present even though the show's creators were Jewish.) Think of how

lipstick-lesbian and unsympathetic Susan and Carol were, of all the gay-panic jokes at the expense of Chandler and Ross (and sometimes Joey), and of Chandler's shabby treatment of his trans father. (These elements were present, even though Crane was gay.) And think of how white the show's New York was, and how few characters of color there were, either as neighbors, love interests, or other guest roles.

In fact, the show's vanilla casting was the subject of criticism even when the show was still on the air; much was made at the time of how Charlie (Aisha Tyler), a love interest for both Joey and Ross who appeared near the end of the series, was the first prominent black character on *Friends*. The lack of people of color still stung in 2017, when Jay-Z's "Moonlight" video began with an extended spoof of *Friends*, cast with black stars. The clip featured Tiffany Haddish as Phoebe, Issa Rae as Rachel, Lil Rel Howery as Chandler, LaKeith Stanfield as Joey, Jerrod Carmichael as Ross, and Tessa Thompson as Monica. There's a bit where the six alternate-universe *Friends* frolic in a fountain, but it's scored to the song "Friends," recorded by Whodini a decade before the show premiered.

One could argue with these criticisms, noting that *Friends* was a product of its time, and that much of what seems retrograde now (like the treatment of Carol and Susan) was considered bold and cutting-edge a quarter-century ago. Nonetheless, it's easy for a contemporary viewer to look at the casting, or at Monica's apartment, or at the marginally employed characters' surprising ability to live in Manhattan and pay their bills, and dismiss *Friends* as a fantasy about privileged, straight, ridiculously good-looking white people who have few real-world problems.

And yet, none of this affects the show's ongoing popularity. Generations Y and Z—the millennials and younger credited with driving awareness of diversity and cultural sensitivity—have embraced *Friends* the way older audiences did when the show first aired. They recognize

*Friends* as sharply written, crisply directed, and well-acted by performers who are charismatic, funny, and attractive. The characters may not look like them, but they're caught up in recognizable situations that people of all backgrounds can appreciate. They're people like you, or like your own friends, particulars of race, class, gender, and orientation aside. Even if you're not yet in your twenties—or are far beyond them—you can relate to what the *Insomnia Cafe* pitch described as that special time in your life when your friends are your family. Indeed, if remote tribespeople living in caves in Morocco can identify with the characters, then *Friends* really does have universal appeal.

We are in an age of remakes, reboots, and nostalgia. Creators Kauffman and Crane have been vocal that there is absolutely never going to be a *Friends* reunion. When asked in 2019 if she understands why that question keeps coming up, Kauffman said, "I absolutely understand it. I really do. Our concern is it can only disappoint. They are not the same. It's not that time in their lives anymore. Some of them don't even look exactly the same. It would feel like, 'What happened to the six of them?' I just don't think we can beat what we've done. And isn't it better to have people wanting than to be disappointed?"

What's more, the show's not going away anytime soon. It's still too beloved—and too lucrative—to fade away. Those oversized mugs of coffee remain bottomless, that orange sofa still cozy and inviting. Someone you're happy to see is always bursting through that purple door, and Monica's fridge is always stocked with gourmet comfort food. For years to come, you'll be able to depend on *Friends* the way you depend on your friends in real life. No matter who you are, how low you feel, or how many times you've seen each episode . . . *Friends* will be there for you.

# Bibliography

Acuna, Kirsten. "An Episode of *Friends* Was Heavily Changed After 9/11 and You Probably Never Realized It." *Business Insider.* September 11, 2017. https://www.businessinsider.com/9-11-friends-monica-chandler-airport-deleted-scenes-2017-9

Adalian, Josef. "How *Friends* Decided to Pair Off Monica and Chandler." *Vulture.* September 29, 2014. https://www.vulture.com/2013/11/friends-monica-chandler-how-writers-paired-them-off.html.

American Media Entertainment Group. "The One with All the *Friends* Magna Doodles—See All the Hilarious Drawings!" *Life & Style,* October 20, 2017. https://www.lifeandstylemag.com/posts/the-one-with-all-the-friends-magna-doodles-see-all-94-drawings-61820/.

Aniston, Jennifer. "Jennifer Aniston: The Naked Truth. Interview by Tig Notaro." *Harper's Bazaar,* May 6, 2019. www.harpersbazaar.com/culture/features/a27321171/jennifer-aniston-interview-2019/.

Aquilina, Tyler. "Danny DeVito Didn't Get to Take Off as Many Clothes as He Wanted Playing a Stripper on *Friends.*" *Entertainment Weekly.* March 29, 2019. ew.com/tv/2019/03/29/danny-devito-friends-stripper-couch-surfing/

Archerd, Army. "Press Wants Info on Liebman's *Friends.*" *Variety,* May 8, 1997. https://variety.com/1997/voices/columns/press-wants-info-on-leibman-s-friends-1117863066/

Azaria, Hank. "The Interviews: Hank Azaria." Interview by Jenni Matz. *Television Academy Foundation,* April 6, 2015. https://interviews.televisionacademy.com/interviews/hank-azaria

Bacardi, Francesca. "Elle Macpherson Reveals Why She Regrets Her *Friends* Arc." *E! News,* September 26, 2016. https://www.eonline.com/news/797593/elle-macpherson-reveals-why-she-regrets-her-friends-arc

Barna, Dan. "Ross and Rachel's 'Break' on *Friends* Almost Didn't Happen." *Glamour,* September 28, 2018. https://www.glamour.com/story/friends-ross-rachel-break

Barna, Dan. "You Will Not Believe How *Friends* Almost Ended." *Glamour,* October 4, 2018. https://www.glamour.com/story/friends-series-finale-season-9-cliffhanger

Bell, Amanda. "Where Are Joey Tribbiani's Sisters Now?"

*MTV News,* February 24, 2016. http://www.mtv.com/news/2743243/joey-tribbianis-sisters-friends/

Bloom, David. "Why Paying $100 Million for *Friends* Still Might Be a Bargain for Netflix." *Forbes,* December 5, 2018. https://www.forbes.com/sites/dbloom/2018/12/05/netflix-warnermedia-friends-licensing-bargain-streaming-video-rights/#5fd9cadc180d.

Blum, Sam. "This Map Shows the Most Popular Netflix Shows in 91 Countries." Thrillist. May 11, 2017. https://www.thrillist.com/news/nation/netflix-map-shows-most-popular-shows-in-91-countries

Bradley, Laura. "*Friends* Fans, Rejoice! We Finally Know What Ugly Naked Guy Looks Like." *Vanity Fair.* May 31, 2016. https://www.vanityfair.com/hollywood/2016/05/friends-ugly-naked-guy-actor.

Bradley, Nina. "Lisa Kudrow's Comments on How the *Friends* Cast Embraced Her Pregnancy Will Make You Super Nostalgic." Bustle. July 31, 2018. https://www.bustle.com/p/lisa-kudrows-comments-on-how-the-friends-cast-embraced-her-pregnancy-will-make-you-super-nostalgic-9954518.

Bravo Media LLC. "Bravo Profiles: Lisa Kudrow." *Bravo TV.* September 17, 2001. Retrieved on July 29, 2019. https://www.youtube.com/watch?v=ztRHJqkeCCc

Bricker, Tierney. "Surprising Secrets of *Friends'* Final Season Revealed: Lots of Tears, Personal Drama and the One Storyline the Cast Hated." *E! News.* May 10, 2019. www.eonline.com/news/1040188/surprising-secrets-of-friends-final-season-revealed-lots-of-tears-personal-drama-and-the-one-storyline-the-cast-hated

Brockes, Emma. "I Don't Feel Like a Drip." *The Guardian,* November 28, 2003. https://www.theguardian.com/stage/2003/nov/28/theatre2

Broster, Alice. "*Friends* the Musical Is Coming to the UK & Could I BE Any More Excited?" *Bustle.* www.bustle.com/p/friends-the-musical-is-coming-to-the-uk-could-i-be-any-more-excited-17040500

Brown, Lauren. "Did You Ever Notice This Weird Thing About Phoebe's Brother on *Friends?*" *Glamour,* April 4, 2015. https://www.glamour.com/story/friends-phoebe-brother

Bullock, Andrew. "You won't believe what happened to the actress who was originally Ross' ex-wife on *Friends.*" *Express,* May 24, 2016. https://www.express.co.uk/showbiz

/tv-radio/673420/You-won-t-BELIEVE-actress-Ross-Geller-exwife-Friends-David-Schwimmer-Anita-Barone-Carol

Butler, Bethonie. "Should we forgive *Friends* for feeling a little offensive in 2016?" *The Washington Post.* www.washingtonpost.com/lifestyle/style/should-we-forgive-friends-for-feeling-a-little-offensive-in-2016/2016/02/18/e8d47280-d0d3-11e5-b2bc-988409ee911b_story.html.

Choudhary, Vidhi. "*Friends* Most Watched English Show on Indian TV in January– June." *LiveMint.* July 11, 2016. https://www.livemint.com/Consumer/dDVVsqf2rxjlcyo7u24g8I/What-India-watched-in-English-entertainment-between-January.html

Cohen, Jonathan. "Pearl Jam Helps Bid Adieu to *Friends.*" *Today.* May 11, 2004. https://www.today.com/popculture/pearl-jam-helps-bid-adieu-friends-wbna4955410.

Comedy Central UK. "17 Things *Friends* Fans Never Knew About the One in London, Baby." Retrieved on July 29, 2019. http://www.comedycentral.co.uk/news/16-things-you-never-knew-about-friends-being-filmed-in-london.

Comedy Central UK. "Here's the Carol and Susan Scene That Was Banned from *Friends.*" September 15, 2017, http://www.comedycentral.co.uk/news/articles/heres-the-carol-and-susan-scene-that-was-banned-from-friends

Comedy Central UK. "Here's the Story Behind Every Celebrity Cameo in *Friends.*" May 8, 2016, http://www.comedycentral.co.uk/friends/articles/78-famous-faces-youve-seen-in-friends

Comedy Central UK. "*Friends* Storylines That Were Lightyears Ahead of Their Time." Retrieved on May 27, 2019. http://www.comedycentral.co.uk/news/friends-storylines-that-were-lightyears-ahead-of-their-time

Comedy Central UK. "Jennifer Aniston Reveals Cast Hated One Key Element of *Friends.*" Retrieved May 27, 2019. http://www.comedycentral.co.uk/friends/articles/jennifer-aniston-reveals-cast-hated-one-key-element-of-friends

Comedy Central UK. "Signs Monica and Chandler Were Always Destined to Get Together." Retrieved July 29, 2019. http://www.comedycentral.co.uk/friends/articles/signs-monica-and-chandler-were-always-destined-to-get-together

Coughlan, Sean. "The One About *Friends* Still Being the Most Popular." *BBC News,* January 30, 2019. https://www.bbc.com/news/education-47043831

Cox, James. "Could It Be More Obvious? *Friends* Fans Take YouGov Poll to Officially Decide if Ross and Rachel Were on a Break." *The Sun,* February 3, 2018. https://www.thesun.co.uk/tvandshowbiz/5491066/friends-ross-rachel-on-a-break-yougov/.

Cronin, Brian. "Which Surprising *Friends* Character Was Going to Have a Kid During the Series?" Huffington Post. April 19, 2016. https://www.huffpost.com/entry/which-surprising-friends_b_9718012

Duncan, Amy. "*Friends* Made a Huge Mistake in Ross and Emily's Wedding Episode—and We Bet You Didn't Notice." *Metro.* June 23, 2016. https://metro.co.uk/2016/06/23/friends-made-a-huge-mistake-in-ross-and-emilys-wedding-episode-and-we-bet-you-didnt-notice-5963200/.

Earnshaw, Jessica. "Dermot Mulroney FORGOT About 'Obscure' *Friends* Role Till Fans Reminded Him: 'Who's Gavin?'" *Express.* November 23, 2016. https://www.express.co.uk/celebrity-news/735525/Friends-Pure-Genius-Dermot-Mulroney-Gavin-Jennifer-Aniston

Eggenberger, Nicole. "Jennifer Aniston: *Friends* Was My Sixth TV Pilot, Had to 'Sit Out' Cast Photos." *Us Weekly,* October 8, 2013. https://www.usmagazine.com/entertainment/news/jennifer-aniston-friends-was-my-sixth-tv-pilot-had-to-sit-out-cast-photos-2013810/

Elliott, Stuart. "The Media Business: Advertising; NBC's *Friends* Finale Is the Super Bowl of Sitcoms with 30-Second Commercials Selling for $2 Million." *The New York Times,* May 3, 2004. https://www.nytimes.com/2004/05/03/business/media-business-advertising-nbc-s-friends-finale-super-bowl-sitcoms-with-30.html

Eng, Joyce. "*Friends* Boss on Coming to Blu-ray, the Episode That Never Happened and Where Everyone Is Now." *TV Guide.* www.tvguide.com/news/friends-blu-ray-kevin-bright-1055975/

Enright, Don, and Les Alexander, Executive Producers. "The One that Goes Behind the Scenes." Present Tense Productions, Inc. Produced in Association with the Discovery Channel. 1999. https://www.youtube.com/watch?v=2L3gFYWU3hs

Finn, Natalie. "Inside Jennifer Aniston and Reese Witherspoon's Sweet History of Fangirling and Friendship." *E! News,* March 27, 2019. https://www.eonline.com/news/1026911/inside-jennifer-aniston-and-reese-witherspoon-s-sweet-history-of-fangirling-and-friendship

Fishman, Elana. "*Friends* Costume Designer Looks Back on 10 Seasons of Weddings." *Racked,* June 7, 2017. https://www.racked.com/2017/6/7/15742358/friends-tv-show-weddings.

Flint, Hanna. "'He's a Good Kisser': Elle Macpherson Reminisces About THAT Kiss with Matt LeBlanc on *Friends.*" *Daily Mail.* September 12, 2016. https://www.dailymail.co.uk/aushowbiz/article-3786505/Elle-Macpherson-reminisces-kiss-Matt-LeBlanc-Friends.html.

Fretts, Bruce. "NBC's Newest Hit Sitcom." *Entertainment Weekly.* January 27, 1995. https://ew.com/article/1995/01/27/nbcs-newest-hit-sitcom/.

G, Katherine. NBC's *Friends* Tribute: 12 Fun Facts Revealed, Fame10. www.fame10.com/entertainment/nbcs-friends-tribute-12-fun-facts-revealed/

Galindo, Brian. "25 Fascinating Facts You Might Not Know About *Friends.*" BuzzFeed, August 7, 2013. https://www.buzzfeed.com/briangalindo/25-fascinating-facts-you-might-not-know-about-friends

Garcia, Jennifer. "Anna Faris Welcomes a Baby Boy." *People,* August 25, 2012. https://people.com/parents/anna-faris-has-a-baby-boy/

Gawley, Paige. "*Friends* Actress Lauren Tom Recalls Kissing David Schwimmer and Her Favorite Episode (Exclusive)." *ET Online,* August 23, 2018. https://www.etonline.com/friends-actress-lauren-tom-recalls-kissing-david-schwimmer-and-her-favorite-episode-exclusive.

Gidlow, Steve. "Anna Faris of CBS' *Mom*: Forever a Friend of *Friends.*" MediaVillage. June 1, 2016. https://www.mediavillage.com/article/anna-farriss-forever-a-friend-of-friends/.

———. "Eddie Cahill of ABC's *Conviction*: Forever a Friend of *Friends.*" MediaVillage. October 14, 2016. https://www.mediavillage.com/article/eddie-cahill-of-abcs-conviction-forever-a-friend-of-friends/.

———. "George Newbern of ABC's *Scandal*: Forever a Friend of *Friends.*" MediaVillage. November 15, 2017. https://www.

mediavillage.com/article/George-Newbern-of-ABCs-Scandal-Forever-a-Friend-of-Friends/.

Gil, Natalie. "The *Friends* Scene That Was Banned Around the World." *Refinery29*. September 15, 2017. https://www.refinery29.com/en-gb/2017/09/172330/friends-banned-scene-lesbian-gay-rights

Gladman, Bella. "The One Where Tom Ford Loved the Clothes: *Friends* Costume Designer Debra McGuire on the Show's Fashion." *The Telegraph,* February 21, 2016. https://www.telegraph.co.uk/fashion/people/the-one-where-tom-ford-loved-the-clothes-friends-costume-designe/

Golembewski, Vanessa. "Have You Noticed They're Always Reading on *Friends*? Yes, Even Joey." *Glamour*, July 2, 2018. https://www.glamour.com/story/all-the-books-on-friends

Greene, Andy. "Readers' Poll: The 10 Best Pearl Jam Deep Cuts." *Rolling Stone*, July 15, 2015. https://www.rollingstone.com/music/music-lists/readers-poll-the-10-best-pearl-jam-deep-cuts-72928/yellow-ledbetter-50890/

Hammond, Pete. "Giovanni Ribisi Talks 'Sneaky Pete', Losing 'Junior Star Search' & Why He Can't Escape *Friends*—The Actor's Side." *Deadline*, April 19, 2017. https://deadline.com/2017/04/giovanni-ribisi-sneaky-pete-interview-pete-hammond-1202072374/

Harris, Will. "Tom Selleck on *Jesse Stone, Friends*, and fighting for *Magnum P.I.*" AV Club, October 14, 2015. https://tv.avclub.com/tom-selleck-on-jesse-stone-friends-and-fighting-for-m-1798285640

Hartlaub, Peter. "*Friends* Challenge—Finding the Right Words to Say Good-Bye." *SFGate*, January 15, 2004. https://www.sfgate.com/entertainment/article/Friends-challenge-finding-right-words-to-say-2830232.php.

Hegedus, Eric. "*Riverdale* Actor Crushed on Jennifer Aniston as Kid Star on *Friends*." *New York Post*. March 8, 2017. nypost.com/2017/03/08/riverdale-actor-crushed-on-jennifer-aniston-as-kid-star-on-friends/.

Heller, Corinne. "Lisa Kudrow Reunites with Courteney Cox, Talks Favorite *Friends* Episode and Ideal Cast Reunion—See the Pic!" *E! News*. November 6, 2014. https://www.eonline.com/news/595716/lisa-kudrow-reunites-with-courteney-cox-talks-favorite-

friends-episode-and-ideal-cast-reunion-see-the-pic.

Highfill, Samantha. "*Friends* PopWatch Poll: Were Ross and Rachel on a Break?" *Entertainment Weekly*. May 6, 2014. https://ew.com/article/2014/05/06/friends-poll-ross-rachel-break/

Hodgson, Claire. "34 Things You Never Knew About *Friends*." *Cosmopolitan*. April 7, 2016. https://www.cosmopolitan.com/uk/entertainment/news/a29836/friends-facts-33-things-you-never-knew/

Hodgson, Claire. "Monica and Chandler Were Never Meant to Get Married in *Friends*." *Cosmopolitan*, June 8, 2015. www.cosmopolitan.com/uk/entertainment/news/a36298/monica-chandler-never-meant-married/

Hoggatt, Aja. "Michael Rapaport Reveals Which *Friends* Star Would Make the Best Cop." *Entertainment Weekly*, October 2, 2018. https://ew.com/tv/2018/10/02/michael-rapaport-couch-surfing-friends/

Igoe, Katherine J. "This *Friends* Guest Star Almost Played Ross Geller." *Marie Claire*, February 7, 2019. https://www.marieclaire.com/celebrity/a26233478/friends-david-schwimmer-mitchell-whitfield/

Ivie, Devon. "Matthew Perry Refused to do One *Friends* Story Line Because He Hated It So Much." *Vulture*, May 20, 2017. https://www.vulture.com/2017/05/matthew-perry-refused-this-friends-plotline-for-chandler.html

Jarvis, Rebecca and Dunn, Taylor. "Why Christina Applegate Stays Out of the Spotlight, on 'Real Biz with Rebecca Jarvis.'" *ABC News*, May 20, 2016. https://abcnews.go.com/Business/christina-applegate-stays-spotlight-real-biz-rebecca-jarvis/story?id=39225881

Jeffery, Morgan. "8 huge *Friends* goofs—and our attempts to explain them." *Digital Spy*, June 4, 2018. https://www.digitalspy.com/tv/ustv/a839159/friends-mistakes-goofs/

———. "*Friends* Almost Ended a Year Earlier—on a Cliffhanger." *Digital Spy*, March 10, 2018. https://www.digitalspy.com/tv/ustv/a867553/friends-alternate-ending-season-9-cliffhanger/

———. "Matt LeBlanc 'Was Very Firmly Against' Joey and Rachel Getting Together on *Friends*." January 10, 2018. *Digital Spy*. www.digitalspy.com/tv/ustv/a867413/friends-joey-rachel-matt-leblanc-against-storyline/

Jordan, Julie. "Jennifer Aniston Gets First Tattoo." *People*. June 25, 2011. https://people.com/celebrity/jennifer-aniston-gets-first-tattoo/.

Kahn, Mattie. "Jennifer Aniston Pours Cold Smartwater on Your Joey and Rachel Fantasies." *Elle*. August 21, 2017. https://www.elle.com/culture/celebrities/news/a47530/jennifer-aniston-wellness-joey-rachel-friends.

Kale, Sirin. "'Jennifer Aniston Cried in My Lap:' The Inside Story of *Friends*." *The Guardian*. February 6, 2019. www.theguardian.com/tv-and-radio/2019/feb/06/jennifer-aniston-cried-lap-inside-story-friends

Kaplan International. "*Friends* Helps Global Television Audience Learn English." *Kaplan International English Blog*, December 3, 2012. https://www.kaplaninternational.com/blog/friends-helps-learn-english-40

"Katie, Biography" IMDb, retrieved on June 11, 2019. https://www.imdb.com/name/nm1442174/?ref_=nmbio_bio_nm

Keck, William. "*Friends*: A 20th Anniversary Oral History." *Television Academy*, September 16, 2014. https://www.emmys.com/news/industry-news/friends-20th-anniversary-oral-history

Keepnews, Peter. "TELEVISION/RADIO; Off Go Paul & Jamie, Realistic to the End." *The New York Times*, May 23, 1999. https://www.nytimes.com/1999/05/23/arts/television-radio-off-go-paul-and-jamie-realistic-to-the-end.html

Kelly, Emma. "*Friends* star Jane Sibbett took the role of Carol two days after giving birth." *Metro*, September 19, 2017. https://metro.co.uk/2017/09/19/friends-star-jane-sibbett-took-the-role-of-carol-two-days-after-giving-birth-6939624/

Kinane, Ruth. "Here's How the *Friends* Production Designer Turned a Stage into an NYC Park for 'The One with the Football.'" *Entertainment Weekly*, November 20, 2018. https://ew.com/tv/2018/11/20/friends-thanksgiving-the-one-with-the-football/.

———. "How many Emmys did *Friends* win?" *Entertainment Weekly*, September 8, 2017. https://ew.com/emmys/2017/09/08/how-many-emmys-did-friends-win/

Kramer, Cindy Clark. *Friends* Marcel the Monkey is Alive and Well and Modeling with Kendall Jenner!" *USA Today*, February 12, 2015. https://www.usatoday.com/story/life

/entertainthis/2015/02/12/friends-marcel-the-monkey-is-alive-and-well-and-modeling-with-kendall-jenner/77594880/.

Krentcil, Faran. "Wellness Powder Is a Thing Thanks to Elle Macpherson." *Elle*. December 19, 2016. https://www.elle.com/beauty/health-fitness/news/a41517/elle-macpherson-aerin-lauder/.

Kudrow, Lisa. "The Interviews: Lisa Kudrow." Interview by Karen Herman. *Television Academy Foundation*, December 22, 2012. https://interviews.televisionacademy.com/interviews/lisa-kudrow

———. "A Minute With: Lisa Kudrow on Boss Baby, *Friends*, Hollywood Sexism." Interview by Piya Sinha-Roy. Reuters. March 29, 2017. https://uk.reuters.com/article/us-film-lisakudrow-idUKKBN1702TE

———. "The Origin of 'Smelly Cat': Lisa Kudrow Answers Social Media Questions." Interview by Larry King. *Larry King Now*. July 30, 2013. https://www.youtube.com/watch?v=VxRZQDZbkPs

Kudrow, Lisa and Matthew LeBlanc, "Lisa Kudrow and Matt LeBlanc Dish on Why Phoebe and Joey Never Hooked Up." *People*, September 11, 2015. https://people.com/tv/friends-matt-leblanc-lisa-kudrow-on-phoebe-and-joey-never-hooking-up/

LeBlanc, Matt. "Matt LeBlanc Reveals the *Friends* Props He Stole from Set." Interview by Jimmy Fallon. *The Tonight Show Starring Jimmy Fallon*, Season 6, Episode 86. NBCUniversal. January 26, 2019. https://www.youtube.com/watch?v=RWRhaSBJ-co.

Lorre, Rose Maura. "Revisiting 'Blackout Thursday,' NBC's Epic 1994 Promo Stunt." *Esquire*, November 3, 2014. https://www.esquire.com/entertainment/tv/a30592/revisiting-blackout-thursday/

Lyons, Margaret. "*Friends* Countdown: How Jane Austen Inspired 'The One Where Rachel Finds Out.'" *Vulture*, December 8, 2014. https://www.vulture.com/2014/12/ross-rachel-finds-out.html

Marchese, David. "In Conversation: Kathleen Turner." *Vulture*, August 7, 2018. https://www.vulture.com/2018/08/kathleen-turner-in-conversation.html

Marsh, Steve. "Jon Lovitz on *Sing Your Face Off*, Robert Downey Jr., and the *SNL* Character He Wishes He'd Created." *Vulture*, May 30, 2014. https://www.vulture.com/2014/05/jon-lovitz-sing-your-face-off-snl-opera-man-chat.html

McCarthy, Sean L. "Jon Lovitz May Be Master Thespian, But Can He Sing Your Face Off?" Comic's Comic. May 30, 2014. https://thecomicscomic.com/2014/05/30/jon-lovitz-may-be-master-thespian-but-can-he-sing-your-face-off/.

McGilvray, Ken, Producer. The Story Behind: *Friends*. Pop TV. February 18, 2015.

McGowan, Mark. "The Lesbian Wedding Episode of *Friends* Was Banned from Airing." *LADbible*. March 21, 2018. http://www.ladbible.com/entertainment/film-and-tv-one-friends-scene-was-banned-from-airing-for-ridiculous-reason-20170918.

Melrose, Kevin. "TV Legends Revealed: The One Where We Learn Which *Friends* Character Nearly Had a Baby." CBR .com. July 22, 2015. https://www.cbr.com/tv-legends-revealed-the-one-where-we-learn-which-friends-character-nearly-had-a-baby/.

Meredith Corporation. "Baby Name: Vikram." Parents.com, retrieved June 6, 2019. https://www.parents.com/baby-names/vikram/.

———. "Blue-Eyed Beauty." People.com. May 8, 1995. https://people.com/archive/cover-story-blue-eyed-beauty-vol-43-no-18/

Miller, Adam. "*Friends* Boss Reveals Ross and Rachel Were Never Supposed to Go on a Break in the First Place and Imagine What Could Have Been." *Metro*, September 27, 2018. https://metro.co.uk/2018/09/27/friends-boss-reveals-ross-and-rachel-were-never-supposed-to-go-on-a-break-in-the-first-place-and-imagine-what-could-have-been-7985775/.

Miraudo, Simon. "Interview: Jon Favreau, Director of *The Jungle Book*." *Student Edge*, April 7, 2016. https://studentedge.org/article/interview-jon-favreau-director-the-jungle-book

NBC Los Angeles. "Jennifer Aniston on Her GQ Cover: 'It's Photoshopped.'" *Access Hollywood*. July 17, 2009. www.nbclosangeles.com/entertainment/celebrity/Jennifer_Aniston_On_Her_GQ_Cover___It's_Photoshopped__.html

News Corp Australia. "10 Things You Never Knew About TV Show *Friends*." News.com.au. https://www.news.com.au/entertainment/television/things-you-never-knew-about-tv-show-friends/news-story/383b0915471e86e4cf0bacfb8a067ab8

News Corp Australia. "Elle Macpherson's *Friends* Cameo: "I May Not Have Chosen to Do It." News.com.au. September 26, 2016. https://

www.news.com.au /entertainment/tv/flashback /elle-macphersons-friends-cameo--i-may-not-have-chosen-to-do-it/news-story /ead6721c27dedc 2f6a05f9243e53aa84

Nguyen, Vi-An. "10th Anniversary of the *Friends* Finale! The Best Episode from Each of the 10 Seasons." *Parade*, May 5, 2014. https:// parade.com/287893 /viannguyen/10th-anniversary-of-the-friends-finale-the-best-episode-from-each-of-the-10-seasons/

Oaks, Rachel. "Netflix: What the World Is Watching." High Speed Internet. September 19, 2017. https://www. highspeedinternet.com /resources /netflix-what-the-world-is-watching.

Oxford University Press. "My BFF Just Told Me 'TTYL' Is in the Dictionary. LMAO." *OUPblog*. September 16, 2010. https://blog.oup. com/2010/09/noad3/.

Park, Andrea. "So This Is Why Monica's Walls Were Purple on *Friends*." *Glamour*. March 20, 2018. https:// www.glamour. com/story/friends-production-designer-explains-monicas-apartment-purple.

Radloff, Jessica. "David Schwimmer Reveals the *Friends* Episode He Can't Wait to Show His Daughter." *Glamour*, January 27, 2016. https://www. glamour.com/story/david-schwimmer-reveals-the-fr.

———. "Exclusive: The Creators of *Friends* Reveal Brand-New Secrets About the Show." *Glamour*. February 16, 2016. https://www.glamour.com /story/exclusive-the-creators-of-frie.

Rampton, James. "When Helen Baxendale Was in *Friends* She Got Mobbed in the Street, but Now She Reveals: I'm So Glad I Gave Up Fame for a Family." *Daily Mail*. February 10, 2012. https://www.dailymail.co.uk /tvshowbiz/article-2099082 /When-Helen-Baxendale-Friends-got-mobbed-street-reveals-Im-glad-I-gave-fame-family.html.

Rankin, Seija. "In Honor of National Cheesecake Day, Let's Remember the Best Cheesecake Moment in Pop Culture History." *E! News*. July 30, 2016. www.eonline.com /news/783886 /in-honor-of-national-cheesecake-day-let-s-remember-the-best-cheesecake-moment-in-pop-culture-history.

Robinson, Jill. "Friends with Benefits: *Friends* Fans Stunned as They Notice the Entire Geller Family Has Made Sex Tapes." *The Sun*. March 28, 2019. https:// www.thesun.co.uk/

tvandshowbiz/8738096 /friends-geller-family-sex-tapes/

Robinson, Joanna. "Before They Were Famous, the Cast of *Friends* Took a Trip to Vegas Together." *Vanity Fair*. February 18, 2016. https:// www.vanityfair.com /hollywood/2016/02/friends-reunion-vegas-trip.

Romero, Kat. "All the *Friends* Special Guest Appearances from Reese Witherspoon and Denise Richards to Bruce Willis." *Mirror*. January 22, 2018. https:// www.mirror.co.uk/tv /tv-news /friends-famous-cameos-most-list-11879342

Rudd, Paul. "Paul Rudd on a *Friends* Reunion Plus Playing Mike Hannigan's Imaginary Piano Again!" Interview by Ms Lyn Ching. June 26, 2018. https://www.youtube.com /watch?v=PN1AFbvY7nc.

Schwimmer, David. "David Schwimmer Goes from *Friends* to Director." Interview by Medianews and Bob Strauss. *East Bay Times*. April 2, 2008. https://www.eastbaytimes. com/2008/04/02/david-schwimmer-goes-from-friends-to-director/.

———. Interview by David Letterman. *Late Show with David Letterman*. CBS. October 1, 2002. https:// www.youtube.com /watch?v=7njgMPyEtpw.

Shattuck, Kathryn. "14 TV Shows That Broke Ground with Gay and Transgender Characters." *The New York Times*. February 16, 2017. https:// www.nytimes.com/ 2017/02/16/arts/ television/14-tv-shows-that-broke-ground-with-gay-and-transgender-characters.html.

Shen, Maxine. "Friends for Sale—Fan's Guide to the Right Stuff—and How to Get It." *New York Post*. May 4, 2004. https://nypost. com/2004/05/04/friends-for-sale-fans-guide-to-the-right-stuff-and-how-to-get-it/.

Silverman, Stephen M. "*Friends* Leads Nielson Ratings Charge." *People*. October 2, 2002. https://people.com/celebrity /friends-leads-nielson-ratings-charge/.

Smith, Oliver. "12 *Friends* Filming Locations in New York, London and Beyond." *The Telegraph*. February 21, 2016. https://www.telegraph. co.uk /travel/destinations /north-america/united-states /new-york/articles /friends-filming-locations/.

Snierson, Dan. "*ER*, *Friends*, *Seinfeld*: Top 10 Ratings Chart from 1996." *Entertainment Weekly*. May 19, 2016. https:// ew.com/article/2016/05/19

er-friends-seinfeld-top-10-ratings-1996/

———. "*Friends* Finale: Marta Kauffman and David Crane Look Back. *Entertainment Weekly*. April 16, 2014. https:// ew.com/article/2014/04/16 /marta-kauffman-david-crane-friends-finale/

Staughton, John. "Salt Water Taffy: Is It Really Made from Salt Water?" Science ABC. Accessed August 26, 2019. www.scienceabc.com/ eyeopeners/salt-water-taffy-is-it-really-made-from-salt-water.html.

Suhas, Maitri. "This *Friends* Deleted Scene Is the One Clip Most Diehard Fans Probably Haven't Seen Yet—VIDEO." *Bustle*. August 18, 2015. https://www.bustle.com /articles/105071-this-friends-deleted-scene-is-the-one-clip-most-diehard-fans-probably-havent-seen-yet.

Tom, Lauren. "My First (and Nearly Last) Day on *Friends*." Fresh Yarn. http://www. freshyarn.com/10/printer_ ready/print_tom_myfirst.htm.

Tyler, James Michael. "Central Perk's Gunther from *Friends* TV Show Interview." Interview by Susanna Reid, Ben Shephard, and Charlotte Hawkins, *Good Morning Britain*. ITV. September 15, 2015. https://www.youtube. com/watch?v=a8hunwmu69c.

Van Luling, Todd. "5 Stories You've Never Heard About *Friends*, as Told by Monica and Rachel's Super." HuffPost TV. December 6, 2017. https://www. huffpost.com/entry/friends-stories_n_7171600.

———. "11 More Things You Didn't Know About *Friends*, Even If You're a Superfan." HuffPost Entertainment. December 6, 2017. https://www.huffpost. com/entry/friends-show-trivia_n_7564546.

———. "Here's A Brand New Thing You Didn't Know About *Friends*." HuffPost Entertainment. August 3, 2016. https://www.huffpost.com /entry/friends-interview-phoebe-david-mike_n_57a0f1 01e4b0e2e15eb791f8.

———. "My Year-Long Quest to Uncover the Identity of 'Ugly Naked Guy.'" *Huff Post Entertainment*, May 31, 2016. https://www.huffpost.com /entry/ugly-naked-guy-frie nds_n_573caa4ae4b0ef861 71ceaf1f.

———. "Paul McCartney Almost Ended Up on *Friends*." HuffPost Entertainment. May 26, 2015. https://www. huffpost.com/entry/friends-paul-mccartney_n_7417348.

Vollero, Lexi. "14 Times the Cast of *Friends* Has Reunited Since the Finale." *Entertainment Weekly*. May 6, 2019. https:// ew.com/tv/friends-cast-reunions/

Warner Bros. Entertainment Inc. *Friends*: The Complete First Season. Burbank, California: Warner Bros. Television, 2002. DVD.

———. *Friends*: The Complete Second Season. Burbank, California: Warner Bros. Television, 2002. DVD.

———. *Friends*: The Complete Third Season. Burbank, California: Warner Bros. Television, 2003. DVD.

———. *Friends*: The Complete Fourth Season. Burbank, California: Warner Bros. Television, 2003. DVD.

———. *Friends*: The Complete Fifth Season. Burbank, California: Warner Bros. Television, 2003. DVD.

———. *Friends*: The Complete Sixth Season. Burbank, California: Warner Bros. Television, 2004. DVD.

———. *Friends*: The Complete Seventh Season. Burbank, California: Warner Bros. Television, 2004. DVD.

———. *Friends*: The Complete Eighth Season. Burbank, California: Warner Bros. Television, 2004. DVD.

———. *Friends*: The Complete Ninth Season. Burbank, California: Warner Bros. Television, 2005. DVD.

———. *Friends*: The Complete Tenth Season. Burbank, California: Warner Bros. Television, 2010. DVD.

Warner, Sam. "*Friends* Creator Reveals the One Joke She'd Cut from the Sitcom Today." *Digital Spy*. February 5, 2019. https://www.digitalspy.com /tv/ustv/a27341774 /friends-jokes-transgender-hermaphrodite-marta-kauffman/

Weber, Lindsey. "*Friends* Countdown: Is Rachel Green Jewish?" *Vulture*. December 17, 2014. www.vulture. com/2014/12/friends-countdown-is-rachel-green-jewish.html.

White, Adam. "From Marcel to Keiko: Whatever Happened to Some of Film and TV's Most Famous Animal Stars?" *The Telegraph*. July 7, 2017. https:// www.telegraph.co.uk/films/0 /marcel-keiko-whatever-happened-film-tvs-famous-animal-stars/katie-monkey-friends/.

Wilkinson, Amy. "A *Friends* Oral History: 'The One with All the Thanksgivings' Episode." *Entertainment Weekly*. November 22, 2016. https:// ew.com/article/2016/11/22 /friends-oral-history-one-all-thanksgivings/.

Wolk, Josh. "How *Friends* Recruited Reese Witherspoon for Her Guest Role." *Entertainment Weekly*. February 3, 2000. https:// ew.com/article/2000/02/03 /how-friends-recruited-reese-witherspoon-her-guest-role/

Xidias, Angelica. "This Is What It Was Really Like Working on the Set of *Friends*." *Vogue Australia*. February 8, 2019. https://www.vogue.com.au /culture /features/this-is-what-it-was-really-like-working-on-the-set-of-friends/news-stor y/27eaea88f796b9364f5d6b df05633439